DIRECTOR'S CHOICE

THE HUNTERIAN
UNIVERSITY OF GLASGOW

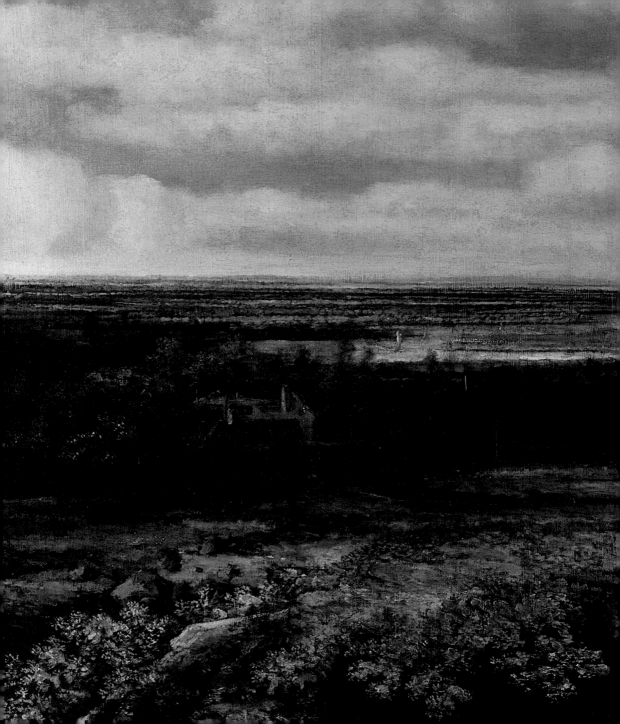

DIRECTOR'S CHOICE

David Gaimster

THE HUNTERIAN
UNIVERSITY OF GLASGOW

SCALA

INTRODUCTION

WITH OVER 1.3 MILLION OBJECTS, The Hunterian at the University of Glasgow is one of the leading university museums and galleries in the UK, if not the world. The Hunterian was the first museum to have its entire collection Recognised as being of National Significance for Scotland.

Founded in 1807, The Hunterian is Scotland's oldest public museum. The Palladian temple built by William Stark in the grounds of the Old College in the centre of Glasgow was designed to house the bequest of Dr William Hunter (1718–1783), the pioneering physician and scientist with a passion for collecting. A former student of the university, Hunter found fame and fortune in London as physician to Queen Charlotte and as a renowned teacher of anatomy and obstetrics. He was elected a Fellow of the Royal Society and of the Society of Antiquaries, and became the first Professor of Anatomy at the Royal Academy of Arts. Hunter was well acquainted with the leading figures of the Georgian Enlightenment, who assisted him in creating an extensive collection of art, antiquities, manuscripts, numismatics, ethnography and natural history specimens, which, together with his anatomical teaching collection, he bequeathed to the university in 1783.

The world's foremost universities have great collections, and Glasgow belongs to that elite group that have invested in museums for research and learning across a wide spectrum of disciplines. Amongst The Hunterian's treasures today are the scientific apparatus used by James Watt, Joseph Lister and Lord Kelvin; monumental sculpture and antiquities from the Antonine

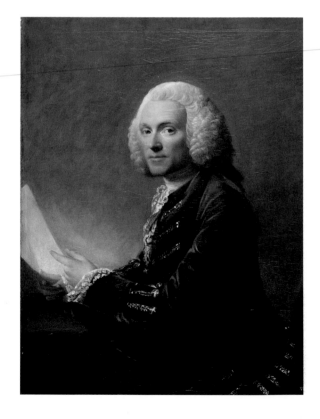

William Hunter, *c.*1764–65, by Allan Ramsay (1713–1784).

The Hunterian Museum, 1807–70, by William Stark (1770–1814). [Photograph by Thomas Annan, *c*.1870]

The Hunterian Museum main gallery (part of the new University of Glasgow campus) designed by Sir George Gilbert Scott (1866–1870).

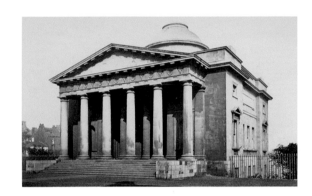

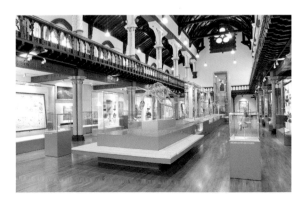

Wall; major earth and life sciences holdings; Scotland's most important print and numismatic collections; rare 'first contact' artefacts from the Pacific Ocean; and extensive collections of European and Scottish art and design, including the personal estates of the artist, James McNeill Whistler, and the architect and designer, Charles Rennie Mackintosh.

The Hunterian has undergone many changes since 1807. The relocation of the University of Glasgow from the industrialised city centre to the west in 1870 meant the demolition of the first Hunterian and the creation of new galleries within the Gothic Revival teaching campus designed by Sir George Gilbert Scott. Both Hunterians have been blueprints for subsequent generations of museum architecture. A new art gallery designed by William Whitfield was opened in 1980, together with a building housing the interiors of the Glasgow home of Mackintosh. Recently, new galleries have been created, including *The Antonine Wall: Rome's Final Frontier*. Today, as before, The Hunterian supports its university in delivering exemplary research, in providing an excellent student experience and in reaching the global community.

Having only arrived at The Hunterian a year ago, the prospect of writing a *Director's Choice* on such an encyclopaedic collection was a daunting one. However, it has been a truly absorbing experience to tour the collections and to speak to our curators and our visitors about the objects that most appeal to them. I hope this final conspectus gives a good sense of the scope and strengths of our collections. The objects I have chosen all tell a compellng narrative in respect of their origin and what they reveal about the changing intellectual climate of collecting and research over 200 years. I would like to think William Hunter might approve of this *Director's Choice*.

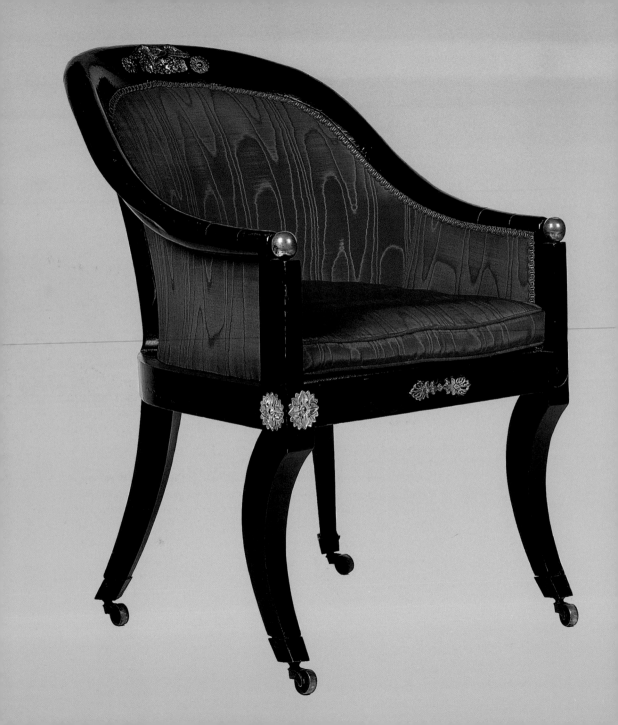

Chair, 1809

MESSRS CLELAND & JACK
Glasgow *c.*1791–1865
Black-painted hardwood, moreen and brass ornaments, 87 x 56 cm
C.12

DR WILLIAM HUNTER bequeathed his extensive collections of human and natural history to the University of Glasgow, his alma mater, before his death in 1783. In 1807 they were transferred from London to a new pur-pose-built museum in the grounds of the Old College designed by Glasgow architect William Stark. The exterior of the museum, executed in the Roman Doric order, was of temple form, raised on a plinth with a wide flight of steps leading to the entrance portico. It was one of a group of newly erected public buildings, including hospitals, churches and banks that gave early nineteenth-century Glasgow the stamp of a well-planned classical city.

Invoices in the university archives reveal that the interior of the new museum was furnished by the local cabinet makers and upholsterers, Cleland & Jack, between May 1808 and September 1809. The eight Roman chairs belong to an order otherwise containing a circular library table with lion feet and two writing tables. The chairs, covered with fine crimson moreen (an embossed wool and cotton fabric) and fitted with brass orna-ments, were supplied at a cost of £35 each. Their design – continuous bow back and sabre forelegs, the uprights capped in brass ball finials – is found in British country houses of the Regency period. The Cleland & Jack invoices give some idea of the colour scheme of the museum 'saloon', which appears to have been mahogany and black, offset by the dazzling crimson upholstery of the Roman chairs. The Palladian architecture and Empire-style interior of Scotland's first public museum combined to create one of the finest classical buildings in Regency Britain. The Roman chairs and other furnishings of the 1807 Hunterian are a unique survival of the interior aesthetic of early nineteenth-century museums.

Carved stone ball, *c.*3200–2500 BC

Scotland, Neolithic period
Igneous rock, perhaps diorite or syenite, diameter 6.9 cm
Bishop Collection, B.1914.355

CARVED SPHERICAL STONE BALLS, of which there are several complex forms, are a uniquely Scottish feature of the Neolithic period, with over 425 known. The majority are similar in size, their carving ranging from shallow incised spirals, dots and rings to deeply carved discs and multiple nodules, as in the case of this Hunterian example. A variety of stone was used, many being made from dark, greenish igneous rock, such as diorites, dolerites and basalts.

The technical knowledge and craftsmanship required to fashion these stone balls was considerable. Most balls would have been rounded before decoration, presumably by sand and water. Lab analysis suggests that percussion chipping was common and that flint would have been used for the sharper edges, although bronze tools may also have been employed, especially to define the deeply carved nodules.

Many archaeologists have speculated over the years as to the purpose of these beautiful objects. One recent theory emphasises the uniform mass and aerodynamic qualities of the balls to suggest that they were optimal for throwing by hand, perhaps in competition or as a projectile weapon. The elaborate decoration would have assisted the grip of the ball and helped to identify ownership. So few of the balls have been found in graves that it is perhaps more likely they served as family or clan possessions rather than personal ones. Given the time and energy invested in manufacture, it is clear that the balls were prestige objects. However, concrete evidence for their use continues to elude us. Notwithstanding this uncertainty, our admiration for these objects and the skilled Stone Age craftsmen who made them is undimmed.

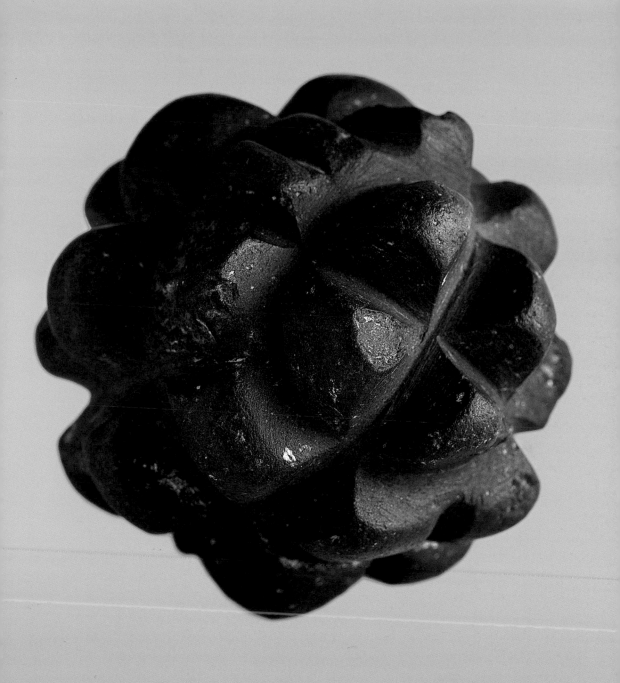

Inscribed distance slab of the twentieth region, *c.*142–43 AD

Roman, Antonine Wall, Scotland
Sandstone, 75 x 95 x 14 cm
Gift of Mr J. McIndeor, 1969
F.1969.22

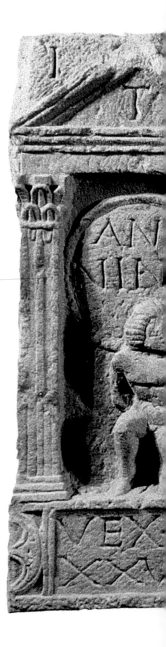

THE ANTONINE WALL is one of the UK's foremost historical and artistic monuments, but its precise purpose and short lifespan remain somewhat of an enigma. Constructed in the early 140s AD and abandoned within a generation, it stretched some 60 km from the Firth of Forth to the River Clyde. It was the most northerly border in the Roman Empire and Britannia's final frontier.

The arrival of the Romans in Scotland not only altered the structure of local society but also changed the landscape itself. Roman architecture, in particular the stone buildings with glass windows and decorated columns, would have looked and felt very alien to the native Iron Age population. The new frontier transformed the horizon, both physically and mentally.

The brutal reality of that clash of cultures is represented in the scenes depicted on the Antonine Wall 'distance slabs'. Designed to record lengths or 'distances' of the wall completed by each legion, their carved iconography celebrates the Roman military victories that preceded the construction of the Antonine Wall. Placed on the south side of the wall and facing the empire, the sculpted scenes served as powerful political propaganda for a civilian emperor who needed to acquire a quick military reputation. This powerfully carved slab from Hutcheson Hill, Bearsden, symbolises Roman victory over the Caledonian tribes. The central female figure is probably Britannia who, as the representative of the Romanised population of the province, congratulates the Roman troops on their success.

The 18 surviving slabs, of which all but two are in The Hunterian's collections, mark the culmination of a successful campaign by the Romans to extend the limits of their empire and recall scenes on a triumphal arch, celebrating the army victorious and the native population in defeat.

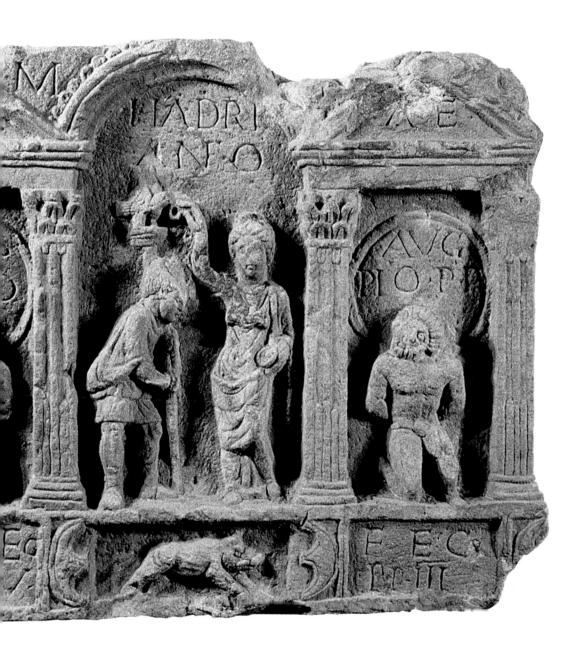

Drain cover, *c*.142–43 AD

Roman, Antonine Wall, Scotland
Sandstone, 105 x 94 x 14 cm
Scottish Development Department. Ancient Monuments (now Historic Scotland), 1978
F.1982.6

THE ANTONINE WALL was supported by a complex network of forts and other military installations. Forts housed the occupying Roman troops and were themselves supported by adjoining civilian settlements.

Excavations of the Antonine Wall forts over the years have produced a rich picture of the adoption of the Mediterranean lifestyle on the northern British frontier. Almost everywhere we find imported luxury domestic goods from around the Mediterranean and western Europe, including jewellery, moulded glass and refined ceramic vessels, many of which found their way into use amongst the local Iron Age population. The archaeological record illuminates the considerable imperial and cultural investment involved in maintaining the northern frontier of the empire.

Bath-houses with piped water and drainage systems are a key feature of the Roman military settlement on the wall. An insight into the architectural and engineering sophistication of these buildings comes from Bothwellhaugh fort, North Lanarkshire. Here an elaborately carved drain cover was preserved in situ in the paved floor of the bath-house's frigidarium (cold room). The cover has a pierced central circular opening in the form of a six-pointed star inside a wavy frame. Given the thickness of the slab, the carving is a highly skilled achievement and serves to emphasise the importance in the Roman world of combining style with utility.

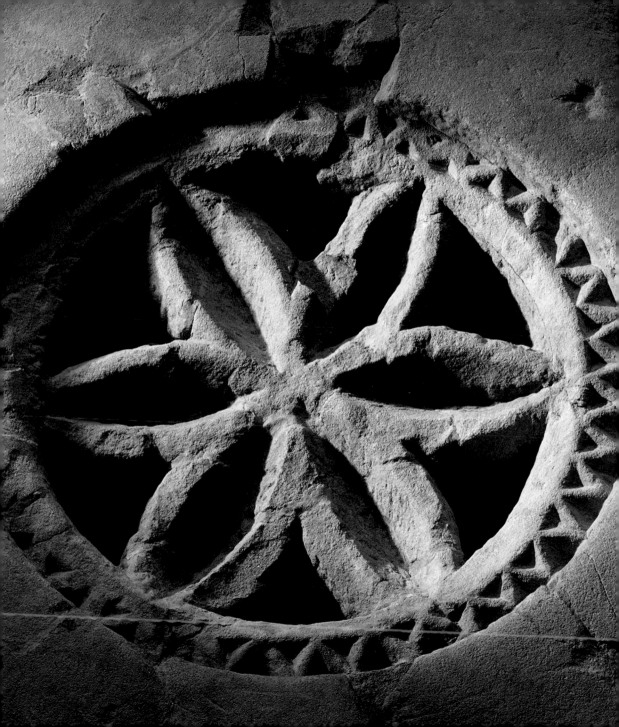

Kunyu Quantu (A Map of the Whole World), 1674

FERDINAND VERBIEST
Flanders 1623–1688
Woodblock print on paper lined with linen, approx. 168 x 307 cm
William Hunter bequest, 1783
E.289

WILLIAM HUNTER'S COLLECTING interests were truly encyclopaedic. Sometime between 1765 and 1779 Hunter purchased the library of Heinrich Walter Gerdes (d. 1742), a Lutheran pastor in London and Fellow of the Royal Society. Amongst Gerdes's collection was a copy of Ferdinand Verbiest's *Map of the Whole World*, which the deceased had acquired from Theophilus (Gottlieb) Siegfried Bayer (d. 1738), Professor of Greek and Roman Antiquities in St Petersburg, who had connections to Jesuit missionaries in Beijing.

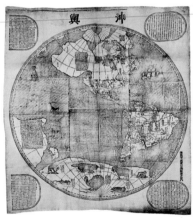

Ferdinand Verbiest's *Map* is a rare survival of early global cartography produced by Jesuit missionaries in China, who were welcomed by the imperial court on account of their scientific knowledge, particularly of mathematics and astronomy. In 1669 the Flemish Jesuit Ferdinand Verbiest was appointed director of the Imperial Observatory. The second Manchu Qing emperor, Kangxi (1662–1722), was concerned with consolidating his power and so required reliable maps of the empire and the world beyond.

The map reflects many of the tensions in Western and Chinese cartography in the seventeenth century. Western map makers were concerned with perspective and scale, while their Chinese counterparts did not think this was important. Here we see mountains drawn in elevation and rivers in plan. To compensate for the absence of an accurate scale, the map is heavily annotated.

Based on Mercator's projection, the map consists of two hemispheres showing the five continents as they were known at the time: Asia, Africa, America and Magellanica (the uncharted southern part of the globe). Cartouches record information on the size, climate, land-forms, customs and history together with details of natural phenomena, such as eclipses and earthquakes. Columbus's discovery of America is also noted. Images of ships, together with real and imaginary animals and sea creatures taken from Western sources, create a visually stunning effect.

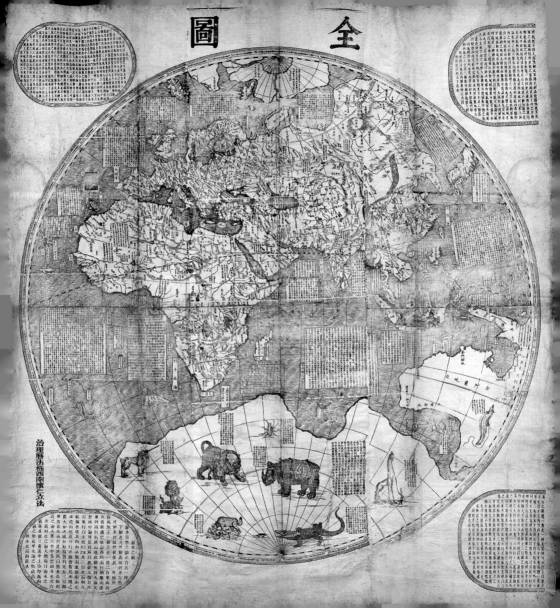

Headrest, late 18th century

Tonga, western Polynesia
Hardwood, length 106.3 cm
William Hunter bequest, 1783
HMAG E441/3

CAPTAIN JAMES COOK (1728–1779) made three exemplary voyages of exploration across the Pacific during the third quarter of the eighteenth century. These voyages brought new scientific, geographic and cultural knowledge to Enlightenment Britain. Today, museum collections in Britain and Europe are the beneficiaries of Cook's expeditions for their 'first contact' collections of natural specimens and cultural objects from the Polynesian world. On Cook's third voyage (1776–79), where he also met his death, the *Resolution* and the *Discovery* visited New Zealand, Tonga, the Society Islands and Hawaii, where they bartered nails, metal tools, cloth and clothing in exchange for local natural specimens and artefacts. On the expedition's return to England in October 1779, Sir Joseph Banks, the eminent natural historian and member of the first voyage, became the principal recipient of

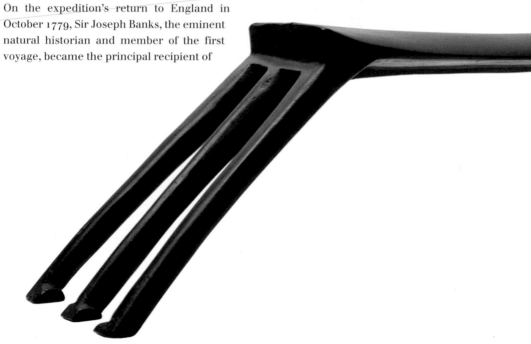

their collections. William Hunter probably acquired his Polynesian and North West Pacific cultural objects from Banks, a fellow member of the Royal Society and Society of Antiquaries.

Listed as a 'sleeping stool' by Captain John Laskey in his 1813 catalogue of The Hunterian Museum, this spectacular headrest most likely derives from Cook's third voyage which landed at Tonga in western Polynesia. Carved from a solid block, it was intended as a pillow to prevent the elaborate hairstyles of high-status people from becoming disarranged. Although in principle a single form, all the headrests collected on the expedition vary in the profiling of the headrest and the shaping of the legs. This metre-wide splayed three-legged structure is almost architectural, if not proto-Bauhaus, in design.

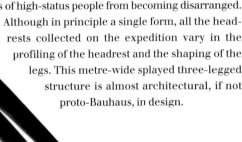

Stater of Athens, *c.*295–294 BC

Athens
Gold, diameter 1.7 cm
William Hunter bequest, 1783
GLAHM 18628

IT WAS RECORDED at a meeting of the Society of Antiquaries of London in 1782 that Dr William Hunter possessed a coin cabinet that was second only to that of the King of France. Hunter spent a total of £22,000 on building up his numismatic collections, with the result that, on his death in 1783, it surpassed that of King George III.

Hunter's principal interest lay in classical coins. Amongst the most visually compelling are the gold 'staters' of Athens of the third century BC, minted with the helmeted portrait of Athena as goddess of war and the Owl of Wisdom, the goddess's secondary attribute. Gold issues are very rare; most are struck in silver from Athenian mines. This particular coin was issued during the so-called tyranny of Lachares, the Athenian general who ruled Athens briefly with the help of mercenary soldiers between *c.*297 and 294 BC. Lachares is reported as having stripped the gold sheet from the shields on the Acropolis friezes in order to produce gold bullion to pay his mercenaries, Athens being under siege at this time from Demetrius Poliorcetes ('the besieger'), King of Macedon.

The Athenian gold stater is probably one of the most iconic coins to survive from ancient Greece, but its history and the source of its precious metal makes it one of the most historically poignant. When King George III gave this coin to William Hunter it was the only specimen known.

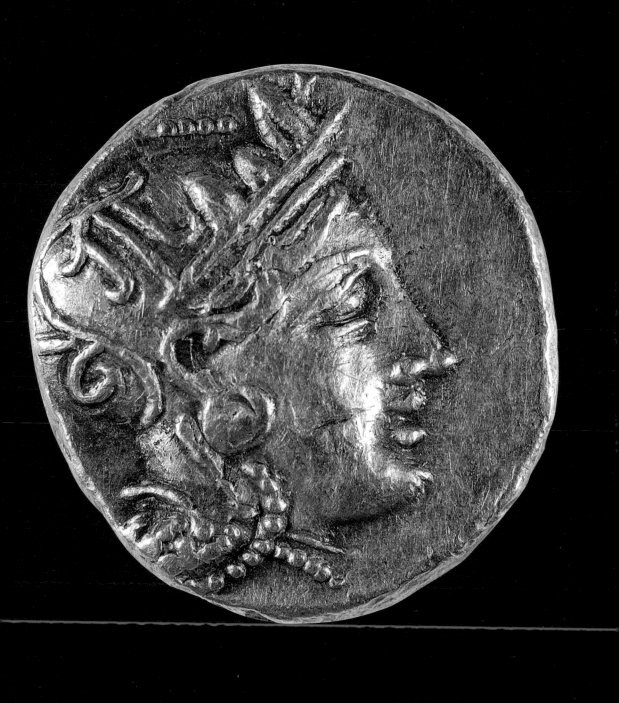

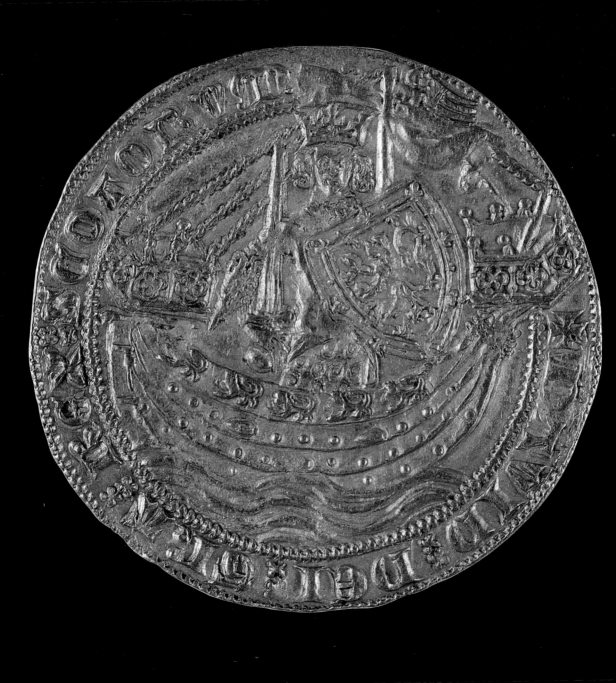

Noble of King David II, *c.*1357

Scotland
Gold, diameter 2.2 cm
William Hunter bequest, 1783
GLAHM 18629

IN ADDITION TO CLASSICAL COINAGE, William Hunter was also tempted by British historical coins, amongst which this rare gold 'noble' of King David II of Scotland (1329–1371) stands out. David Bruce, son of Robert, invaded England in 1346 and was captured at the Battle of Neville's Cross near Durham, remaining a prisoner of King Edward III for 11 years before the ransom of 100,000 marks was promised for payment over 10 years.

One of four David II gold nobles known to survive, this coin was probably minted with the principal purpose of helping to pay David II's ransom. Once delivered, these would have been restruck into English nobles: hence the low survival rate. The Scottish noble is a direct replica of the Edward III noble of 1351, except for the king's name and title and the lion rampant appearing on the shield held by the king standing in the ship. The reverse of the noble has an elaborate cross with crowned lions and the legend from Luke IV:30, 'IESUS AUTEM TRANSIENS PER MEDIUM ILLORUM IBAT' ('But Jesus, passing through the midst of them, went his way'). It is thought that the biblical quote around the edge served to deter clipping. The gold noble was the largest single coin in circulation in the fourteenth century and was the equivalent of half a mark (6s–8d).

William Hunter purchased the David II gold noble for £21 in 1780. It belonged to a hoard of 226 gold nobles, predominantly those of Edward III, discovered in 1775 beneath the flagged floor of an upper room at Fenwick Tower in Northumberland. The hoard represents one of the greatest treasure finds in British history and is testament to a truly catastrophic episode in Scottish relations with England, both militarily and financially.

Pistole of William II, 1701

Scotland
Gold, diameter 2.4 cm
William Hunter bequest, 1783
GLAHM 18630

By THE TIME OF HIS DEATH in 1783 William Hunter had amassed a cabinet containing over 30,000 coins and medals. Amongst his Scottish series is this rare gold 'pistole' issued in 1701 during the reign of William II of Scotland (King William III of England). A rising sun over the sea is the crest of the Company of Scotland Trading to Africa and the Indies, which, having acquired a quantity of gold dust from Guinea, persuaded the Privy Council to issue gold coins 'for the honour and interest of the kingdom'. The company made some profit on the undertaking by making the coins weigh 10 per cent less than they should. The profit was, however, considerably reduced since the gold was found to be below standard and had to be refined at some cost.

The coin is an important historical document of the Company of Scotland, founded in 1695 and also known as the Scottish Darien Company after its failed colony in Darien on the Isthmus of Panama, which was intended to be a trading point between Europe and the Far East. Although five ships and 1,200 Scottish colonists landed successfully at Darien, the settlement of 'New Caledonia' was poorly provisioned and eventually abandoned (only 300 survivors finally returned to Scotland). Word of the disaster did not reach Scotland in time to prevent a second larger expedition, which occupied the deserted settlement but was quickly besieged by the Spanish. More than a thousand succumbed to hunger and disease, and in April 1700 two ships carried the survivors back across the Atlantic.

The 'Darien Scheme' drained Scotland of an estimated quarter of its liquid assets and was instrumental in encouraging Scots support for the Act of Union of the Kingdoms of Scotland and England in 1707. The new joint government agreed to cover the Scottish government debt to its people. Whilst the rising sun radiates optimism, Darien was a bitter experience for Scots in this early encounter in the New World.

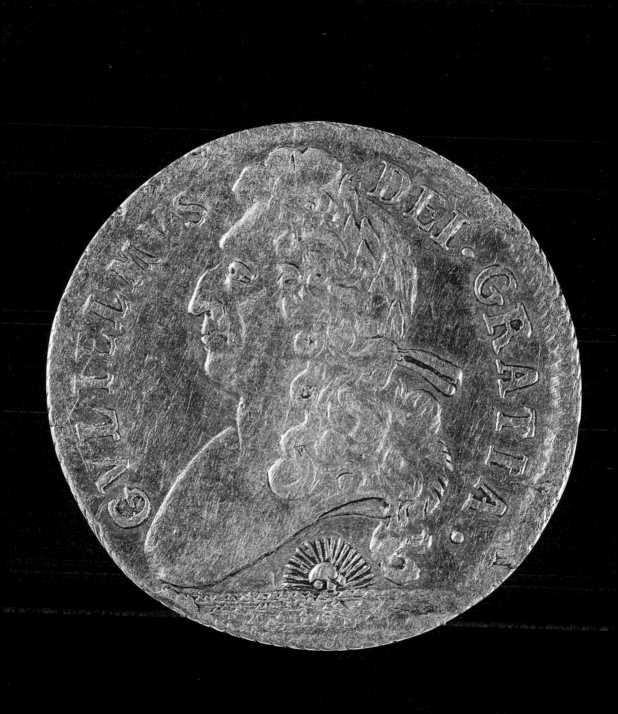

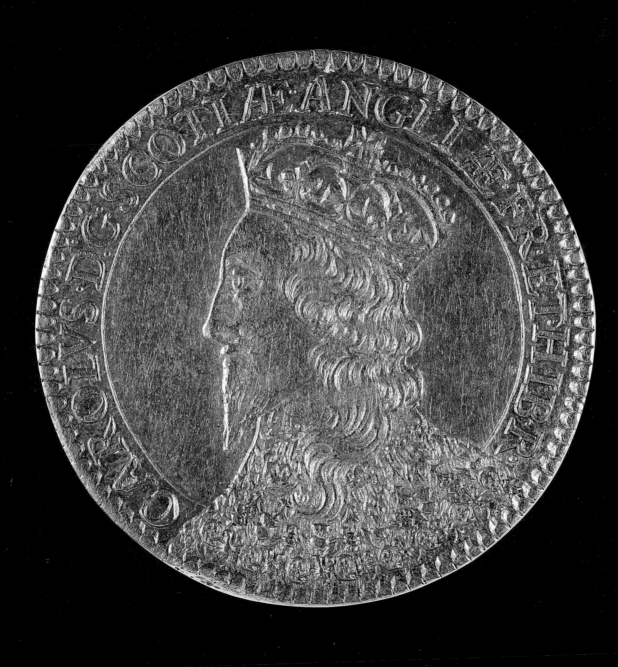

Coronation medal of King Charles I, 1633

Scotland
Gold, diameter 2.8 cm
William Hunter bequest, 1783
GLAHM 19097

WILLIAM HUNTER managed to acquire one of only three known gold coronation medals of King Charles I, designed by Nicholas Briot and minted in Edinburgh in celebration of the king's Scottish coronation on 18 June 1633. The medal, showing the bust of the king wearing the collars of the Garter and the Thistle, is minted from Scottish gold mined chiefly in Niddesdale and Clydesdale.

Such a medal, probably commissioned as a gift for prominent coronation guests and ambassadors, features in the inventory of pictures and rarities belonging to Charles I and is cited as '… much worn in his Majty's pocket'.

Raised in England since he was a toddler, Charles made his first return visit to his ancestral homeland for his coronation as King of Scotland. He might not have bothered to come home at all. Despite repeated requests, his countrymen had refused to send the Scottish regalia, or crown jewels, to London. And so it was with some reluctance that he made the journey to Edinburgh. Charles's lack of understanding of Scottish sensitivities shines through this whole episode. He did not like the thought of Scone, the traditional crowning place of Scottish kings, and opted for the Palace of Holyroodhouse instead. He was accompanied by the Archbishop of Canterbury, and the Anglican gloss on the ceremony was obvious. Charles's relationship with Scotland as its monarch had got off to a poor start and would contribute to his eventual downfall.

Mastodon tooth, *c.*12,000–8,000 BC

Pleistocene epoch
Height 15 cm
William Hunter bequest, 1783
GLAHM V5132

WILLIAM HUNTER WAS AN ANATOMIST, physician and medical teacher, but also a collector and influential natural scientist engaged at the epicentre of London's scientific community in the mid-eighteenth century. In 1768 he was the first to argue in a paper read to the Royal Society, based on anatomical studies of its jaws and teeth, that the recently discovered mastodon or 'American *incognitum*' was an unknown species that was probably extinct. In postulating that the beast had been a monstrous carnivore, Hunter caused a sensation, giving the Founding Fathers on the eve of the American Revolution a rationale for making the Ice Age mammal a symbol of the new nation. Hunter's theory contributed to a new national myth, that an enormous quadruped could surely best the lion, the emblem of British imperial power. During the Revolution George Washington and Thomas Jefferson collected its bones; for them its massive jaws symbolised the violence of the natural world and the emerging nation's own dreams of an empire in the western wilderness.

Hunter's pioneering theories on extinction played a significant part in scientific thought of the Enlightenment and in the development of American national consciousness. Because the birth of the nation occurred simultaneously with this discovery of prehistoric nature, early American national rhetoric was filled with images drawn from biblical accounts of the Earth's history, creating an American antiquity that the nation's inhabitants related directly to Noah's Ark and the Flood. Genesis and geology, prehistory and patriotism were decisive ingredients in the making of the national creation myth. For republicans the fossil remains of the mastodon symbolised the Manifest Destiny of the chosen people, descending from the history of the Earth rather than from the ruins of ancient Greece and Rome, so admired in Augustan England. Rarely has an antediluvian fossil acquired such potency as a political totem.

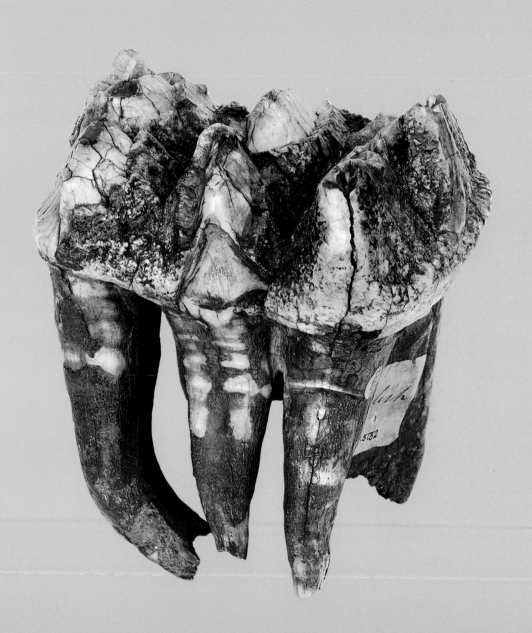

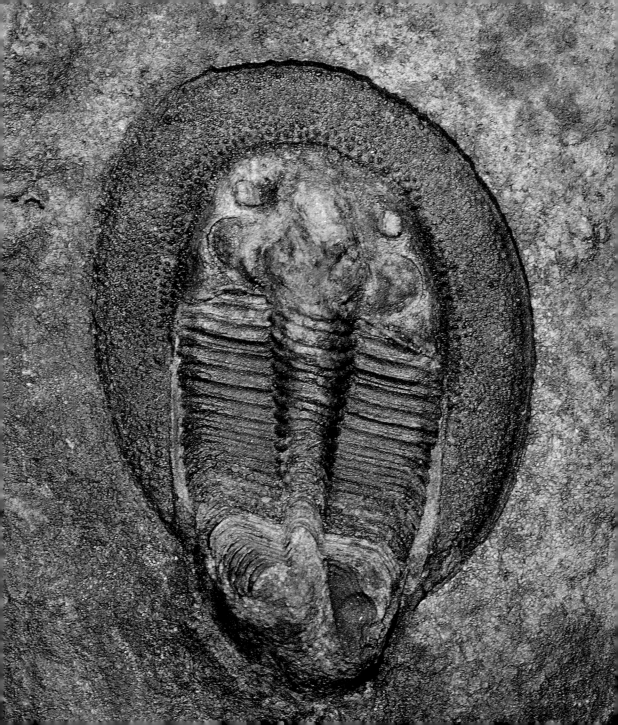

Trilobite, 447 million years old

Ordovician epoch
Length 6 cm
George Rae bequest, 1998
GLAHM 114854

SCOTLAND HAS AN INCOMPARABLE VARIETY of geology for a country of its size. For centuries it has been the origin of many significant discoveries and several important figures in the development of the discipline. Amongst The Hunterian's Scottish fossil collection are the Bearsden shark and the world's smallest dinosaur footprints from the Isle of Skye. Dinosaur remains always attract, but amongst the most compelling are the trilobites collected by the pioneer geologist George Rae from rock exposures near Girvan, South Ayrshire. The area is well known as a trilobite hunter's paradise. George Rae spent much time and energy collecting from one particular 447 million-year-old (Ordovician) rock exposure called the Lady Burn Starfish Beds. The rocks revealed the remains of animals caught up in submarine sediment slides that dragged them into the murky depths of the ocean and entombed them in sand and sediment. As a result many of the fossils are well preserved and often complete.

Trilobites are a fossil group of marine anthropods that first appeared 526 million years ago in the Cambrian period. Trilobites completely disappeared around 250 million years ago during a mass extinction that eliminated 96 per cent of the species on Earth. They were among the most successful of all early animals that roamed the oceans for over 270 million years. Because trilobites had an easily fossilised exoskeleton, which moulted several times in a lifetime, an extensive fossil record remains, with some 17,000 known species. Trilobites lived either on the sea bed or swam at great depths in the oceans, as predators and scavengers, feeding on plankton or filter feeding. The Hunterian trilobites help us better to understand ecological events in the ancient Iapetus Ocean, the precursor of our Atlantic. Ohio has adopted the trilobite as its state fossil. Perhaps Scotland could emulate the geological allegiance of the Midwest?

Meteorite, about 4,560 million years old

5.6 x 5.2 x 3.4 cm
Given by Miss Crawford, 1810
M172

JUST OVER 200 YEARS AGO, on 5 April 1804, quarrymen working at High Possil, on the edge of Glasgow, were astonished when what they thought was a cannonball smashed into the ground only yards from where they were working. One observer described a trail of smoke containing a 'red object'. The *Glasgow Herald and Advertiser* for 30 April notes a sound resembling 'four reports from the firing of a canon [sic], afterwards the sound of a Bell, or rather a Gong, with a violently whizzing noise'. Parts of the meteorite were recovered and then donated to the newly opened Hunterian Museum at the University of Glasgow.

The High Possil meteorite belongs to the chondrite family, which, like most meteorites, comes from the asteroid belt between Mars and Jupiter, where small fragments of rock left over from the formation of our solar system around 4,560 million years ago orbit around the sun. Occasionally some are dislodged from their orbit and crash into a planet as meteorites. Astonishingly, about 100 tons of meteorite debris falls to Earth each day, mainly as small dust particles; and large meteorites are much rarer. The High Possil meteorite is estimated to have been in the order of 4.5 kg on impact, and this is the largest surviving fragment.

Until relatively recently there was little understanding of matter deriving from outer space. A common explanation was that such objects were volcanic or were even created by divine thunderbolts. However, the High Possil event was one of three witnessed meteorite falls at the turn of the nineteenth century that were carefully documented and helped to create a more scientific understanding of creation. This is the oldest object at the Hunterian, and predates the birth of our own planet.

Crystallised silver in calcite, geological date unknown

Collected mid-18th century from the silver mine at Alva, Clackmannanshire
5.1 x 4.1 x 3.4 cm
William Hunter bequest, 178
M953

BETWEEN 1765 AND 1781 William Hunter spent at least £1,500 on mineral specimens, enabling him to amass one of the finest research collections in Britain for the time. The collection survives largely intact today, and his library contains pioneering mineralogical and geological works, including his presentation copy of William Hamilton's classic 1776 study of the lavas of Vesuvius.

Among Hunter's collection is the finest specimen of silver known to survive from the mine worked by the Erskine family at Alva, Clackmannanshire. The mine has an extraordinary history. The silver deposit was discovered on the lands of Sir John Erskine of Alva just prior to the first Jacobite uprising in 1715. Sir John was a staunch supporter of the Stuart cause in exile, while Lady Erskine kept the mine secret, and buried a stockpile of silver ore to prevent Government confiscation. Following the unsuccessful revolt, Lady Erskine managed to gain a pardon for her husband by offering the Government a share of the silver mine. Isaac Newton, by then Master of the Mint, was involved in assaying the silver ore to ensure that the mine was as valuable as claimed. In 1758 cobalt ore was discovered in the mine, and it gained a new, if short, lease of life supplying blue pigment for the porcelain industry.

Very few silver specimens survive from the illicit Jacobite mine. The Hunterian specimen, with its spectacular crystallised branch formations or dendrites, documents one of the most dramatic episodes in British mining history. Mining for precious metals is being revived in Scotland in response to soaring bullion prices, although it is unlikely that any new discoveries could possibly match the striking appearance or historical importance of the Erskine specimen.

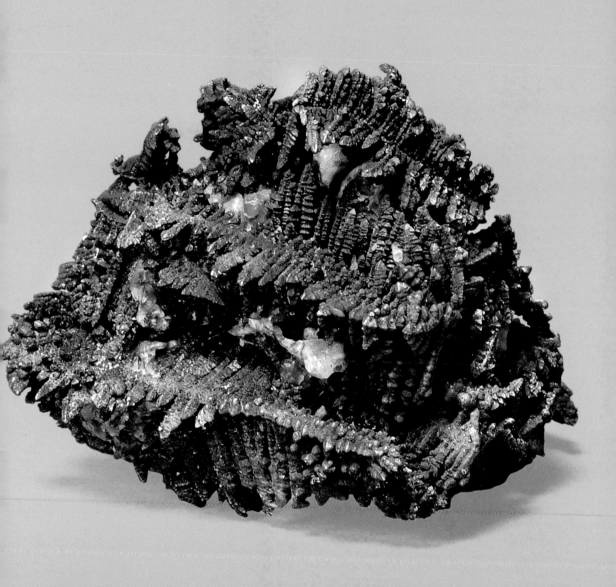

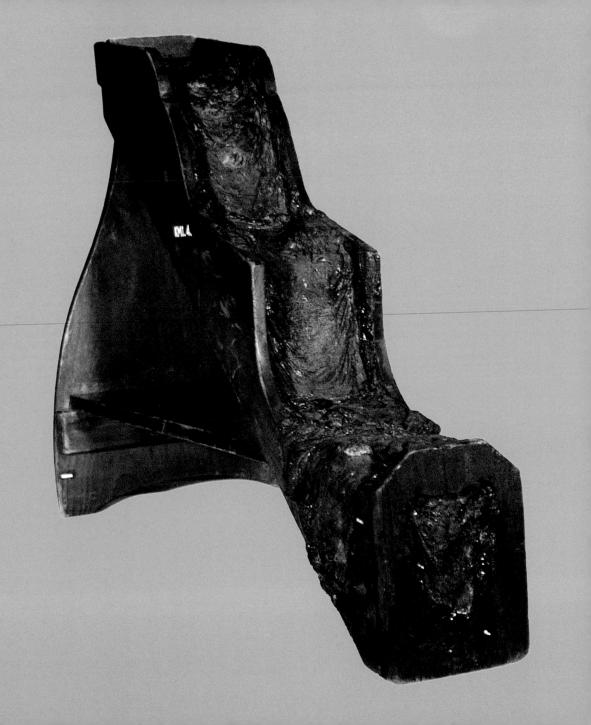

Pitch glacier experiment, 1887

SIR WILLIAM THOMSON, BARON KELVIN OF LARGS
Belfast 1824–1907 Largs, Ayrshire

Wood and pitch, 75.5 x 31.2 x 54 cm

Transferred from Department of Physics and Astronomy, 1981

GLAHM 113597

LORD KELVIN PIONEERED the mathematical analysis of electricity and the formulation of the first and second laws of thermodynamics, and is rightly regarded as the greatest applied physicist of the Victorian age. The Hunterian holds much of Lord Kelvin's original experimental apparatus, created during his 53-year tenure at the University of Glasgow, which he began in 1846 at the age of 22, as Professor of Natural Philosophy. A hallmark of Kelvin's problem-solving technique was his use of experimental apparatus. He could visualise scientific phenomena more effectively by designing a model: 'I am never content until I have constructed a mechanical model of the subject I am studying. If I succeed in making one, I understand; otherwise I do not.' Kelvin introduced the then revolutionary practice of teaching science by example and demonstration.

In the later 1880s Kelvin was intrigued by the theory that the atmosphere around us consists of tiny particles that are possessed of energy, and thus can exert force upon larger matter. This demonstration piece, the 'creeping pitch glacier', is composed of cobbler's wax positioned on a stepped wooden support. The pitch glacier was used to show that small, persistently applied forces are sufficient to produce unlimited changes in the shape of a substance over long periods of time. The experiment is still live after over 120 years. This ingenious model gives new meaning to the phrase 'glacial progress'.

Kelvin designed a number of experiments to explore the longevity of scientific phenomena, including another that still runs. Begun in 1872, it consists of twin tubes 5.3 metres high, filled respectively with copper sulphate solution and coloured alcohol over water. Over time, gradual mixing of the liquids occurs.

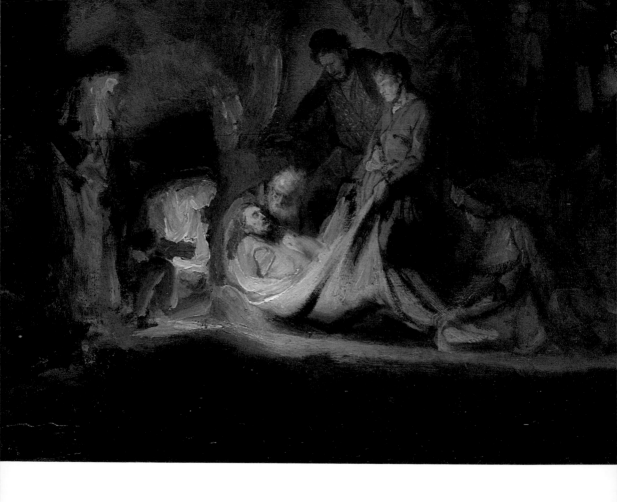

A Sketch of the Entombment, c.1636–46

REMBRANDT HARMENSZ. VAN RIJN
Leiden 1606–1669 Amsterdam
Oil on panel, 32.3 x 40.5 cm
William Hunter bequest, 1783
GLAHA 43785

THIS WELL-PRESERVED PAINTING is surely one of the jewels of William Hunter's collection of 60 Old Masters, and is only one of 10 oil sketches known by Rembrandt. The identification of the painting as a 'sketch' can be traced to its earliest mention in Rembrandt's insolvency inventory of 1656, when a work hanging in his private living room was identified as 'Een schets van de begraeffenis Christi'. Whether intended as a design for an etching or whether it is simply a small unfinished painting, there has never been any doubt about the emotive power of this magnificent work.

The image is close to the *Entombment* canvas painted between 1636 and 1639 as part of the Passion series for the Dutch Stadholder, Frederick Henry of Orange, now in the Munich Pinakothek. Its scale is indeed close to other works that functioned as preparatory studies for etchings. But there are significant differences, not least the fact that comparable monochrome studies, such as the *Ecce Homo* sketch on paper in the National Gallery, London, has a laboured emphasis on the outlines and forms to be followed by the engraver. We await the results of recent scientific analysis, but possibly the painting should be seen as an example of the small-scale history paintings that were regarded as Rembrandt's greatest achievements by the very man who commissioned the Munich Passion series for the Stadholder, Constantijn Huygens. Huygens's description of the young Leiden artists, Jan Lievens and Rembrandt, written in 1629–31, is famous for the contrast he drew between the monumental works of Lievens and the intense emotional studies of Rembrandt, as here, on a small scale.

Landscape in Holland, *c.*1665

PHILIPS KONINCK
Amsterdam 1619–1688

Oil on canvas, 116.8 x 155 cm
William Hunter bequest, 1783
GLAHA 43744

THIS TRULY IMPRESSIVE PAINTING was probably among William Hunter's earliest art acquisitions but bore a false signature of Rembrandt applied by an optimistic or unscrupulous dealer. This painting is, in fact, an outstanding example – perhaps the most characteristic – of Philips Koninck's very distinctive speciality, the panoramic landscape. On a large and vivid scale, and with no specific topographical references, Koninck confronts the viewer with the phenomenon of the flat and watery Dutch landscape.

Koninck's technique of alternating patterns of light and dark, with clusters of trees, water and open ground, up to where the landscape meets the sky, leads the viewer visually from foreground to distance. The artist was perhaps the master of the elevated bird's-eye view. For me, the vertiginous scene, half of which is given over to rolling clouds and sky, provokes a kind of out-of-body sensation. Another Koninck elevated landscape panorama exists in the National Gallery, London, but the Glasgow picture, with its added interest of the town with its spires and windmills in the foreground, has the greater drama. Standing in front of it, I find this painting quite mesmerising in its technical brilliance and visual effect.

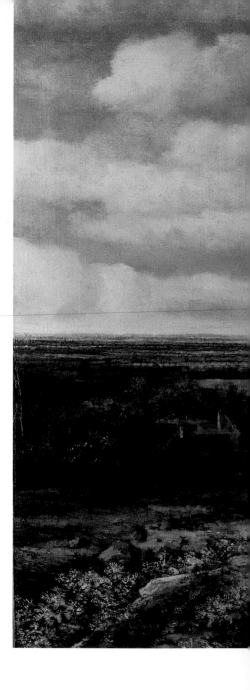

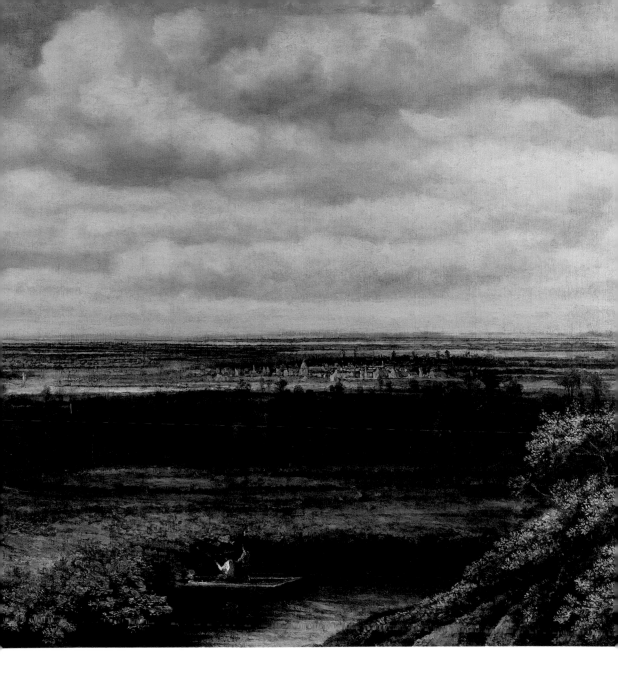

Still Life with Gun and Fowling Equipment, 1684

JOHANNES LEEMANS
The Hague *c.*1633–1688

Oil on canvas, 114.3 x 156.2 cm
Gift of Miss Ina Smillie, 1963
GLAHA 43751

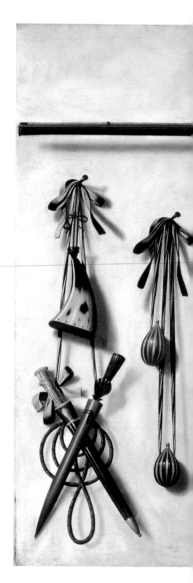

THIS LARGE DEPICTION of full-size hunting equipment was painted in The Hague, home to the Dutch court, a city with areas of dunes and woods perfect for hunting wildfowl. This painting is a *trompe-l'œil* (French for 'deceiving the eye'), a deceptively accurate depiction intended to trick the viewer into believing for a brief moment that he is being confronted with real objects, not a two-dimensional image of them. One characteristic of seventeenth-century Dutch painting is a high degree of specialisation, including within the still-life genre. A number of artists took up the fashion for *trompe-l'œil* painting, which itself split into various sub-genres, including dead birds, hunting equipment and letter racks. The subject matter was depicted protruding from a neutral background, typically a board or plaster wall, giving the illusion that the objects were actually in the same room as the viewer. The paintings were often used as 'overdoors', a format well suited to the genre.

Johannes Leemans specialised in fowling pieces with decoy, hunting rifle, powder horn and hunting bags suspended on large nails and arranged symmetrically around the canvas. At the centre is a bird cage with seed trough. The historical authenticity of every object can be verified either in museum collections or archaeologically, thus amplifying the illusionary reality of the scene even to the modern observer. In the seventeenth century the Dutch were well attuned to the double meanings of all kinds of painting, not least still lifes, and prolific interpretative sources existed for them in the literature of the emblem book and in popular prints. They would have had no difficulty in identifying the erotic charge of this image of bird cages and hunting equipment, since the Dutch word *vogelen*, meaning bird hunting, was used as a synonym for fornication.

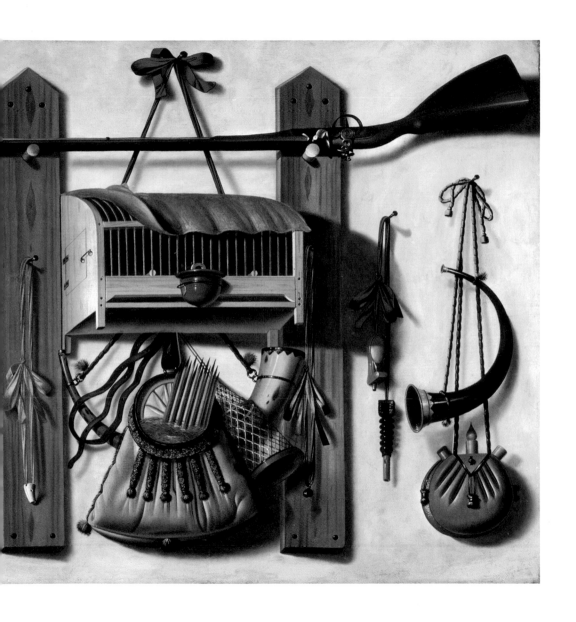

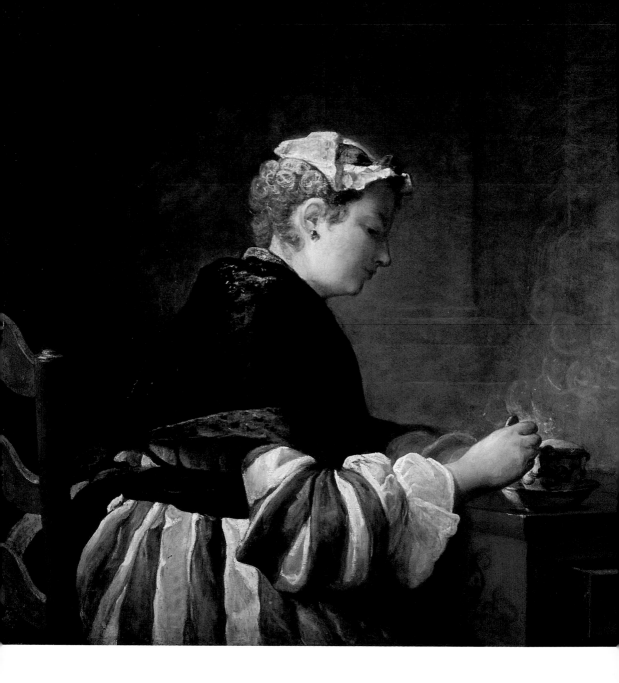

A Lady Taking Tea, 1735

JEAN-SIMÉON CHARDIN
Paris 1699–1779
Oil on canvas, 81 x 99 cm
William Hunter bequest, 1783
GLAHA 43512

WILLIAM HUNTER's acquisition of a major work by the leading French genre and still-life painter Jean-Siméon Chardin puts the collector at the very centre of the European art world in the mid-eighteenth century. Hunter's Francophile friends included the Countess of Hertford and her husband who were in Paris from 1753 to 1765, where Lord Hertford was British ambassador to the court of Louis XV. The Hertfords became acquainted with artists such as François Boucher (1703–1770) and Chardin, and may have helped Hunter acquire this work.

Chardin specialised in scenes from the everyday life of the middle classes to which he belonged, executed in the tradition of Dutch genre pictures, which were in vogue in Paris at the time. His work, however, goes far beyond verisimilitude and through its directness achieves a sense of gravity, or at least silence and calm. There could be nothing simpler at first glance than a still life by Chardin and, conversely, nothing more complex. Chardin paints what we see but, even more, he paints the unseen. Perhaps more than any other work by Chardin, this painting exemplifies what the noted art critic Denis Diderot (1713–1784) found so compelling when he wrote that the artist's compositions 'have a colouristic vigour, an overall harmony, a liveliness and truth, beautiful massing, a handling so magical as to induce despair...'

Painted in 1735, this is an image of Chardin's wife, Marguérite Saintard, who died later that year of a long and painful lung disease. The tea-drinking scene provides an insight into the domestic materiality of the age, from the dusting of wig powder on the shoulders to the fashionable Chinese teapot and porcelain tea bowl resting on the red-lacquered table, all combining to underpin this intimate portrayal of the artist's consumptive wife warming her hand on the tea bowl for comfort.

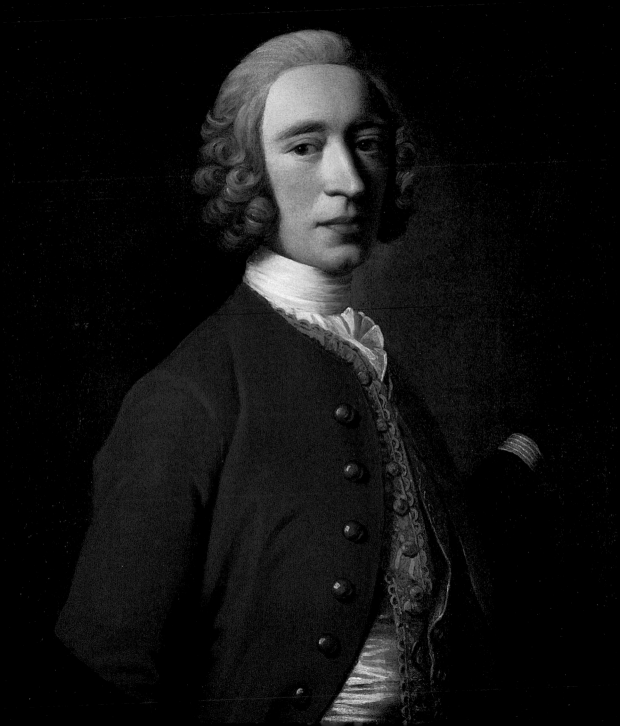

Portrait of a Man, 1746

ALLAN RAMSAY
Edinburgh 1713–1784
Oil on canvas, 76 x 64 cm
Bequest of Dr Charles Hepburn, 1971
GLAHA 44024

ALLAN RAMSAY was born in Edinburgh. His father, also Allan Ramsay, was an important Scottish poet from whom the younger Ramsay inherited a tradition of strong national pride. Ramsay junior was instrumental in formulating a native Scottish style of painting as his father had done for poetry. Ramsay studied in London at St Martin's Lane Academy and at Hans Hysing's studio, before going to Italy. He worked in Rome from 1736 to 1738 and in Naples under Francesco Solimena. On his return to Britain in 1739

the artist settled in London, where he brought a cosmopolitan air to British portrait painting. He was elected a Fellow of the Society of Antiquaries in 1743. Ramsay became the outstanding portraitist in London until the rise in fortunes of Joshua Reynolds in the mid-1750s. His portrait of William Hunter of 1764–65, probably commissioned to commemorate Hunter's appointment as Physician Extraordinary to Queen Charlotte in 1762 (see Introduction), has been described as a 'masterpiece of "natural" portraiture'. Much to his rival Reynolds's irritation and envy, Ramsay was appointed Painter-in-Ordinary to George III in 1760.

Prior to the picture coming to The Hunterian, the sitter was traditionally identified as Major General James Wolfe of Quebec. Wolfe's profile, however, is unmistakable, and this is not him, although the red coat and gold-braided tricorne hat may possibly denote a military rank. Despite our uncertainty, the portrait of this young man conveys an arresting intensity and is surely one of the most striking and confident works by a great Scottish artist.

Anatomical figure modelled on William Hunter's life cast, 1761

MICHAEL HENRY SPANG
Danish, d. 1762

Wax, height 25 cm

William Hunter bequest, 1783

GLAHM C.6

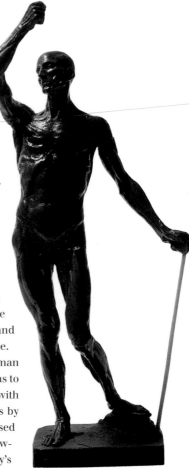

THIS WAX STATUETTE was made by the Danish neoclassical sculptor Michael Henry Spang. It is a reduced version of a flayed human figure or *écorché* cast in plaster by William Hunter for use in anatomical teaching at the St Martin's Lane Academy in London around 1750. Spang came to London to train as an artist; he died young, and therefore little is known about him. However, he is recorded as working in London around 1760, both as one of architect Robert Adam's stone carvers, and as a teacher of drawing to the sculptor Joseph Nollekens (1737–1823). This wax statuette is evidence that he studied anatomy with William Hunter at St Martin's Lane. Hunter's life-size *écorché* figure is now lost, but it was taken, with other equipment, to the embryonic Royal Academy in 1768, and it appears in the background of Johan Zoffany's (1733–1810) painting of the Royal Academy life class of 1771, showing Hunter performing as the Academy's first Professor of Anatomy. Spang exhibited his wax reduction of Hunter's figure at the Society of Artists in 1761. The artist died soon afterwards, and Hunter seems to have acquired the wax, and to have made bronze casts to provide artists with a portable version of his anatomical figure, of which several still survive. The artist James Paine (1745–1829) carried one with him on his journey to Italy in 1768 and reported that it was much admired in Paris and Rome for its excellence.

Figurative artists needed knowledge of the surface form of the human body. Understanding the skeleton was useful, but the greater need was to understand the musculature, which appears in a different formation with every action. The anatomist helps the artist to see these structures by removing the surface layers that encase the muscles. These miniaturised *écorché* figures helped to revolutionise and promote the accurate drawing of human anatomy. The Spang figure became to artists what Gray's *Anatomy* would later become to doctors.

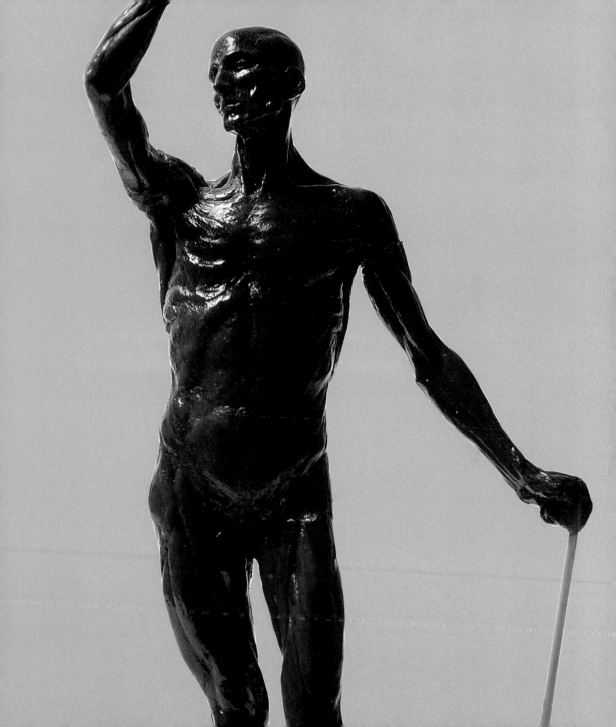

The Moose, 1770

GEORGE STUBBS
Liverpool 1724–1806 London
Oil on canvas, 61 x 70.5 cm
William Hunter bequest, 1783
GLAHA 43823

WILLIAM HUNTER wrote but did not publish a paper on elk and the giant Irish deer. The study reflects his interest in animal speciation, extinction and related philosophical topics of the day. He addressed three questions: what exactly an elk was; whether the North American moose (known by the native name) was the same animal as the European elk; and whether either were related to the giant Irish deer, the fossil remains of which were being found in Irish peat bogs.

In 1770 Hunter viewed the first male moose imported to Britain, a yearling presented to the Duke of Richmond (Hunter was physician to the duke's family). He commissioned George Stubbs, the most celebrated of all equine painters, to paint the animal. Hunter was highly critical of contemporary descriptions and depictions of elk, finding them erroneous or misleading. He required accuracy. In 1773 he returned to view a second two-year-old bull moose acquired by the duke. He took Stubbs's painting with him in order to make comparisons, noting that it looked partly like a deer, partly like a horse. Hunter requested Stubbs to depict a pair of moose antlers in the foreground of the picture in order to enable comparison with the fossil Irish deer, concluding that the horns were dissimilar and that the Irish deer 'was a noble animal of unknown species, which like the American elephant or incognitum is now probably extinct'.

Hunter's patronage had a positive impact on Stubbs's career, bringing the artist commissions for further exotic animals from his brother and fellow physician John, the naturalist Joseph Banks and others. Stubbs's involvement with the Hunter brothers led the artist to take up comparative anatomy, and to write a treatise, 'A Comparative Anatomical Exposition of the Human Body with that of a Tiger and a Common Fowl'.

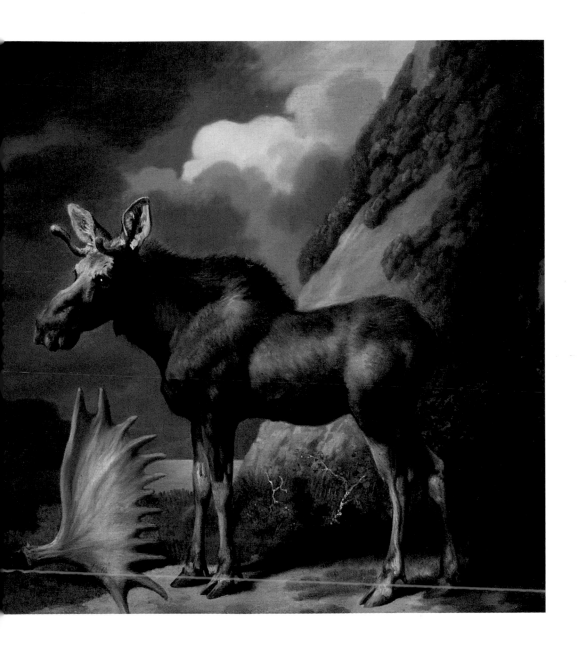

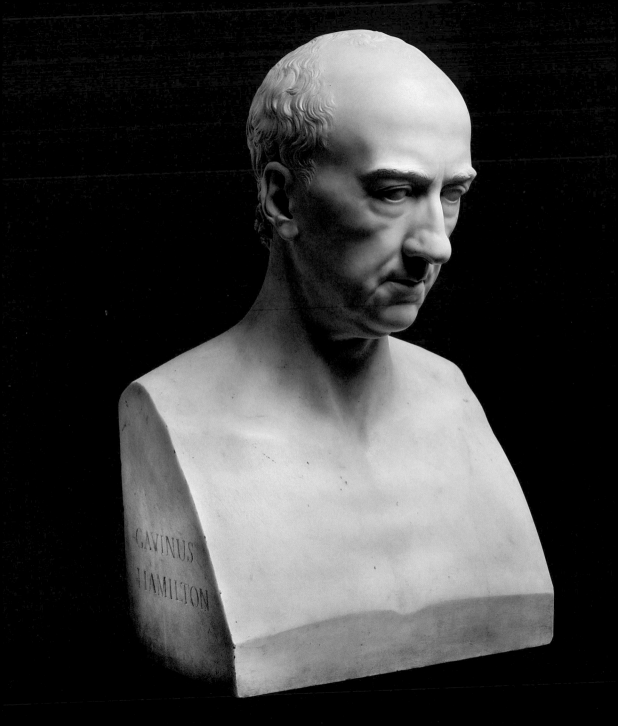

GAVINUS
HAMILTON

Portrait of Gavin Hamilton, 1784

CHRISTOPHER HEWETSON
Thomastown, Co. Kilkenny, Ireland *c.*1737–1798 Rome
Marble, 58 x 33.5 x 33.5 cm
Gift of the Honourable Mr Greville, 1810
GLAHA 44220

CARVED IN ROME for Christopher Hewetson by a specialist working from a measured plaster model, the style closely follows an ancient Roman portrait idiom. This bust is the principal portrait of the Scottish painter, archaeologist and picture-dealer Gavin Hamilton (1723–1798). There may be more than one version of this bust in marble; indeed there is a record of one in the collection of Sir William Hamilton (1731–1803), although this example may be that very one since The Hunterian received it from his relative Charles Greville in 1810.

Gavin Hamilton's importance in the history of eighteenth-century European art far outweighs his artistic ability. He is recognised as one of the founders of neoclassical history painting, and his compositions of grand classical subjects, which achieved wide circulation through engravings, inspired the subject matter and designs of numerous artists. A graduate of Glasgow Old College, he settled in Rome from 1756, where he was a leading member of the neoclassical circle of Anton Raffael Mengs and Johann Joachim Winckelmann. There he became one of the foremost dealers and excavators of classical sculpture. His stock is represented in some of the finest collections in Britain and his enthusiasm for the antique had a profound influence on the taste of more than a generation of painters and collectors throughout Europe, among them Jacques-Louis David, John Flaxman, Johan Tobias Sergel, Benjamin West and Angelica Kaufmann, as well as his countryman David Allan. Christopher Hewetson spent his career largely in Rome, mastering his highly refined hallmark technique of portrait sculpture, which combined the naturalistic treatment of the sitters' features with the classical idiom. Hewetson's bust of Hamilton captures perfectly not only the distinctive scholarly style of male portrait sculpture in ancient Rome, but also the character and authority of the great Scottish antiquary.

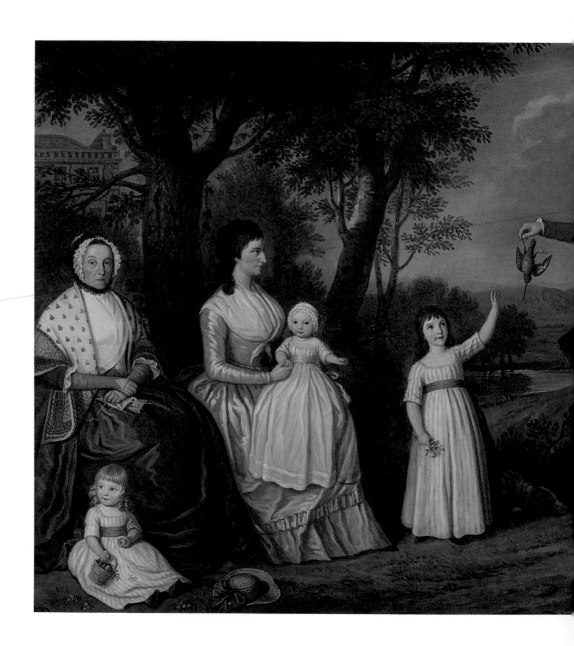

The Spreull Family, *c.*1793

DAVID ALLAN
Alloa, Clackmannanshire 1744–1796 Edinburgh
Oil on canvas, 117.5 x 154.2 cm
Gift of Marilyn Malmquist (Spreull), 2009
GLAHA 51993

THE HUNTSMAN is James Shortridge or Spreull (1760–1824),
a graduate of the University of Glasgow, City Chamberlain
and Superintendent of the Clyde. He is surrounded by his
mother Hannah (Park), his wife Margaret (McCall Spreull),
and three children, Helen, John and Margaret. The house is
probably Linthouse, by the banks of the Clyde, near Govan.
The Spreull family was one of the oldest West Country fam-
ilies and had strong connections with Glasgow University.
David Allan, Scotland's first genre painter, was also the prin-
cipal early exponent of the Scottish conversation piece. After
studying at the Foulis Academy in Glasgow in the 1750s and
early 1760s, Allan spent 10 years in Italy and two years in
London before settling back in Scotland in 1779 because of
poor health. This fine conversation piece belongs to a dozen
family portraits painted in the last two decades of his life.

The landowning family portrait contains several gener-
ations, the grandmother being an unusual addition to the
group. Costume details of adults and children and even
the knitting on the grandmother's knee help to define the
generational and gender differences. The mighty trees with
ancient crags along the riverbank hint at the lineage of the
family and their link to the landscape. These peculiarly
British images of the family have been especially valued for
conveying a sense of period and lifestyle. I think there is far
more to this one. Here we gain an insight into the social
hierarchy of the late eighteenth-century gentry family. And
finally, what do we make of the dead bird being presented
to the elder daughter? Is Allan conveying a message about
mortality or inheritance?

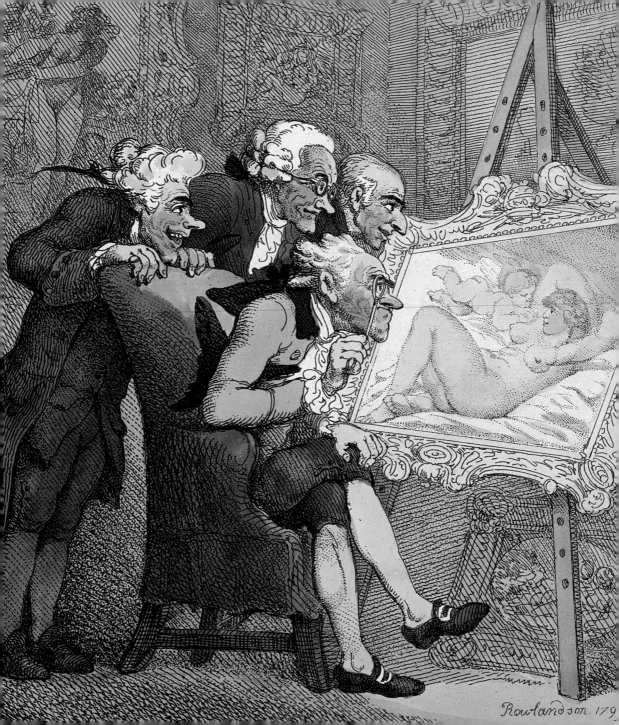

Rowlandson. 179

The Connoisseurs, 1799

Thomas Rowlandson
London 1756–1827
Hand-coloured etching, 28.2 x 22.2 cm
Bequest of Miss Rosalind Birnie Philip, 1958
GLAHA 44493

Art collectors and antiquarians did not escape the acid wit of the satirist and caricaturist Thomas Rowlandson. Elderly and middle-aged connoisseurs admiring a picture of a naked Venus are the subject of many Rowlandson drawings from the 1790s onwards. The distinction between connoisseurship and voyeurism – observing and ogling – are captured in a deliberately ambiguous manner. The subject of Susannah and the Elders, Rowlandson's favourite biblical story, hangs in the background, a scene reminiscent of the very activity the connoisseurs are engaged in. The 1828 sale of the artist's pictures lists an engraving of the scene by Earlom after Rembrandt.

On leaving school, Rowlandson became a student at the Royal Academy and exhibited there often over the course of his career. We know that he attended anatomy lessons given by the Academy's Professor of Anatomy, Dr William Hunter. He would have had access to the Academy's rooms at Somerset House and would have noted the various activities of academicians and antiquaries frequenting the meetings of the learned societies that were based there. Although hardly flattering, Rowlandson's lampoon of the connoisseurs is relatively sympathetic. He reserved his more savage satires for the medical profession, rich clergymen and lawyers. It is amusing to note that Whistler once owned this etching. He understood how the value of a work might be inflated by the tastes of a small group of amateurs.

Monument to James Watt, 1830

FRANCIS LEGGATT CHANTREY
Norton, nr. Sheffield 1781–1841 London
Marble, height 149.8 cm
GLAHA 44337

WHILE WORKING as a mathematical instrument maker at the University of Glasgow, James Watt (1736–1819) became interested in the technology of steam engines. He was tasked by John Anderson, then Chair of Natural Philosophy, to mend a broken model Newcomen engine used in teaching. It was Watt's failure to coax this machine to optimum working efficiency that led to his invention of the separate condenser chamber, an innovation that was to power the rapid acceleration of the Industrial Revolution in Britain. Watt patented an improved steam engine in 1775 in partnership with manufacturer Matthew Boulton. Due to its improved fuel consumption, Watt's invention quickly overtook the Newcomen engine, and Boulton & Watt's engine soon became ubiquitous. The Hunterian still possesses the original Newcomen model engine that inspired Watt.

James Watt is commemorated widely around the British Isles in painting and in sculpture. The monuments in marble by Sir Francis Leggatt Chantrey R.A., one of the leading portrait sculptors of late Georgian England, are among the most expressive. Many critics have remarked on the naturalness of the pose of this life-size statue in The Hunterian as one of Chantrey's greatest achievements. The statue cements the presence of Watt as an eminent engineer, lost in thought, within the university where he worked between 1756 and 1764. Chantrey had made a bust of Watt from life in 1815, and so this posthumous portrait is rightly regarded as among the portraits that most closely resemble him. At life-size, the monument captures both the genius of the renowned engineer and also the confidence of the great portrait sculptor at the height of his artistic power. In 1838 the observer T. F. Dibdin described it thus: 'The figure is all life; the countenance is all soul. In the latter, you discern the gentle workings of deep thought; some truth discovered; so mighty a result anticipated. Inspiration sits upon the brow...'

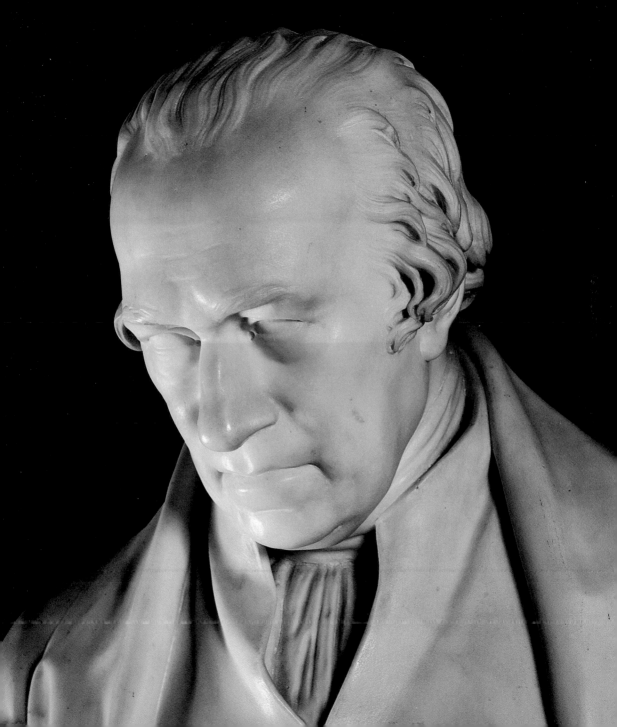

Blue and Silver: Screen with Old Battersea Bridge, 1871–72

JAMES MCNEILL WHISTLER
Lowell, Massachusetts 1834–1903 London

Distemper paint mixed with quartz particles on paper laid on canvas;
painted gilded wood frame; painted silk verso; 195 x 182 cm (fully open)
Bequest of Miss Rosalind Birnie Philip, 1958
GLAHA 46379

THIS UNIQUE AND STRIKING WORK by the American-born painter and central figure of the Victorian art world, James McNeill Whistler, combines the artist's interest in night-time views ('nocturnes'), the Thames, interior decoration and the fine and decorative art of the Far East. It was a prized personal possession. Despite financial pressures, he never sold it.

Blue and Silver is Whistler's most ambitious Thames nocturne, drawing on his favoured motif, the Thames at dusk, with Battersea Bridge in the foreground and the Albert Suspension Bridge under construction on the right panel. The screen crosses boundaries between the fine and decorative arts, boundaries Whistler himself did not recognise. The reverse of the screen comprises Chinese silk panels painted with birds and peach trees by the female Japanese artist, Osawa Nampo (b. 1845). The whole ensemble creates an intriguing dialogue between day and night, urban and pastoral. Whistler's own composition is indebted to Japanese woodblock prints of the early nineteenth century, and masters such as Hiroshige and Hokusai, in its low viewpoint and dramatic perspective through a bridge.

Whistler spent almost 30 years living in Chelsea, in houses near to or overlooking the Thames. In the 1870s, he often spent the night travelling the river by boat sketching and capturing its quiet atmosphere without the heavy daytime traffic. Controversial at the time, the river nocturnes were at the heart of Whistler's artistic enterprise, conveying both a sense of nostalgia and also ambivalence for a riverfront being transformed through London's position as a capital of Empire. Whistler was a radical, not only in his choice of subject matter but also in his experimentation with technique and materials. Here he experimented with texture by adding quartz-sand particles to the paint.

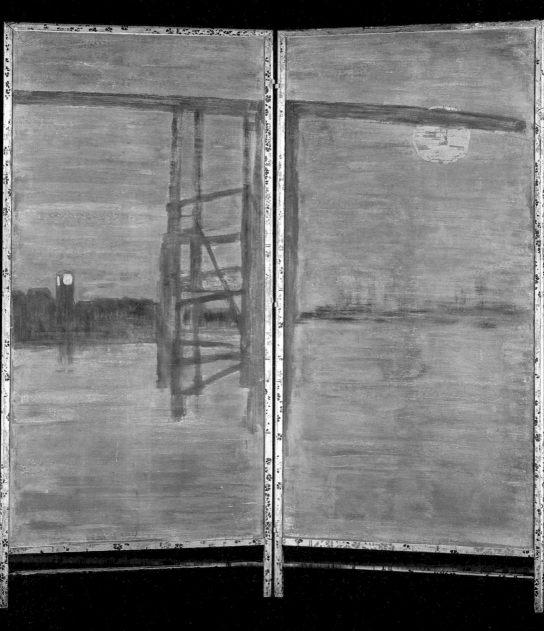

In the Man's Brain, 1897

EDVARD MUNCH
Løten, Norway 1863–1944 Ekely, nr. Oslo
Colour woodcut, 37.1 x 55.7 cm
Purchased, 1967
GLAHA 17985

THE HUNTERIAN'S COLLECTION OF PRINTS – the most important
in Scotland – features many late nineteenth- and early twen-
tieth-century prints, including works acquired by Whistler in
Paris in the 1890s. Prints by the influential Norwegian Expres-
sionist Edvard Munch stand out. The woodcut medium was
ideally suited to Munch's imagery, in which mood and colour
were essential. Munch's woodcuts are among his most inno-
vative works, and they inspired a fashion for the historic print
medium among German Expressionist artists at the turn of the
twentieth century.

Munch had endured a traumatic childhood (his father was
almost dementedly pious and his mother and eldest sister had
died of consumption when he was young), and his art gave
expression to the neuroses that haunted him throughout his
life. The themes of jealousy, sickness and sexual longing occur
repeatedly, and he depicted extreme psychological states with
an often frenzied intensity. Here the man's head is represented
as a primitive mask and, above, attached by wavy lines that
represent his thoughts, floats the image of a prostrate naked
woman. Several of Munch's prints, such as *Jealousy* and
Melancholy III, show us, in a separate plane, events that
happen in a person's imagination. Here is a more 'totemic
statement', according to print curator Peter Black, about man's
obsession with woman: the intense longing weighs down his
spirit and enfeebles his strength. Both in its supremely well-
crafted design and also in its projection of a universal truth
about male sexual desire, *In the Man's Brain* is a truly
monumental graphic achievement of the North European
Expressionist art movement.

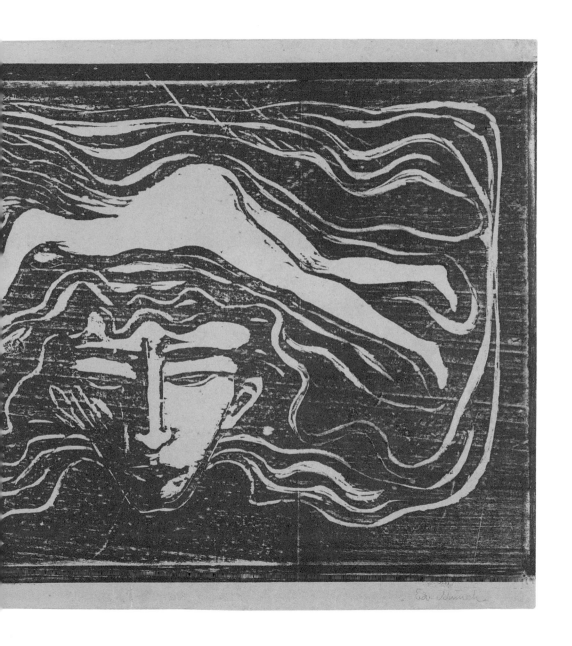

Les Eus, *c.*1910

JOHN DUNCAN FERGUSSON
Leith 1874–1961 Glasgow
Oil on canvas, 216 x 277 cm
Gift of the J. D. Fergusson Art Foundation, 1990
GLAHA 43493

AS ONE OF JOHN DUNCAN FERGUSSON's most ambitious canvases, and one of the foremost icons of Scottish Colourist art, *Les Eus* belongs to a significant group of large-scale nudes painted in Paris between 1910 and 1913. Encouraged by the example of Whistler and the Glasgow Boys, J. D. Fergusson made regular trips to Paris from the mid-1890s where he studied the Impressionists. He settled in the French capital after 1907 and painted in the Fauve manner. This painting can be seen as a culmination of all he had absorbed there, from influences as diverse as medieval tapestries in the Musée de Cluny to Cézanne's *Bathers* (a Cézanne retrospective was held in Paris in 1907) and perhaps even to Matisse's *La Danse*, which was first exhibited in 1910.

The six sculptural nudes dancing against a stylised background is one of many contemporary paintings exploring the theme of dance, perhaps inspired by new dance forms that were coming to Paris through Isadora Duncan and Loie Fuller, for example. Becoming a *sociétaire* of the Salon d'Automne brought Fergusson free tickets for concerts, the theatre and the ballet. Modern dance, epitomised by the Ballets Russes, was moving away from the formality of classical ballet towards dance as an original, purer, freer form.

The title *Les Eus* has given rise to many interpretations, some speculating that *Les Eus* means 'The Healthy Ones' or the 'The Well People', or alternatively was derived from 'Eurythmics', a term coined by Émile Jacques-Dalcroze in 1911 for his new science of dance. Irrespective of the tantalising title of this work, *Les Eus* connects powerfully with the prevailing pre-Great War mood of breaking with the past, unlacing corsets and allowing skin to feel the warmth of the sun. *Les Eus* is a manifesto for the healthy body, for companionship between men and women and a celebration of life itself.

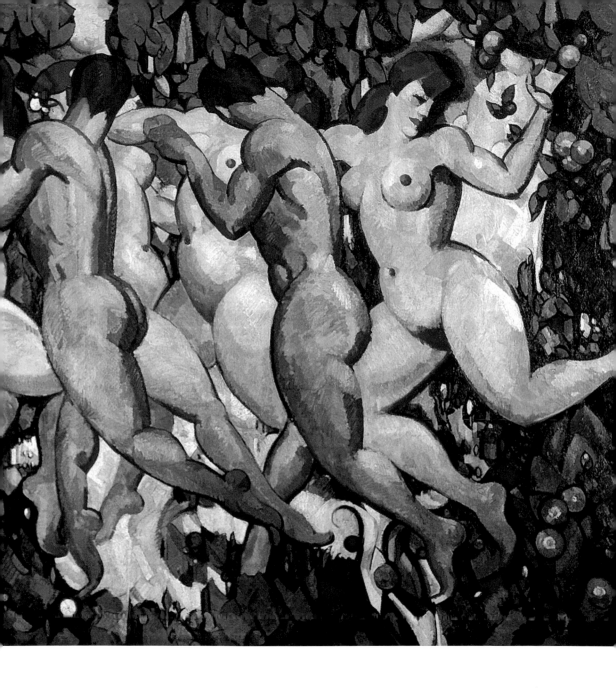

Interiors of The Mackintosh House, 1906–14

CHARLES RENNIE MACKINTOSH
Glasgow 1868–1928 London

MARGARET MACDONALD MACKINTOSH
Newcastle-under-Lyme 1864–1933 London

Reassembled by WHITFIELD PARTNERS, London, 1973–81

THE HUNTERIAN has the largest single holding of the work of the acclaimed Scottish architect and designer Charles Rennie Mackintosh, and his wife, the designer and artist Margaret Macdonald Mackintosh. The collection is founded on the artists' estate and on the interior and contents of the *Künstlerpaar*'s Glasgow home at 6 Florentine Terrace in the fashionable district of Hillhead overlooking Sir George Gilbert Scott's buildings for the University of Glasgow.

6 Florentine Terrace was constructed in the 1860s, and was typical of Glasgow terrace housing of the period, with three main floors and an attic. Mackintosh made a number of decisive interventions, transforming the conventional Victorian house into a distinctive designer home. The alterations sacrificed three of the five bedrooms to open out the drawing room and main bedroom, and to make a new bathroom. New panelling, doors and fireplaces were introduced and the fenestration altered to open the house up to light from the south. The characteristic tall proportions of the Glasgow town house of the period were replaced by a new horizontality produced by such devices as the breaking through of adjoining rooms and the hanging of a continuous picture rail. The floors were covered wall-to-wall with plain pile carpet, uniting the spaces. The use of toned white paint throughout much of the interior was a radical innovation and further helped to give the modified rooms an almost Futurist aspect. Alongside Mackintosh's own furniture designs, his wife created Symbolist furnishings and artworks. In effect, the house was both a home and a showroom for their 'Glasgow Art Nouveau' style. In common with other leading architects of the day, Mackintosh saw himself as being responsible not just for the fabric but the complete design of the building, including furniture, fixtures and decorations. He was a leading exponent of the room as a work of art, creating interiors of a symbolic and restrained beauty.

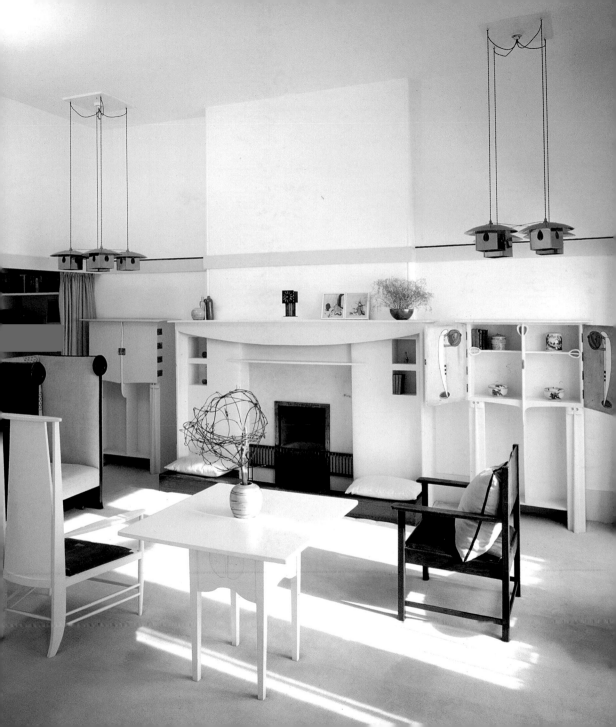

The house at 6 Florentine Terrace was demolished in 1963 but not before its principal interiors had been rescued to be reassembled as an integral part of the planned Hunterian Art Gallery. The rooms were relocated inside a shell which replicated the proportions, interrelationship and orientation of the original house, thus presenting the front section of the house complete over three floors. Internally, the sensation is to be transported back to Mackintosh's old home, holding on to the Victorian balustrade as you ascend. Instead of replicating the sandstone elevation of Florentine Terrace, the architect William Whitfield set the front door and principal windows into the rough-cast finish used by Mackintosh for his major domestic commissions, thus creating an exterior exhibit in its own right. Controversial, certainly, when it opened in 1981 ('Distinctly odd', remarked the *Sunday Times*), today The Mackintosh House is a compelling visitor experience – a unique combination of turn-of-the-twentieth-century interiors ripped out of a mid-Victorian building and reconstituted within a Brutalist late twentieth-century carapace.

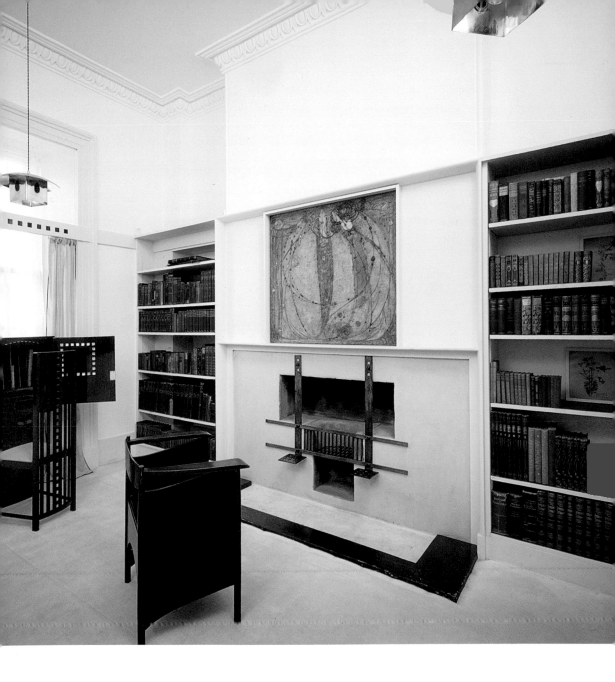

La Rue du Soleil, 1927

CHARLES RENNIE MACKINTOSH
Glasgow 1868–1928 London
Pencil and watercolour, 39.7 x 38.2 cm
The Mackintosh Estate, gift of Sylvan McNair, 1947
GLAHA 41039

IN THE 1920s, towards the end of his life, Charles Rennie Mackintosh, the Glasgow architect and most famous exponent of the Glasgow Art Nouveau style, moved to the French Mediterranean coast where he devoted himself to painting in water-colour. Meticulously executed and brilliantly coloured, these works are conceived with a sense of design and an eye for pattern in nature, which owe much to Mack-intosh's genius as an architect and designer, together with his wider knowledge of current developments in European art. Years of

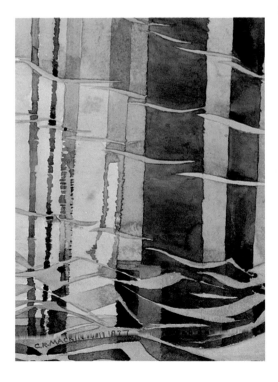

sketching had honed Mackintosh's skills of obser-vation, refined the quality of his analytical drawing technique and accustomed him to working in the open air. These skills underpin his French water-colours, which are striking, to say the least. They exude a mixture of obsessive detail and bold stylisation, which probably owe something to the compressed and telescoped compositions, geomet-ric motifs and elevated horizons (often excluded altogether) of townscapes by the Vienna Secession-ists Gustav Klimt (1862–1918) and Egon Schiele (1890–1918).

Perhaps more than any other work, *La Rue du Soleil* vividly illustrates Mackintosh's pleasure in settling in such a sun-drenched, healthy environ-ment, far removed from the oppressive industry and pollution of early twentieth-century Glasgow. Here he clearly delights in the effect created by the elongated reflections of quayside buttresses and buildings in the rippling water. The effect of the almost abstract geometry and colourful rhythm is truly mesmerising, almost hallucinogenic.

Glasgow Close, 1960

JOAN EARDLEY
Warnham, Sussex 1921–1963 Glasgow

Oil on canvas, 61 x 51.2 cm

Gift of Emeritus Professor Alexander Macfie, 1973

GLAHA 43473

WITHIN SCOTLAND Joan Eardley is one of the most popular painters of the post-war era, reminding Scots of lost urban manufacturing communities and the wild beauty of the landscape. Unusual for the time, she saw vitality in the street life of Glasgow's crumbling post-industrial tenements. In the early 1950s Eardley moved into the slum area of Townhead, where her studio became an attraction for the local children who regularly featured in her works. The childhood pictures are characterised by a restless energy and evoke a strong sense of kinship and community, with hands held, arms thrown around shoulders and prams being pushed by older siblings. 'Only in an occasional Goya do I remember the translation of small children into paint mixed so inseparably with warmhearted self-identification with the inner life of the child', wrote Eric Newton, the *Guardian* art critic in 1963.

Through photography and painting Joan Eardley documented the soon-to-vanish Glasgow tenement childhood of the 1950s to early 1960s. In contrast to their bleak and half-derelict environment, the children are a dynamic life force. In this scene the clothes of the children form bright zones of colour against the grey soot of the tenement block.

Eardley has been a revelation to me. Her works convey a strong sense of time and place, while her ability to capture children, in their thought, mood and action, somehow combines the artistic insights of Pieter Bruegel and Charles M. Schulz. Eardley died tragically young at the age of 42, having been elected a Royal Academician earlier that year. Her Glasgow tenement children form a fitting and enduring epitaph.

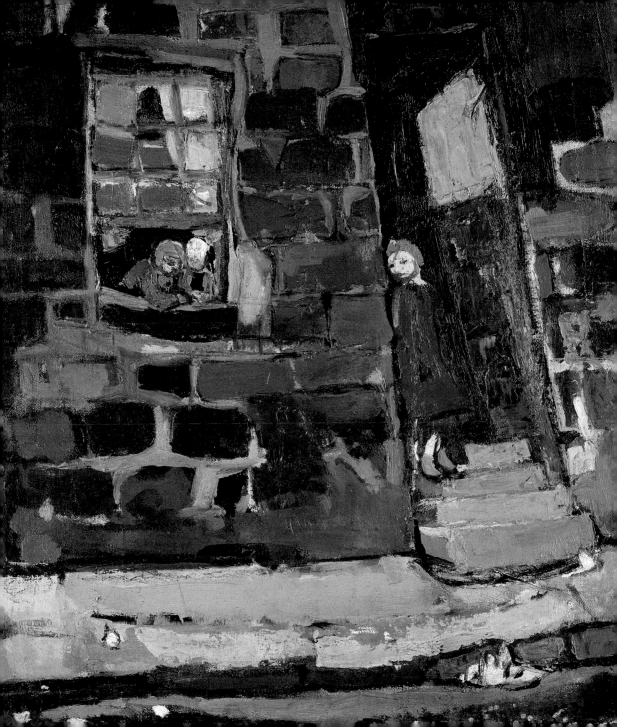

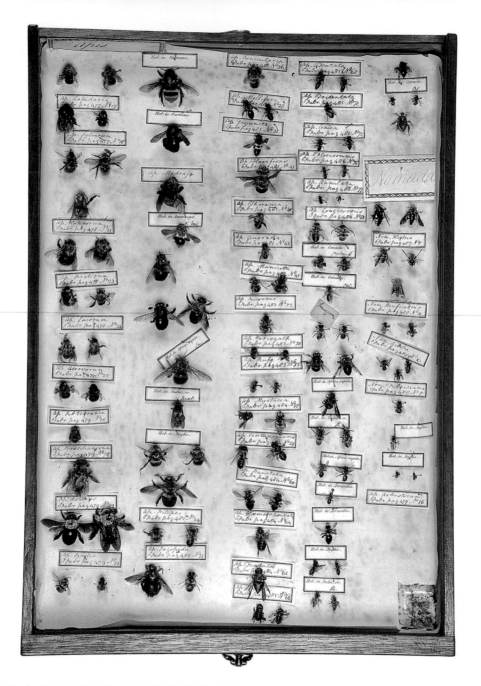

Insect tray containing bees, 1765–83

Mahogany, cork and paper, with brass pins, 42 x 29 x 5.5 cm
William Hunter bequest, 1783
GLAHM 150474 – 150580

THE EIGHTEENTH-CENTURY insect collection of William Hunter contains over 7,500 specimens dating from the beginning of descriptive entomology, and formed an essential part of the early taxonomy and the emerging understanding of insect diversity. Specimens were donated by the leading naturalists of the day, including Joseph Banks, the Forsters and David Nelson, who participated in Captain Cook's circumnavigations.

The Danish naturalist Johann Christian Fabricius (1745–1808), the 'entomological Linnaeus', was engaged by Hunter as his insect curator. Hunter's two cabinets, containing 127 drawers, include insects representing the basis for the descriptions of approximately 500 new species.

Hunter's insect collection was arranged according to the published works of Fabricius. This tray of bees from around the world contains some of the Danish naturalist's original labels. Substantially intact eighteenth-century cabinets of insects are extremely rare. The historical interest in Hunter's cabinets is enhanced by the complete survival of the original cork and paper linings together with the brass pins used to secure the insects. The pins date from a period when such objects were expensive, hand-made and employed mainly for securing fabric in dressmaking or papers in banking or legal businesses. The trays also show evidence for the use of plant thorns in the event that metal pins ran out while collecting in the field. The curatorial use of pins meant that the specimens could be kept safely in glass-topped drawers and so provided the basis for study by later generations of scientists. In a sense, the pinning of insects is the equivalent of the improved methods of taxidermy for birds and mammals that were developed during the same period.

Hunter's insect collection provides a unique insight into the developing taxonomic practice of the European Enlightenment and the transition of natural specimen collecting into a modern scientific discipline.

Seabird diorama, late 19th–early 20th century

CHARLES KIRK
Edinburgh 1872–1922 Glasgow
Taxidermy exhibit in wood and glass case, 145 x 90 x 36 cm
Gift of Professor John Graham Kerr, 1910–20
GLAHM 140295

THE HUNTERIAN ZOOLOGY MUSEUM possesses several fine examples of naturalistic Victorian taxidermy, none finer than this exquisite case featuring nesting seabirds on a cliff face. This diorama by the Glasgow taxidermist Charles Kirk recreates the auk colony of razorbills and guillemots on Ailsa Craig in the Firth of Clyde.

Charles Kirk, born in Edinburgh, spent part of his early life in London and trained as a taxidermist at the world-famous firm of Rowland Ward. Kirk set up a business in Glasgow in 1896 which grew to become the largest taxidermy business in Scotland, with 16 employees in the years before the First World War. Kirk was an expert naturalist and a skilled taxidermist producing work of the highest quality, in the tradition of his training. He was a pioneer bird photographer, scaling cliffs on Ailsa Craig to capture birds in their attitudes and natural settings, which informed his subsequent taxidermy work. In addition to the splendid bird mounts, Kirk was recognised for his realistic groundwork – he used sheets of metal or lumps of peat covered in plaster, glue and paint to recreate the precarious granite ledges of Ailsa Craig's seabird colonies.

Rising to over 1,100 feet, Ailsa Craig, a volcanic plug, is a familiar landmark on the Clyde coast. Its spectacular cliffs are home to internationally important breeding colonies of gannets, auks and kittiwakes which have fascinated and inspired ornithologists and naturalists for generations. During the twentieth century, rats, an accidental human introduction to the island, had decimated seabird breeding, particularly that of puffins. However, since the eradication of the rats in the early 1990s, puffins have returned to breed and the colonies of seabirds thrive again.

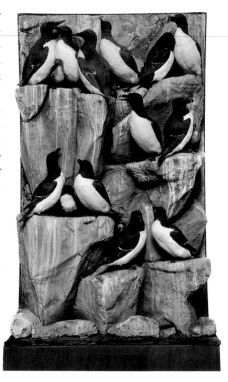

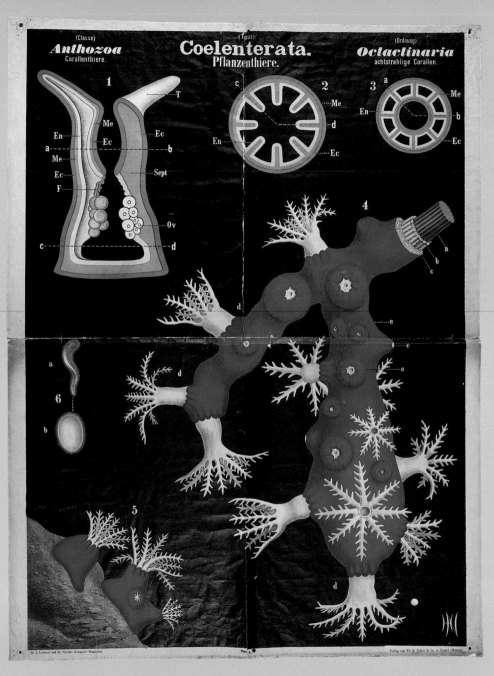

(Classe)

Anthozoa
Corallenthiere.

(Typus)

Coelenterata.
Pflanzenthiere.

(Ordnung)

Octactinaria
achtstrahlige Corallen.

Dr. R. Leuckart und Dr. Nitsche: Zoologische Wandtafeln.

Taf. g.

Verlag von Th. G. Fischer & Co. in Kassel (Hessen)

Teaching chart, 1877

RUDOLF LEUCKART, Germany 1822–1898
HEINRICH NITSCHE, Germany 1845–1902
Published by THEODOR FISCHER, Kassel, Germany
Paper on canvas, 136 x 100 cm
Gift of Department of Zoology, 2002

UNIVERSITY MUSEUMS AND ARCHIVES often hold rich collections relating to the history of teaching. Each professorial generation has devised new techniques and approaches to the instruction of students. Prior to the introduction of the lantern slide in the early twentieth century, wall charts were a very popular means of illustrating a lecture or a school class. Photographs of the early twentieth century in the University of Glasgow archives show teaching charts suspended at the front of the lecture hall.

Rudolf Leuckart was born in 1822 and studied medicine under Rudolph Wagner at the University of Göttingen where he was later appointed a zoology professor. After expeditions to the North Sea to study marine invertebrates, further studies in invertebrate morphology led Leuckart to elucidate various aspects of multicellular animal classification. He was regarded as an excellent teacher, and researchers and students came from many universities to attend his lectures. In collaboration with other scientists and professional illustrators he produced a series of wall charts between 1877 and 1892 which were used as visual aids in teaching at a time before projection technology. As in the case of the charts of the other principal academic authors of university teaching charts, Paul Pfurtscheller (Austria) and Rémy Perrier & Cépède (France), Leuckart's products were purchased by universities and museums worldwide.

Natural history teaching charts, often designed to maximum chromatic effect, are now of growing historical interest. This particular chart illustrating the structure and biology of precious red coral was Leuckart and Nitsche's first chart to be published in 1877 and is a truly spectacular example of late nineteenth-century graphic art. These charts had a long currency and at Glasgow were in use right up to the outbreak of the Second World War.

CHAPTER
ONE

At first they thought it was the body of a child. Later, when they got it out of the water and saw the pubic hair and the nicotine stains on the fingers, they realised their mistake. Male, late twenties or early thirties, naked but for one sock, the left one. There were livid bruises on the upper torso and the face was so badly disfigured his mother would have been hard put to recognise him. A courting couple had spotted him, a pale glimmer down between the canal wall and the flank of a moored barge. The girl had telephoned the guards, and the desk sergeant had dialled Inspector Hackett's office, but Hackett was not there at that hour, and instead he got the inspector's assistant, young Jenkins, who was in his cubbyhole behind the cells writing up his week's reports.

"A floater, Sarge," the desk man said. "Mespil Road, below Leeson Street Bridge."

Detective Sergeant Jenkins thought of telephoning his boss but then decided against it. Hackett was fond of his night's sleep and would not take kindly to being disturbed. There were two fellows in the duty room, one, Quinlan, from the motorbike corps and the other in off his beat for a tea break. Jenkins told them he

needed their help. Quinlan had been about to go off duty, and was not pleased at the prospect of staying on. "He's on a promise from his missus," the other one, Hendricks, said, and snickered.

Quinlan was big and slow, with slicked-back hair and eyes that bulged. He had his leather gaiters on but had taken off his tunic. He stood with his helmet in his hand and looked at Jenkins stonily out of those gooseberry eyes, and Jenkins could almost hear the cogs of the big man's mind turning laboriously, calculating how much overtime he could screw out of the night's work. Hendricks was not due off until 4a.m. "Fuck it," Quinlan said at last, and shrugged in vexed resignation, and took his tunic down off the hook. Hendricks laughed again.

"Is there a car in the yard?" Jenkins asked.

"There is," Hendricks said. "I saw one there when I came in."

Jenkins had never noticed before how flat the back of Hendricks's skull was — his neck ran sheer all the way to the crown of his head. It was as if the whole rear part of his cranium had been sliced clean off and his hair had grown back to cover the scar. Must have a brain the size of a lemon; half a lemon.

"Right," Jenkins said, trying to sound both brisk and bored, as his boss somehow always managed to do. "Let's get going."

They had a hard time of it getting the body up. The level in the lock was low, and Hendricks had to be sent to Portobello to rouse the lock-keeper out of his bed.

4

Sergeant Jenkins set Quinlan to examining the scene with a flashlight, while he went and spoke to the couple who had spotted the body. The girl was sitting on a wrought-iron bench under a tree, white-faced in the shadows, clutching a hankie and sniffling. Every few seconds a great shiver would run through her and her shoulders would twitch. Her fellow stood back in the gloom, nervously smoking a cigarette. "Can we go now, Guard?" he said to Jenkins, in a low, worried voice.

Jenkins peered at him, trying to make out his features, but the moonlight did not penetrate that far under the tree. He seemed a good deal older than the girl, middle-aged, in fact. A married man and she his bit on the side? He turned his attention back to the girl. "What time was it you found him?"

"Time?" the girl said, as if she did not recognise the word. There was a wobble in her voice.

"It's all right, miss," Jenkins said gently, not quite knowing what the words were supposed to mean — it was the kind of thing detectives in the movies said — and then turned businesslike again. "You phoned straight away, did you, after you found him?" He glanced at the man in the shadows.

"She had to go down nearly to Baggot Street before she could find a phone that worked," the man said. He had given his name but Jenkins had immediately forgotten it. Wallace? Walsh? Something like that.

"And you stayed here."

"I thought I'd better keep an eye on the — on the body."

Right, Jenkins thought — in case it might get up out of the water and walk away. Making sure not to be the one to make the phone call, more like, afraid of being asked who he was and what he had been doing on the canal bank at this hour of the night in the company of a girl half his age.

A car passing by slowed down, the driver craning to see what was going on, his eager face at the window ashy and round like the moon.

The girl had permed hair and wore a tartan skirt with a big ornamental safety pin in it, and flat-heeled shoes. She kept clearing her throat and squeezing the hankie convulsively. She had the man's jacket draped over her shoulders. The man had on a Fair Isle sleeveless jumper. The night was mild, for April, but he would be cold, all the same. A display of chivalry; in that case, he must certainly be her fancy-man.

"Do you live nearby?" Jenkins asked.

"I have a flat over there in Leeson Street, above the chemist's," the girl said, pointing.

The man said nothing, only sucked on the butt of his cigarette, the tip flaring in the dark and throwing an infernal glow upwards over his face. Small bright anxious eyes, a big nose like a potato. Forty-five if he was a day; the girl was hardly more than twenty-one. "The guard here will take your details," Jenkins said.

He turned and called to Quinlan, who was squatting on the canal bank looking down into the water and playing his flashlight over the floating body. He had found nothing round about, no clothes, no belongings, so whoever it was down there must have been brought

6

here from somewhere else. Quinlan straightened and came towards them.

The man stepped quickly from under the tree and put a hand on Jenkins's arm. "Listen," he said urgently, "I'm not supposed to be here. I mean I'll be — I'll be missed at home, this late." He looked into Jenkins's face meaningfully, attempting a man-to-man smile, but the one he managed was sickly.

"Give your name and address to the guard," Jenkins said stiffly. "Then you can go."

"Is it all right if I give my office address?"

"Just so long as it's somewhere we can contact you."

"I'm a surveyor," the man said, as if he expected this to be a significant factor in the night's events. His smile kept flickering on and off, like a faulty lightbulb. "I'd be grateful if —"

They turned at the sound of heavy steps behind them. Hendricks was coming down the cinder bank from the road, accompanied by a heavy-set man with an enormous head and no hat. The man was wearing a striped pyjama top under his jacket. It was the lock-keeper. "Jesus Christ," he said, without preamble, addressing Jenkins, "do you know what hour it is?"

Jenkins ignored the question. "We need the water level up," he said. "You'll have to do it slowly — there's a body in there."

As he moved away, the man Walsh or Wallace tried to pluck at his sleeve again to detain him but was ignored. The lock-keeper went to the edge of the canal bank and leaned forward with his hands on his knees and

squinted down at the body. "Jesus," he said, "it's only a child."

They positioned the squad car sideways with its front wheels on the path so the headlights would illuminate the scene. The lock-keeper had used his key and the water was falling in a gleaming rush through the opening in the sluice-gates. Quinlan and Hendricks got on to the barge and found two long wooden poles and braced them against the wall of the canal to keep the barge from swaying in and crushing the body.

The corpse was turned face down, the arms lolling and its backside shining with a phosphorescent glow. Walsh or Wallace and his girl had given their details to Quinlan but still had not departed. It was apparent the girl wanted to be gone, but the man hung on despite his earlier anxieties, eager no doubt to have a look at the corpse when it came up. Quinlan had brought a sheet of tarpaulin from the boot of the squad car and now he spread it on the grass, and the two guards knelt on the granite flagstones and hauled the sodden body from the water and laid it on its back. There was silence for a moment.

"That's no child," Quinlan said.

Hendricks leaned down quickly and peeled off the man's one sock. It seemed the decent thing to do, somehow, though no one made any comment.

"Look at his face," the man said in an awed voice. They had not heard him approach, but he was leaning in between them now, staring avidly.

"Kicked the shite out of him, they did," Quinlan said. Jenkins gave him a look; Quinlan had a foul mouth and no sense of occasion. It was a dead man he was speaking of, after all. Hendricks knelt on one knee and folded in the tarpaulin on either side to cover the lower half of the body.

"Poor bugger," the lock-keeper said.

No one had thought to send for an ambulance. How were they going to get the body out of here? Jenkins thrust a fist into the pocket of his overcoat and clenched it in anger. He had no one but himself to blame; that, he reflected bitterly, was what it was to be in charge. Hendricks went to the squad car for the walkie-talkie, but it was being temperamental and would produce only a loud crackling noise and now and then a harsh squawk. "There's no use shaking the fucking thing," Quinlan said, with amused disdain, but Hendricks pretended not to hear. He kept putting the machine to his ear and talking loudly into the mouthpiece — "Hello, Pearse Street, come in, Pearse Street!" — then holding it away from himself and glaring at it in disgust, as if it were a pet that was refusing to perform a simple trick he had spent time and energy teaching it.

Jenkins turned to the girl sitting on the bench. "Where was that phone box?"

She was still in a state of shock, and it took her a moment to understand him. "Away down there," she said, pointing along Mespil Road. "Opposite Parson's bookshop. The one on Leeson Street is broken, as usual."

9

"Christ," Jenkins said under his breath. He turned back and spoke to Quinlan. "Go over there along Wilton Terrace and have a look. There might be one nearer."

Quinlan scowled. His expression made it clear that he did not relish taking orders.

"I'll go," Hendricks said. He shook the walkie-talkie again. "This yoke is useless."

Jenkins dithered. He had given a direct order to Quinlan; it should have been obeyed, and Hendricks should have kept out of it. He felt giddy for a moment. Getting people to acknowledge your authority was no easy thing, though Inspector Hackett did it seemingly without effort. Was it just a matter of experience, or did you have to be born with the knack?

"Right," he said to Hendricks gruffly, although Hendricks had already set off. Should he call him back, make him salute, or something? He was pretty sure a fellow on the beat was supposed to salute a detective sergeant. He wished now he had phoned Hackett in the first place and risked the old bugger's wrath.

Walsh or Wallace, who was showing no sign at all now of his earlier eagerness to be gone, went up to Quinlan and began to talk to him about a match that was set for Croke Park on Sunday. How was it that sporting types always recognised each other straight off? They were both smoking, Quinlan cupping the cigarette in his palm — officers were not supposed to smoke on duty, Jenkins was certain of that. Should he reprimand him, tell him to put that fag out at once? He decided to pretend he had not seen him light up. He

realised he was sweating, and ran a finger around the inside of his shirt collar.

The girl on the bench called softly to the man — "Alfie, will we go?" — but he ignored her. He was bare-headed as well as being without his jacket, and though he must have been freezing by now, he appeared not to mind.

Jenkins looked at the body lying on the grass beside the towpath. The water had drained from the hair, which seemed to be red, though it was hard to be sure in the stark glow of the streetlamp. Jenkins felt himself shiver. What must it be like, being dead? Like nothing, he supposed, unless there really was a Heaven and a Hell, all that, which he doubted, despite what the priests and everyone else had spent years earnestly assuring him was the case.

At last Hendricks came back. He had found a phone box. The Holy Family was the hospital on duty tonight. The ambulance was out but they would send it as soon as it came in. "Have they only the one?" Jenkins asked incredulously.

"Seems like it," Hendricks said.

"A fine player, that lad," Wallace or Walsh was saying. "Dirty, though."

"Oh, a tough bollocks," Quinlan agreed, and chuckled. He took a drag of his cigarette, throwing a glance of lazy insolence in Jenkins's direction as he did so. "I seen him in the quarter-final against Kerry," he said, and laughed again. "I'm telling you, if that little fucker got his elbow in your ribs you'd know all about it."

The girl stood up from the bench. "I'm going," she said to the man's back. He flapped a hand at her placatingly, and Quinlan said something under his breath and the man gave a loud guffaw. The girl moved irresolutely towards the cinder track that led up to the road. When she reached the gate in the railings she turned back, though it was not the man she looked at this time but Jenkins, and she smiled. For years afterwards, whenever he thought of the case of the body in the canal, it was that sad, wan little smile that he remembered, and he felt, every time, a mysterious pang.

CHAPTER
TWO

Quirke had an abiding dislike of rain. Every woman he had ever known had laughed at him for it. Women did not seem to mind getting wet, unless they had just got their hair done. Even when they were wearing good shoes or a new hat they would stride through the downpour and appear not to notice. He, on the other hand, would wince when he heard the first hollow taps on the brim of his hat and saw the pavement in front of him greyly sprinkled. Rain gave him gooseflesh, and he would shudder even at the thought of a drop getting under his collar and sliding down the back of his neck. He hated the way his hair went into kinks when the rain wetted it, hated too the smell of sheep his clothes gave off, which always reminded him of being at Sunday-evening devotions in the chapel at Carricklea, the institution where he had spent the better — or rather the worse — part of his childhood. For as long as he could remember, rain seemed to have been falling on his life.

He had got out of the taxi by the river because the sun was shining, but he was still not even in sight of the hospital when a shadow swept across the street and a wind out of nowhere set dust devils spinning in the

gutters. Spring was not his favourite season, though for that matter he was not sure which one was. He quickened his pace, pulling his hat low on his forehead and keeping in close by the brewery wall. A tinker boy mounted bareback on a piebald pony, with a bit of rope for reins, clattered past over the cobbles. A warm and slightly nauseating smell of hops was coming over the brewery wall, from the big vats simmering away in there.

The air about him grew darker still. He had been drinking whiskey the night before and there was a metallic taste at the back of his tongue, even though he had left McGonagle's early and gone home to bed, alone — Isabel Galloway was off touring in *A Doll's House*, which would have made him a grass widower if he were married to her, which he emphatically was not. The thought of Isabel set going a familiar confusion of emotions inside him. He sighed. Why was it not possible to switch the mind off, to stop it thinking, remembering, regretting, even for a moment? Isabel was a good-hearted woman, kindly behind a mask of brittleness, and if she was no longer exactly young she was still good-looking. He did not deserve her. Or rather, he told himself ruefully, she, being decent, did not deserve him, and all that he was and was not.

Sure enough, it began to rain.

There were cranes and cement mixers in the hospital grounds, where a new extension was being built, an ugly concrete cube that was to be a recovery ward for young mothers who had suffered complications giving birth. It would be called the Griffin Wing, after the late

14

Judge Garret Griffin, Quirke's adoptive father, as it happened, who had left money in his will to build it. Oh, yes, Quirke thought. Conscience money.

The rain was coming down heavily now, whipped sideways by the sudden wind, and he sprinted the last twenty yards and at last gained the shelter of the red-brick portico. He stopped, and took off his hat and tried to shake the rain from it. The legs of his trousers were cold and clammy against his calves. A young couple appeared behind him, coming out from Reception, the fellow holding the door for his wife, who seemed hardly more than a girl, drained and dazed-looking, with lank blonde hair. She was carrying a baby in her arms, wrapped in a pink blanket. She smiled shyly, tentatively, at Quirke, while the young man scowled. He had an oiled quiff and long sideburns and wore drainpipe trousers and a coat-length jacket with high shoulderpads. Through the doorway the hospital breathed out its sharp, caustic smell; it was a smell Quirke had never got used to, although it was in his pores by now and must be the smell he too gave off. The teddy boy, for all his scowling, went on holding the door until Quirke, nodding at him and his drab wife, had stepped through. They must think he was a doctor; a real doctor, that is.

There was a new nurse at Reception, pretty in a mousy sort of way, and painfully young. Often these days Quirke had the feeling that he was older than everyone around him. He realised suddenly that he was missing Isabel. He was glad she was not young, at least not young like this nurse or like the couple he had

15

encountered in the doorway, half-grown-up children. When he smiled at the nurse she blushed and bent her head and pretended to be looking for something on the desk.

He went down the big curving marble staircase, and as he did so he had, as always, the panicky yet not entirely unpleasant sensation of slowly submerging into some dim, soft, intangible element. He thought again of being a child at Carricklea and how, when he was having his weekly bath and if there was no Christian Brother around to stop him, he would let himself slide underneath the water until he was entirely submerged. He would keep his eyes open, for he liked the shiny, swaying look of things through the water, the gleaming taps and the rippling edge of the bath and the ceiling that all at once appeared immensely far off above him. Often he had stayed like that for so long it had seemed, thrillingly, that his lungs would burst. More than once, when things were bad, and things at Carricklea could be very bad indeed, he had thought of keeping himself under until he drowned, but had never been able to summon up the courage to do it. Besides, if there was a world waiting for him on the far side of death he had a strong suspicion it would be another version of Carricklea, only worse.

At the foot of the stairs he turned left along the green-painted corridor. The walls down here had a permanent damp sheen, like sweat, and the air smelt of formaldehyde.

Why, he wondered, did he think so much about the past? The past, after all, was where he had been most

unhappy. If only he could forget Carricklea his life, he was sure, would be different, would be lighter, freer, happier. But Carricklea would not let him forget, not ever.

Bolger, the porter, with mop and bucket, was swabbing the floor of the dissecting room. He was smoking a cigarette; it dangled from his lower lip with a good inch and a half of ash attached to it. Bolger, Quirke reflected, could smoke for Ireland in the Olympics and would win a gold medal every time. How he managed to keep the fag adhering to his lip like that, without the ash falling off, was a mystery. He was a stunted fellow with a sallow face and a big set of badly fitting dentures through which, when he spoke, tiny whistling sounds escaped, like faint background music. Quirke, as far as he could recall, had never seen him without his drab-green coat, which gave him, oddly, something of the look of a greengrocer.

"Morning, Ambrose," Quirke said. Everyone else called him Ambie, but Quirke always gave the name its full flourish, for the mild comedy of it.

Bolger returned the greeting with an awful grin, showing off those outsized and unnervingly regular teeth. "Rain again," he said, with grim satisfaction.

Quirke went into his office and sat down at his desk and lit up a Senior Service. He still had that tinny taste in his mouth. The strip of fluorescent lighting in the ceiling made a continuous fizzing. There was a slit of window high up in the wall that was level with the pavement outside, where heavy rain was still falling. Now and then a passer-by was to be seen, the feet only,

hurrying past, oblivious of walking over this place of the dead.

Bolger came to the open door, mop in hand, bringing with him a whiff of stale water. "There's a new one in," he said. "Fished out of the canal in the small hours. Young fellow."

Quirke sighed. He had been looking forward to an idle morning. "Where's Dr Sinclair?" he asked.

"Off today, I believe."

"Oh. Right."

Bolger detached the cigarette from his lip and knocked the ash from it into his cupped palm. Quirke could see he was getting ready for a chat, and stood up quickly from the desk. "Let's have a look at him," he said.

Bolger sniffed. "Hang on." He laid his mop aside and crossed to one of the big steel sinks and dropped the cigarette ash from his palm into it, then went out and returned a moment later wheeling a trolley with a body draped in a nylon sheet. The rubber wheels of the trolley squeaked on the wet tiles, setting up a brief buzzing in Quirke's back molars. He wondered how many years there were to go before Bolger's retirement; the man could be any age from fifty to seventy-five.

Bolger had reinserted the butt of his cigarette into the left side of his mouth, and had one eye screwed shut against the smoke. He drew back the sheet. Red hair in a widow's peak plastered to a skull that was small enough to have been that of a schoolboy. Bruises on the face, purple, mud-blue, yellow ochre.

"Right," Quirke said, "get him on the table, will you?" He began to move towards the sinks to scrub up, then stopped, turned, stared at the corpse. "Jesus Christ," he said. "I know him."

CHAPTER
THREE

Grafton Street was redolent of rain on sun-warmed concrete. Another shower had passed and the sun had come out and already the roadway was steaming. Quirke stopped at a flower stall and bought a bunch of violets. Violets were his daughter's favourite flowers; to Quirke they smelt a little like dead flesh. The stall-keeper, a jolly, raw-faced woman, gave him his change and said she hoped the rain would keep off. He said he hoped so too. They both looked at the sky and the great bundle of icy-white cloud boiling above the rooftops — Quirke thought again of the corpse on the trolley — and the woman laughed sceptically and shook her head. He tried to think of something more to say; he was not eager to get to where he was going. He had a difficult task ahead of him, and he did not relish the prospect of it.

He moved on at last, but still he dawdled, watching vans being unloaded, the second post being delivered, and stopping at every other shop to stare vacantly into the window. He was like a schoolboy, he thought, with homework undone, trying not to get to school. He considered going into Bewley's for coffee and a bun. What he really needed was a stiff drink, of course, but

that, as he resentfully acknowledged, was out of the question at this hour of the day, for it was not long past noon and he was supposed to have sworn off midday drinking.

Here was the shop, the Maison des Chapeaux. He crossed to the other side of the street and made for the purple shadow under the awning outside Lipton's. The one-way street was busy with pedestrians and motorcars and the odd dray, and he had only an intermittent view of the window of the hat shop. He could see, dimly behind the glass, his daughter attending to a customer, taking down boxes and lifting out the hats and turning them this way and that for inspection. He could not understand how she put up with the work. Phoebe had a good brain, and at one time had wanted to be a doctor, but nothing had come of it. Things had gone wrong in her life, and bad things had happened to her. Maybe this mindless job was part of the long process of recuperation, of healing. As he watched her, with people and cars flashing past, he experienced a sudden swooping sensation in his chest, as if his heart had come loose for a second and dropped and bounced, like a ball attached to elastic. He had long ago given up hope of being able to tell her how much he cared for her. After all, he was one of the bad things that had happened to her — for the first two decades of her life he had kept her in ignorance of the fact that he was her father. What right had he to tell her he loved her, even if he could manage to get the words out? Yet his longing to be allowed to look after her somehow, to protect her from the world's awfulness,

21

was a constant, hollow and unassuageable ache at the centre of his being.

None of the hats was to the customer's liking, it seemed, and she left the shop, while, inside, Phoebe set about putting the silly concoctions back in their nests of tissue paper and stowing the boxes away on the shelves. Quirke waited for a bus to pass by, then crossed the street and pushed open the shop door.

Phoebe turned in surprise. "Oh, hello," she said.

A faint flush spread upwards quickly from her throat, making her pale cheeks glow. He had startled her, walking in from the street unannounced, and she did not like to be startled, he knew that. She glanced behind her, in the direction of the made-over broom cupboard at the back of the shop that the proprietor, Mrs Cuffe-Wilkes, liked to call her office.

"I was passing," Quirke said, keeping his voice low. "I thought I might take you to lunch." She looked at her watch. "Oh, come on," he said cajolingly. "It's past noon."

At that moment Mrs Cuffe-Wilkes appeared. She looked at Quirke sharply and frowned — men seldom entered the shop, certainly not men on their own — but then recovered herself and smiled. She was a large, florid woman with brassy hair and an extensive smearing of rouge. She had prominent, bright eyes and a crooked little rosebud mouth. In her voluminous dress of shiny green silk, with her big bosom and short legs, she bore, Quirke thought, not for the first time, a strong resemblance to Queen Victoria in her late heyday.

Phoebe moved forward quickly, as if her employer could be expected to charge and must be headed off. "This is my father," she said.

The woman reinstated her frown; she had heard of Quirke. He nodded, trying to appear pleasant and affable. "I was just saying," he said, "that maybe I could take Phoebe to lunch."

Mrs Cuffe-Wilkes sniffed. "Oh, yes?" Both Quirke and Phoebe could see her dithering. Quirke might be disreputable in certain ways, but he was a medical man, a consultant at that, and his well-cut suit was of Harris tweed and his shoes were hand-made. She forced herself to smile again, managing at the same time to keep those tight little lips pursed. "I'm sure that will be all right." She glanced at Phoebe. "It's nearly lunchtime, after all."

They went round the corner to the Hibernian. The restaurant was not busy and they were shown to a table under a potted plant at the big window that looked out on Dawson Street, where the lemon sunlight glared on the roofs of passing cars.

"What's the occasion for this unexpected treat?" Phoebe, smiling, asked.

"I told you," Quirke said. "I was passing by."

She put her head to one side and gave him an arch look. "Oh, Quirke," she said, "you know you're never just 'passing by'."

He nodded towards the sunlit street. "It's spring," he said. "That's worth celebrating, isn't it?"

She was still regarding him suspiciously, and he buried his face in the menu. She could never quite decide what to think about her father — what to *feel* about him, or for him, was beyond speculation — but today she could see that something was the matter. She knew well that assumed air of bonhomie, the forced and slightly queasy smile, the furtive eye and fidgeting hands. Maybe he had broken up with Isabel Galloway again and was trying to screw up sufficient courage to tell her. Phoebe and Isabel were friends, sort of, although in fact there had been a marked coolness between them ever since Isabel had taken up with Phoebe's father. And then there had been Isabel's suicide attempt after Quirke had left her the last time . . .

Quirke was talking to the waiter now, consulting him about the Chablis. Phoebe studied him, trying to guess what it could be he had to tell her — there must be a reason for him to take her to the Hibernian at lunchtime on an ordinary weekday. It was not to do with Isabel, she decided: Quirke would not be so agitated over a woman.

"I thought you weren't going to drink during the day any more," she said, when the waiter had left.

He gave her his wide-eyed look. "I'm not drinking."

"You just ordered a bottle of wine."

"Yes, but *white* wine."

"Which has just as much alcohol as red."

He waved a hand dismissively. "No no no — that's only what the producers put on the label to make you think you're getting your money's worth."

She laughed. "Quirke, you're incorrigible."

"Eat your prawn cocktail," he said. "Go on."

She cast a glance at his plate. He had pushed his own portion of prawns around in their pink sauce but as yet had not taken a bite of a single one. He must have a hangover, she decided; he never ate when he was hung-over. She thought of delivering the standard lecture on his drinking, but what good would it do?

"How's that boyfriend of yours?" he asked.

"David?"

He gave her a wry look. "How many boyfriends have you got?"

She had wanted to see if he would follow her in saying David's name, but of course he would not. To Quirke, his assistant was always just Sinclair. "He's very well," she said. "Don't you see him?"

"Not in the way you do. He's not *my* beau."

"My *beau*!" She gave a hoot of laughter. "I doubt he thinks of himself as anybody's *beau*."

The waiter came with the wine and Quirke went through the ritual of sipping and tasting. It was pathetic, Phoebe thought, the way he tried to pretend he was not dying for a drink. Next their fish was brought, and Quirke tucked his napkin into his shirt collar and took up his knife and fork with a show of enthusiasm, but it was again obvious that he had no stomach for food.

"Any sign of a ring?" he asked, not looking at her but poking at the sole with his fork.

"What kind of a ring would that be?" Phoebe enquired innocently, putting on a puzzled frown. "A Claddagh ring, do you mean? A signet?"

Quirke ignored this. "The two of you have been going together for how long now?" he asked. "About time he declared his intentions, I'd have thought."

She laughed again. "My 'beau'," she cried, "'declaring his intentions' — honestly, Quirke!"

"In my day —"

"Oh, in *your* day! In *your* day a gentleman had side-whiskers and wore a frock-coat and gaiters and before proposing had to ask a damsel's father for her hand in marriage, don't you know."

Quirke only smiled, and went on toying with his fish. "Wouldn't you like to marry, settle down?" he asked mildly.

"Married is one thing. 'Settling down' is quite another."

"I see. You're going to be the independent type, wear trousers and smoke cigarettes and run for parliament. Good luck."

Phoebe gazed at him, where he sat with his head bent over his plate. His tone had suddenly taken on a sharper edge.

"Maybe I will do something like that," she said, sitting up very straight, "go into politics, or whatever. You don't think I'm capable of it."

He was silent for a moment, looking sideways now into the sunlit street. "I think you'd be a success at whatever you set your mind to," he said. He turned his eyes to hers. "I only want you to be happy."

26

"Yes," she said. "But is being married the only kind of happiness you can imagine?"

She saw him wanting to say more but holding back. She supposed she was a disappointment to him, working in a hat shop and having his assistant for a boyfriend. How ironic, she thought, considering all the years he had gone along with the pretence that she was his sister-in-law's daughter and not his. Yet she could not be angry with him. He had suffered so much. The woman he loved had married someone else and then the woman he did marry had died. What right had she to pass judgement on him — what right had she to pass judgement on anyone?

They talked for a while of other things, her work at the shop, the crassness of customers, Mrs Cuffe-Wilkes's bullying ways. She mentioned a trip to Spain that she was considering going on. She waited for him to ask if David would go with her, but he did not, and the unspoken question hovered above the table like a heat haze, warping the atmosphere between them. This was delicate territory. She knew Quirke wanted to know if she and David were sleeping together, but she knew too that he would never have the nerve to ask.

"Tell me," he said, "how is that friend of yours? — what's his name?"

"Which friend?"

"That chap who works for the *Clarion*."

"Jimmy Minor?"

"Yes. That's him." He was, she saw, avoiding her eye again.

"What about him?"

With an index finger he pushed his plate carefully to one side. "Have you seen him recently?"

"Not for a week or two. You haven't touched your fish."

"No appetite."

He was frowning, and now he took a long swallow of wine. She watched him closely, feeling the first inkling of alarm. Jimmy: it was Jimmy he had brought her here to talk about. Oh, God, what kind of hot water had her friend got himself into this time, she wondered.

"I saw him this morning," Quirke said. He sucked his teeth. He would look at anything except her.

"Oh? Where?"

He reached inside his jacket and brought out his cigarette case, flicked it open, offered it across the table. She shook her head. "I forgot, yes," he said. "You gave up. Good idea. Wish I could."

He lit his cigarette, blew smoke towards the ceiling. Then he looked directly at her, for the first time, it seemed to her, since they had sat down, and smiled peculiarly, with a woeful, apologetic slant. "I saw him at the hospital," he said. "I did a post-mortem on him."

Afterwards, when it was too late, he realised how clumsy he had been, how badly he had managed it. At the time he had felt that by mentioning the post-mortem first he would be sparing her the shock of being told straight out that Minor was dead. But of course his words had the opposite effect. To him the term "post-mortem" carried no weight, was entirely neutral, while to Phoebe, he supposed, it conjured up

an image of her friend laid out on a slab with his sternum cut open and all his glistening innards on show.

In the moments after he had made his *faux pas* she had sat very still, gazing at him blankly, then had stood up so quickly her chair had fallen over backwards, as if in a dead faint, and she had hurried from the room with her napkin pressed to her mouth. Now he waited, in consternation, furious at himself. He splashed out the last of the wine from the bottle and drank it off in one go. Putting down the glass, he noticed a stately matron at the next table glaring at him accusingly. Probably she thought him a drunken *roué* whose indecent suggestions had caused the young woman he was treating to lunch to flee from the table. He glared back, and she turned away with a flounce of her head.

After a while Phoebe returned, and sat down again gingerly in the chair that he had set upright for her. She was starkly pale; he guessed that she had been sick. He did not know what to say to her. She sat before him with eyes downcast and her hands in her lap clutching each other as if for dear life. "What happened?" she asked, in a small voice.

"We don't know yet."

" 'We'?"

"I," he said. "I don't know. He was beaten, very badly. I'm sorry."

She was looking out into the street now. "Isn't it strange," she said, as if to herself, "how sunlight can suddenly seem to go dark?" She turned her eyes to him. "Are you saying he was killed? That he was murdered?"

"Well, killed, certainly. I suppose whoever it was that gave him the beating may not have intended that he would die. But when he did they dumped him in the canal at Leeson Street Bridge, by the towpath there." Quirke knew the spot, knew it well, and now he saw it in his mind, the darkness, and the dark, still water.

"Poor Jimmy," Phoebe said. She sighed, as if she were suddenly very tired. "He always seemed so — so defenceless." Now she looked at him again. "You met him, didn't you?"

"Yes, yes, of course."

"Did I introduce him to you?" It seemed a point to which she attached much significance.

"I don't remember," Quirke said. "Maybe you did. But I would have known him anyway. He was a crime reporter, after all."

"Yes, of course." A thought struck her. "Do you think it was to do with his work? Do you think someone he was writing a story about might have . . .?"

Quirke was rolling a crumb of bread back and forth on the table under a fingertip, making a pellet of it. He did not speak for some time, and then he did not answer her question. "Was he working on something, do you know?" he asked. "I mean, was he writing something, something in particular — something important?"

She gave a mournful little laugh. "Oh, I'm sure he was. There was always a 'story' he was following up. 'Jimmy Minor, Ace Reporter', that's what he used to call himself. He meant it only partly as a joke — he really saw himself as a newshound out of the pictures.

You know, one of those ones in trench coats, a card with 'Press' written on it in their hatbands, and always with a cigarette in the corner of their mouths." She sighed again, distractedly; she seemed more baffled than distressed. The full realisation of the thing, Quirke knew, would come only later.

"Did he have other friends, as well as you?" he asked. "Someone close to him, someone who might know more about what he was up to?"

Phoebe shook her head. "I don't know," she said. "I'm just realising how very little I knew about him, about his life, or the people he went around with. He'd just appear, and then go off again. I'm not sure he even thought of *me* as a friend."

"What about his family?"

"I don't know about them, either. He was secretive, in odd ways. I mean, he was friendly and — and warm, and all that — I liked him — but he kept himself to himself. He never spoke about his family that I can recall. They live somewhere down the country, I believe. I think his parents are alive — I just don't know." She paused. "Isn't it awful? I was around him for years and yet hardly knew him at all. And now he's dead."

A single tear slid down swiftly from her left eye and ran in at the corner of her mouth. She seemed not to notice it.

"Did he — did he have a girlfriend?" Quirke asked.

Phoebe looked up quickly. She had caught something, a question behind the question. "He was very fond of April Latimer," she said carefully, seeming

to select the words and lay them out before him on the table, like playing cards. April Latimer had been a friend of Phoebe's who had disappeared, who perhaps had been killed, as now Jimmy had been. Her mind shied away from the horror of it all. "I sometimes thought they might . . ." Her voice trailed off.

"But — they didn't?"

"No."

She shivered. Quirke reached a hand across the table but stopped short of touching her. "Are you all right?" he asked.

"Yes," she said. "No." She shook her head. "I don't know." She gave him a look of desperate appeal. "Did he — would he have suffered, a lot?"

"No," he said, making himself sound brisk and persuasive. "Not at all, I'd say. He was hit on the head. The blow would have knocked him unconscious." He did not mention the terrible bruises on Jimmy's chest and flanks, the gouged right eye, the mangled pulp at his crotch. "But whoever did it was either very angry with him, or had been told to make a thorough job of it."

Phoebe did her sad little laugh again. "Yes," she said. "Jimmy had a way of getting under people's skin. He saw it as his professional duty to annoy everyone. If there wasn't somebody angry at him he knew there must be something he was doing wrong."

"But he didn't mention anything, or anyone, in particular, the last time you saw him?"

She began to answer, then stopped, and gave him a sharp look, narrowing her eyes. "You're playing at

32

detectives again," she said, "aren't you? Yes, you are — I can hear you getting interested. Have you talked to your friend Inspector Hackett yet?"

"I'll probably be seeing him before long," Quirke said shortly, looking away.

"It's supposed to be his job, not yours, you know," she said, "catching people who do things like this."

They were both thinking of the time, years before, when Quirke himself had been badly beaten up — he still had the trace of a limp. He had been playing at detectives then, too.

"I'm aware of that," he said. "But you'd like to know, wouldn't you, what happened to Jimmy?"

"Yes," she said. "All the same, I'll say it again — it's not your job to find out."

He beckoned to the waiter and ordered a glass of brandy for her. She began to protest. "It will do you good," he said. "The shock hasn't hit you yet."

She did not fail to note that he had resisted ordering a brandy for himself; it was considerate of him, and she supposed she should appreciate the gesture.

They were silent while they waited for the drink to be brought. Both were aware of a constraint between them. Death the transgressor had no respect for the niceties of social occasions.

"You say his people live down the country," he said, when the waiter had come and Phoebe was taking a first, wincing sip from her glass. "Any idea where?"

"They'll know at the paper, surely."

"Yes," Quirke said. "They're bound to." Inspector Hackett, he reflected, was probably at this minute

talking to Harry Clancy, the editor of the *Clarion*, who would be shaking his head in a show of dismay and shedding crocodile tears. Phoebe was right: Minor had done little to make himself liked by anyone, especially the people he worked for. "And you don't know," Quirke asked, "of any particular story he was following up?"

"No," Phoebe said, "I don't. In fact, I can't remember when we last spoke."

"And he had no girlfriend."

Again Phoebe gave him a sharp look, hearing again that other, unspoken question behind her father's words. "Are you asking me," she said, "if he was — you know — that way?"

He gazed back at her expressionless. "Was he?"

"I don't know," she said. It was the truth. But what she did know was that there had always been something about Jimmy that had made him hold himself apart, a remoteness, a physical aloofness. She was certainly no vamp, but between her and most men there was always a hint of something, a sort of crackle in the air, like electricity; it was normal, it was the way things were between men and women. Jimmy, however, had generated no lightning.

When Quirke said nothing, Phoebe asked, "Do you think, if he was inclined that way, that it might have something to do with what happened to him? I mean, men who are like that sometimes get beaten up, don't they, just for being what they are?"

"Yes," Quirke said, "so they say."

34

Phoebe looked at her hands, which were again clasped tightly in her lap. "It would be terrible," she said quietly, "if something like that got dragged up. His family . . ."

"I don't think you need worry on that score," Quirke said. "Even if it's true, the *Clarion* won't print it, and nor will anyone else. Sometimes the kind of censorship the papers impose on themselves is a blessing."

The waiter came and cleared their plates, and they sat silent again, both of them, looking into the street. How strange it was, Phoebe thought, to be here in this lavishly appointed room, with all this burnished cutlery and these sparkling white napkins and gleaming wine glasses, beside this window and this sunlit, busy street, while her friend was laid out dead in that chill, bare basement where her father worked all day long, delving and probing into bodies just like Jimmy's.

CHAPTER
FOUR

There were few aspects of a murder investigation that Inspector Hackett enjoyed, but what he disliked most was dealing with a victim's relatives. It was not that he was unfeeling or did not have sympathy for these suffering parents, these brothers and sisters, sons and daughters — quite the opposite, in fact — only he never knew what he was supposed to say to them, what comfort he was supposed to offer. True, he was not required to console them. He was a professional, in the same way that a doctor was. Quirke, for instance, was not expected to hold a grieving mother's hand, to put an arm around the shoulder of a dazed sibling, to pat the head of a weeping orphan. There was a lot to be said for being a pathologist, as he often reminded Quirke. Handling the dead was easy, or easy at least compared to coping with the living. Why did he always have to feel responsible? Why did he think he had to share, or to give the impression of sharing, in these people's pain? But it was too late now to harden his heart, or harden his behaviour, anyway.

He met the Minors in the lobby of the Holy Family Hospital. It was early afternoon. The Minors were well named, for they were, all three of them, short people.

Not only short, but miniature, almost, like scaled-down models of themselves. The mother was a wisp of a thing, with hardly a pick on her, as Hackett's own mother would have said. She wore old-fashioned spectacles with circular wire frames and thick lenses through which she peered about her frowningly, making constant, tiny movements of her head, nervous and bird-like. She seemed more preoccupied than grief-stricken, and kept sighing and vaguely murmuring in a distracted way. Her husband, a spry little fellow with rusty hair going grey, was the dead-spit of his murdered son. He had an apologetic manner, and seemed to be embarrassed by the trouble his family was suddenly causing to so many people. Both parents referred to their son as James, not Jimmy. They spoke of him in tones of nostalgic fondness, as if he were not dead but had gone off to some distant country to make a new life for himself, far away from them but not entirely beyond reach.

"He was the busy one, our James," Mr Minor said. "Never stopped, always on the go." Having spoken he fell back a step, startled it seemed by the sound of his own voice, and his wife moved a little apart from him, as if she also felt he had spoken too loudly, or out of turn.

"Yes," Hackett said, "he was full of energy, right enough."

At this they both looked surprised. "Did you know him?" Mrs Minor asked.

"I did indeed, ma'am," Hackett said. "In the course of my work, you know." He smiled. "The police and the press are always close."

Patrick Minor, Jimmy's brother, cleared his throat pointedly, a man impatient of small-talk. He carried himself like a boxer, twitching his shoulders and flexing his elbows with a flyweight's intensity and pugnaciousness. He had red hair too, like Jimmy and his father, but not much of it. His manner was brusque, as if he considered this business surrounding his brother's death to be altogether exaggerated. He treated his parents as though they were the children and he the grown-up, chivvying them, and interrupting them when they dared to speak. He was, Hackett guessed, five or six years older than Jimmy. A solicitor, he was obviously conscious of himself as a person of significance; Hackett, who also hailed from the world beyond the city, knew the type. Now he put a hand on Minor's arm and drew him aside, and said to him in an undertone that perhaps he should be the one to identify his brother. "Right," Minor said, and seemed to stop himself just in time from rubbing his hands. "Right. Lead the way."

They descended the broad marble staircase, the four of them, and walked along the green-painted corridor. Down here the parents appeared more cowed than ever, and Mr Minor kept close to his wife, linking his arm in hers, not to lead her but to be himself led. They were, Hackett thought, like a pair of lost and frightened children.

Patrick Minor was quizzing him on the circumstances in which his brother's body had been discovered. He was all business, wanting to know everything. It was, the inspector charitably supposed, his way of dealing with grief. Everybody had a different way of doing that.

Quirke was waiting for them. His white coat was open, and underneath he was wearing a waistcoat and a checked shirt and a bow-tie — Hackett had never seen Quirke in such a tie before — looking every inch the consultant, except for those boozy pouches under his eyes. "Mrs Minor," he said, offering his hand, "and Mr Minor — my condolences." Hackett introduced Jimmy's brother, and Quirke shook hands gravely with him as well. It had the atmosphere somehow of a solemn religious occasion; they might have been gathered there for the beatification of a martyr.

None of the Minors would look at the draped figure on the trolley, though it could clearly be seen through the window of the dissecting room.

Bolger the porter materialised out of the shadows and Quirke asked him to show Mr and Mrs Minor into his office, where there was a pot of tea and a plate of biscuits laid out. Quirke followed them to the door and when they had passed through he shut it and turned back to Hackett and Patrick Minor and nodded towards the dissecting room. "It'll just take a second," he said to Minor. "This way."

The three of them went through to the starkly lit room. Minor had a grey look now, and a tiny muscle in his jaw was twitching rapidly. "We weren't close, you know, James and me," he said.

He sounded defensive. Quirke merely nodded, and positioned himself beside the trolley. "There's extensive bruising, I'm afraid," he said. "It'll be a shock. Are you ready?"

Patrick Minor swallowed hard. Quirke lifted back the nylon sheet. "Oh, Lord," Minor said softly, drawing in his breath.

"This is your brother, now, is it, Mr Minor?" Inspector Hackett murmured.

Minor nodded. He wanted to turn away, Quirke could see, yet he could not stop staring at the broken, swollen face of his brother. The bruises had lost their livid shine by now, and had the look of thick awful strips of dried meat laid over the cheeks and around the mouth.

"Who did this to him?" Minor asked. He turned to Hackett in sudden anger. "Who did it?"

"That we don't know," the detective said. "But we'll do all we can to find out."

Minor fairly goggled. "All you can?" he said furiously. "*All you can?* Look at my brother — look at the state of him. He wouldn't hurt a fly, and this is what they do to him, and you say you'll do all you can."

Hackett, tugging at his lower lip with a thumb and forefinger, exchanged a look with Quirke, and Quirke replaced the sheet over the face of what had once been Jimmy Minor.

"Tell me, Mr Minor," Hackett said, "would you know of any enemies your brother might have had?"

"I told you already." The fierce little man spoke through gritted teeth. "I wasn't close to him, not for

years." He nodded grimly, remembering. "He couldn't wait to get out and move up here to the city. Oh, he was going to be the big shot of the family, the great fellow, up in Dublin working on the newspapers and making his fortune." He gave a short, bitter laugh. "Now look at him, the poor fool."

Hackett glanced at Quirke again, and Quirke moved to the glass-panelled door. After opening it, he stood aside to let Hackett and Jimmy's brother go out before him. In Quirke's office Mr and Mrs Minor were standing beside Quirke's desk with cups and saucers in their hands. They looked awkward and uncomfortable, and Quirke had the impression that they had been standing like this for some time, afraid to move, while their two sons, the living one and the dead, were enduring their final encounter. Bolger had made off, to have a smoke somewhere, no doubt.

"Did you see him?" Mrs Minor asked, peering at her son through the pebble-glass of her specs, as if he had indeed been off in that far place where his brother was now and she expected him to have come back with news of his doings. But he ignored her. He had taken a packet of Capstan from the inside breast pocket of his suit and was offering it to Quirke and the detective. Quirke shook his head but Hackett took a cigarette, and he and Minor lit up.

Minor jerked his head upwards at an angle and expelled an angry stream of smoke towards the ceiling. "If you expect help from me you'll be disappointed," he said, in a thin, resentful tone. He had addressed his words not to Hackett but to Quirke, as if Quirke were

41

the investigating officer. "I don't know what he was up to. Even the odd time he came home he'd say little or nothing about what he was doing." He gave another angry laugh. "We knew more from reading what he wrote in the paper than we could get out of him." He glanced towards his parents. "He didn't care twopence for us, and that's the truth."

"Ah, now, Paddy," his father said softly, timidly.

"James was a very loving boy," Mrs Minor said, raising her voice and looking from Quirke to Hackett, as if to forestall a denial from them. "He wrote a letter home every week, and often sent a postal order along with it."

Her son glanced at her sidelong and curled his lip. "Oh, sure," he said. "Our James was a saint, wasn't he?"

She seemed not to have heard him, and went on looking from Quirke to the detective and back again, twitching her head from side to side — like a wren, Hackett thought, like a poor little distressed jenny wren. She had not wept yet for her son, he could see; that would come later, the tears sparse and scalding, the sobs a dry scratching in her throat. He thought of his own mother, thirty years dead. The mothers bear the harshest sorrows.

There was nothing left here to be done. It was clear these people had no help to offer in solving the mystery of the young man's murder. Hackett asked where they would be staying until the funeral. Flynne's Hotel, Patrick Minor told him. Hackett nodded. Flynne's, of course. It was where people from the country stayed.

Boiled bacon and cabbage, loud priests in the bar knocking back whiskeys, and staff with the familiar accents of the Midlands. Ireland, Mother Ireland. Sometimes, Hackett had to admit, this country sickened him, with its parochialism, its incurable timidity, its pinched meanness of spirit. He shook hands with the parents — the son pretended not to notice his proffered hand — and led them to the door. "We'll let you know," he said, "as soon as we have any news, any news at all."

Quirke stepped forward and opened the door. The elderly couple went out, followed by their son, who paused in the doorway and glanced a last time towards the window of the dissecting room and the figure on the trolley there. "He used to come to me in the schoolyard," he said, "looking for me to save him from the bigger boys when they picked on him. I didn't help him then, either." He turned his eyes to Hackett, then to Quirke, but said nothing more.

"So," Hackett said. "What do you think?" He was half sitting with one haunch perched on the corner of Quirke's desk. Quirke was lounging in his swivel chair behind the desk, lighting up a Senior Service. Hackett, swinging one leg, could not take his eyes off that blue bow-tie. It was not like Quirke, he thought, not his style at all. Maybe it was a present from his daughter, or maybe from his lady-friend, the actress — what was her name? Gallagher? No, Galloway. It would be *her* style, a fancy tie like that. But maybe Quirke had bought it himself, maybe he was after a new look: the sleek

medic, top man in his field, sound and dependable but not averse to cutting a bit of a dash. The waistcoat too was a new addition. What next? A couple of gold rings? Eye-glasses on a string? Spats?

Quirke glanced at him sharply through the smoke of his cigarette. "What's so funny?"

"Ah, nothing," Hackett said. "I was admiring your tie."

Quirke put up a hand self-consciously and touched the silk knot. "Is it this you're grinning at?"

"Not at all, not at all. Very smart, it is. Very smart."

Quirke continued to eye him darkly. Hackett's own faded red tie was of the ordinary type, though short, and broad at the bottom, so that it looked a bit like an immensely long tongue, hanging out dejectedly.

"Anyway — what do I think about what?" Quirke said.

Hackett nodded towards the dissecting-room window. "This business."

The swivel chair creaked as Quirke leaned far back in it and put his feet on the desk with his ankles crossed. He pressed a bunched finger to the bridge of his nose. "I don't think anything," he said. "What about you?"

Hackett puffed out his cheeks and expelled a long breath. "God knows," he said. He pointed to the Senior Service packet. "Give us one of them."

Quirke pushed the cigarettes across the desk, along with his lighter. For a while both men smoked in silence, then Quirke spoke. "Anything found at the scene?"

"Not a thing. Footprints and so on, but there'd been a downpour earlier and everything was washed out. Plus, of course, my genius of an assistant, Detective Sergeant Jenkins, had let everyone traipse all over the place, so anything there might have been was trodden into the mud."

Quirke laughed. "Poor Jenkins. I imagine he's still smarting, after you'd finished with him."

The detective sighed. "What would be the use? He's hopeless, the poor clot. But I suppose he'll learn." He paused, picking a fleck of tobacco delicately from his lower lip. "Your daughter," he said, "— does she know?"

"I told her."

"How did she take it?"

Quirke screwed up his face and touched his bow-tie again. "I didn't handle it very well."

"Hmm," Hackett said. "I don't know that there is a good way to handle that kind of thing." He paused again. "Were they close friends?"

Quirke gave him a swift glance. "Are you asking if they were 'romantically involved'? Not at all. In fact, I have a notion he wasn't that way inclined."

"You mean —?"

"It struck me it might be the case, the few times I met him."

The detective took this in. "So," he said, nodding to himself. "That's interesting."

"You think it might be a factor?"

"Oh, anything might be a factor."

"They gave him some going-over."

"Aye — whoever 'they' were."

Quirke had finished his cigarette and now he lit another one from the butt. "I had the impression it was a professional job."

To this Hackett said nothing; the going-over Quirke had once got had been administered by a pair of professionals, so he would know. For a while he said nothing, only sat and smoked meditatively. "I suppose the place to start," he said, "is at the paper." He was still swinging his leg and now he looked at the toe of his shoe. "Will you give me a hand?" he asked.

"A hand?"

"You know what I mean."

They looked at each other, and had they been other than they were, they would have smiled.

CHAPTER
FIVE

Harry Clancy was not cut out to be the editor of a national daily newspaper. Harry knew this: he had few illusions left about himself and his capacities. His had been one of the last appointments, and one of the most unexpected, that Francie Jewell had made before retiring as proprietor and manager of the *Clarion* and handing it over to his son Richard, otherwise known as Diamond Dick. Sometimes Harry wondered if it had not been the old man's idea of a joke, played at his son's expense.

Harry, who had started out on the paper as a copy-boy, had risen to the position of night editor, a job he had held for years, and had been looking forward to an early and uneventful retirement when the call had come from Francie late one rainy Friday night. Harry and Mrs Harry had been at the dog races at Shelbourne Park, and had just come in, and being not entirely sober Harry could not at first grasp what it was the old bastard was saying to him. *I want you for the top seat, Harry,* Francie had said, *the top seat.* And then he had done that laugh of his, a cracked cackle that ended in a fit of coughing. Harry had stood in the hall with the phone in one hand and his rained-on hat

in the other, asking himself perplexedly what the bloody hell Francie meant by the *top seat*, while Mrs Harry stood beside him, trying anxiously to read in his face what was going on — years afterwards she had confessed that she had thought he was being given the sack. It was not the sack, however, far from it, and the following Monday morning Harry Clancy had found himself lowering his bottom uneasily and with grave misgivings into the very top seat, lately and ignominiously vacated by his humiliated and bewildered predecessor, who was to die six months afterwards, of a broken heart, as many people on the paper claimed.

Harry's passion was golf. Everything he had achieved in journalism — and for a boy from Lourdes Mansions he had achieved a lot — he would have given up for a crack, just one crack, at one of the big championships. He was good, better on his best days, he considered, than his five handicap indicated, but it was too late now: his joints were not what they had been, and more than once recently he had heard on the down-swing a click in his right elbow that had sounded an unmistakable warning of something serious on the way. Still, he had his memories. For instance, there was the round he had played at Portmarnock one sunny afternoon with Harry Bradshaw — the great Harry Bradshaw, the man himself — which had ended all square with both of them on seventy-four. Afterwards in the clubhouse the two Harrys had shared a bottle of Bollinger, poured it sizzling into a silver cup that the barman took down for them from behind the bar,

which they drank from in turns, slapping each other on the back. That had been a day to remember.

This morning he had been practising his putting when his secretary had come in all of a fluster to tell him the news about Jimmy Minor. The office was small and a putt of seven feet or so was the maximum he could manage, setting a diagonal trajectory from the corner of his desk to the tumbler he had put lying on its side on the carpet by the door. It was not practice, not really. The carpet was too smooth, and he had to give the ball a harder tap than the distance warranted to get it to go over the lip of the glass and into the tumbler. Still, it was soothing, on a slow day, to knock a few balls about, and a great way of not thinking about anything at all. Miss Somers had been in such a state when she flung open the door that she had not seen the golf balls all over the carpet and had nearly tripped on them. Harry chuckled to himself. What a sight that would have been if she had taken a tumble, the prissy old maid sprawling on her back with her legs in the air and her bloomers on show. She had given him a fright, running in like that, and he had thought that at the very least the Russians and the Yanks must have started firing off bombs at each other.

Strange, but he was not all that surprised to hear about Minor. It was a shock, certainly, but there was a sense of inevitability, too. Why was that? There had always been something of the victim about Jimmy Minor. He had been too intense, had taken everything too seriously. He had never acknowledged the entertainment aspect of what they did, the showbiz side

49

of newspapers. He had seen himself as a crusader, a Clark Kent who one day soon would turn into Superman. Harry stood at the window now, leaning on his putter and gazing down on the rain-washed quayside and the stippled grey river. What had Minor been up to that a person or persons unknown had thought it necessary to beat the living daylights out of him? Was his death connected with his work, or was it something personal that had done for him? He had been the secretive type, a loner. The misfortunate poor little bastard.

He picked up the phone and dialled zero. Miss Somers still had a tremor in her voice. He asked if Smyth, the news editor, was in yet, and she said yes, and he told her to send him in. Smyth knew everything there was to know about his staff men.

Archie Smyth had been running the news desk for longer than anyone could remember. He seemed ageless, with a baby's blue eyes and oiled black hair combed back tight against his skull. His trademark was a sleeveless blue pullover that he wore every day — the office joke was that eventually he would have to go into hospital and have it surgically removed. He was a decent fellow, hard-working and diligent; a Protestant, of course, hence the y in his surname. Harry trusted him, and depended on him to be his eyes and ears about the office. If there was anyone who could shed light on Jimmy Minor's death, it would be Archie.

"You heard?" Harry said.

Archie nodded. "I heard."

Over the years Archie's blue pullover had been steadily shrinking, and by now it was so short that it did not quite cover the waistband of his trousers, where the latches of his braces were to be seen, like two pairs of splayed fingers giving upside-down V-signs. Recently he had lost his wife, but had been back on the job the day after the funeral. There was a son who worked on one of the Fleet Street papers, the *Telegraph*, was it, or *The Times*? Archie was fiercely proud of him.

"Any ideas?"

Archie shook his head. "Can't say I have."

"Was he on a story?"

"If he was he didn't tell me. But that wouldn't be unusual — you know what he was like."

In fact, Harry did not know what Jimmy Minor had been like. Harry avoided direct dealings with the staff. Most of them despised him, he knew, especially the older lot, who still had not forgiven him for replacing Bill Burroughs, his predecessor to whom Francie Jewell had unceremoniously given the shove. "But you hadn't put him on anything?" he persisted now.

Archie made a show of trying to recollect. "No, there was nothing special — so far as I know, as I say. He'd been on Dáil duty but asked to come off it."

"Why?"

"He didn't say." Harry had a keen look fixed on him. "Listen, boss, Jimmy was a good lad. He had a good nose. There aren't many on the desk I'd have given the kind of leeway to that I gave him."

Harry held the putter at arm's length and sighted along it with one eye shut. "What about his — his private life?"

"What about it?"

Archie had taken on a stony expression: knowing what was going on in the office was one thing, but it was no business of his to stick his nose into whatever it was his staff might get up to in their own time.

"He wasn't married?" Harry said, still peering along the shaft of the club.

"No."

"Girlfriend?"

Archie gave a slight cough. "I never asked."

"Right." Harry set the putter leaning against the windowsill and threw himself down in his chair behind his desk. Rain whispered against the window panes. "Come on, Archie," he said impatiently. "You know what I'm asking you."

Archie was still stony. "He used to go around with April Latimer," he said.

"The one that disappeared?" Harry gnawed at a knuckle, thinking. "When you say, 'go around with', what does that mean?"

"They were friends."

"But she wasn't his girlfriend."

Archie shrugged. Harry turned in his chair and looked out again at the river and the great swag of lead-blue cloud louring above it. "Has the chief been told?" he asked.

The chief was Carlton Sumner, proprietor of the *Clarion*, having taken it over from Diamond Dick

Jewell's widow. The mere mention of his name brought a slight chill into the air. Everyone in the building was more or less afraid of Carlton Sumner, which was exactly how Carlton Sumner wished everyone to be.

"*I* haven't told him," Archie said, by which he meant it was Harry's job to break that kind of news to Sumner.

Harry bit at his knuckle again. "I'd better call him, I suppose," he said gloomily.

At that moment, as if on cue, the telephone on his desk rang. He snatched up the receiver. He listened for a moment, then sighed. "Send him in," he said, and replaced the receiver in its cradle. He looked at Archie. "It's Hackett."

Harry did not like policemen: they made him nervous, as if he had a guilty secret he had forgotten about that they were going to remind him of. Hackett was one of the sly ones, pretending to be a simple fellow up from the country while in reality he was as sharp as a tack. He came in now with his hat in his hand, wearing his bland, froggy smile. He nodded to Archie, who nodded back. All three had known each other for a long time.

"This is a bad business," Hackett said, and put his hat down on the corner of Harry's desk.

Harry, who had not risen from his chair, looked at the hat, then glanced up at the detective narrowly. "Yes," he said. "A tragedy. Terrible for the paper, too — for all of us."

Hackett was still smiling, his tongue stuck at the corner of his wide, thin mouth. "Oh, aye," he said, with

only the faintest hint of irony, "a tragedy indeed. His family is fairly upset too."

Archie Smyth watched the two men with a keen eye. Archie was a peaceable soul, and it fascinated him how suddenly animosity could spring up between two men, especially men such as these. Harry, the working-class boy made good, was always on the lookout for slights. It was obvious he found Hackett's smile irritating, and resented his air of prizing and deeply enjoying a private joke. Now Hackett took a chair that had been standing by the wall and brought it to the desk and sat down. Archie noted his lumpy, bright-blue woollen socks; his missus must have knitted them for him.

"Do you know who did it?" Harry Clancy asked.

"I do not," Hackett said, almost complacently.

Harry scowled. "You must have some idea."

The detective shook his head, still easy, still smiling. There was a silence. From deep down in the bowels of the building a low, drumming sound began to build that made the floor vibrate under their feet. The presses had started up, and would soon be printing the early edition of the *Evening Echo*, the *Clarion*'s sister paper, which came out in the late afternoon.

"I'd like," Hackett said, "to have a look at Jimmy Minor's desk."

Harry Clancy glanced at Archie. "Has he got a desk?"

"Shares one," Archie said. "With Stenson — Stenson is on the *Echo*. He has it during the day, Jimmy at night."

Hackett turned to him. "Can I see it?"

54

Archie hesitated, but Harry Clancy waved a hand dismissively and said to Hackett that of course he could see the bloody desk, that they had no secrets here. He was getting into one of his tempers, Archie saw, and was glad of the excuse to make an exit. "This way," he said to Hackett.

The detective rose and moved towards the door that Archie had opened for him. "Don't forget your hat," Harry said sourly.

Hackett turned and grinned at him. "Can I leave it with you for a minute?" he said. "I'll be back."

The desk that Jimmy Minor had shared with Stenson of the *Echo* was a scarred and ink-stained table with a big old Remington typewriter standing on it in state. There was a U-shaped plywood contraption with pigeon-holes, all of them full, stuffed with out-of-date press releases and yellowing cuttings. "I'd say this is all Stenson's," Archie said. "Jimmy was the tidy type."

"Is Stenson around?"

"Gone home. Will I call and tell him to come back in?"

The detective seemed not to be listening. He sat down at the table and ran a finger along the brittle edges of the old papers in the pigeon-holes. "Would you know Jimmy's handwriting?" he asked.

"Stenson would, probably."

Hackett nodded, then looked up at the news editor. "You think there'd be anything here?"

"I doubt it. As I say, Jimmy kept things tidy."

"He was secretive, you mean?"

"I don't know that I'd say secretive. But he had notions of himself — saw too many Hollywood pictures, thought he was Humphrey Bogart." He smiled, remembering. "He was a bit of a romantic, was young Jimmy."

Now Hackett was fingering the keyboard of the Remington, like a blind man reading braille. "Do me a favour," he said. "Ask Stenson, when he's in again, to have a look through all this stuff and separate off anything of Jimmy's. Notes, I mean, memos, that kind of thing." He looked up at Archie again. "He wasn't that tidy, was he, that he wouldn't have left a few bits and scraps?"

"I'll put Stenson on to it," Archie said. "Maybe there'll be something."

Hackett continued gazing at him, still distractedly playing with the typewriter keys. "Is there anything you can tell me, Mr Smyth," he asked, "anything at all?"

The noise from the presses in the basement was now a steady, thunderous roll.

"Like what, for instance?"

Hackett smiled. He really did have the look of a frog, Archie thought, with that broad head and doughy face, and the mouth a bloodless curve stretching almost from ear to ear.

"You're an experienced chap," Hackett said, "you must have some sort of an idea of what could have happened. It's not every day of the week a reporter in this town is murdered. Did Jimmy have any dealings with subversives?"

56

"You mean the IRA?" Archie said, and gave a small laugh. "I doubt it. He'd have considered them a crowd of half-wits, playing at soldiers and blowing themselves up with their own bombs."

Hackett considered. There was a line across the detective's forehead, a match for his mouth, where the band of his hat had left its mark. "What about the criminal fraternity?" he asked. "The Animal Gang, or their cronies?"

"Look, Inspector," Archie said, opening his hands before him, "this is a newspaper office. We cover fires, traffic accidents, politicians' speeches, the price of livestock. Whatever Jimmy might have dreamed of, we're not in the movies. God knows what he was up to. People have their secrets, as I'm sure you're only too well aware. How he ended up in that canal I don't know, and furthermore don't like to speculate. As far as I'm concerned, he can rest in peace."

He stopped, with a sheepish expression, surprised at himself: he was not known for loquaciousness. He supposed he must be more upset by Jimmy's death than he had thought. The detective, still seated, was studying him, and now again he let that broad, lazy smile spread across his face. "The thing is, Mr Smyth," he said, "my job is just that — to speculate. And so far I'm staring at a blank wall."

Archie looked away. He scratched the crown of his head with the little finger of his right hand, making Hackett think of Stan Laurel. Hackett was feeling a stirring of annoyance. He had slipped many a morsel of useful information to Archie Smyth over the years, and

now it was time for Archie to return the compliment. He waited. It was his experience that people always knew more than they thought they did. Things lay torpid at the bottom of their minds, like fat, pale fish in the depths of a muddy pond, and often, with a bit of effort, those fish could be made to swim up to the surface.

Sure enough, a light dawned now in Archie's expression. "There was something he mentioned, all right," he said, "I've just remembered it — something about tinkers."

"Tinkers?"

"Yes. He'd been out to some place where they were camped, out in Tallaght, I think it was. Yes, Tallaght."

"Why?"

Archie blinked. "What?"

"Why did he go out to Tallaght? I mean, what brought him out there?" For a news editor, Hackett thought, Archie was not exactly fast on the uptake.

"I don't know. Someone must have given him a tip-off."

"About what?"

"I told you — tinkers."

"That's all?"

Archie shrugged. "I was only half listening."

"When was this?"

"Last week some time. He wanted me to sign a taxi docket. I asked him what was wrong with the bus. Jimmy thought he was too good for public transport."

"He took a taxi to Tallaght?"

"Ten or fifteen shillings it would be, for that distance. And of course he had to taxi back in again."

Hackett was gazing at Archie's blue pullover. He knew better than to try to hurry people, but sometimes he felt like grabbing the Archies of this world by the throat and shaking them until their cheeks turned blue and their eyes popped. "Did he say where the tinker camp was?"

"I told you — in Tallaght."

"Yes, Mr Smyth, you did. But there's a lot of tinkers in Tallaght, or there were, the last time I was out there. Did Jimmy mention a name?"

Archie laughed. "What use would that have been? They're all called either Connors or Cash."

Hackett suppressed a sigh. "So, no name, then. Anything else?"

"Sorry. No."

"And when he came back from Tallaght, did you see him? Did he have anything to say then?"

Archie shook his head. "I heard no more about it, about tinkers or Tallaght or anything else."

"But he'd have kept notes, wouldn't he?"

"I suppose so, if he thought there was a story. You haven't found his notebook, I take it."

"We found nothing — the poor fellow was stripped of everything he had."

"What about his flat?"

Hackett stood up; he seemed suddenly weary. "That," he said, "is my next port of call." He paused. "Mr Smyth," he went on, "can I ask you a favour? Would you ever mind fetching me my hat from your

59

boss's office? I think Mr Clancy and I have said all we have to say to each other, for the present." He smiled. " 'Sufficient unto the day', eh, Mr Smyth?"

"— is the newspaper thereof," Archie said.

They both chuckled, without much conviction.

The landlord's name was Grimes. He was a large, pale, smooth man, with a hooked nose and a condescending smile. He wore a three-piece suit with a broad chalk-stripe and a camel-hair overcoat with a black velvet tab along the collar. His manner was slightly pained, as if he were being compelled to take part in something he considered beneath him. He made a show of having difficulty with the front-door key, to demonstrate, Hackett assumed, how little familiarity he had with such a down-at-heel establishment, despite the fact that he was the owner. The house, in a russet-and-yellow-brick terrace on Rathmines Road, was of three storeys over a basement. Mr Grimes said he was not sure, actually, how many flats there were. Hackett nodded. He could guess how inventive Mr Grimes would have been in the disposition of partition walls. Despite his disclaimer he would know exactly how many cramped little boxes he had managed to divide the old house into.

In the high-ceilinged, gloomy hall the very air seemed dejected. There was a smell of must and of cooked rashers. A large rusty bicycle stood propped against the hall table. Mr Grimes clicked his tongue. "Look at that," he said testily, glaring at the bike. "They have no respect."

60

They climbed the stairs, their footfalls sounding hollow on the worn and pitted lino. Above them somewhere Nat King Cole was crooning creamily on a gramophone about the purple dusk of twilight time; elsewhere a baby was crying, giving steady, hiccupy sobs, sounding more like a doll than a real child. Mr Grimes wrinkled his great pallid beak.

When they had climbed to the third-floor landing they were both breathing heavily. The door of the flat had the number seventeen nailed to it, the enamel seven hanging askew. Again Grimes fussed with the key, then paused and turned to the detective. "Shouldn't I be asking to see a search warrant or something?" he said.

Hackett did his slow smile. "Ah, that's only in the pictures." Still Grimes hesitated. The detective let his smile go cold. "It's a murder investigation," he said. "Your cooperation will be greatly appreciated, Mr Grimes."

Inside the flat the air was chilly. Hackett knew he was imagining it, yet he had a distinct sense of desolation in the atmosphere. He felt constrained, tentative, almost ashamed to be there. Places where the recently dead had lived always made him feel this way — he supposed it was a very unprofessional reaction. He remembered the first corpse he had dealt with. A tramp, it was, who had died in a doorway in a lane behind Clery's department store on O'Connell Street. He had been a big fellow, not old, and there was no sign of how he had died. Hackett at the time was a uniformed rookie, not long out of Templemore. It was summer, and he was at

61

the end of his beat when the early dawn came up, a slowly spreading greyish stain above the jagged black rooftops. The look of the corpse, the shabbiness of it, made him feel doubly alone and isolated, as he squatted there amid the smell of garbage, with scraps of paper blowing to and fro and making a scraping sound on the cobbles. An oversized seagull — gulls always seemed huge at that time of the morning — alighted on the rim of a nearby dustbin and watched him with wary speculation. The tramp was not long dead, and when Hackett put his hand inside the dirty old coat in search of some form of identification, he felt as if he had reached not just inside the fellow's clothes but under a flap of his still-warm flesh. *You're too sensitive for that job you're in*, his wife would tell him scoldingly. *You've too much heart.*

"It must be a trouble to you," he said to Grimes, "losing a tenant."

Grimes shrugged dismissively. "As swallows they come, as swallows they go, as the poet says."

The flat consisted of one big room that had been divided in two by a thin plaster partition. In the front half there was a further sub-division where a galley kitchen was separated off behind another sheet of plasterboard. The sink contained crockery and a couple of blackened pots; a frying pan with congealed grease in it was set crookedly on the gas stove. On the small square table before the window in the main part of the room lay the remains of what must have been breakfast, or supper, maybe: tea things and a teapot, a smeared plate, a turnover loaf with two uneaten slices beside it

on the breadboard. Hackett touched the bread: stale, but not gone hard yet. *The condemned man ate his last meal* . . . He thought again of the dead tramp huddled in that doorway behind Clery's.

Grimes waited at the mantelpiece, fitting a cigarette into an ebony holder. "There's a month's rent owing," he said thoughtfully. "I wonder what I can do about that."

Hackett went into the back room. Single bed, unmade, with a hollow in the middle of the mattress; a rush-bottomed chair; a big mahogany wardrobe that must have been there since before the partitions were put up. A shirt with a soiled collar was draped over the back of the chair. On the floor beside the bed books were stacked in an untidy pile: Hemingway, Erie Stanley Gardner, Orwell's *Homage to Catalonia*, a selected Yeats. Beside the books was a tin ashtray advertising Pernod, heaped high with crushed butts that gave off an acrid smell.

Hackett stood in the middle of the floor and looked about. Nothing here; nothing for him. In one corner there was a tiny handbasin with a rim of dried grey suds halfway up the side; looking closer, Hackett saw reddish bristles embedded in the scurf.

He went to the window. There was a straggly garden at the back, mostly overgrown except for a plot at the near end that had been recently dug and planted — he could make out potato drills, and bamboo tripods for beans, and seedbeds where shoots were already showing.

He returned to the front room. Grimes was at the sideboard now, going through a sheaf of documents there.

"Who's the gardener?" Hackett asked.

Grimes barely glanced at him. "Minor was. He asked if he could plant out some things. It didn't matter to me. I suppose it'll all go to waste, now."

Hackett nodded. "I'd be grateful," he said mildly, looking pointedly at the papers Grimes was searching through, "if you'd leave that stuff alone."

"What?" Grimes paused in his search. It was plain he was not accustomed to being told what and what not to do. "I'll have to clear the place," he said. "I can't leave it standing idle." He smiled, though it seemed more a sneer. "Space is money, you know."

"All the same," Hackett said. "Just leave things as they are for the moment. I'll want a couple of my fellows to have a look around."

"What for?" Grimes's sneering smile broadened, which made the sharp end of his big nose dip so far it nearly touched his upper lip. "Searching for clues, is it?"

"Something like that."

Grimes tossed the papers back on to the sideboard. "There's a letter there from a priest," he said, with a sniff of amusement. "Would that be the kind of clue you're after?"

CHAPTER
SIX

Carlton Sumner's rare visitations to the offices of the newspapers he owned burst upon the place like summer storms. First a prophetic and uneasy hush would fall throughout the building, then a distant disturbance would be felt, a sort of crepitation in the air, to be followed swiftly by the irruption of the man himself, loud and terrible as the coming of Thor the thunder-god. That Wednesday morning Harry Clancy hardly had time to get his feet off of his desk before the door burst open and Sumner came striding in, smelling of horse-leather and expensive hair-oil. He was a big man, with a big square head and a black, square-cut moustache and large, slightly drooping and surprisingly soft brown eyes. He was dressed like the businessman he was, in a three-piece suit of light-brown herringbone tweed, a white shirt with a thin blue stripe and a blue silk tie, yet as always he gave the impression of just having dismounted after a long, hard gallop over rough terrain. He was Canadian, but spoke and moved and acted like an American out of the movies.

"All right, Clancy," he said, "what's going on?"

Harry, although still seated in his swivel chair, had a vision of himself cowering on his knees with his fingers

clamped on the edge of his desk and only the top of his head and his terrified eyes visible. He licked his lower lip with a dry tongue. "How do you mean, Mr Sumner?" he asked warily.

Sumner gave his head an impatient toss. "I mean what's going on about this reporter of yours who got himself murdered? What are you doing about it?"

Harry forced himself upright in his chair, straightening his shoulders and clearing his throat. His wife often lectured him about his craven attitude to his boss. Sumner was only a bully, she would say, and threw his weight around to entertain himself. She was right, of course — Sumner always showed a glint of amusement, even in his stormiest moods — but the bastard had a mesmerising effect, and Harry, steel himself though he might, felt like a frightened rabbit trapped in the glare of those big, and deceptively melting, glossy brown eyes. "Well, the police were here," he said. "Detective Inspector Hackett . . ." He faltered, remembering, too late, that Hackett had been instrumental in having Sumner's son deported to Canada for his involvement in a recent series of nefarious doings.

Sumner frowned, but either he had not recognised Hackett's name or was pretending to have forgotten it. "So what are *they* going to do," he said, "the cops?"

"They've launched a murder investigation."

Sumner gazed down at him, his moustache twitching. "A 'murder investigation'," he said. "Jesus, Clancy, you've been working in newspapers too long. You're beginning to talk like them." He walked to the window and stood looking out at the river, his hands in

66

his trouser pockets. "You know I almost missed it?" he said.

"Missed what, Mr Sumner?"

"The report of this kid's death. It was buried at the bottom of page five."

"Page three."

Sumner gave a harsh laugh. "So it was page three! Great." He turned and came back and tapped hard on Harry's desk with the tip of a thick, blunt, but perfectly manicured finger. "The point is," he said, "why the goddamn hell wasn't it on page one? Why wasn't it *all over* page one? Why wasn't it *all* of page one, period?"

"This is a delicate one, Mr Sumner," Harry began, but Sumner pushed a hand almost into the editor's face.

"Don't talk to me about delicate," he said. "What do you think we're running here? *House and Garden?* The *Ladies' Home Journal?*" Now he jammed both elbows into his sides and splayed his hands to right and left over the desk, like an exasperated hoodlum in a gangster film. "It's a newspaper, for God's sake! We have a story! One of our very own reporters gets kicked to death and thrown stark-naked in the river *and you bury it on page five?* Are you a newsman, or what are you?"

Noosman, Harry repeated to himself and, in his imagination, curled a contemptuous lip.

There was a brief, heavy silence, Sumner leaning over the desk with his hands held out in that menacingly imploring gesture and Harry looking up at him wide-eyed, his mouth open.

"Canal," Harry said, before he could stop himself.

Sumner blinked. "What?"

"It was the canal he was dropped into, not the river."

Sumner, frighteningly quiet, nodded to himself. He let his hands fall to his sides in a gesture of helpless resignation. He pulled up a straight-backed chair and sat down and planted his elbows on the desk. "How long have you been in this job, Harry?" he asked, purring, sounding almost friendly, as if he really wanted to know.

"A year," Harry said defensively. "Two, in September."

"You like your work? I mean, you get satisfaction out of it?"

Harry's mouth had gone dry again. "Yes, of course," he said.

Once again Sumner was nodding. "I'm glad to hear it," he said. "I like to think the folk working on my newspapers are happy. It gives *me* satisfaction, to know that *you're* happy. You believe that?" Harry only looked glum, and Sumner smiled, showing his big white teeth. "You'd *better* believe it, because it's true. But you've got to realise" — he leaned back and brought out from the breast pocket of his jacket a box of cheroots and flipped open the lid — "I'm in business here. We're all in business here."

The cheroots were of a blackish-brown colour, obviously handmade; long and thin and misshapen, they reminded Harry of shrivelled dog turds. Sumner selected one, held it up before him between his fingertips and gazed at it with satisfaction. Harry pushed a heavy desk lighter towards him but Sumner

shook his head and brought out a box of Swan Vestas. "Lighters taste of gasoline," he said. "A good cheroot deserves a match."

He lit up with a flourish, making a business of it, while Harry looked on in dull fascination. Sumner shook the flame until it died, then set the smouldering matchstick carefully on a corner of the desk, ignoring the ashtray that Harry was offering, and exhaled with a soft sigh a flaw of blue, dense-smelling smoke. "The point is, Harry," he said, settling back on the chair and crossing his left ankle on his right knee, "newspapers thrive on — well, you tell me. Come on. Tell me. What do newspapers thrive on, Harry?"

Harry regarded him helplessly with a glazed stare. By now he felt less like a rabbit than a torn and bloodied mouse that a cat had been toying with for a long time and was about to eat.

"*Noos*, Harry," Sumner said, almost whispering the word. "That's what they thrive on — *noos*."

He smoked in silence for a time, smiling to himself and gazing at Harry almost benignly. Harry was bitterly reminding himself that, although Sumner had taken over the *Clarion* less than a year before, obviously he saw himself as an expert at the business.

Below them, deep in the bowels of the building, the presses were starting up for a dummy-run.

"So," Harry said, "what do you want me to do, exactly?"

"Me? — *I* don't want you to do anything. What I want is for *you* to tell *me* what *you're* going to do. You're the professional here, Harry" — he paused,

seeming about to laugh at the notion but settling for a broad smile instead — "you're the one with the know-how. So: impress me."

Harry could feel the sweat forming on his upper lip; he was sure Sumner could see it, beads of it glittering against his already forming five-o'clock shadow, which on him always began to appear mid-morning. He had spent time in the army when he was young. He had been had up on a shoplifting charge, nothing very serious, but the judge had given him the option of Borstal or the ranks. It was a period of his life he did not care to dwell on. There had been a sergeant who was the bane of his life — what was his name? Mullins? No, Mulkearns, that was it. Little stub of a fellow, built like a barrel, with slicked-back hair and a Hitler 'tache. He was a bully too, like Sumner here, the same dirty, gloating smirk and the same air of enjoying himself hugely at others' expense. *You say these here spuds are peeled, do you, Clancy? Well, now you can get going on peeling the peelings.* Oh, yes, Mulkearns and Carlton Sumner were of a type, all right.

"We could run a feature, maybe," Harry said, though it sounded unimpressive even to his own ears. "The increasing instances of violence in the city, gangs on the rise, Saturday-night drunkenness, the youth running wild . . ."

He let his voice trail off. Sumner, lounging on the chair, had put his head back and was gazing at the ceiling, slack-mouthed and vacant, the cheroot in his fingers sending up a swift and, so it seemed to Harry, venomously unwavering trail of steel-blue smoke. Then

70

he snapped forward again, straightening his head with such suddenness that a tendon made an audible click in his thick, suntanned neck. "No no no," he said, with a broad gesture of his left hand, as if he were brushing aside a curtain of cobwebs. "No: what I see is a front-page splash. 'JIMMY MURDER: NEW DEVELOPMENT'. Run it across eight columns, top of the page. A photo of Jimmy thing; — what was his name?"

"Minor."

Sumner frowned. "Sounds kind of ridiculous, doesn't it, 'Jimmy Minor'? If he'd been a kid it would be fine — 'Little Jimmy Minor', like 'Little Jimmy Brown'." He brooded. "Still, run a nice picture of him, with something in the caption like, 'Our man, brutally slain'. Right?"

"Right," Harry said, trying to sound in forceful agreement. He fingered a sheet of copy-paper on the desk in front of him. "But," he said, "this 'new development' — what would that be?"

Sumner looked at him, his cheeks and even his eyes seeming to swell and grow shiny. "What do you mean?"

"Well . . . there haven't been any developments."

"There must be developments. There's always developments. Even if there's not, the cops pretend there are. What do they say? 'Following a definite line of enquiry'. Get on to that detective, what's-he-called, and make him give you something. If he says he has nothing, invent it yourself — 'love tangle clue to killing', 'mystery woman seen in vicinity of the crime', that kind of thing."

"But . . ."

"But what?"

Harry heard himself swallow. "It's not really . . . We can't just . . ."

"Why not?"

Sumner's moustache was twitching again. Was he trying not to laugh? The missus was right, Harry had to acknowledge it: Sumner was no newspaper man. He was just amusing himself here, making Harry peel the potato peelings. Harry shifted in his chair. "We can't just invent things, Mr Sumner. I mean, there's a limit."

Sumner, gazing at him, slowly shook his head. "That's where you're wrong, Harry," he said, in almost a kindly, almost an avuncular tone. "There are no limits, except the ones you impose on yourself. That's a thing I've learned from a lifetime in business. There's no limits, there's no line that can't be crossed. You take a risk? Sure you take a risk. Otherwise you're not in the game at all." He stubbed the remains of his cheroot in the ashtray on the desk and got to his feet, brushing his hands together. "The mystery woman," he said. "That's the line to follow."

"But —"

"There you go again," he said, smiling genially, "butting the buts." He winked. "*Cherchez la femme* — there's always a broad, Harry, always." He began to turn aside but a thought struck him and he stopped. "He wasn't queer, was he, our little Jimmy Brown?"

Harry was about to reply, but paused. Here was a way, maybe, to get Sumner to back off. No paper was going to splash a story if it involved a nancy-boy getting done in. Even Sumner would know that. "We've no

72

reason to think he was that way inclined," Harry said carefully. "On the other hand —"

"Good," Sumner said briskly. "Let's get going, then."

Harry's spirits sank. No good resisting, Sumner would not be deterred.

"There *was* a woman there, that night," Harry said, tentatively.

"Oh, yes? Who was she?"

"Secretary, lived nearby. She was the one that found the body."

Sumner showed his teeth again in a big, benign smile. "See?" he said. "I told you: there's always a broad."

"Trouble is, she was with someone. Her boss."

"Her boss? Wasn't it the middle of the night when the corpse was found? What the hell was this secretary doing with her boss at that hour?" He laughed coarsely. "Taking dictation?"

Harry shrugged. "I don't think we can call her a mystery woman."

"Sure you can! Or make the boss a mystery man. 'Riddle of Couple on Riverbank'. It's perfect."

"The thing is —"

Sumner made a sudden lunge forward, planting his big hands on the desk in front of Harry and looming at him menacingly. Harry could smell the lingering mundungus stink of his breath.

"Harry, look," Sumner said. "Do this — do it for me, if you like. Find the girl, talk to her, talk to her boss —"

"He won't —"

"He will. You'll make him talk. I bet he has a wife, and if he has, I bet she didn't know about little Miss Secretary being out with him for a midnight stroll and stumbling on a body and the cops coming and taking down her particulars — yes? All anybody needs is a little persuasion, Harry. Lean a little on the two of them and they'll sing like songbirds." He smiled, those white teeth genially agleam. "You'll see — you'll see I'm right." He straightened, and turned and went to the door, then paused again. "You know," he said thoughtfully, glancing up at a corner of the ceiling, "I'm really getting to like this business. I should have gone into newspapers years ago."

He nodded then, and went out, whistling. Harry sat for a long time gazing stonily at the door. "*Noospapers*," he said, with deep disgust, spitting out the word.

CHAPTER
SEVEN

McGonagle's had a new barman, a cocky young fellow with a quiff. His name was Frankie — "like Frankie Sinatra", as he was fond of telling anyone who would listen. He was all energy, diving and dashing about behind the bar like an acrobat, tossing tumblers from hand to hand and operating the beer-pulls with a fancy flick of the wrist. He had a smart mouth, and made wisecracks, addressing the older customers facetiously as "Your Honour", or "Squire", or "Captain", depending on what he thought they looked like. More than one of the regulars had complained about him to Paschal, the manager, but Paschal had told them to have a heart, that Frankie was only a young fellow and would soon settle down. Quirke, however, was inclined not to have a heart in the matter of Frankie, for he did not like the look of him at all, and not just the look of him, either. Quirke scowled when he came near. He found particularly irritating the way the young man had of throwing up his chin and yanking his fake bow-tie to the end of its elastic and letting it snap back with a sharp smack. No, as far as Quirke was concerned, Frankie was exactly what McGonagle's did not need.

Quirke had been in an irritable mood even before he arrived at the pub, having been caught in yet another shower of rain on his way up Grafton Street, and the sight of Frankie's cheeky grin set his teeth on a sharper edge. He ordered a glass of whiskey, and when Frankie asked if he wanted ice in it — ice, in a Jameson! — he gave back such a look that Frankie quailed, and only said right-oh, and skidded off to fetch the order.

This evening Quirke had even more things than the rain and Frankie to annoy him. For a start, Isabel Galloway was coming back — in fact, she was back already, her tour having ended the previous night. She had telephoned from the railway station in Mullingar to say her train would be in by six, but that she was tired, having been up till dawn at the last-night party — "To tell you the truth, darling, I think I'm still a bit squiffy" — and would go to bed for a few hours, and see him later. He was surprised at how his heart sank when he heard her voice and realised her return was imminent. Isabel, he reminded himself again, was a splendid woman in many ways, yet he could not deny that he had found the weeks of her absence restful and undemanding. This made him feel guilty, of course, and now he felt guiltier still as he settled down to savour his last few hours of what he could not but think of as freedom.

He spotted Hackett as soon as the detective came in the door. He had his hat on, and the shoulders of his gabardine raincoat were splashed with rain.

"That's a soft evening," Hackett said, settling himself on the stool next to Quirke's. He had struggled out of

his raincoat and now he folded it on his knees and set his hat on the bar beside his elbow.

"What will you have?" Quirke asked.

"A small port."

Quirke stared. "A what?"

"A small port," Hackett said again, unruffled. "If it's all right with you."

"Sure. Certainly." There was a pause. "Since when did you become a port drinker?"

"I take a glass sometimes. It's very calming. You should try it."

Quirke lifted a finger to Frankie. "A glass of port for my friend here." He shook his head, watching as the young man took down the dusty bottle of Graham's from a high shelf. "I suppose next it'll be Wincarnis tonic wine."

"You may mock," Hackett said complacently. "It doesn't trouble me." He glanced at Quirke's tie of blue and white stripes. "You're not wearing it today, I see."

"Wearing what?"

"The dickey-bow."

Frankie set the glass of ruby syrup in front of Hackett. "There you are, Captain," he said. "One port." He lifted a hand towards his throat but caught Quirke's look and left his own bow-tie unplucked.

Hackett sipped his port. "It seems it's getting very popular, these days," he said, nodding towards Frankie's departing back, "the dickey-bow."

Quirke scowled but said nothing. He glanced towards the phone booth at the end of the bar. Should he call Isabel? She would probably be awake by now.

"See the *Clarion* this morning?" Hackett asked.

"No. Why?"

From the pocket of his raincoat Hackett pulled out a wadded-up and slightly damp copy of the paper and unfolded it on the bar. Across the top of page one the headline read, "GIRL SOUGHT IN MINOR CASE". There was a photo of Jimmy Minor. The story had no byline. "Christ almighty," Quirke said.

Hackett nodded. "Some splash."

"That'll be Carlton Sumner," Quirke said. "He thinks he's William Randolph Hearst. Who is the girl supposed to be?"

"The one that found the young fellow's body. She was courting along the canal bank with her fancy-man. He happens also to be her boss."

"Then what does it mean, 'girl sought'?"

"It means nothing," Hackett said dismissively. "The fellow, Wilson, the girl's boss, asked to be kept out of it for —" he sucked his teeth "— domestic reasons. He has a wife." He shifted his backside on the stool. "She's going to be finding out more than she wants to know, if the *Clarion* has its way."

"And will it? Have its way?"

The detective lifted his shoulders to the level of his earlobes and let them drop again. "The *Clarion* won't have far to seek for 'the girl'," he said drily. "Or for Mr Wilson, either." He sipped his port, pouting his froggy lips and licking them after he had swallowed. "I went around to his place," he said, "Jimmy Minor, where he lives. Lived."

"Oh, yes? And?"

"Nothing much. I sent Jenkins and a couple of lads up there this morning, to see what they could turn up. I'm waiting for their report. I haven't a high expectation of results." He drank again from his glass. Between the rows of bottles behind the bar they could see their fragmented reflections in the speckled mirror; the mirror had an advertisement for Gold Flake emblazoned in gilt on its upper half, a tarnished sunburst. Frankie was energetically polishing a glass with a dirty tea-towel and whistling faintly through his teeth.

"He was a gardener," Hackett said.

Quirke frowned. "A gardener? Who?"

"Jimmy Minor. Out the back of the house in Rathmines where his flat is he had a bit of a garden going, a plot, like. Spuds, beans, carrots too, I think. They were just starting to come up."

Quirke wanted another whiskey and was trying to catch the eye of Paschal the manager, but Frankie spotted his empty glass and put away the rag and came down behind the bar, cracking his knuckles and grinning. "Same again, Squire?"

Quirke nodded sourly.

"Did he own the place?" he asked Hackett.

"No. The landlord let him at it. Nice little plot, well tended. Good soil there, plenty of leaf-mould laid down over the years. He'd have had a tidy crop. The potatoes, I'd say, would do particularly well."

They fell silent, the two of them. Frankie brought Quirke's drink, but sensing some darkening of their mood he set it down without flourishes and said

nothing, only took the ten-shilling note Quirke proffered and turned to the till.

Quirke cleared his throat. "So otherwise you found nothing," he said.

Hackett did not answer, but reached inside his jacket and brought out from the breast pocket a creamy-white envelope and placed it on the bar. It had Jimmy Minor's name and address typed on it, and in the top left-hand corner, in dark-blue lettering, was stamped the legend:

FATHERS OF THE HOLY TRINITY
TRINITY MANOR
RATHFARNHAM
COUNTY DUBLIN

"It was with his stuff," Hackett said.

Quirke picked up the envelope, opened it and took out the letter, feeling as he did so a sort of click in the region of his breastbone. Was it the look of the paper, the smell of it, that had set something going in him? Then he remembered: he had been given a letter like this to carry with him when he was being sent to Carricklea; strange, how clearly he remembered it, after all these years. *We are directed to entrust this boy into your care* . . . He blinked the thought away. The letter, this letter now in his hands, was typed, in very black ink, on a single sheet of embossed paper — the fathers, it was clear, did not stint themselves in the matter of stationery. The Rathfarnham address was stamped here, too, and underneath it the letter began.

80

Dear Mr Minor

We are in receipt of your letter addressed to Father Michael Honan, to which I have been directed to reply by Monsignor Farrelly, our Father Superior.

You do not make it clear in what connection you wish to interview Father Honan, but in any case it is not possible for you to do so. Father Honan is extremely busy at present, as he is about to embark for the mission fields in Africa, and is therefore unable to comply with your request.

If you require information about the work of the Trinitarian Fathers, here or abroad, please address your questions directly to Msgr Farrelly, or to me.

Yours in the Grace of Our Lord Jesus Christ
Daniel Dangerfield, FHT

Quirke read it over twice, then looked at Hackett. "'Daniel Dangerfield'," he said. "That's a mouthful." He put the paper down on the bar, where it slowly closed itself along its folds, like a fly-eating flower. "What's it mean?"

"Don't know."

"Then why . . .?"

"The name was familiar," Hackett said. He took a packet of cigarettes from his jacket pocket, offered one to Quirke, took one himself, and flipped up the lid of his Zippo lighter. He thumbed the blackened wheel to make a spark. "Honan," he said, narrowing one eye against a cloud of cigarette smoke.

"Familiar in what way?"

"I couldn't think, at first, only I knew I knew the name. Then I remembered." He drank the last of the port, smacking his lips, and held the darkly smeared glass up to the light and peered through it. "There was a complaint made against him — this was a few years ago. Father of one of the young fellows at Windsor College — it's run by the Holy Trinity order — came in with some story about his son being mistreated by this same Father Honan . . . or I presume it's the same."

"Mistreated?" Quirke said.

"Aye. It wasn't clear what was meant — the boy, it seems, wouldn't go into details about it, even to his father. The super at the time, Andrew O'Gorman — do you remember him? Not the most imaginative fellow, our Andy — he tried his best to get out of the father what the whole business was about, but it was all very vague."

"And what happened?"

Hackett shrugged. "Nothing. There was nothing to go on. I think the super sent someone out to talk to the lad, but he still wasn't forthcoming, so the thing fizzled out." He chuckled. "You can imagine how eager Andy would have been to start quizzing the reverend fathers. Next thing there'd be a thunderbolt from the Archbishop's Palace, asking" — here he put on a sepulchral voice — "*by what right did the Garda Síochána think it could bring unfounded accusations against a hard-working and well-respected priest of this parish*, blah blah blah and Yours in Christ Our Saviour. So it was dropped."

82

Quirke beckoned to Frankie again, pointing to Hackett's empty glass, and the young man came with the bottle of Graham's and poured another measure.

"What was your involvement?" Quirke asked.

"Hmm?" Hackett was attending to his port.

"With this business about the priest — about the complaint."

"I wasn't involved," the detective said, "not directly."

"But what? — you had a hunch?"

"No, no. Not really. But I asked around a bit. You know."

Quirke smiled thinly, nodding. "And what did you hear?"

The detective pressed the butt of his cigarette into an ashtray on the bar, grinding it in slow half-circles, thoughtfully. An angry flare of smoke rose quickly and dispersed. "A busy fellow, the same Father Honan. Ran a boys' club out of one of the tenements in Sean McDermott Street. Athletics, swimming, boxing, that sort of thing. Got local businesses to cough up, persuaded Guinness's to sponsor equipment, jerseys, football boots, so on. Made him very popular with the locals."

"No complaints like the previous one?"

"No fear! The man was a saint, as far as Sean McDermott Street was concerned. Set up a temperance society too, bringing the men in and persuading them to take the pledge. There was a tontine society that he got going to pay for the funerals of the poor. Oh, aye, Father Mick was the local hero. Did work for

the tinkers, too, trying to get them to settle down and quit stravaiging the country. A busy man, as I say."

Quirke was lighting another cigarette. "But you were sceptical."

Hackett made a large gesture, rolling his shoulders and lifting up the empty palm of one hand. "I had nothing against the man," he said. "I never even met him."

They were silent again. Behind them the bar was filling up, and the electric light, under siege from the clouds of cigarette smoke, was turning into an almost opaque blue-grey haze. Barney Boyle was somewhere in the crowd; Quirke, hearing the playwright's loud, slurred tones, kept his head well down. He did not feel up to dealing with Barney, not this evening.

"So," he said. "Are you going to follow it up?"

Hackett made his Spencer Tracy face, pressing his tongue hard into his cheek and screwing up an eye. "I thought we might amble out there and have a word with Father Honan, before he departs for the mission fields, with his pickaxe and spade."

"You mean, you thought *you* might amble out."

"Ah, now, Doctor, you know you've a great way with the sky pilots — I've noticed it before."

"You have, have you?"

"I have." The detective chuckled. "I imagine they think of you as being in the same line of business as themselves, more or less — you handle the bodies, they do the souls."

Quirke shook his head. "You're a terrible man, do you know that?" he said. "Here, buy me a drink — it's the least you can do."

This time Hackett signalled to Frankie, who came down the length of the bar in a hip-rolling sashay. "What'll it be, gents?" he asked, and pulled out his bow-tie past its limit and released it, smirking. Quirke lowered his head and looked at him narrowly; he might have been sighting along the barrel of a gun.

CHAPTER
EIGHT

He had settled down with a nightcap and a history of Byzantium that he had been trying to finish for weeks when Isabel rang up. He sat and looked at the telephone and let it ring a dozen times before lifting the receiver, which he did gingerly, as if it might explode in his hand. He knew it would be Isabel. It was nearing midnight, and he had thought he was safe, that she must have slept through the evening and would not get up so late, but no. Her tone was dispiritingly bright. He tried in turn to sound enthusiastic, loving, happy to hear her voice.

Isabel said she supposed he was in bed himself by now, with his teddy and his toddy, but that she would come over anyway, and maybe join him there, in the scratcher — she liked to use slang words, pronouncing them with an arch, actorly flourish, stretching out the vowels and rolling the rs. He could think of no reasonable means of putting her off. Good, she said, she would jump in a taxi right now. He put down the phone and gazed unseeing at the book lying open in his lap. It always annoyed him, that way she had of saying *Bye-eel*, with another theatrical trill.

Yet when she arrived and at the front door flew into his arms and kissed him, breathing hotly into his ear, his heart gave a familiar gulp. She was a warm, happy, grown-up woman, after all, and she loved him, so she said, and to prove it she had tried to kill herself for his sake. He held her now, at once desiring her and wishing she had not come. What did he want from her? he asked himself, for the thousandth time. The self-cancelling answer was, everything and nothing, and therefore it was all impossible. Cringing with guilt he pressed her all the more tightly to him, while in his mind, suddenly, longingly, he had a vision of the towpath by the dark canal, and how it would be there, the hushed trees bending low, the moon shimmering in the water and the dry reeds whispering together, and not a soul anywhere about.

"Did you miss me?" she whispered, grazing his neck with her lips. "Tell me you did, even if you didn't."

"Of course I missed you," he said, making his voice go thick as if with emotion. "How can you ask?"

When they were in the flat she looked about with lively interest, as if she had been away for years. She took off her headscarf and shook out her dark-bronze hair. She was wearing the short fur coat that he had bought her for her birthday, over a dark-blue silk suit with a narrow skirt that accentuated the curve of her bottom. When she had taken the coat off she turned her head back sharply and glanced down to check the seams of her stockings, and seeing her do it, as she did so often, he felt himself smile. He had missed her, he told himself; it was not entirely untrue.

"Can you light a fire or something?" she asked. "It's bloody freezing in here."

He squatted in front of the fireplace and put a match to the gas fire, and the gas ignited with its usual soft *whomp!*. That was another thing that irritated him about Isabel, that she seemed always to be cold.

He made coffee for them both and laced it with whiskey. He asked if she was hungry, and offered to make an omelette for her, but she said no, that she had been forced to endure enough boarding-house meals in the past six weeks to cure her of wanting to eat anything ever again. "Do you think I've put on weight?" She surveyed herself critically in the big and incongruously ornate mirror behind the sideboard. "I think I have. God!"

Quirke was admiring the way the hem of her buttoned-up short jacket flared out over her slim hips. "You look wonderful," he said, and was relieved to realise that he meant it.

"Do I?" She turned from the mirror and looked at him, measuring him up and down with an arched eyebrow. "I wish I could say the same for you. I suppose you've been boozing non-stop since I left."

"Oh, non-stop," he said. "Blotto every night."

"You should let me marry you," she said.

"Should I?"

"Yes, you should. I'd see to it that you were set straight. Cook proper meals for you, iron your shirts, put you to bed at night with a warm flannel on your chest to ward off the chill. And if you came home late

I'd be standing behind the door with a rolling pin to teach you the error of your ways. Can't you see it?"

"I can. Andy Capp and Flo."

"Who?"

"Andy Capp and his battle-axe missus — cartoon characters in the paper."

She put her head to one side, smiling thinly. "A cartoon strip," she said, in a voice suddenly turned brittle. "Is that how you see us? Give me a cigarette."

She sat on the arm of the armchair by the fireplace and crossed her legs, while he went to the mantelpiece and took two cigarettes from the silver box there, lit both, and gave one to her. She was leaning across to look at the book he had left lying open on the chair's other arm. "Belisarius," she read. "Who's he when he's at home?"

"Byzantine general. They say the emperor Justinian had his eyes put out and left him to beg in the streets."

"Why?"

"Too successful in the wars, a threat to the throne."

"Typical."

"Of what?"

"Men."

"Who was the typical one, Belisarius or the emperor?" She gave him a scathing glance. "Anyway," he said, "it's only a legend."

"Like all history."

He smiled at her blankly, nodding. Something dangerous had come into the atmosphere, a sense of rancour. He did not want a fight.

"So," she said, "tell me what's been happening. It feels as if I've been away for ever."

He saw again fleetingly, but with startling clearness, that image of the canal bank, the soft darkness over the water, the leaning, stealthy trees. "Jimmy Minor was killed," he said.

Still perched on the chair-arm, with her shapely legs crossed, she had forgotten about the book and was examining idly the toe of one of her shoes. Now she frowned, and seemed to give herself a tiny shake. "What?"

Quirke added another drop of whiskey to the cold dregs of coffee in his cup and drank. The bitter taste made him wince. "Jimmy Minor," he said. "You met him, didn't you? Reporter on the —"

"I know who he was," she said sharply, turning to look at him. "That friend of Phoebe's. Killed, you say?"

"Murdered. Someone, or some*ones*, beat him to death. He was found in the canal below Leeson Street Bridge."

She was gazing at him now in what seemed a kind of wonderment. "When?"

"Couple of days ago."

"My God," she said tonelessly. She rose and walked to the fireplace and put one hand on the mantelpiece and stood there, facing the mirror, her eyes hooded. She was silent for a time, then spoke in an oddly far-away voice. "Don't you ever feel anything?"

He looked at the pale back of her neck. "How do you mean?"

90

"You just — you just announce these things, as if . . ." She stopped. She was shaking her head. Now she turned. She was pale, and her mouth quivered. "Don't you even care?"

"About what? About Jimmy Minor being killed? Of course I care —"

"You *don't*!" she cried. "You couldn't, and speak of it in that — that offhand way."

He sighed. "I care," he said, "of course I care. But what good does caring do? Caring is only another way of feeling sorry for yourself."

She was looking at him with such intensity that her eyes seemed to have developed a slight cast. "What a monster you are, Quirke," she said softly, almost in a murmur.

He turned away from her, suddenly furious. It was always the same: there was always someone telling him how awful he was, how cold, how cruel, when as far as he could see he was only being honest.

"What about Phoebe?" Isabel asked behind him. "Is she all right?"

"She's fine. She was upset when she heard, but now she's fine." He wanted to say, *She's my daughter, isn't she? And the Quirkes don't care*. But he was remembering Phoebe in the hotel that day, after he had told her, her ashen face, her trembling hands. Perhaps she was not fine; perhaps she was not fine at all. "You might ring her up," he said.

He still had his back turned to her, afraid she would see the bloodshot anger in his eyes. But then, suddenly,

in an instant, the anger drained away, and he just felt tired.

He returned to the mantelpiece and took another cigarette and lit it. Isabel had sat down again, in the armchair this time, and was staring into the pulsing grid of the gas fire. "Give me some more whiskey, will you?" she asked. "In a glass. I don't suppose you have any gin?" She frowned distractedly. "I should buy a bottle, keep it here —" she gave a cold laugh "— for emergencies."

He fetched a tumbler from the kitchen and poured a measure of whiskey and handed it to her, his fingers brushing hers; her skin felt cold and slightly moist. He had an urge to take her by the arm and drag her behind him into the bedroom and strip her of her clothes and lie down with her and clasp her against him, the chill, long length of her, and smell her hair and her perfumed throat, and put his lips to hers and forget, forget everything, if only for a few minutes. He wondered why he was so upset. Perhaps after all he did care about Jimmy Minor; perhaps he cared more than he knew or dared acknowledge. He was a mystery to himself, always had been, always would be.

"Tell me what happened," she said.

He leaned an elbow on the mantelpiece. He realised that he was glad of the heat of the fire; he too must have been cold, without knowing even that. "A courting couple spotted the body," he said. "It was naked, in the water —" *It*. He glanced at her, expecting her to pounce on the word and begin berating him again, but she said nothing. "He was beaten to death, as I say.

Kicked, and so on. I hardly recognised him, when they brought him in."

She lifted her head. "You did the post-mortem?"

"There was no one else."

"Doesn't it —" her gaze drifted back to the fire "— doesn't it trouble you, doing that to someone you know?"

"I couldn't do my job if I let it trouble me."

She gave her head a dismissive toss. "Yes, yes, of course. You always say that, and I always forget you're going to say it."

He looked at a framed photograph beside his elbow. There were four people in the picture, and two of them, his wife and her sister, were dead. He had loved them both. "A corpse is a corpse," he said, sounding harsher than he had intended. "There's no one there any more. Hard to care for flesh when the soul is gone."

She laughed, a soft snort. "I thought you didn't believe in the soul."

"I don't."

"Then what is it that's alive, what is it that goes when the body dies?"

"I've no idea." He was *tired*.

She looked at him and smiled sadly. "You've lived too long among the dead, Quirke," she said.

He nodded. "Yes, I suppose I have." She was not the first one to have told him that, and she would not be the last.

He liked the coolness of her bare flank under his hand, when she lay on her side like this, turned away from

him, lightly sleeping. The bed was not really wide enough to accommodate their two recumbent bodies. His right arm, trapped under her, had gone to sleep, but he left it there for fear of waking her. He had turned off the bedside lamp, and the moon was in a high-up corner of the window, a fat, indifferent eye watching over the world. In his thoughts he was seeing yet again the dark canal, the silent towpath. What was out there in the night that he was longing for? Rest, quiet, escape. Death, maybe. But what kind of death? Isabel was right: he had seen too many corpses, had sectioned them out and delved into their innards, to entertain any illusions about what the priests used to call our final going forth. Dying, he was convinced, was no more than an ending.

No, what he yearned for in his deepest heart was not death, not the grand and terrible thing that priests and poets spoke of, but rather a state of non-existence, of simply not being here. Yet that state was unthinkable, for in it there would be no being — it would not be him, inexistent, but not-him. It would not be a state at all. It would be nothing, and nothing is inconceivable. All his life, for as long as he could remember, he had wrestled with this conundrum. Was that why he had become a pathologist, in hope of penetrating nearer to the heart of the mystery? If so, it had been in vain. The dead did not give up their secrets, for they had none; they had nothing, were nothing, only a parcel of blood and bones, gone cold.

Without his realising it, his hand must have tightened on the soft flesh above Isabel's hip, for suddenly she

94

started awake and tried to sit up, leaning on an elbow. "What?" she said sharply. "What is it?" He touched his fingers to her face soothingly, cupped her cheek in his palm, and said it was all right. She lay down again slowly on her side, facing him now. "I was dreaming," she murmured. She was staring into the darkness; he could see the glint of her eyes in the moonlight. "Something about my — something about my father. He was crying." She moved forward, pressing her face against his shoulder. He reached past her and switched on the bedside lamp. She whimpered in protest and clung the more tightly to him. He scrabbled for his cigarettes, found them, lit one. Isabel drew back, sighing. "Where's my slip?" she said. "I'm perished."

He got out of bed and picked up her clothes where she had piled them on a chair; in the deeper folds there was still a trace of the warmth of her body. How long had they been in bed? "Give me the blouse," Isabel said. "It's warmer."

She took it from him and put it on, squirming amid the clinging bedclothes. He went to the bathroom and came back wearing a dressing-gown. Isabel was sitting with her back against a bank of pillows, combing her fingers ineffectually through her hair. "You shouldn't smoke so late at night," she said distractedly.

He sat down on the side of the bed, half turned away from her. She smiled, and lifted a hand and touched the comma of hair at the nape of his neck. "You really do look terrible, do you know that?"

He nodded dully. He was thinking of going out to the kitchen and pouring himself another whiskey, as a

pick-me-up, but he knew it would only lead to more nagging.

"You are glad to have me back, aren't you?" Isabel asked brightly, though he caught the nicker of anxiety in her voice. It was an unanswerable question, or at least a question to which there could be no answer forceful enough to sound convincing. Why did everything have to be so difficult?

"I did miss you," he said, flinching inwardly at the inadequacy of the words, the banality.

"Tell me about Jimmy Minor," Isabel said, changing the subject, her voice gone hard. "Tell me what happened."

"I told you. There's nothing more. He was beaten to death and thrown in the canal."

"Why?"

He showed her his hands. "I don't know."

"What about the police? They must have some idea. That inspector friend of yours — what's his name?"

"Hackett."

"What does he think?"

"He doesn't know what to think."

Isabel was watching him, her mouth tightly set at the thought of Jimmy Minor and his violent end. "Oh, Quirke," she said, "why do you have to have such a horrible job?"

He felt sympathy for her. It could not be easy, dealing with him, trying to find a way past the barriers he had spent his life erecting and which he never ceased to tend and maintain. Why did she bother? If he were to ask, she would say it was because she loved him, and he

supposed she did, but he was not sure what that meant. Other people seemed to understand love without it being explained to them; what was the matter with him, to be so baffled? He would drive Isabel away, some day, just by being what he was, without any special effort. When that time came she would not try again to kill herself, he was sure of that. By now she knew such gestures, however dramatic, would do no good.

"And Phoebe?" she asked. "Is she *very* upset?"

He looked to the window. The moon was lower now, and in part hidden behind the sash. "I didn't do a very good job of breaking it to her, either."

"I can imagine," Isabel said drily. "You are hopeless, Quirke, you realise that."

He nodded. She touched the back of his neck again with her cool fingertips.

"I think he was working on something, Jimmy Minor," he said. "Something to do with a priest."

"Oh, yes? What priest?"

"Just a priest. Honan — Father Mick, they call him. Does good works, operates in the slums."

"I think I've heard of him. Why would Jimmy have been interested in him?"

"I keep telling you — I don't know. I ask the same questions and get no answers. Jimmy tried to interview this priest, was refused."

"Why?"

"Why was he refused? The order wouldn't allow it — Holy Trinity Fathers. He's leaving for Africa, so they say. Must be very busy packing."

"And you think it was because of him, this priest, that Jimmy was murdered?"

Quirke did not reply. He was still watching the moon. Half cut off by the edge of the window as it was, it seemed to be tipping him an awful wink. He knew what Isabel was not saying. As a child Quirke had been abused, body and soul, by priests and brothers, at Carricklea, and other places before that. When it came to the clergy he could not be expected to think calmly or clearly. Isabel had once said that he saw a priest under every bed. She had meant it lightheartedly, but the look he gave her had made her draw back and swallow hard. With Quirke, some things were not to be joked about.

"Did I ever tell you," he said now, "about a fellow by the name of Costigan?"

"No, I don't think so. Who is he?"

"Just someone I knew. In fact, I didn't know him, he made himself known to me. One of the Knights of St Patrick, teetotaller, Pioneer pin in his lapel, the usual. He explained to me once that there are two worlds, the one that we — you and me and all the other poor idiots like us — think we live in, and the real one, behind the illusion, where people like him are in charge. He was honest about this other world, I'll give him that. A tough place, he admitted, a nasty place, in many ways, but the real thing, nevertheless, where the real decisions are made, where the necessary actions are taken. Without people like him, he said, people prepared to face reality and do the dirty work, the rest of us

wouldn't be able to live our comfortable, deluded lives. We'd be in the muck too, up to our necks."

He paused, smoking the last of his cigarette. "I was impressed, I have to admit it. It's not that he was telling me something I didn't know — every mouthful of meat has a tang of the slaughterhouse — but the way he told it was impressive, the matter-of-factness of it. There are Costigans everywhere, behind the scenes, running things, controlling things, keeping the meat-grinder going." He paused, almost smiling. "Yes, I remember Mr Costigan. I remember him well."

Isabel, in the lamplight, gazed at him. She had folded her arms around herself, as if for protection. "But *you* live in that world," she said, "the world he talked about."

He considered. "No, I don't. I wouldn't have the stomach for it, wouldn't have the courage. But I have one foot in it, that's true."

"You should have done something else — some other job, I mean."

"Such as?"

He knew what she would say.

"You could have been a doctor — I mean a doctor for the living."

He gave a faint laugh. "Ah, the living," he said. "I don't know much about them, that's the trouble."

She rose up suddenly, scrambled to her knees and put her arms around him. "I hate to hear you say things like that," she said, her mouth once more against his ear. "You say them too complacently, too comfortably. I sometimes think you love your wounds."

He laughed again, leaning his forehead against her hair. "Yes," he said, "like the leper with his begging bowl, who has to love his stumps."

She took his face in her hands and turned it towards her own and kissed him on the mouth, then drew back and looked solemnly into his eyes. He tried not to shy from her gaze. "You could be happy, you know," she said. "It's not impossible. Other people have done it, people with more awfulness in their lives than you have."

He nodded, but at last had to look away. She was right, of course, everything she said was right; he just wished she would not insist on saying it, repeatedly. Perhaps he did not want to be happy. He had little talent for it, that was certain. Besides, happiness was another of those words, like love, the meaning of which he could never quite grasp. He wanted to tell her about his vision of the canal bank in the dark, how all evening since she had arrived he had kept seeing it, and how it filled him with mysterious longing. He wanted to make her understand, too, what a danger he was, what a menace, to those who came near him, who tried to come near him. But then surely she knew that. She had tried, however half-heartedly, to kill herself, for love of him; things that he touched tended to droop and die.

"I'm sorry," he said. It was a thing he often found himself saying, although he was never sure what he was apologising for. Everything, he supposed, everything that he was and did. It was a wearisome business, being himself. He would have liked a break from it, a holiday away from being who he was.

100

In the morning, a cobweb-coloured sky cleared suddenly and the sun came out, spiking in at the side of the window where last night he had watched the moon. He had wakened with a start of nameless dread, the sun in his eyes and his heart thudding. Now he lay breathing, shallowly and slowly, righting himself. It was like this every morning, the waking into fright, then the relief to find that he was not at Carricklea but in his own bed, no longer a child, safe and unmolested. Isabel was up already; she would be in the kitchen, making breakfast. He stretched luxuriantly, yawning so hard the hinges of his jaws crackled. He would take the day off, perhaps, and they would go to lunch somewhere, the Russell, maybe, or —

"What's this?" She was standing in the bedroom doorway, wearing his dressing-gown, with a hand on her hip, holding up some brightly coloured thing for him to see. An item of scanty underwear, perhaps, that she had bought to please him?

He sat up, rubbing his eyes and peering. What she had in her hand was a blue bow-tie. She had given it to him as a going-away present when she left on tour. "I found it in the kitchen," she said icily. "In the rubbish bin."

CHAPTER
NINE

Sergeant Jenkins drove them out to Rathfarnham. Quirke and Inspector Hackett sat in the back seat of the unmarked squad car, each looking out of the window beside him. It rained at first and then abruptly stopped, and the sun came out and shone on the wet road and made a blinding glare on the roof of the car.

Quirke felt distinctly peculiar. It was as if he had a hangover, even though he had drunk no more than a few whiskeys the night before, first with Hackett at McGonagle's and afterwards with Isabel. He wondered if he might be in for a dose of flu. His head seemed packed tight with cotton wool, and he had the sensation of being somehow separate from himself. He found himself welcoming the prospect of being ill — he would be glad of a day or two in bed, with a book and a bottle of Jameson. Isabel, however, would insist on taking care of him. He thought of her doing her Florence Nightingale act, making hot drinks for him and plumping up his pillows. He liked to be alone when he was sick. It was an opportunity to think, to assemble his thoughts, to reassess his life. He grinned briefly at his faint reflection in the window, showing his teeth. His life; ah, yes, his life.

102

"Funny about the garden," Hackett said.

Quirke turned to him. "What?"

"The garden that Jimmy Minor had going, behind where he lived. I wouldn't have thought of him with a spade in his hands. You never know people, do you?"

"I find that's generally true, yes," Quirke said drily.

The detective nodded, not listening. "I remember one of the instructors when I was at Templemore, the Garda training college there. 'Lads,' he used to say, 'never jump to conclusions about a person until you know all the facts about him — and the fact is, you'll never know all the facts.'"

"Words of wisdom," Quirke said.

Hackett glanced at him sidelong, and said no more. He had long ago got used to Quirke and his unpredictable moods. He fixed his gaze on the back of Jenkins's head and his translucent jug ears. He could not get the thought of Jimmy Minor's scrap of a garden out of his head, the raised potato beds, the neat lines of seedlings, the cane tripods. It would be let run wild now, of course. In a year, two at the most, there would be hardly a sign of it left. It would be gone to wrack and dust, like the young man himself. He thought of time and its depredations and felt an inward shiver.

There was a metalwork arch above the gates of Trinity Manor, with a big wrought-iron medallion in the middle holding a blue-painted metal cross, and a legend underneath in Latin that he could not make out, except the word *Trinitas*. The house, away off at the end of a curving drive, amid flat expanses of lawn, was massive and grey. The trees, sycamores and beeches

and the odd oak, were bare still, their branches etched in stark black against a sky of bird's-egg blue and big pilings of silver-white cloud; looking more closely, though, with a countryman's eye, Hackett spied the dusting of spring's new shoots, soft green against the black bark. Contemplating all this, he felt nostalgic for the landscapes of his youth, the rolling fields, the river meadows, the wild woods. No: in all the years he had lived in the city he had never quite reconciled himself to it.

They pulled up on the gravel in front of the house. The blinds were half drawn on the big windows. There was a set of granite steps and a broad door painted navy-blue, with a brass knocker. The house in the old days had been the residence of some British dignitary — the lord lieutenant, was it? No, his place was in the Phoenix Park. Somebody like that, anyway. How quick the priests had been, after the English went, to seize the best of what they had left behind. Hackett had not much time for the Church, but he had to admire its relentless way of getting power and, having got it, the tenacity with which it held on to it.

Jenkins was told to wait in the car and the two men climbed the steps to the front door. Hackett glanced at his companion: had Quirke's greyish pallor turned greyer? No doubt the very sight of a place such as this brought back harsh memories of his childhood and the institutions he had spent it in.

The door was opened by a tiny and very old man in a leather apron and a black suit that was shiny at the elbows and the knees. He was afflicted with curvature

of the spine, and was so bent he had to squint up sideways to see them, baring an eye-tooth in the effort. Hackett gave his name, and said he was expected. The old man replied with a grunt and shuffled backwards and to the side, drawing the door open wider, and the two men stepped into the hall.

The old man shut the door, pushing the weight of it with both hands. "This way, gents," he said. His voice was a harsh croak. He turned and set off down the hall. As he walked he swung his right hand back and forth in long, slow arcs; it might have been an oar and he the oarsman, paddling himself along. They could hear his laboured breathing. The hall had a mingled smell of floor polish and must. All around them in the house a huge and listening silence reigned.

Father Dangerfield's office was a large, cold room with a corniced ceiling and three tall windows looking out on a broad sweep of lawn and, beyond the grass, a stand of stark-looking trees. The carpet had a threadbare pathway worn in it, leading up to an antique oak desk with many drawers and a green leather inlaid top. There was an acrid tobacco smell — Father Dangerfield was evidently a heavy smoker. He was narrow-shouldered, thin to the point of emaciation, with a narrow head and a pale dry grey jaw that had the look of a cuttlefish bone. He wore spectacles with metal rims, in the lenses of which the light from the windows weakly gleamed. He stood up as they entered — he was tall, well over six feet — and smiled with an evident effort, pursing his lips. The bent old man went out crabwise and shut the door soundlessly behind him.

"Gentlemen," the priest said. "Please, sit."

Quirke and Hackett had each to fetch a chair from the far side of the room and set it down before the desk. Hackett was holding his hat as if it were an alien thing that had been thrust into his hands.

Father Dangerfield resumed his seat. Hackett did not much like the look of him, with his raw, bone-dry face and purplish hands, and the shining lenses of his spectacles that magnified his eyes and gave him a look of vexed startlement. The priest leaned his elbows on the arms of his chair and steepled his fingers and touched the tips of them to his lips. It was a studied pose, practised, Hackett surmised, over long hours spent in the confessional, listening in judicious silence to the sins of others. *Never jump to conclusions* . . .

"So," Father Dangerfield said. "What can I do for you?" He had an English accent, precise and slightly prissy.

"We were hoping," Hackett said, "to speak to Father Honan."

The priest frowned, his eyes behind the glasses growing wider still. "For what reason, may I ask?"

Hackett smiled easily. "There's a couple of things we'd like to talk to him about." At the word *we* Father Dangerfield glanced in Quirke's direction, as if he were registering him for the first time. "This is Dr Quirke," Hackett said, and left it at that, as though merely the name would be enough of an explanation for Quirke's presence.

106

The priest turned to Hackett again. "Please tell me, what are these things you wish to discuss with Father Honan?"

"A young man died on Monday night. Name of Minor — you might have read about it in the papers."

"Why?" the priest asked. Hackett blinked, and the priest gave a faint grimace of impatience. "I mean, why would I have read about it?"

"Well, it was a murder, we think. There was a subsequent report on it in the *Clarion*. Big story, page one."

Father Dangerfield put the joined tips of his fingers to his lips again and sat very still for a long moment. "Ah," he said at last, and again seemed somewhat impatient, "in the papers. I see. You must understand, we're rather —" he smiled his wintry smile "— sequestered here."

It struck Hackett that the fellow had all the tone and mannerisms of a Jesuit, one of those clever English ones who spend their time in the drawing rooms of great houses, sipping dry sherry and covertly working to convert the upper classes. How had he come to join the Trinitarians, an order not known for subtlety or sophistication? Had there been some misdemeanour, committed in another jurisdiction, that had resulted in him ending up here?

Now the priest spoke again. "Who was the young man? — you say his name was Myler?"

"Minor," Hackett said. "Jimmy Minor. He was a reporter on the *Clarion*, as it happens."

"And what befell the poor man?"

Befell. Hackett could not remember having heard anyone use the word before; in the pictures, maybe, but not in real life. "He was beaten to death and left in the Grand Canal at Leeson Street."

Father Dangerfield nodded. "I see," he said again. He crossed himself quickly. "May the good Lord have mercy on his soul." The piety was perfunctory, and seemed feigned. Abruptly he got up, in a flurry of black serge, and strode to the window and stood with his hands clasped behind him, looking out at the lawn and the bare trees at its far edge. Thin sunlight was on the grass, giving it a lemonish hue. "What I don't see," he said, without turning, "is the connection there could be between the unfortunate young man's death and your wanting to see Father Honan."

"Well, there was a letter," Hackett said, twisting sideways in his chair the better to study the priest's tall, gaunt figure dark against the window's light. "A letter from you, in fact."

Now the priest did turn. "From me? To whom?"

"To Jimmy Minor. About Father Honan."

"Ah."

Quirke had not said a word since they had come in; Hackett turned his head and glanced at him. He was slumped in his chair with eyes downcast, studying his hands where they lay clasped in his lap.

The priest returned and sat down again.

Quirke produced his cigarette case and held it aloft enquiringly. "Do you mind?"

"Please, go ahead," the priest said, his tone distracted. He seemed to be thinking hard.

108

Quirke lit his cigarette. Hackett noticed that the hand holding the lighter trembled slightly. As the smoke drifted across the desk the priest's nostrils quivered. From outside came the ratcheting chatter of a magpie, followed by a blackbird's sentinel pipings.

"When," Father Dangerfield asked, "did I write to him?"

"The letter was dated last week. The seventeenth."

"Last week." The priest looked down at the desk-top with its inlay of green leather. Then he lifted his eyes again. "Have you got it, this letter?"

"We have," Hackett said. He had set his hat on his knees.

"And may I see it?"

Hackett passed over this blandly. "You don't remember writing it?" he asked.

"Yes yes," the priest said, "of course, I remember now. I didn't connect the name. You must understand, a great deal of correspondence crosses my desk. He asked if he could see Father Honan. If he could interview him, I believe." He was watching Quirke take a second long drag at his cigarette.

"Did he say," Hackett enquired, "what it was he wanted to interview Father Honan about?"

"What?" The priest dragged his eyes away from Quirke's cigarette and gazed at Hackett with his big pale eyes, seeming at a loss.

Hackett smiled tolerantly. He brought out a packet of Player's and offered it across the desk, with the top open. "Would you care for a smoke, Father?" he asked, in a kindly tone.

Father Dangerfield shook his head. "No, thank you," he said, with a tense, pained frown. "I've given them up."

"Ah." The detective began to take a cigarette for himself but thought better of it and closed the packet and put it away. He clasped his fingers together and twiddled his thumbs. "Did Jimmy Minor say," he asked again, "what it was he wanted to talk to Father Honan about?"

"When he wrote to me, you mean? No, I don't think so. I can check his letter, if you wish." He looked down at the desk again, as if the letter might magically appear there.

"That would be helpful," Hackett said.

Suddenly Quirke stirred and got to his feet, seemingly with a struggle, and stood swaying. The other two men stared at him. "Sorry," he said, with a wild look. His face was grey and filmed with sweat. "Sorry, I —"

He hurried to the door, but had trouble opening it. Hackett and Father Dangerfield stood up together, as if to rush to his aid. They hovered irresolute, looking at each other. At last, with a great wrench, Quirke got the door open and plunged through it and was gone.

"Good heavens," the priest said, and looked at Hackett again. "Is he —?"

Slowly the heavy oak door, impelled by a draught, swung to and shut itself with a sharp click.

It took him a long time to find his way through the house. He stumbled along what he took to be the

110

hallway down which the crippled old man had led him and Hackett after he had first let them in, but instead of arriving at the front door he found himself facing a floor-to-ceiling stained-glass window, or wall, rather. Behind it was a chapel, for he could dimly see through the lurid panes the pinprick ruby-red glow of what must be the sanctuary lamp. He turned and blundered back the way he had come. The silent building seemed deserted — where could they be, the priests, the people who worked here, the officials, the secretaries, the cleaners, even? Yet how familiar it was, this poised stillness all about him, familiar from long ago, longer than he cared to remember. His heart was beating very fast; it felt as if it had come loose somehow and were joggling about inside his ribcage. It occurred to him that he might be having a heart-attack, or suffering a stroke — that he might, in fact, be dying. Far from being frightening, the idea was almost funny, and despite his distressed state he gave a wheezy laugh, which made his pulse beat all the faster and started up a burning sensation in his chest. He put a hand to his face. His cheeks and forehead were chill and stickily moist. The word *infarction* came to him, but for the moment he could not think what it meant, which was absurd — was his memory going, too?

What seemed to be an electric bell was dinning somewhere nearby; he could not decide if it was in his head or if a telephone was ringing. Here, around a corner, was another hallway, or corridor, with heavy-framed paintings on the walls, large, muddy and very bad portraits of venerable clerics interspersed with

111

martyred saints writhing in picturesque agony. His heart, still hammering, now seemed to be swelling and rising slowly up through his chest, pressing from beneath against his oesophagus, robbing him of breath. He stopped and stood still and shut his eyes, pressing the lids together tightly. He told himself he must stay calm. This would pass. It was a seizure of some kind, but he was sure now it would not kill him. In the darkness inside his head great whorls of multi-coloured light formed and burst, like fireworks going off in silent slow-motion. He opened his eyes and stumbled on. Was there no one to help him?

Then suddenly there was the front door, at last. Panting, he dragged it open and almost fell through it, on to the stone step outside, gulping mouthfuls of air.

The sky was overcast now, yet the light was as intense as a magnesium flare, and he had to shut his eyes again for a moment. He felt exhausted, as if he had all at once become very old and infirm, and he sat down on the step, slowly and carefully. The granite was comfortingly cool to the touch. Through slitted eyelids — the light was searing still — he peered this way and that about the grounds. The yellow-green grass now had an even more unnaturally acid cast, and the stark branches of the trees looked like so many arms flung upwards in surprise or horror or both. He put a hand to his heart: it was still struggling behind his ribs like a big, heavy bird in a too-small cage. Yet he was aware of a calm descending on him, as if a veil of some transparent gossamer stuff were being laid gently over him from head to foot. Was he dying, after all? Was this

how it would be, not violence and terror but a calm, slow sinking into oblivion?

A blackbird alighted on the lawn just beyond the ring of gravel and began busily stabbing at the turf with its orange beak, its rounded, gleaming blue-black head moving jerkily, like the head of a clockwork toy. He watched it at its delving. The bird seemed to mean something, to be something, something beyond itself. He had a sense of dawning wonderment, as if he had never really looked at the world before, had never before seen it in all its raw vividness.

The door opened and he heard a step behind him. It was the old man with the crooked back. "Ah, Lord, sir, what ails you at all?" he said.

The blackbird flew off, sounding a shrilly urgent, repeated note.

Quirke tried to scramble to his feet but his knees refused to work. They felt as if they were made not of bone but metal, as if they were two hinged metal boxes that the rivets had fallen out of, and he was afraid the loose flanges would tear the skin covering them and break through and bleed and begin to rust in the harsh April air. The old man was bent so far forward that although he was on his feet his face was at the same level as Quirke's where he sat. The eyes were a whitish-blue colour — cataracts, Quirke thought distractedly.

"Felt a bit queer," Quirke said, his voice sounding unnaturally loud. "Just having a rest here for a minute."

He tried again to get his legs to work, flexing the muscles gingerly, afraid that those hinges in his knees

would come asunder if he put pressure on them. It was a novel sensation — comical, yes — sitting here in a heap on the stone step with the old man's face in front of him on a horizontal and so close up to his own that he could see the grey stubble on the other's ancient, wrinkled chin.

"Will I give you a hand?" the old fellow said, speaking with measured distinctness, as if he were addressing a child. Quirke had an image of himself being hauled to his feet and of the two of them tottering together down the steps hand in hand, both of them bent over, with limbs akimbo, like a pair of chimps, the old one leading the younger and hooting soft encouragements. "No, no," he said, "no, I'm fine."

At last he got himself up and stood swaying. His knees seemed to be all right, after all. The old man squinted up at him, that tawny side tooth bared again. "Come inside and we'll get you a cup of tea," he said.

They made their way through the house again, the old man going ahead, hobbling along crablike at a surprisingly rapid pace, paddling the air beside him as before with a long and seemingly boneless hand. The pounding in Quirke's chest had subsided, though he was weak all over, as if he had come to the end of some extended and inhumanly demanding task. Yet he was certain now that he would survive. This knowledge afforded him curiously little comfort. On the contrary, he had a vexed sense of having been let down, by someone, or something. There had been a moment, out there on the front step, while he had watched the questing blackbird, when everything had seemed on the

114

point of a grand, final resolution. It was not death he had been cheated of, he thought, for even death was incidental to whatever it was that had been coming and had not come, that had been withheld from him, at the last instant.

"How are you doing there?" the old man asked, twisting round and glancing back at him. "Are you all right?"

"Yes," Quirke said, "yes, I am, I'm all right."

It came to him suddenly: Nike. It was Nike, the memory of him, that had sent him stumbling in a panic out of Father Dangerfield's room. Nike, with his thin smile, an eyebrow permanently cocked, a cigarette smouldering in his slender fingers. Nike the Inevitable.

The kitchen to which the old man led him was an enormous room with greyish-white tiled walls and a long refectory table of scrubbed deal, and two big twin stone sinks with old-fashioned copper taps stained with verdigris. There was a mighty stove, too, the top of it black and the sides the colour of porridge, and there were ranks of pots and pans, venerable and battered, hanging on hooks about the walls. A big metal-framed window looked out on a concrete yard where dustbins loitered, their lids askew, like mendicants waiting in hope of scraps. All this was somehow familiar.

"Sit yourself down there now," the old man said, and went to fill a kettle at one of the sinks.

Quirke sat. It seemed to him that he was suspended inside himself, intricate and frail, like a ship in a bottle.

The dissecting room: that was what this kitchen looked like. The light was the same, stark white and

shadowless, and there was a sense of chill numbness, as if the very air had been anaesthetised.

The old man, still holding the kettle under the running tap, gave him a sly backwards glance. "Or maybe you'd prefer something a bit stronger," he said, and winked.

Quirke said nothing, but the old man nodded knowingly and put the kettle aside. He went out through a narrow door into what must have been the scullery, whence there came a clink of glass, and he reappeared cradling in both hands, like a baby, a bottle of Powers Gold Label. "Would you ever," he said, "get yourself down one of them tumblers off of that shelf."

Nike, at Carricklea. Dean of discipline; the title had always struck Quirke as absurdly grand. His name was Gallagher, Father Aloysius Gallagher. No one knew why he had been called after a Greek goddess, for the nickname had been conferred on him immemorially. He was tall and thin, like Father Dangerfield, had the same scraped-looking dry jaw and wore the same kind of wire-framed spectacles. He had sour breath and his soutane always smelt of stale tobacco. He chain-smoked, holding the cigarette in a curious fashion, not between the first and middle but between the middle and third fingers of his left hand, even though he was right-handed. Sitting at his desk, with his bony knees crossed under his soutane and that hand held upright with the fag in it, like the hand of the Sacred Heart statue lifted in benediction, he had indeed the look of some celestial figure seated in judgement. Or no, no, what he was like was someone pretending, pretending

116

to be a judge, playing the part of one, for a joke, but a joke that no one would dare laugh at, and that would end with whoever it was who was on trial being found guilty, and sent away red-faced and sobbing, with bruised and swollen palms clamped under his armpits and his bare knees knocking. Nike affected a little cough, it was hardly more than a dry clearing of the throat, which in the corridors of Carricklea the boys had learned to listen out for, since it was the only warning they would have of his approach, for he moved with wraith-like quiet, seeming not to walk but glide, on soundless soles.

In his years at Carricklea Quirke had not been beaten very often by Nike, and, even if he had, that would not have been the thing that frightened him the most. It was a special kind of fear that Nike instilled, intimate, warm and clammy, and faintly indecent. When the figure of the dean broke in on Quirke's thoughts, especially at night, as he lay in bed in the murmurous dark, he would experience a jolt in his chest, like the jolt that would come from suddenly calling to mind some serious instance of wrongdoing, or an unconfessed mortal sin. Even now, thinking of those days, he felt again that same hot qualm of oppressive, objectless guilt.

He looked at the tumbler before him on the table. It was empty. He had no recollection of drinking the whiskey, yet he must have drunk it, for all that was left was a single, amber drop glistening in the bottom of the glass. The old man was saying something. "What?" Quirke said. "Sorry?"

"Ah, nothing, nothing," the old man said, smiling. "You were miles away." He came to the table and seated himself opposite Quirke. It was an effort for him to manoeuvre his twisted body up on to the chair. He sighed hoarsely. "Are you feeling any better?" he asked.

"Yes. Yes, I'm fine now."

"It was the nerves that were at you, I'd say. Nerves can be a terrible thing. Thady is the name, by the way. Thaddeus, that is, but Thady I'm called."

Quirke brought out his cigarette case, opened it on his palm and offered it across the table. He noticed the tremor in his hand, very faint, as if an electric current were passing along the nerves. The old man was gazing greedily at the row of cigarettes laid out invitingly before him. "I'm not supposed to," he said, "due to the bronicals." He took one, however, and leaned to the flame of Quirke's proffered lighter. When he drew in the first mouthful of smoke he was at once convulsed by a bout of coughing that caused his wasted frame almost to close on itself, as if there were a hinge at his waist. When the seizure had passed he sat gasping, a baby-pink spot glowing on each cheekbone and his mouth a quivering oval. "Jesus, Mary and Joseph," he croaked, "they'll do for me yet, the fags."

He poured another go of whiskey into the tumbler on the table. In the aftermath of the coughing fit his hand, too, like Quirke's, had the shakes, and the bottle rattled against the rim of the glass.

They talked. The old man had been here, at Trinity Manor, for more than sixty years. "The fathers took me in, you know, doing odd jobs. I was only a youngster at

118

the time, eleven, I was, or twelve, I can't remember." The place had been an orphanage then, he said. He gave Quirke a quick glance from under his leaning brow. "And you?"

"Me?"

"You have the look about you — the look of places like this place used to be."

"Yes," Quirke said, after a moment. "Yes, I suppose I must have. I was at Carricklea." It sounded strange, when he said it like that, as if he were speaking of his old school, the *alma mater* where he had played cricket, and worn the school tie, and had been surrounded by lots of jolly chums; where he had been happy. "Have you heard of it?"

"Oh, I have, indeed." The old man nodded slowly. "That was a hard station, so I'm told."

"It wasn't easy, no. I was younger than you were when you started here — I was nine."

"And what about before that?"

"Oh, other places. Most of them I don't remember now."

The old man forgot himself and took a deep draw of his cigarette, and once again had to cough, though this time not so violently as before. He thumped a fist, gnarled and waxy like a turkey's claw, into the hollow of his chest. "Ah, God," he said, gasping softly. "Ah, the bronicals."

It occurred to Quirke that Inspector Hackett would be wondering what had become of him. He wondered, himself, how the interview with Father Gallagher had progressed, or if it had progressed at all. No, not

Gallagher — that was not the priest's name. He put a hand to his forehead, trying to remember. Dangerfield! That was it. Nike was Gallagher, but the fellow here, who looked like Nike, was Dangerfield, Daniel Dangerfield. It seemed important to sort out these names, to fix them in his mind. He lifted the whiskey glass but then put it back on the table. The alcohol he had taken already must have gone to his head; that was why his brain was clouded and he could not think straight. Concentrate; he must concentrate. "You'd have known all the priests here, no doubt," he said, "over the years."

The old man cast a sharp look across the table. "Oh, aye," he said, "all the fathers." His manner had turned wary.

Quirke grasped the glass again and this time drank from it. Jameson was his tipple, but the Powers tasted good, all the same. "There's a Father Honan, I believe," he said. "Would you know him?"

"Father Mick, is it?" The old man smiled, though his eyes kept a guarded look. "He's a grand man."

"So they say."

The old man waited, silent and watchful. What had he said his name was? Thaddeus — Thady. "Do you know him well?" Quirke asked.

"Oh, I do. Sure wasn't he living here for the past I-don't-know-how-long. A good and holy man."

Quirke looked deep into Thady's clouded eyes. Was there something lurking in there that belied his warm words? "You say he *was* living here — where is he now?"

120

"He's going off to Africa, I hear."

"Yes, but where is he staying in the meantime?"

The old man let his gaze drift. "I believe he's visiting his home place."

"And where's that?"

"Donegal."

"That's a long way away."

"It is. It's as far away as you can get."

A silence fell. They could hear rain whispering at the window now, yet at that very moment a swish of sunlight filled the room. April. The old man offered the whiskey bottle again but Quirke put his hand over his glass. He was convinced there were things the old man knew but was not saying about Father Mick. He was asking the wrong questions, obviously — but what were the right ones? If only he could get his head clear. Beyond the window, off in the trees, some small shiny thing kept flashing, as if it were sending him an urgent signal. He should leave. His pulse was beginning to race again. "I'd better be going," he said. He tried to stand but once more his knees would not obey him.

"You'll get wet," the old man said. "Listen to that rain." He was bent so far forward his chest was almost resting on the table. His head as well as his hands trembled slightly, and Quirke thought of a tortoise, its leathery skull waggling on a stalk of neck, its ancient eyes filmed over with a grey transparency. Thady. Thaddeus. He was gazing vacantly off to the side, and seemed to have forgotten Quirke was there. "He's a great man for the good works," he said, "the same Father Mick."

Quirke blinked; that flashing thing in the trees was making his eyes ache. What was it? Something in a magpie's nest, perhaps, a stolen brooch or shard of coloured glass. But did magpies really steal things, or was that only a myth? "Good works?" he said, trying to concentrate.

Thady nodded. "Aye. With the kiddies, and the like. And the tinkers."

Quirke waited, fingering the whiskey glass that by now was empty again. The rain was still beating on the window, yet there was a wash of watercolour sunlight on the opposite wall that was making the pale tiles paler still. "Why is he going to Africa?" he asked. "Is he being sent?"

The old man squinted up at him. "Sent?"

"If he's doing such great work here, why is he going away?"

"Oh, I wouldn't know about that. Don't they take a vow of obedience?"

"So he *is* being sent."

The old man smiled softly. "Sure, who would send him?"

"The father superior?"

Thady frowned, his jaw working as if he were grinding some small thing between his teeth. Suddenly he cackled. "His reverence? His reverence hasn't been in communication with anyone, only me, this many a year." He put a finger to his temple and made a screwing movement. "He's not the best up top, so he's not. Father Dangerfield is the boss now. He's the man in the saddle."

"I spoke to him. He seemed to know very little about Father Honan."

"Did he, now." The old man shook his head, greatly amused. "He keeps his cards close to his chest, does Father Dangerfield." A bell tinkled. There was a board of bells high up on the wall above the stove. The old man peered up at it. "That'll be the father superior now," he said, "wanting his pap." He laughed again, a string of phlegm making a wet twang in his sunken chest, then rose and went to a cupboard and took from it a tin of Ovaltine and carried it to the stove.

"A young man was killed the other night," Quirke said. "Murdered."

The old man brought forward a sort of foot-stool and set it in front of the stove and stepped up on to it. He opened the tin and shook a measure of the dull-brown powder into a small saucepan. "Would you do me a favour," he said, "and go into the scullery there and bring me the bottle of milk that's in the safe? I'm sick to my soul of climbing up and down on this bloody yoke."

Quirke did as he was asked. The green-meshed food-safe was set into a rectangular hole in the wall so that the air from outside could circulate through it. There were raindrops on the milk bottle. He carried it back to the kitchen and gave it to the old man. "Are you a detective?" the old man asked, watching himself pour the milk into the saucepan.

"No," Quirke said. "I'm a doctor, sort of."

"What sort would that be?"

"Pathologist. Dead people."

The old man nodded, stirring the mixture in the saucepan with a tarnished metal spoon. "Who was the poor fellow that died?" he asked.

"A reporter — a newspaper reporter."

"That's right. I saw it in the papers. Was he some relation of Father Honan's?"

"Not that I know of."

"Well, well, the poor chap."

Quirke's brain was buzzing. He knew he should not have drunk whiskey at this hour of the day. That must be what was wrong with him, that's what was making his heart pound and his thoughts turn in circles. He wondered again where Hackett was — surely he was not still with Father Dangerfield.

The rain had stopped, and the sun was shining in more strongly at the window now. Faintly from outside came the fluting calls of a blackbird — was it the same one he had seen earlier, digging for worms on the lawn? For some reason he thought of Isabel, sitting up in bed in her room above the canal, enthroned there in her silk tea-gown, his regal lover. She was a beautiful, clever and talented woman, too good for him, far too good. Sometimes he forgot what she looked like. He would remember the colour of her hair and her eyes, the shape of her nose, the curve of her mouth, but he would not be able to summon her image to his mind, hard as he might try. That must mean something. It must mean he did not love her, as she would wish him to love her, however that was.

124

The old man lifted the saucepan off the stove. "I'd better not let it boil," he muttered. "He always knows when it's after being boiled."

He stepped down from the stool and bore the saucepan to the left-hand sink and set it on the draining-board. He turned to Quirke. "Will you get us that mug up there?" he said, pointing to a high cupboard on the wall. Quirke took down the thick enamel mug. "Thanks," the old man said. He grinned. "I could put in a word and get you a job here, maybe. Chief assistant to the head bottle-washer." He did his cackle, and poured the steaming beverage into the mug. His chin was on a level with the draining-board. "What was his name again?" he asked.

"Who?"

"The young fellow, the one that was killed."

"Minor. Jimmy Minor."

"That's a queer name, Minor. I never heard of anybody called by that name before. Where was he from?"

"Somewhere down the country, I don't know. The Midlands."

"Ah, well, God rest him anyway." He stood, holding the mug. "Minor," he murmured. "Minor. No, that's a new one on me."

"Did he ever come here?" Quirke asked.

The old man glanced at him quickly. "Here? Why would he come here?"

"To see Father Honan."

"What would he want to see Father Honan for?"

"I don't know. He might have been writing a story about him, an article about his good works with the kiddies, and the tinkers."

The old man pondered. "No, I don't remember anybody of that name. And now I'd better bring his reverence up his hot drink or he'll start his roaring again." He swivelled his head up sideways as far as it would go and looked at Quirke. "You'd want to take care yourself," he said. "The old nerves can be a killer, worse than the bronicals."

More tiles, pale grey like the ones in the kitchen. A window was open: he could feel cool damp air on his face. He was standing by it, by the window; it was small and square and looked out on to a concrete yard. The top half of the sash was pulled all the way down. The concrete outside, with the rain on it, was the colour of wet sand.

Porcelain, the chill, smooth, thick feel of porcelain. It was a bathroom he was in, no, a lavatory, with a small handbasin under the small window. How had he got here? How had he come to be standing here, with the air of outside in his face and his left hand gripping the porcelain basin to support him? He had an extraordinary sense of well-being. His heart was calm, his mind was clear. He could smell the rain in the yard, and there was the scent of wet grass, too, and of unseen trees. Beside him on the wall there was a little rectangular mirror with a crack running diagonally across it from top left to bottom right. He looked at his

face reflected in the glass, severed in two from temple to chin. Faintly he heard again the blackbird whistling.

He found Hackett in the hall, sitting on a throne-like chair next to the front door, with his hat on his knees. The chair, of age-darkened oak, had a high back topped with wooden spires and heavy, carved armrests.

"You'd make a good bishop," Quirke said. He thought his voice sounded very loud again; it seemed to reverberate between the walls and the high ceiling.

"Not a cardinal?" Hackett said.

"Scarlet wouldn't suit you," Quirke answered, and laughed, and his laughter also sounded strangely exaggerated, a falsely hearty, bogus booming, a sound that not he but someone else must have produced. He carried himself carefully, still with that sense of being a large, frail vessel with something frailer inside it.

The detective rose from the chair with a grunt. "Are you all right?" he said.

"Yes, I'm fine, I'm fine — why?"

"You look a bit shook."

Quirke heard someone approaching behind him and turned. "Ah, Thady," he said. "There you are."

The old man peered up at him warily. "Beg pardon, sir?" he said.

Quirke turned to Hackett again. "Thady and I had a long chat in the kitchen — didn't we, Thady?"

The old man frowned. "The name is Richie, sir," he said.

"But . . ." For a moment it seemed to Quirke that the floor had tilted under his feet. "But you told me . . ."

The old man stepped past him and opened the door, drawing it back with an effort. "Good day, sir," he said, addressing Hackett.

Quirke and the detective stepped out into the air. Scuds of rain were blowing across the shadow-skimmed lawn. Feeling suddenly cold, Quirke drew the collar of his overcoat close against his throat. His innards seemed to quiver, as if he had been struck by lightning a moment ago and were still vibrating from the shock. "Tell me," he said, "how long was I gone?"

"Oh, five minutes or so," Hackett said.

"That's all?"

"About that."

"Five minutes . . ."

The policeman was watching him sidelong. "Are you sure you're all right?"

"Yes, yes. I felt a bit — a bit nauseous, that's all. It's passed, now." They walked towards the car, the wet gravel squeaking under their shoes. "What did he say?"

"Who?"

"The priest, Dangerfield."

"Not much more than you heard. He was not —" he made a sucking sound with his teeth "— he was not forthcoming, shall we say."

"What about Jimmy Minor's letter?"

"That was not to be found. A filing error, according to the good Father Dangerfield."

Quirke was trying to order his thoughts. It was like wrestling with the wheel of a car that had spun out of control. "And Father Honan is gone off to Donegal, it seems," he said.

"Is that so? Strange — Father Dangerfield says he's here, in Dublin."

Quirke was about to speak again, but said nothing, only frowned.

Detective Sergeant Jenkins was lolling in a bored trance behind the wheel of the squad car. Seeing the two men approach he straightened hurriedly and started up the engine. Hackett, about to climb into the back seat, stopped and turned and looked up at the grey, forbidding frontage of the house. With the clouds racing above the roof it seemed for all its bulk to be surging forward massively, almost as if it might topple over on them, crushing the car and the three of them with it. "Do you ever think," he said to Quirke, "that some things might be better left undisturbed?"

"What?" Quirke said, as if he had not heard.

Hackett sucked his teeth again. "I have a bad feeling about this business," he said. "The young fellow's death, that won't be the end of it."

They got into the car, and Jenkins engaged the gears and the big machine rose up off its haunches and lumbered forward, its tyres crunching the stones.

When it had gone, and the smell of exhaust smoke had dispersed, the blackbird alighted on the lawn again and began to dig with its beak in the rain-soaked loam. From a bough above, a magpie looked down at the questing bird out of glossy, blue-black eyes and stirred one wing, flexing its brittle feathers.

CHAPTER
TEN

She told herself she was imagining it, yet all the same she could not get rid of the feeling that she was being followed, being followed and watched. More than once, at work, she had glanced up and felt sure that someone in the street outside, among the crowd of passing shoppers, had been looking in at her intently, and had moved on a moment before she lifted her head. In the evenings, on her way home, she would draw to a halt suddenly and pretend to be absorbed in looking into a shop window while scanning the street out of the corner of her eye. At night, before she went to bed, she would turn off the light and stand in the darkness monitoring the pavement below her window. There were usually a few working girls out, loitering under the streetlamp or walking up and down, smoking, eyeing the cars going past, but they were familiar to her, and she paid no heed to them or the men who stopped to bargain with them. She did not see anyone who seemed suspicious, not once; yet the feeling persisted that there was someone out there, someone whose only interest was her.

She was not frightened, not exactly — apprehensive, perhaps, but what she felt most strongly was curiosity,

and a kind of eager expectancy. It was not the first time she had found herself in this condition. After her friend April Latimer had disappeared someone had watched outside her flat night after night, a shadowy presence under the streetlamp. Often she had thought it might be April herself, in trouble and wanting to talk, yet not daring to cross the road and ring the bell. April had died, had been murdered, or so the authorities had concluded; she, though, had never quite believed that April was gone, and could not let go of the wistful hope that her friend might return some day. And now maybe she had come back — maybe it was April who was watching her, shadowing her, waiting for the right moment to reveal herself.

But it was not April.

She was walking over Baggot Street Bridge in the rain. It was Friday, but she had the afternoon off — Mrs Cuffe-Wilkes was having her hair done, an elaborate and lengthy procedure, which meant the shop had to be closed, for Mrs Cuffe-Wilkes trusted no one, not even Phoebe, and was not willing to leave her alone with the cash register for an entire afternoon. A wind was blowing along the canal, and just at the crest of the bridge her umbrella turned inside-out, and as she struggled with it she dropped her handbag, and someone walking behind her stopped to pick it up for her. The umbrella was difficult to control — the wind was blowing a terrific gale — and one of the spokes nearly poked her in the eye, but at last she got it righted.

"Oh, thank you," she said, taking the proffered handbag, "thank you!"

She was flustered and felt a little foolish. The young woman who had picked up her bag was about her own age. She wore a plastic raincoat and a green woollen tarn with a bobble, from under which waves of red hair, darkened by the rain, flowed to her shoulders. She had a broad face with freckles, her skin was milky white and her eyes were a shade of shining chestnut brown. Those eyes, the big soft irises flecked with gold, were her most striking feature. The lids were elongated at the outer corners and had a little lift that gave her face an Oriental cast. Phoebe thanked her again, and the young woman smiled, and said it was all right and wasn't the wind a terror. There was, Phoebe felt, something familiar about her — was she someone she had been at school with, maybe?

The young woman walked on, but had to stop at the traffic lights at the corner where the bank was, so that Phoebe, who had furled the recalcitrant umbrella, caught up with her. Standing side by side they smiled at each other again. Phoebe felt shy suddenly, and was surprised to hear herself say, "I'm sorry, but have we met before?" The young woman glanced away. The lights had turned red and the traffic had stopped yet they did not cross, but remained standing on the edge of the pavement.

"No," the young woman said. She was still looking away. "But I know who you are."

★　★　★

They went to a café a few doors up from Searsons. The window was steamed over, and when they sat down at a table beside it the young woman rubbed a clear circle in the mist and looked out, leaning back and forth to see both ways along the street. Her name was Sally. "Sally Minor," she said, and smiled.

The waitress came to take their order, but for a moment all Phoebe could do was stare at the young woman before her. Sally Minor ordered a pot of tea and a plate of scones. How peculiar it sounded to Phoebe when she said it — *a plate of scones* — as if she had asked for a serving of consecrated hosts.

Phoebe's mind was racing, and she did not know where to begin or how to frame the questions crowding in her head. Perhaps it was just a coincidence of names. But no, Sally Minor had said she knew who Phoebe was, so there must be a connection with Jimmy.

Phoebe was about to speak when the young woman put one hand on the edge of the table and leaned forward and said softly, "Yes — I'm his sister."

Phoebe nodded. She became aware that her mouth was open, and immediately she clamped it shut. There were many things she had not known about Jimmy, but all the same it was a great shock to think that he had never mentioned a sister. Sally was smiling at her still, somewhat ruefully now. "I'm the black sheep of the family," she said. "They tend to keep quiet about me."

The girl brought their tea, and the plate of scones. Phoebe realised that, although she could not say why, she suddenly felt happy.

Sally Minor told her story. She had always been in trouble, she said, right from the start. In convent school she had defied the nuns, so that they had to call in the parish priest to "put manners on her", as the nuns said. "It didn't work, though." Sally laughed, brushing crumbs from her chin. "Their idea of manners wasn't mine." At sixteen she had left home and come to the city to attend a secretarial college, where she had taken a course in shorthand and typing. She had never had any intention of being a secretary, however. Jimmy — or James, as she called him — was already a cub reporter on the *Evening Mail* and she had hoped he might get her a job there. "Then I met Davy," she said, and laughed, and threw her eyes upward.

Davy had come to work as an instructor at the secretarial college. The job was only a stop-gap, he said, for he had plans to go to England and get a position with one of the big agencies there. " 'Oh, Sally, me dear, me darling,' " he would say to me, opening wide those big brown eyes of his, 'won't you come too, and we'll make our fortune over there together?' "

"And did you go?"

"Oh, I went, of course. The original girl who can't say no, that's me."

Though she greatly doubted it was so, Phoebe was amused. "And what happened?" she asked.

"Davy got a job at a place in High Holborn, very upper-crust, where only the most genteel young ladies were taken on, so he assured me. Young they may have been, but ladylike they were not. They took one look at Davy's curls and those googly eyes of his and were all

134

over him. I've never seen anything like it — they were shameless. And that, of course, was me out in the cold."

"Did you have to come home?"

"Certainly not! Come home and spend my life thinning beets and mucking out pigsties? — no fear. I hung around the pubs in Fleet Street and got picked up by an old boy who worked, if that's the word, for the *Daily Sketch*. Godfrey was his name, a terrible boozer and a lecher into the bargain, but he made me laugh, and, more than that, he got me temping jobs on the paper. The features editor was one of those Fleet Street women, tough as old boots and able to drink the likes of Godfrey under the table. She took a shine to me and let me write the odd par for her — you know, the latest coffee bar that's 'in', and what they're wearing this year at the Chelsea Flower Show. My big breakthrough was a story I did on a mink farm in Henley-on-Thames, lots of colour and a few jokes. The piece was noticed, and the following week I was offered a staff job."

Phoebe's tea had gone cold without her noticing. "But now you're back," she said.

Sally laughed dismissively. "Oh, no," she said. "No, I am not. I came over because of James. I had two weeks' holiday due, and here I am."

"Have you seen — have you seen your family?"

"They don't know I'm in Dublin. I'm sure they're convinced the newspaper job is a fiction and that really I'm working in a whorehouse over there. My brother — have you come across my brother?" Phoebe shook her head, and Sally grimaced. "You haven't missed anything."

135

The clear patch she had made on the window had misted over again, and again she cleared it and peered out at the street.

"Are you expecting someone?" Phoebe asked.

"What? No. No, I'm just —" She frowned, and looked into her cup. She was silent for a time. "Do you see the oily skin that's on the surface of the tea?" she said, pointing into the cup. "I complained about that once to a waiter, in the Savoy, of all places — Madge the features editor was treating. It wasn't tea I was drinking, in fact, but a glass of wine. The waiter gave a disdainful little smile and leaned over, very confidential, and said, 'It is caused by your lipstick, modom.' I was mortified, of course. But that's London for you."

They laughed, both of them, then Sally was silent again. At last, without looking up, she said, "What happened to James? Do you know? I mean, do you know the details?"

Phoebe suddenly found herself longing for a cigarette. She had given up smoking years ago, and was surprised by the force of this unexpected craving. If she were to smoke now it would probably make her sick. It was so strange to be sitting here with Jimmy's sister. It should be a sad occasion, but somehow it was not. It was impossible not to be charmed by the young woman's stories, her dry manner of speaking, her laughter. She was the kind of person Phoebe would have liked to have as a friend. What a pity that she lived in London. Thinking this, Phoebe found herself wondering, as she often did, at her own decision to stay here, in this grim little city, working for Mrs

136

Cuffe-Wilkes and dining with her father once a week in the sepulchral gloom of the restaurant in the Russell Hotel, pretending not to notice how anxiously Quirke watched her glass, worried she would drink more than her share and leave him short. That was her life. There was David Sinclair, of course, but as much as she liked him — perhaps loved him, even — he was Quirke's assistant and therefore a part of Quirke's world. She did not often admit to herself how lonely she was, but now she did. This made her feel sorry for herself, not in the way that, she suspected, most people felt sorry for themselves, but at a remove, dispassionately, almost. Right now, for instance, she was able to look at herself quite coldly, at her drab coat, her black dress with the bit of white lace at the collar, her sensible shoes, the ruler-straight seams of her stockings. Phoebe Griffin, lonely, needy and sad. Yet it was *that* Phoebe who was all these things; she herself, this other Phoebe, was over here, standing to one side, looking on. This gift of impersonality, if gift it was, she had inherited from her father, she knew that.

"How long have you been here?" she asked.

Sally shrugged. "Oh, a few days," she said. This was followed by another silence, and then she laughed. "All right," she said, "I know you're too polite to ask, but I admit it: I *have* been following you."

"Why?"

"I wanted to see what you were like. From the way James talked about you, I expected a cross between Joan of Arc and what's-her-name, Clark Kent's girlfriend."

Phoebe was astonished. "Did Jimmy talk about me?"

"'Jimmy' — of course, that's what you call him. It sounds so odd, as if it's someone else. Did he talk about you? My dear, he never stopped. He wrote about you in his letters, and then he used to phone me from the office, late at night — when the copy-takers had gone home and there was no one around to know he was making trunk calls. Phoebe this and Phoebe that — you must have wondered why your ears were burning all the time."

Phoebe's mouth had gone dry. She felt like a scientist, a naturalist, say, or an anthropologist, who after years of studying a particular species makes an unlooked-for discovery about it that means all previous assumptions must be revised and adjusted. Jimmy had been her friend, but not what she would have considered a close friend; however, from what his sister was saying it seemed that Jimmy had thought otherwise. Now Phoebe had to go back over all the years she had known him and re-examine everything. Was it possible — she had to ask herself the question — was it possible he had been in love with her? She could not credit it. In all the times they had met and spoken, he had never once shown her anything more than the commonplace tokens of friendship. In fact, she had always taken it for granted that he despised her a little, in his self-important way, considering her a spoilt daughter of the bourgeoisie — Jimmy liked to pretend he had read Marx — who knew nothing of the harsh realities of the world. And then there was the fact — and it was a fact, though she hated to acknowledge it —

that in her heart she had always assumed that Jimmy had not been interested in girls, that he had not been that way inclined at all. "So," she said now, with a show of nonchalance that she did not feel, "you must know everything about me that there is to know."

"Well," Sally said, "I knew where you lived, for a start."

"Oh," Phoebe said. "Yes." She was picturing herself standing in the dark by the window in her flat, peering down into the street, searching the shadows for a lurking form. It was a thought she did not care to dwell on.

Sally must have sensed her discomfort, for now she leaned forward and said, "I'm sorry for spying on you, really, I am. I didn't mean to — I mean, I didn't think of it as spying. Only —"

A man opened the door of the café but did not come in. He stood in the doorway for a moment, looking about from table to table. He wore a brown sheepskin jacket with a zip, and a peaked cap pulled far down on his eyes. His shaded glance settled first on Sally, then on Phoebe. Having registered them both, he withdrew. Sally rubbed yet again at the misted window beside her and craned her neck to look after him as he walked off along the street.

"Only what?" Phoebe said. Sally looked at her blankly. "You were saying," Phoebe said, smiling, "that you didn't mean to spy on me. And?"

Sally opened her handbag and fumbled in it, frowning. She brought out a packet of Craven A. Phoebe saw how unsteady her hands were. She offered

139

the cigarettes across the table but Phoebe, despite her earlier sudden desire to smoke, shook her head. The match trembled in Sally's fingers, the flame quivering. "Your father is a detective, isn't he?" she said.

Phoebe laughed. "No, no. I think he sometimes thinks he is, but he's not. He's a pathologist."

"Oh. But James said —"

"He has a friend. *He*'s a detective. Hackett is his name, Detective Inspector Hackett. Jimmy probably mentioned him too, did he? Hackett often gets my — my father to help him. They're sort of a team, I suppose you could say."

"Has he — your father — has he any idea what happened to James — to Jimmy?"

Sally's brightness of a minute ago was gone now, and she looked tense and worried. Had she recognised the man in the doorway? The line of smoke from her cigarette trembled as it rose.

"I don't think anyone knows what happened to him," Phoebe said. She had an urge to reach out and touch the back of Sally's unsteady hand. "It must be awful for you that there's no explanation, no — no reason." She bit her lip, not wanting to go on. She felt a flush rising to her throat. It was impossible, of course, but she was afraid that Sally would somehow sense her suspicions about Jimmy. It embarrassed her even to entertain the thought that he might have been — well, that he might have been "one of those", as people said.

Although she had taken no more than three or four puffs from her cigarette, Sally abruptly crushed it out

140

and gathered up her handbag and her woollen cap. "I should be going," she murmured, as she stood up.

Phoebe put out a hand. "Wait," she said. Sally looked at her, and then at her fingers, which were resting lightly on her wrist. Phoebe did not take her hand away. Sally sat down again, slowly. "You seem nervous," Phoebe said. "You seem — I don't know — you seem afraid."

Sally pressed her lips together, and a frown made a knot between her eyebrows. She looked suddenly young and vulnerable. "The last time I spoke to James — it was a couple of nights before the night when he was — when he was killed — he said something strange." She paused, her eyes fixed on the tabletop. "I wish I could remember what it was, exactly." She looked up. "It wasn't even what he said, it was the way he said it."

"What was it about? — what did he say?" Phoebe asked.

Again Sally eyed the table, as if some word or image might appear there that would help her to remember. "He was talking about tinkers. I wasn't really listening — it was late, he was calling from the office and had woken me up and my mind was in a daze. He was saying something about a campsite somewhere, I can't remember where."

"Was that the story he was working on, something about tinkers?"

"I don't know — it was 'something big', he said. It was his tone that struck me, though. He sounded excited, you know — well, you *do* know, if you knew him at all. He had that sort of shake in his voice that he

141

got when he thought he was on to a scoop. But there was something else, too, something in the sound of his voice, the inflection. I've thought and thought about it, trying to recall exactly how he sounded. He was excited, but I think he was — I think he was afraid, too. Oh, I know —" she held up a hand, although Phoebe had not spoken "— I know you'll think I'm just saying this out of hindsight, because of what happened to him. But I remember, that night, after he'd hung up and I lay down again, I couldn't sleep. I kept hearing his voice in my head, and thinking how he sounded the way he used to sound when he was little and had done something that was going to get him into trouble. There was excitement, but, yes, he was frightened, too."

She stopped, and Phoebe saw that there were tears in her eyes, and now they overflowed, one from each eye, two glassy beads rolling down her cheeks. Phoebe touched her wrist again with her fingertips. "Where are you staying?" she asked.

Sally was fumbling in her bag again, for a handkerchief this time. "At a place in Gardiner Street," she said. She laughed mournfully. "It's an awful hole, but it's all I can afford."

"Right," Phoebe said briskly, rising to her feet. "Let's go."

Sally gazed up at her, damp-eyed. "Go where?"

"To collect your things. You're going to come and stay with me."

The hotel was called the Belmont. It was a converted three-storey house in a grimy terrace on Gardiner

Street. There was a dusty fern in each of the two downstairs windows. When the front door opened a bell rang, as in a shop. Worn dark-red carpet, cheap prints of views of Dublin, cheaply framed, a plywood reception desk with a chipped Formica top. The manager, who Phoebe guessed was also the owner, was a spiv-ish type with oiled hair and a thin black moustache that ran along the rim of his upper lip as if it had been traced there in ink. He insisted on talking to Phoebe, as if it were she who was the guest and not Sally. "The young lady", which was how he kept referring to Sally, had checked in for two weeks, and if she was going to leave early she would have to pay for the room for the full period, that was the law. Phoebe, surprising herself by her firmness, said this was nonsense, that there was no such law, as she knew very well, since her family had been in the hotel business for generations and she herself worked for a solicitor. These were good lies, she thought, really quite convincing, and she was pleased with herself for her quickness in thinking them up.

They went up to the room, she and Sally, and Sally packed her suitcase and the vanity bag in which she kept her toilet things, and then they returned downstairs. The manager was in a cold fury by now. He took Sally's money for the three nights she had stayed, and said there would be a surcharge of two pounds — "For the inconvenience," he said, and gave Phoebe a glare of baleful defiance.

When they came out into the street, with the tinny reverberations of the bell still in their ears, they stopped

on the pavement and burst into laughter. Phoebe glanced back and saw the manager in the window, fingering his moustache and watching them narrowly from behind the drooping fronds of a potted fern. Doubt, like a wave of dizziness, made her feel light-headed for a moment. What had she done? — what had she let herself in for? But then she looked at Sally, with her dark-red hair and her beautiful soft brown eyes, and she took the valise from her, and said, come on, they would get her settled in, and then they would go together and see Quirke.

CHAPTER
ELEVEN

Isabel had a rehearsal, and suggested to Quirke that they should meet afterwards in the Shakespeare. When she came in he was there already, sitting on a high stool at the bar reading the *Mail*, with a glass of whiskey at his elbow. She paused in the doorway for a moment. She knew by the look of him that the whiskey was not his first drink of the day. Not that he seemed drunk — Quirke never looked drunk, to the naked eye. But there was a certain heaviness in the way he was sitting there, a certain plantedness, that she had come to know well. She went forward and tapped a finger on his knee, and was startled by the look of alarm he gave her and by the momentary panic in his eyes. She said nothing, though, only kissed him quickly on the cheek and perched herself on the stool next to his, taking off her gloves finger by finger.

"I think, William," she said to the barman, whom everyone else called Bill, "I think I might risk a G-and-T — to bathe the vocal cords, you know." She smiled at Quirke. "That's a nice shirt," she said. "Blue does suit you." She had forgiven him in the matter of the discarded bow-tie, or said she had, at least. Now she looked about. "Good to be back," she said. "The

old haunts have their attractions." The tour had not been a success; rural Ireland, she had observed wryly, did not seem ready yet for Ibsen.

Quirke had folded his paper and put it aside. "What news of the world?" Isabel asked. He did not answer, and she peered at him more closely. "What's the matter?"

He glanced away. "What do you mean, what's the matter?" he growled.

"You look — I don't know. Odd." She was wondering how long he had been here and just how many whiskeys he had drunk.

"I'm all right," he said shortly.

She went on studying him, tilting her head to one side, as if she were measuring him up for a portrait. Strange, but it was when he was in his lowest spirits or at his most distressed that he seemed most beautiful to her. She supposed "beautiful" was not the appropriate word, for a man so troubled and dour, yet it was the one she used, to herself. His grey eyes had a greenish gleam that made her think of the sea at evening, aglow and deceptively calm. He had delicate hands, too, for his size, and then of course there were those absurd feet, dainty as a ballet dancer's, although a dancer's feet, she reflected, in reality would be anything but dainty.

What was she to do with him? It was a question she asked herself repeatedly, in no expectation of an answer. One day he would leave her again, she had no doubt of that. The thought, for a reason she could not fathom, made her feel all the more tenderly towards

him, as if it were his suffering that was in prospect, not hers. She had once wanted to die because of him, or thought she had, but that had been another self, one she had left behind in the hospital bed where she had lain, recovering from the overdose, and readjusting her life. She was a different person now, harder, more detached, more determined to protect herself. And yet she still loved Quirke, she could not deny it, poor sap that she was.

"Had a peculiar experience," Quirke said now, still not looking at her.

"Not funny-funny, you mean?"

He took a drink of his whiskey, followed by the familiar grimace that he did, drawing his lips back and making a sharp hissing sound between his teeth. "No, not funny-funny," he said. "I'm not sure I know how to describe it."

"Well, it's left you in a peculiar state, that's certain."

Now he did look at her, giving her a sidelong glance, and she saw again the glint of panic that made him seem impossibly young, as if there were a frightened little boy inside him, peering out — which, in a way, she supposed, there was. He told her how he and Hackett had gone to Trinity Manor, and about the priest there, Father Dangerfield, who had reminded him of Nike, and how the memory of Nike had upset him so much he had broken into a cold sweat and had almost run out of the room. "And then the old doorman, who said his name was Thady, took me into the kitchen and gave me Powers whiskey to drink, and told me about this

other priest that Hackett wanted to see, and where he was."

Isabel was listening intently. "What was strange about that?" she asked.

Quirke shook his head and gave a sort of laugh. "That wasn't the strange part," he said. "The strange part was when I left the kitchen. Suddenly I was —" He stopped, and signalled to the barman.

"You haven't drunk the one you have," Isabel said, pointing to his glass and the whiskey in it.

"What?" He stared at the whiskey, and frowned, a look of confusion in his eyes. "Yes. Right."

Bill the barman came, and Isabel said she would have another gin and tonic, even though her glass, too, was still half full. "And the good doctor here," she added drily, "will have another Jameson, in case you might suddenly run out of the stuff."

A customer came in, and between the opening and the shutting of the door Isabel glimpsed the pale-yellow April sunlight on the pavement outside and the slanted, damp purplish shadows there. At the party in Mullingar, Jack Fenton, who had been playing Torvald to her Nora, had made a pass at her. It was a surprise — she had vaguely assumed he was queer — and rather flattering. She had considered taking him up on his offer, but then had thought better of it. She wondered if she should tell Quirke about him, about how he had put his hand on her bum and smiled his lopsided, cajoling smile. Quirke might be amused, and of course, although he would not admit it, he would be secretly gratified — all men loved to hear of their rivals being

148

spurned. But no, she thought. Quirke was hardly in the mood this evening for romantic banter.

"The strange thing is," he said, his eyes fixed on a point in space in front of him, "after I left the kitchen I must have had some kind of blackout, because the next thing I knew I was in a lavatory, standing by an open window with the rain blowing in my face." He shook his head again, like an animal trying to shake off a cloud of flies. "Then I found Hackett waiting for me in the hall, and it seems only five minutes or so had elapsed, even though I thought I'd been with the old man in the kitchen for — I don't know, half an hour, at least. And then . . ."

There was a side to Quirke, the uncertain, baffled side, that frightened Isabel, a little. She had thought about this in Mullingar, after the party, lying sleepless and a bit drunk in a lumpy hotel bed. A girl had to consider the future, especially a girl in her uncertain profession, and at her age, unmarried and childless. She did not think she had it in her to devote her life to looking after a weak man. She was weak herself, and needed strong people around her, to lean on. But what could she do? Love was love, and always demanded more than a lover was capable of giving. All the same, maybe she should not have shaken off Jack Fenton's hand quite so brusquely.

"And then," Quirke resumed, "the old man appeared, to see us out, but when I called him Thady he said that wasn't his name."

"So what was he called?" Isabel said, trying to keep the note of impatience out of her voice.

"I don't know. Richie, or something. But not Thady, anyway. And from his demeanour, the way he looked at me, and spoke, it seemed he had forgotten our talk in the kitchen. In fact, he behaved as if I hadn't been with him in the kitchen at all."

Isabel took a drink from her glass, playing for time. Now, affected by what Quirke was telling her, and the tone in which he told it, she too felt unsettled. "Well," she said, "yes, I see what you mean about it being peculiar." There was a brief silence. "So did you imagine it all, do you think? How could that be?"

"I don't know," Quirke said. "I must have blacked out somehow and dreamed the whole thing. But it wasn't like a dream — it felt completely real."

He was still staring before him, frowning hard. Isabel had the image of a man trapped in a dark maze, groping his way along leaf-strewn paths, helplessly. "Had you been drinking?" she asked.

"No, no — I told you, it was morning."

She allowed herself a wry smile. "That wouldn't necessarily mean you were stone-cold sober. Anyway, you probably had a hangover, like every other morning."

He gave her a dark and louring look. "You don't understand," he said. "It wasn't that kind of experience."

"People have nervous attacks," she said. "They imagine the strangest things. I had an aunt —"

"It wasn't anything to do with my nerves," Quirke snapped, through gritted teeth.

"I'm only trying to —"

150

"I know, I know. I'm sorry." He picked up the second whiskey and drank it off in one go, throwing his head back, and put down the empty glass, wincing, and making that hissing sound again. Isabel reached out to touch his hand but he drew away from her, pretending not to have noticed her gesture. "Let's go," he said, stepping down from the stool. "I don't want to drink any more."

The sun had gone and it was twilight in the streets now, and there was the metallic smell of rain on the way. Seagulls were swooping in great circles above the dome of the Rotunda Hospital. Isabel took Quirke's arm and pressed it against her side. "I'm cold," she said. He did not reply, and seemed not to have heard.

They went to his flat. She insisted that he sit in the armchair at the fireplace and went into the kitchen and made coffee. When she came back into the living room he was sitting as she had left him, hunched forward with his forearms resting on his thighs, gazing emptily at the unlit gas fire. "Put a match to that, will you?" she said. "It's bloody freezing in here."

While he fumbled with the matches she set down his cup on the coffee table beside the armchair. When he had lit the fire he sat back into the chair. His cheeks had a greyish tinge. She knelt in front of him, with her fists on his knees. "Are you worried?" she said.

He blinked; he seemed to be having difficulty focusing on her. "What do you mean?"

"About this — whatever it was, this blackout, this nervous attack."

151

His eyes slid away from hers. "I don't know," he said. "If I could understand it I could deal with it. As it is I'm just puzzled. I —"

The telephone rang, causing them both to start. Quirke made to rise but she would not let him. "Leave it," she said. "Whoever it is will call back."

But he put his hands on her shoulders and pushed her to one side and rose from the chair and stepped past her. She almost lost her balance and had to hold on to the chair-arm to keep from falling over. Both her kneecaps were sore from kneeling. She was suddenly angry.

Quirke crossed to the telephone and picked up the receiver.

"Dr Quirke?" the voice said. "Honan is the name. Father Michael Honan."

II

CHAPTER
TWELVE

Quirke had an aversion of long standing to Flynne's Hotel. It was not the threadbare carpets or the greasy armchairs or even the pervasive smell of boiled cabbage that he most objected to. The place was a throwback, shoddily preserved from an older, harsher time. When he thought of Flynne's, he thought of cobwebs and musty dampness and the particular glistening blackish-brown shade of the varnish that was smeared over every inch of every exposed wooden surface, of floors, banisters, chair-backs, even the flanks of the grandfather clock that stood in the shadows in the narrow lobby, half hidden by a tasselled brocade drape, ponderously ticking off the time that seemed to pass more slowly here than anywhere else.

Quirke's father, or, rather, his adoptive father, Judge Garret Griffin, used to come in here on Sunday afternoons to drink whiskey with his cronies and swap courtroom gossip, and sometimes he would bring Quirke with him. Quirke recalled those seemingly interminable afternoons with a shiver. Garret had thought he was bestowing a rare treat on the boy, letting him sit with him and the other dusty denizens of the Law Library in a private dining room in the dim

back regions of the hotel, surrounded by talk and tobacco smoke, a glass of fizzy orange slowly going flat on the table in front of him. And now, this evening, when he sprinted from the taxi — a shower was imminent — and climbed the granite steps and entered the lobby, his heart quailed before the awful familiarity of the place, while behind him, in the lamp-lit street, the inevitable April rain began to fall.

He made for the bar, and paused in the doorway. Low-wattage lamps in brackets on the walls lent a sullen glow to the flocked crimson wallpaper. The air reeked of turf smoke and the spicy tang of alcohol; he swelled his lungs with a deep draught of these mingled savours. He found bars like this dispiriting and yet mutedly exciting, too, despite himself. They were, he supposed, the kind of shabby-genteel places, dimly lit, forlorn and slightly sinister, where he felt most at home.

And then, of course, there was the sense too of all sorts of louche possibilities, of chance encounters, of passing and, as it usually turned out, ill-advised liaisons. One night he had met a woman, in another bar in the city, and she had brought him here to Flynne's, where she was staying, and they had spent the night together in her room. He recalled how they had crept past the night porter and up the creaking staircase. The woman had been a little tipsy, and had leaned against him, giggling, and whispering lewdly in his ear. On the first landing she had made him stop and turn and kiss her, and had thrust her hand into his trousers pocket. This token of wantonness had filled him with sudden

misgiving. What was her name? Anne? Amy? Aileen? Something like that. She had told him she was a saleswoman for a Donegal weaving firm, down in Dublin to do the rounds of the big stores in hopes of securing orders. Her room was at the front of the hotel and looked down into a deserted Abbey Street. He noticed her slipping off her wedding ring and putting it under the pillow on what was going to be her side of the bed before she went into the bathroom. Between the sheets she had been unexpectedly shy. She swore she had never gone to bed like this with a strange man before, though he did not believe her. He had liked her accent, the soft northern lilt of it. In the morning they had not known what to say to each other, and she had turned away from him to fasten her suspenders. Aine! That was her name. Aine from Inishowen, way up there in the wild north.

Now he stood in the doorway of the bar and scanned the room. Three priests sat around a small table near the fireplace, with drinks and a jug of water and an overflowing ashtray between them. In the fireplace a dolmen of turf logs was smouldering sullenly. The priests made Quirke think of a trio of magpies — was it three for bad luck? They were talking about a colleague, another priest, who had been summoned to Rome to work in the Vatican. "God, now," one of them said, in low, envious tones, a young man with black horn-rimmed glasses, "I wouldn't mind being him. Rome! The fountains alone, they say, have to be seen to be believed." The other two nodded, an Italianate

radiance reflecting for a moment in their shiny, flushed faces.

Quirke's eye moved on. Two elderly women in balding fur coats, one with a cluster of fake cherries pinned to the lapel, were ensconced in a corner, demurely sipping glasses of port. At a table in an opposite corner a young man and his girl were arguing with hushed ferocity. The girl wore a pillbox hat pinned to her hair at a sharp angle; each time she snapped a remark at the young man between clenched teeth the hat gave an inappropriately jaunty little nod. The boyfriend's shirt collar was a couple of sizes too big for him and stuck up at the back. The barman was polishing a pint glass and whistling softly to himself. Quirke recognised the tune. "April Showers".

Someone walked up quietly behind him. "Dr Quirke, I presume?"

He was large and ruddy, with reddish-brown hair cropped short so that the paper-pale skin of his scalp shone through. He did not look like a priest. He wore a nondescript grey suit, striped shirt, a dark-blue tie, slip-on shoes with small gilt buckles. However, the white socks, which Quirke noted at once, were the give-away. "Father Honan?" he said.

"Indeed!" They shook hands. The priest's palm was soft and dry and warm. He smiled. "You weren't fooled by the mufti, so," he said, glancing down ruefully at his suit and tie and buckled shoes. "The aim is anonymity, to come and go without being noticed. Fat chance, says you." His voice had a faint northern burr — Armagh? Antrim? or Inishowen, maybe, where Aine the travelling

saleswoman hailed from — and he spoke softly, in intimate tones, as if they were in the confessional rather than a public bar. "But tell me now," he said, "what will you drink?"

They moved together to the bar. The priest gave off a strong, pungent waft of cologne. His eyes were shards of grey flint, and the plump backs of his hands were freckled all over and stuck like pincushions with fine, almost colourless hairs. Moisture glistened on his forehead and his upper lip; he was a man who would sweat a lot.

Quirke asked for a Jameson. "Good man," the priest said. "I'll join you."

They stood half facing each other, each with an elbow on the bar, a hand in a pocket, like counterparts, two men of the world, sharing a drink. This was not what Quirke had expected. But then, what had he expected? Someone lean and watchful, thin-lipped, pale, with a jaw like a knife-blade, a Nike or a Father Dangerfield, not this thickset golfing-club type with a drinker's nose and a mesh of broken veins in the shiny skin over his cheekbones. In the light here at the bar his hair was a darker shade of red than it had seemed at first, and beads of sweat were sprinkled through it.

"May I ask," Quirke said, "how you knew my phone number?"

Father Honan, drolly smiling, let an eyelid briefly droop. "Oh, we have our sources," he said. He sipped his drink, watching Quirke over the rim of his glass. "Father Dangerfield said you were looking for me.

Something to do with this young fellow who was killed?"

"Jimmy Minor, yes."

"And there was a detective with you?"

"Hackett. Inspector Hackett, Pearse Street."

"Yes," the priest said. "Hackett, I've heard of him. A good man, they tell me."

The girl in the pillbox hat stood up suddenly and marched from the room, her eyes fixed straight ahead of her in a furious glare. After a moment the young man rose sheepishly and followed her, clearing his throat and blushing. "Ah, the bumpy road of love," the priest murmured. He nodded towards the table the couple had vacated. "Shall we?"

They crossed the room with their drinks. The young priest with the horn-rimmed spectacles glanced in Father Honan's direction and said something to his two companions, who turned to look also. A downdraught in the chimney sent a ball of turf smoke billowing out of the fireplace to roll across the carpet. Through a window beside him Quirke looked out into the glossy darkness and saw the rain dancing on the pavements and the roofs of parked cars.

"There was a letter, I believe," Father Honan said. "Desperate Dan told me about it — sorry, that's Father Dangerfield. We think the world of him, only he's a bit of a Tartar, as no doubt you noticed."

"He didn't seem to know your whereabouts," Quirke said.

"Oh, Father Dangerfield is the soul of discretion," the priest said, in his soft, breathy voice, and laughed.

160

His way of speaking, with smiles and winks and little nods, made it seem as if everything he said, even the most innocuous commonplace, were being imparted as a confidence and meant for no one else's ears. He produced a cigarette case and offered it across the table. "What was it, do you know, that this unfortunate young man wanted to see me about?"

"That's what we — that's what Inspector Hackett was wondering," Quirke said.

The priest sat back in his chair with his elbows on the armrests and his hands clasped before him, a cigarette clamped at a corner of his mouth and one eye screwed shut against the smoke. "May I ask, Dr Quirke," he said, "what you . . .?"

"What's my interest? I knew Jimmy Minor. He was a friend of my daughter's."

The priest nodded, but his eyes were narrowed. He still had the cigarette in his mouth; it jiggled up and down when he spoke. "And Inspector Hackett," he asked, "is he a friend of *yours?*"

"The inspector and I have — what shall I say? We've cooperated in the past."

"Yes. So I'm told."

Who had told him? Quirke wondered. And if he knew about him and Hackett already, why had he asked? And anyway, why in the first place had he contacted him and not the inspector?

The three priests at their table had ordered another round. The older two were drinking whiskey, the younger one a glass of Guinness. How did they come to be out together like this on a weekday night, drinking

161

and gossiping in Flynne's? A birthday? Some other celebration? Flynne's was a haven for the clergy, a safe house for them in the city.

"I don't think I ever came across this young man, this Jimmy Minor," the priest said reflectively. "He was a reporter, is that right?"

"On the *Clarion*. Used to be with the *Mail*."

"I wonder what he wanted to talk to me about."

"Something to do with your work, maybe. You run clubs and so on in Sean McDermott Street, I hear."

"And other places."

The priest kept his eyes narrowed, and Quirke could see only the merest ice-grey glint between the lids. His eyelashes, like the hairs on the backs of his hands, were so pale they were almost invisible.

"Was there something in particular you wanted to talk to me about, Father?" Quirke asked. "If not Jimmy Minor, I mean."

The priest opened his hands and held them far apart, palm facing palm. "I've heard things about you," he said.

"Oh? What sort of things?"

"Just — things. You know what this city is like — everyone knows everyone else's business, or thinks he does." He had taken the cigarette from his mouth and now leaned forward and knocked the ash from it into the ashtray on the table with a deft flick of his wrist. "Anyway, I thought I'd take the opportunity of meeting you. I'm the same as everyone else — I like to keep abreast of what's going on, and who's going on with it."

162

He smiled again, showing a big mouthful of sallow teeth.

Quirke was holding his whiskey glass in front of him and looking into it. "Tell me," he said, "who it was that talked to you about me, that told you whatever the things are that you heard about me?"

"Oh, various people," the priest said blandly. "Joseph Costigan was one." Quirke had gone suddenly still. The priest watched him, seeming amused. "Although I'd say now," he said, "the good Joe wouldn't be one of your favourite people in the world."

Quirke was frowning. "I couldn't say I know him," he said. "I've met him a couple of times." Costigan was a fixer for rich and powerful Catholics in the city, the same Costigan he had told Isabel about, the Costigan who knew how the world worked and where the real power resided.

"He speaks very highly of you, you know," the priest said, "very highly indeed. You doubt that, I can see, but it's true, nevertheless." He lowered his voice to a feathery whisper. "He knows you for an honest man, a man of principle." He signalled to the barman to bring another round of whiskeys, and leaned back once more in his chair. "I grant you, Doctor, poor Joe would not be, shall we say, the most immediately appealing of men, in general, on a personal level. He takes himself very seriously as a dedicated warrior of the Church Militant. That kind of thing makes for a certain — what's the word? — a certain abrasiveness."

The barman brought their drinks on a pewter tray. The bespectacled young priest at the other table was

163

watching them again, and again spoke in an undertone to the other two. Quirke sat silent, his eyes fixed on the cigarette case on the table. He was trying to make out the monogram on the lid.

"Would I be right in thinking, Doctor," Father Honan said, tipping a little water into his whiskey from the jug the barman had brought, "that you're not a believer?" He offered the jug to Quirke, who shook his head. "Well, to tell you the truth, neither am I." Quirke stared, and the priest smiled back happily, pleased with the effect his words had produced. "You're shocked, I can see." Quirke took a drink and felt the whiskey spreading hotly through a network of branching filaments behind his breastbone; remarkable how that sensation seemed new every time. "I'd make a further guess," the priest said, "that you've not had the happiest of experiences at the hands of the clergy."

"I was at Carricklea," Quirke said. "I spent a long time there, when I was a child."

The priest turned his mouth down at the corners and slowly nodded. "Ah, yes," he said. "I thought it would be something like that."

Quirke looked to the window again. The rain had stopped, and the street out there glistened in the darkness between the pools of light falling from the streetlamps. He had almost forgotten why he was here, in Flynne's Hotel, drinking whiskey and trying not to think of the past. What did this priest want with him? Why had he spoken of Costigan — why had he brought up that name, of all names? He saw yet again the canal bank in the darkness, the leaning, listening trees.

"When I say I'm not a believer," the priest said softly, glancing towards the trio at the other table, "I should explain what I mean. The Church, Dr Quirke, like Heaven, has many mansions. There's room in it even for the sceptic." He chuckled, a fan of fine wrinkles opening outwards at the side of each eye. "I fear our poor old Mother Church doesn't always act in her own best interest. It's a broad Church, of course, and has to pay heed to all sorts and varieties of belief and opinion and prejudice across the world, in America, in Africa, in Asia, even. But she has an unfortunate way — I think it's unfortunate — of treating all her children as if they were just that, children. Look at our own benighted little country, hidebound by rules and regulations formulated in the corridors and inner chambers of the Vatican and handed down to us as if graven on tablets of stone. So when I say I'm not a believer, it's *that* Church — which I think of, the Lord forgive me, as the Church of the Blessed Infants — that I turn a sceptical eye towards. No: my Church is the one that traces its roots back to Greece and classical Rome, not the arid deserts of Palestine and the childish people who lived there when the Bible stories were written. My Church is the Church that recognises the tragic element in our lives. My Church is the Mater Misericordiae, the mother of sorrows and forgiveness, who spreads her cape wide and shelters all of us, saint and sinner alike."

He stopped, and laughed quietly, and leaned forward again. "Forgive me, Dr Quirke," he murmured, "I must remember I'm not in the pulpit. In fact, I'm rarely in the pulpit, and not often in church, either, for that

matter. My work is carried on in the streets, in the tenements, in the campsites of the travelling people. I don't flatter myself that this makes me a better minister of God than the monk in his cloister or even the lowly law-giver in the Vatican. We all have our allotted tasks, our theatres of operations."

One of the old ladies across the way rose and tottered to the bar, an empty glass in each hand. "Ah, Mags," the barman said, pretending to be cross, "you should have shouted and I'd have come over to you."

Outside in Abbey Street, a lone drunk passed by, singing "Mother Machree" in a high, strained, sobbing tenor voice.

"You're going to Africa yourself, I hear," Quirke said.

The priest put on an exaggeratedly doleful expression. "I am — for my sins. Nairobi first, then some godforsaken parish out in the bush that will be twice the size of Ireland, I don't doubt."

"Have you been there before?"

"Not that part. I was in Nigeria for a while, some years back. I still come down with fever in the rainy season. What about yourself? Do you ever travel?"

"I used to go to America — worked there years ago, in Boston."

"Ah, Boston is a grand city."

The drunk could be heard from somewhere along the rain-washed street, still crooning tearfully.

"Have you family yourself, Dr Quirke?" the priest asked.

"No. My wife died."

"But you have a daughter."

166

Quirke frowned. "Yes, I have," he said. "I forget, sometimes."

The priest gazed at him in silence for a long moment. He seemed to be thinking of something else. "Your father was Garret Griffin," he said. "Am I right?"

"My adoptive father, yes."

"A fine man, Garret."

"Did you know him?"

"I came across him now and then. A great friend of the Church."

"A great friend of your man, Costigan, too."

The priest smiled, biting his lip. "I don't believe Joe has friends, as such."

"What, then?"

A little flurry of tension gripped the air between them, as if a dust devil had suddenly risen up in a dervish dance on the tabletop. "We're both men of the world, Doctor," the priest said. "And a hard and recalcitrant world it is."

"So there must be people like Costigan to keep it all in check."

"To keep some of it in check," the priest said, and smiled, softly reproving. "But even the Church's powers are limited — even Joe Costigan can't control everything."

Quirke stood up and went to the bar and asked for two more whiskeys. There was a constriction in his chest and his heart was doing its muffled, trapped-bird thrashings. Was this, he wondered in alarm, the preliminary to another bout of alienation and fantasy, like the one he had undergone at Trinity Manor? He

had been in the presence of a priest on that occasion, too. Maybe he was developing an allergy to men of the cloth. Or maybe he was just angry at the thought of Costigan and his endless machinations.

He turned now, while the barman was preparing the drinks, and saw that Father Honan had risen from his chair and was standing by the table where the trio of clerics was seated, his hands in his pockets, saying something and laughing. The three men sat looking up at him with awed expressions. He would be a star in their firmament, of course, the famous Father Mick, champion of the poor and the downtrodden, the kiddies' friend, the tamer of drunken fathers and lawless tinkers.

Quirke carried the drinks to the table. Father Honan, with a parting quip that left his three admirers shaking their heads and chuckling, came back and sat down. "My Lord, Doctor," he said, picking up his glass and admiring the whiskey's amber glow, "you'll have me under the table."

"You didn't know Jimmy Minor, then," Quirke said.

The priest looked from the glass to him and back again. He took his time before answering. "I think I said, didn't I, that I'd never met the poor chap?"

"Yet he must have known of you, or something about you."

The grey eyes narrowed again, glinting. "Something about me?" the priest said, very softly. When he spoke like this, so quietly, he seemed to caress the words, and Quirke thought of a hand with fine pale hairs on the

back of it caressing a cheek, fresh, smooth, unblemished.

"He wrote to you," Quirke said. "He asked to interview you."

"Apparently he did. But I don't know what it could have been that he wanted to talk to me about. Do you?"

"I'll say again — something about your work, maybe."

"Maybe so, maybe so. We'll never know, now, will we?"

They watched each other, sitting very still, hunched forward a little in their chairs. One of the turf logs in the fireplace collapsed softly, throwing sparks on to the hearth and rolling another ball of smoke out across the floor. Quirke picked up the cigarette case. "What's this?" he asked, pointing to the monogram on the lid.

"Fleur-de-lis," the priest said. "A woman had it done for me, years ago." He smiled at Quirke's raised eyebrow. "Oh, yes, Doctor, I too was loved, once."

"What happened?"

"Nothing happened. She was married, and I was young. She came to me for confession, invited me home to meet her husband. He was a builder — or an architect, was it? I can't remember. Well-to-do people, anyway. She knitted socks for me, and gave me that" — pointing to the cigarette case — "and nothing, Dr Quirke, nothing happened. I suppose you can't imagine a love like that?"

Quirke gazed at the cigarette case where it lay on his palm. "Why did you telephone me, Father?" he said. "Why did you want to talk to me?"

The priest threw up his hands, laughing softly. "Such questions, Doctor, and you ask them over and over! I already said, people told me things about you. I was curious to see what you were like. And now I've seen you, and I think you are a very angry man. Oh, yes — I can see it in your eyes. That place — Carricklea, was it? — marked you for life, that's plain."

"Are you going to tell me now to forgive and forget?"

"I wouldn't dream of it. Your pain is your own, Doctor. No man has a right to tell you what to do with it." He smiled his glinting smile, then suddenly sat upright and clapped his hands on his knees. "And now," he said, "I must love you and leave you, for the hour is late and Desperate Dan will be fretting that I'm gallivanting about the town and neglecting my priestly duties." He stood up, and held out a hand. "I'm very glad to have met you, Doctor. I hope our paths will cross again. Goodnight to you, sir."

He made a brisk bow from the shoulders, and walked away. Quirke had not spoken, had uttered no farewell. He sat gazing into his glass, in the depths of which the glow from the fire had set a ruby light burning. It reminded him of the light of the sanctuary lamp behind that stained-glass wall he had come up against so disconcertingly at Trinity Manor.

Father Honan, heading towards the door and passing by the three priests at their table, sketched a sort of swift, ironical blessing over their heads. One of them rose hastily to speak to him, but Father Honan did not stop, only put a finger to his lips and shook his head smilingly and passed on out, through the doorway. A

moment later he was back, however, and crossed swiftly to where Quirke sat. "A thing I meant to say to you, Doctor: a great theologian — which of them I can't for the moment recall — once asked, *What kind of a self-respecting God would concern himself with the poor likes of us?* Or words to that effect. I don't know what the answer might be, but the question, I find, affords me comfort, especially in times of anguish and loss of certainty. You might think on it yourself. It lends a little bit of perspective, I find, to the grand scheme of things."

He nodded, and turned, and was gone again. This time he did not come back.

CHAPTER
THIRTEEN

Phoebe had moved the previous winter from a bed-sittingroom in Baggot Street to a flat in Herbert Place. She had hesitated over moving there, since that was where her friend April Latimer had lived before her disappearance. But Phoebe was not superstitious, and anyway the flat was at the other end of the street from where April's had been. And it was a lovely flat; she was lucky to have found it. She had two big rooms on the first floor, the front one overlooking the canal and Huband Bridge and the willow tree that grew there. The back room, the bedroom, was a bit gaunt, with heavy mahogany furniture — a vast wardrobe, two chests of drawers and a tallboy — but it had a big, square-shaped window that was always full of light, particularly in the morning, and quite a few of its many small panes seemed to be the original glass, and gave a wonderful rippling effect, especially when rain was streaming down them. Strange to think of the generations of people, long gone now, who had stood here, looking out on the gardens and the mews and, beyond them, the roofs of the houses on Herbert Street. She did not mind that her father lived just round the corner, in Mount Street: she knew there

would be no question of his dropping in on her. The very notion of Quirke dropping in on anyone was laughable.

She had offered Sally the bedroom, but Sally had taken one look at the four-poster double bed with its absurdly squat legs and said she would be fine on the sofa in the front room. There were spare sheets and a pillow, but for bedclothes she had to make do with a rug from the back of one of the armchairs with her own overcoat on top. When they had done assembling the makeshift bed they stood back to admire it, with their hands on their hips, and smiled at each other in complicitous fashion; friends already, Phoebe thought, and something thickened for a moment at the back of her throat.

Phoebe made cocoa for both of them and with their mugs they sat on the floor in front of the gas fire in the lamplight, listening to the sound of the rain falling outside. Phoebe was reminded of being at boarding school, that time one Easter when she was fifteen, and she and another girl had stayed on when everyone else had gone home for the holidays. Phoebe's parents had been away in America, visiting her grandfather, who was ill. She could not remember what the reason was for the other girl staying behind. Her name, Phoebe remembered, was Monique, which seemed very exotic, like the name of someone in a foreign film. It had been exciting, in a queer, cosy sort of way, being there together, just the two of them, in the almost deserted school, with only the head nun, Sister Aloysius, and a couple of young novices to look after them. They had

scoffed clandestine midnight feasts — not at midnight, of course, but long after bedtime, all the same — and in the afternoons they had lounged in armchairs in the library with their shoes off and their feet folded under them, reading and, more often, talking. Monique had smuggled in a packet of cigarettes, and they had stood and smoked by an open window in the senior girls' bathroom, feeling very grown-up and scandalous. They even planned to sneak out one night and take the bus into town and go to the pictures, but their nerve failed them. Monique had a secret boyfriend at home — she lived in Belfast — who was older than she was, and whom she allowed to do things to her, so she said, that Phoebe at the time could not imagine being done to her.

"It's very kind of you," Sally said, "to take me in like this."

"I haven't 'taken you in'!" Phoebe cried, laughing. "You make it sound as if you were a stray cat, or something."

They sipped their cocoa, watching the silky blue flames throbbing along the bars of the gas fire. Phoebe liked the sensation of her shins being hot while the backs of her legs were cool. She had thought of changing into her dressing-gown but felt it would not be quite the thing to do, in the circumstances. She was not used to having someone staying with her; in fact, no one had ever stayed here overnight, or in the bed-sit in Baggot Street, either, not even David — especially not David. "I knew I'd like you," Sally said now, in a slightly tentative way, as if she had guessed what

174

Phoebe had been thinking. "James and I always liked the same people."

"Did you miss him, when you went to England?" Phoebe asked.

Sally pondered the question. "At the start I was so miserable I couldn't sort out who or what I missed the most. But, yes, I could have done with him being around, to talk to. He always listened to me, to things I was enthusiastic about or that were worrying me, and he never preached, even though he was the older one." She frowned, and Phoebe wondered if there were tears in her eyes or if it was just the effect of the gaslight. "Have you got any brothers or sisters?" Sally asked. Her voice did not seem teary.

"No," Phoebe said. "I'm an only child." It sounded strange, put like that. Why did she speak of herself as a child? But how else was she to put it? She could not have said she was an "only person", or an "only woman". There could only be only children, it seemed. For a long time after she had found out who her real parents were — Quirke and his dead wife — she had thought of herself as an orphan; she had *felt* like an orphan. That had been the loneliest time of her life, but that time had passed. And now? Was she less lonely now, or more so, in a different way?

Sally gave a little laugh. "It's funny," she said. "I always wanted to be an only child. I used to think it would be romantic, that I'd be like — oh, I don't know — Jane Eyre, or someone." She paused. "You always think everyone else is having a wonderful life, don't you? That's one of the reasons, maybe *the* reason, I

found out where you worked and followed you for days around the city. From the way James talked about you, you seemed the most amazing person, leading the most amazing life."

Phoebe laughed. "And now you've discovered the sad and disappointing truth, is that it?"

But Sally's attention had strayed, and she did not reply. Instead she asked, "Have you got a boyfriend?"

"Yes," Phoebe said. "His name is David, David Sinclair. He works with my father." She heard how her voice had become solemn, as if the subject of David Sinclair warranted a certain gravity. Why was that? So many things about David puzzled her, the first one being her feelings for him.

"Is he a doctor too?" Sally asked.

"A pathologist, yes. You must —" now she sounded to herself like a debutante or something, all breathy and bright "— you must meet him."

Once again Sally's thoughts had wandered. "I keep seeing it in my mind," she said, "somebody hitting him and kicking him." She turned to Phoebe with eyes that were suddenly fevered. "Why would they do such a thing? Who would want to harm poor James?" She looked at the fire again, the hissing flames. "He never hurt anyone in his life."

They were silent for a time. The rain had stopped, and outside too all was silent, as if the entire city were deserted. Phoebe thought of Jimmy, his little pinched, pale face, his nicotine-stained fingers, his way of pushing his hat to the back of his head, like the newsmen did in the films that they had often gone to

176

together. "You didn't come back in time for the funeral," she said.

Sally gave a sad shrug. "I couldn't face — I couldn't face *them*. Mam and Dad are all right, but my brother . . . He's so full of anger and outrage. I think he thinks the world was set up specially to annoy him."

Phoebe hesitated. "What is it that — I mean, how did you come to be so distant from them, from your family?"

Sally put her mug on the floor beside her and drew up her legs and put her arms around them and rested her chin on her knees. The gaslight gave her face a bluish cast. "Oh, they never forgave me for going to England. I think they thought I must be pregnant. They couldn't understand anyone wanting to leave, to get away. I don't really blame them — they can't see beyond the little world they grew up in."

"Wouldn't you — wouldn't you think of contacting them, now, of telling them you're here, that you've come home?"

"But I haven't 'come home'!" Sally said. "If they knew I was here they'd assume I was staying. But I'll be going back. My life is there now."

"But if you could make peace with them? Your parents must be broken-hearted, having lost Jimmy. Surely they'd be glad to hear from you."

"I considered trying to get in touch with Daddy — he was always the one I got on best with — but I knew he'd tell my brother."

"You sound almost as if you're afraid of him, of your brother."

"Do I? I don't know — maybe I am. I never understood him. James was so different from him. James liked to talk tough, but underneath he was soft — I'm sure you saw that." She turned to look at Phoebe. "Was there ever — was there ever anything between you and him? Do you mind me asking?"

"No, no, I don't mind. And no — Jimmy and I were friends, never more than that." It made her uneasy, speaking about Jimmy like this. Although she had nothing to hide, still she seemed to detect in her own voice a strident note, as if there were something for her to feel guilty about and deny. But there was nothing, except, she supposed, that she had not given enough attention to Jimmy, that she had taken him for granted. But surely that was how everyone felt when someone died unexpectedly and in tragic circumstances, that there were things they should have done, words that should have been spoken, gestures that should have been made. It struck her that by dying Jimmy had turned himself into a larger presence in her life than he had been when he was alive.

Sally thrust her fingers into her hair and yawned.

"You're tired, I can see," Phoebe said. "We can talk again tomorrow — I'll phone the shop and go in late."

"Will you contact your father? I'd like to see him, to talk to him."

"Yes, I will. He lives nearby, you know. We can try to catch him before he leaves for the hospital."

They took turns in the bathroom, then said goodnight, and Phoebe went into her bedroom. As she was shutting the door she glanced back into the living

Sally cried. "I'm sure I look a mess. My nose
[t]o a Belisha beacon when I cry. That's the
[w]ith being a redhead — one of the troubles."
's no need to be embarrassed. You've been
n awful experience."
ried into the bedroom and found a clean and
n handkerchief in one of the drawers in the
brought it back and gave it to Sally.
sed myself I wouldn't blubber," Sally said
nd now look at me, waking up the house!"
switch on a lamp — we can't keep
n the dark like this."
t, please. I'm tired, I want to sleep. Can I
kie?"
."
, loud snuffle Sally lay back and sank her
he pillow, sighing. Phoebe hovered over
ere was something more she should do,
re she should say. But what? She never
t thing to do at moments of crisis and
oil, and words seemed always to fail her.
ected, another of the ways in which she
ather. They were both cripples of a kind.
as not true, not of her, anyway. In her
ld sympathise, and when something
could put herself in another's place. It
e could not find the means to express
g, and that failure made her mute.
ng was calm now, and she was either
ding to be. Phoebe turned away and
m to the bedroom door and went

room and saw Sally standing in the light from the fire, pulling her jumper over her head. Her hair shone like coils of dark copper.

Phoebe knew she would not be able to sleep. She changed into her dressing-gown and sat on the bed with a pillow behind her back and tried to read — a novel, *Black Narcissus* — but she could not concentrate. Her mind was in a spin. The thought nagged at her that she had somehow let Jimmy down, although she could not think what things there might have been that she had not done for him. Anyway, that was not the point. The fault was not in actions taken or not taken, but in — what? If he had loved her, should she not have recognised it? Perhaps that was what her failure had been, a failure of attention, of — what was the word? — of empathy. The notion troubled her, but she had to acknowledge that she resented it, too. She had never done anything to make Jimmy love her — she had not encouraged him, had not "led him on", as Sister Aloysius used to say, screwing up her mouth in fierce disapproval so that the little brown hairs on her upper lip bristled like tiny antennae.

She put her book aside and switched off the lamp and lay on her back gazing up into the inky shadows. It seemed to her that through Jimmy and his terrible end she had incurred a debt without knowing it, a debt for which she could not feel she was responsible, and did not know how to discharge. Would it be with her all her life? Would her dead friend accompany her always, an

insistent ghost, dogging her steps in a soulful, accusing silence?

A sound came to her, sharp and piercing as a needle. What was it? She lifted herself on an elbow, straining to hear. A cat, down in the garden? Or was there a wireless on somewhere in the house? No. Someone was crying. She got up quickly and without turning on the light tiptoed to the bedroom door and opened it a little way, not making a sound, and put her ear to the crack and listened.

It was Sally who was crying.

Phoebe closed the door and stood in the dimness, listening to her heart beating. What was she to do? The girl out there was a stranger, met for the first time today. She was crying for the death of her brother. That was her right, and it was not for anyone to interfere with her sorrow. She started back towards the bed, but stopped, and again stood listening. Sally must have her face pressed into the pillow, but the sounds she made were high-pitched and thin, and would not be stifled. What was it about the sound of someone weeping, Phoebe wondered, that caused that urgent, pulsing sensation in the chest? Did men feel it, too, or was it a reflex confined to women, something left over from the firelit caves of prehistoric times? It was not to be resisted. She turned back, and went through into the living room.

The darkness was heavier here than in the bedroom — she had closed the heavy curtains earlier, and only the glow from the streetlamp outside penetrated them. She moved to the sofa. Sally had gone silent, like an

animal surprised in its lair. Whe
hand she misjudged the dist
touched the girl's hair, and it w
a gathered bundle of fine ele
whispered, "are you all right?"

Sally's dim form on the s
her face from the pillow and
sorry," she said, her voice bl

"No, no. I was awake. I
should have —"

"It's all right," Sally said
worry about me."

"Can I get you someth

Sally had lifted her kn
she pressed her forehead
know," she said.

For a second Phoeb
not understand. "What

"Twins. James and

"But you said he w

Sally gave a mourn
two minutes."

Now Phoebe knel
say before?"

"Oh, I don't kn
strange about. So
freaks, in a way.
snuffled. "I wond
where my handb

"Shall I put o

"No!"
turns int
trouble w

"There
through a

She hur
folded line
tallboy and

"I prom
ruefully. "A

"Let me
whispering

"No, don
keep the ha

"Of cours
With a las
head on to
her, feeling th
something m
knew the rig
emotional turn

It was, she sus
resembled her
Or, no, that w
heart she cou
affected her she
was just that sh
this fellow-feelin

Sally's breathi
asleep or preten
crossed the roo

through. She could still feel in the pads of her fingers the tingling afterglow of that shock she had experienced when she touched Sally's hair in the dark. It was going to be a long and sleepless night.

CHAPTER
FOURTEEN

Quirke woke in a panic. His blood was pounding in his ears and he felt he was suffocating. He lay on his back, panting and drenched with sweat, pressing his fists down hard on his heaving chest, like those new defibrillator paddles that were being used nowadays to deliver electric shocks to people suffering a heart-attack. This was not the usual morning onslaught of dread and dismay, this was something altogether different. It was as if a huge, malign creature had got hold of him and wrapped its immense arms around his ribs, squeezing the breath of life itself out of him.

He told himself to be calm, but the voice in his head that was telling him so seemed to belong not to him but to some disinterested other, someone who had been passing by and, seeing him in distress, had stopped to tend him, more out of curiosity than concern. He struggled to sit up. The sheet was a constricting tangle and he churned his legs, a fallen cyclist. He was in his vest and underpants. He felt at once ridiculous and horribly frightened. Rain was fingering the window and yet the sun was shining. Absurd season, he thought, and was immediately consoled a little: if he could complain

to himself about so banal a thing as the weather then surely he was not dying.

At last he freed himself from the bedclothes and stood up, then quickly sat down again, his head spinning. He shut his eyes but that made the dizziness worse. His hands were clutching the edge of the mattress. Everything seemed about to tip over, as if he were sitting on the deck of a foundering ship. Then, gradually, his brain righted itself and he stood up again, more cautiously this time. He went to the wardrobe and searched in the pockets of his jacket hanging there and found his cigarette case. He had always liked the smell of moth-balls. What was it they were made of? Camphor. Was that the word? He mumbled it aloud: "Camphor." It did not sound right; it sounded like a nonsense word.

He went back and sat on the side of the bed again and lit a cigarette. The smoke smelt like singed hair.

Isabel — where was Isabel? She had been here in the night and now she was gone. Then he remembered that she had left in the early hours, had called a taxi and gone home. It was tacitly understood between them that on these occasions she would not stay the night; Quirke liked his mornings to himself.

He went out to the living room. A parallelogram of insipid sunlight lay on the floor under the window like the parts of a broken kite. He stood and looked about him, feeling dazed. The morning's watercolour tints lent a novel sheen to familiar surfaces. Everything was as it always was, yet somehow he could recognise nothing. It was as if all that was formerly here had been

swept away in the night and replaced with a shiny new version of itself, identical in every aspect, yet one-dimensional and hollow, like props in a fantastically detailed stage setting.

He walked into the kitchen and saw Isabel sitting at the table in a haze of cigarette smoke, wearing a dark-blue dress and high heels, drinking a cup of coffee and smoking a cigarette. The silky stuff of her dress had a metallic glitter that hurt his eyes; he shut them for a second, and when he opened them again no one was there. *I'm seeing things*, he thought. The commonplace phrase, trite and harmless, had never before struck such fear into his heart.

He took extra care shaving that morning. His hand was steady enough, but that was more than could be said for his thoughts. A small fuzzy something lay at the centre of his consciousness, an unfocused point that seemed to be throbbing in time with his pulse. Everything around him had a discoloured look, the bathroom shelves, the shaving mirror, the porcelain sink — the very air in the room, as if a heavy gas had seeped out of the walls and spread itself everywhere. He knew from experience how certain dreams, weighty and disordered, could infect the waking world for hours, sometimes for days. But had he been dreaming? On the way from the bathroom he stopped in the kitchen doorway again and looked at the table where half an hour ago he could have sworn he had seen Isabel sitting, smiling at him. Everything about the scene had seemed solid, and real, even the incongruously formal outfit the phantom woman had been wearing.

186

What could they mean, these convincingly vivid hallucinations, first the old man at Trinity Manor and now Isabel — what did they signify?

He left the house and walked to the corner of Merrion Square. Sunlight glared on the wet pavements, though in the great trees the shadows of dawn still lingered. He hailed a taxi, and sat in the back seat, eyes fixed unseeing on the streets passing by. He felt as if he were made of an impossibly fine and breakable form of crystal.

Inspector Hackett, it seemed, had not been as careful as Quirke with the morning razor, and had cut himself. A piece of lavatory paper with a stain of dark blood at its centre was stuck to the side of his chin. He took his boots off his cluttered desk and stood up as Quirke was shown in. "There you are, Doctor!" he said brightly. "Isn't it a grand morning? Do you like the spring, the birdies singing, all that?"

Quirke did not bother to reply. The inspector pointed him to the only chair in the room other than his own, a spindly, hoop-backed affair that had seen better days. He sat down. Hackett had his jacket off and was in his shirt-sleeves, his braces on display. Quirke eyed that tie of his. It was broad and greasy, and had once been red but was now so old and ingrained with dirt that in patches it had settled into a shade somewhere between dark blue and shiny black. The knot had a soldered look to it, and obviously had not been untied in months — in years, perhaps — only yanked loose at the end of each day so that the tie could be lifted over Hackett's head and hung on the knob of the wardrobe door or on

a post at the end of the bed. Hackett's domestic arrangements were the subject of occasional idle speculation on Quirke's part. There was, for instance, the question of Mrs Hackett. She was rarely on public display; in fact, Quirke had never yet managed to get even a glimpse of her, so that she had taken on for him the trappings of a mythological figure, hazy and remote. All he knew about her for certain was that her name was May.

"That priest phoned me," he said now. "Honan — Father Mick."

Hackett widened his eyes. "Is that so?" He was sitting back in his swivel chair with his fingers interlaced over his belly. "What did he want?"

"A chat, he said. 'A bit of a chat'. I met him in Flynne's Hotel."

"Did you, indeed. And what did he have to say for himself?"

"Not much." Quirke was lighting a cigarette. "Well, a lot, in fact, but little of it of any consequence. He's a smooth customer."

"In what way?"

"A flatterer. Only simple folk are expected to swallow the pap that Mother Church spoons out for them, while you and he, being so much more sophisticated, know what's really what."

"Ah, yes," the detective said, amused. "I know the type. What about Jimmy Minor? Did he say he knew him?"

Quirke shook his head. "Claimed to know nothing about him, nothing at all."

188

"What about the letter Minor wrote? What about the request for an interview?"

"He said he'd heard there'd been some such letter. Implied Dangerfield had taken it on himself to ignore what was in it, and hadn't even shown it to him."

There was a pause.

"And did you believe him?" Hackett asked. He was scrabbling about in the pile of papers before him on the desk; Quirke knew it as a sign that he was thinking.

"It wasn't a matter of believing or disbelieving," Quirke said. "The Father Honans of this world don't deal in anything so obvious and clumsy as mere fact. All, according to him, is relative." He was thinking again of Isabel as he had seemed to see her this morning, sitting at the table in the kitchen in her blue dress, as vivid as life.

He tried to concentrate. His mind seemed to him suddenly a machine he did not know how to operate that yet had been thrust into his control; he was the passenger who had been called upon to land the aeroplane after the pilot had died. His head ached, and his pulse was beating in his ears again with unnatural intensity. "He's of the opinion," he said, making an effort, "that God doesn't bother Himself with us."

Hackett's eyes grew wide again, and he gave a faint whistle. "Is he now. I wonder is that what he tells them over in Sean McDermott Street when he's coaching young fellows to be boxers and making their daddies take the pledge." He fumbled again through his papers. "What's he like, anyway?"

"Fiftyish, red hair, in a suit and tie."

"In civvies, was he? That's interesting. I always wonder about priests who think they have to get themselves up in disguise."

"He was wearing white socks."

Hackett gave a throaty chuckle. "Ah, yes," he said. "By their socks shalt thou know them."

Through the small window behind Hackett's desk Quirke could see sunlight on chimney pots, and distant seagulls circling against piled-up clouds that were as white and opaque as ice. He knew this roofscape well, since he had sat here so often before, in this fusty office with the jumbled desk and the wind-up telephone, that out-of-date calendar hanging beside the door, the dried magenta smudge on the wall that was all that remained of a swatted fly. He looked again at the sky, those clouds. Every day he dealt with death and yet knew nothing about it, nothing. For a second he saw himself on the slab, a pallid sack of flesh, all that he had been come suddenly to nothingness.

Hackett threw himself forward and smacked both palms briskly on the desk. "Come on," he said. "We'll go out and take a stroll in this fine, fresh morning."

Pearse Street smelt of horse dung and recent rain. Behind the high wall of Trinity College the tops of sea-green trees sparkled in thin sunlight. Quirke had again that sensation of everything having been swept away in the night and deftly replaced with a new-minted version of itself. One push and that wall would fall back with a creak and a crash, the trees

190

would collapse, the sky slide down like a sheet of plate-glass.

They crossed Westmoreland Street and passed under the Ballast Office on to the quays. The river had the dull sheen of polished lead. Two young priests went by on bicycles, the bottoms of their trouser-legs neatly clipped. Gulls screeched, wheeling and diving.

"Did Jimmy Minor ever mention," Hackett asked, "a certain Packie Joyce, otherwise known as Packie the Pike?"

"Not in my hearing," Quirke said. "Why? Who is he?"

"Scrap-metal dealer, based out in Tallaght. Tinker, from God knows where. There's a whole gang of them, sons, daughters, wives, a brood of brats. For years the County Council has been trying to get them to move on, but Packie likes it there and refuses to budge. A hard man, by all accounts. Killed his brother, they say, in a fight over one of their women."

They walked over the hump of the Ha'penny Bridge, the wind coming up from the river and whipping at their coats. Hackett had to hold on to his hat.

"What's the connection to Jimmy Minor?" Quirke asked.

Hackett shrugged. "Don't know," he said. "Might be nothing." They turned along Ormond Quay. Quirke's heart had settled down, and he felt better. Perhaps Isabel had been right: perhaps he was just suffering an attack of nerves. A Guinness dray went past, the Clydesdale's big hoofs sounding a syncopated tattoo on the metalled roadway.

"The name turned up in notes in Minor's desk at the *Clarion*," Hackett said. He was picking his teeth with a matchstick.

"Notes on what?"

"Just names and things, contacts. Packie Joyce's name was underlined, with three big question marks after it."

"Signifying what?"

"Didn't I just say? — I don't know. But they're a fearsome crowd, the Joyces."

"Was Jimmy doing a story on them?"

"Could be," Hackett said. "Could be."

He veered off suddenly and crossed the road, ignoring a single-decker bus that parped its horn at him angrily. Quirke followed when the bus had passed. They went into the Ormond Hotel. Hackett took off his hat and wiped the band inside it with the tail of his tie.

In the deserted bar the wooden floor had been recently washed, and there was a watery odour in the air and a slick smell of soap suds. The morning look of the place, sweetly melancholy, warmed Quirke's already warming heart. Everything would be all right; everything would be fine.

An elderly curator in a long and dirty apron, rheum-eyed and stooped, came in by a far door. "Not serving yet, gents," he said, then looked more closely and recognised Hackett. "Ah, Inspector, 'tis yourself!"

"Morning, Jamesey," Hackett said. "We were passing by and to our surprise discovered we had a thirst. This is my friend and colleague Dr Quirke. He'll take a ball of malt, I'm sure, to cut the phlegm."

192

Jamesey hobbled across and peered out into the lobby, then shut the door and, returning, lifted the counter flap and went behind the bar. "You'll get me sacked yet, so you will," he said to Hackett, taking down glasses and uncorking a bottle of Jameson.

"Ah, now, Jamesey," Hackett said, and winked at Quirke, "don't say things like that — sure, what would they do without you?"

Jamesey set the drinks before them, but when Quirke took out his wallet to pay, the old man lifted a staying hand. "Hospitality of the house, and not a word," he said. "If I take your money I'm breaking the law of the land, a thing I'd never do."

"Good man," Hackett said, and lifted his glass. "Here's health and long life to us all."

Quirke drank, and reflected, not for the first time, that few things tasted so sweet and yet so dangerous as whiskey in the morning.

"So, what have we?" Quirke said, when Jamesey had gone off about his chores. "We have the priest, and this tinker. What's the connection?"

"Father Honan has done work among the travelling folk," Hackett said. "Maybe he came across Packie the Pike. That would be an ill-assorted pair."

"Was there anything else in Jimmy's notes?"

"Ordinary stuff, the usual. It was the name that caught my eye. Packie Joyce is well known to the forces of the law. Maybe it's with him we should be having a word."

Outside, a cloud shifted and sunlight bloomed damply on the frosted window. They could hear the

sound of traffic on the quay, and even, faintly, the voices of gulls. Quirke caught himself thinking how strange it was to be here; how strange to be anywhere.

Hackett was toying with his empty glass. "What do you think?" he said. "Will we risk another?" He called towards the door, "Jamesey!" then looked thoughtfully at his hat on the bar. "Aye," he said. "A word in the ear of Packie the Pike might be the thing, all right."

CHAPTER
FIFTEEN

Phoebe had slept badly and woke in the morning feeling fatigued and headachy. She got up and opened the curtains but then climbed back under the covers and pulled them over her head. She would telephone the shop and say she was sick. Mrs Cuffe-Wilkes would grumble, of course, but she did not care. She lay on her side with a hand under her cheek and looked out of the window, watching scraps of cloud scud across a china-blue sky. The wind must be high today.

She was restless, as if a storm were blowing through her, too, yet at the same time a strange torpidity of mind weighed on her. She was sharply aware of the presence of Sally Minor, sleeping in the next room. Or maybe she was not asleep: maybe she, too, was awake and watching the sky and feeling this same sense of hindered agitation. What must it be like for her, coming to consciousness each morning and remembering yet again her brother's death and the cruel circumstances in which he had died? Would grief for a brother be the same as grief for a parent, or for a lover? She did not think so. Yet who was she to say? She had no siblings to lose. She was not sure that she had a lover, either.

She realised that since she had woken she had been listening for sounds from the other room. Eventually they would both have to get up and begin coping with the day. What would they say to each other — what would they find to talk about? Would they have breakfast together? Phoebe was not sure that there was anything to eat. She was not very good at keeping house; she had no interest in it. She rarely ate more than one meal a day, and that she ate out, in the Country Shop if it was lunchtime or, at night, at that place in Baggot Street, on the other side of the bridge, where they served Italian food, or what passed for it, anyway . . . She caught herself up. She knew what she was doing: she was putting off the moment when she would have to face Sally. She should hop out of bed now and put on her dressing-gown and go out to the front room and say to her — what? What would she say? The very thought of Sally made her fingers tighten on the edge of the sheet as if it were the sail of a capsized boat and she had nothing else to cling on to.

In the end, however, it was all simple and perfectly natural. She had crept down to the bathroom — it was one flight down, on the return — and made herself lie in the tub for a quarter of an hour, and in the heat and the hazed air her mind had grown calm and her nerves had stopped twitching. What was there to be agitated about, after all? When she had dressed she went into the kitchen and Sally was there, sitting at the table by the window, hunched over a mug of tea. Her face was puffy from weeping, the shine of her hair was dulled, and there was a speck of sleep at the inner corner of her

196

left eye. She was just a girl after all, ordinary, and ordinarily vulnerable, and certainly not the momentous presence she had seemed when Phoebe had approached her in the darkness last night and touched the copper filaments of her hair and felt the electric current coursing through them.

"Good morning!" Phoebe said. "How are you? Did you get to sleep in the end?" Her tone sounded callously bright to her own ear, and she tried to amend it. "Would you like some breakfast?"

"Thanks," Sally said. "I'm not hungry."

"Oh, do have something."

Phoebe searched through the cupboards and the fridge, and was surprised to find that there was half a Procea loaf, nearly fresh, and milk and sugar, too, and even a pot of marmalade that she could not remember buying but that looked all right. She put all this on the table, but Sally only looked at it wanly and turned her face away. It was raining outside now, and the brownish light falling in at the window gave a grainy cast to her skin. "You should eat," Phoebe said. "Will I make some toast for you?"

Sally had been looking down into the street, and now she rose a little way from her chair and put her face closer to the glass. "Do you know that man?" she asked.

Phoebe went and stood beside her and looked where she was pointing. The man was standing on the other side of the street, by the railings above the towpath, under the dripping trees. He wore a sheepskin jacket and a cloth cap pulled low over his eyes. He was smoking a cigarette, cupped in the palm of his hand to

protect it from the rain. "I don't know who he is," Phoebe said. "He's just some man, I think. Why?"

"I don't know. He looked familiar. I thought I might have seen him somewhere before."

The man dropped the butt of his cigarette on the pavement and trod on it, then pulled up the fleece collar of his jacket and set his shoulders and walked off in the direction of Baggot Street. Sally craned sideways to watch him go. Then she sat back on her chair and sighed, and wrapped her hands around the mug to warm them. "I'm sorry," she said. "Since James died everyone I see seems to be acting suspiciously. It's just nerves, I suppose. Only . . ."

Phoebe sat down opposite her and leaned forward with her forearms on the table. "Only what?"

Sally shook her head, impatient with herself. "Oh, it's stupid, but I can't help wondering if James's death was something to do with the family, our family."

"How do you mean?"

"I don't know — I don't know what I mean. I suppose it's because James and I were, you know, twins, that I keep thinking" — she fixed wide eyes on Phoebe's — "that maybe I'm next."

Phoebe sat back with a sort of laugh. "Oh, but that's — that's absurd."

"Is it?" Sally said. "It seems absurd that anyone would have wanted to kill our James, but someone did."

She put down the mug and stood up and left the room, but a moment later returned, carrying her handbag. She sat down again and put the bag on the table. "I want to show you something," she said. She

opened the clasp and reached into the handbag and brought out a small, weighty thing wrapped in a red kerchief. She held it on her palm and looked hard into Phoebe's eyes. "This must be between you and me," she said. "Do you promise?"

"I promise, of course."

She began to draw back the corners of the kerchief, and on the instant Phoebe remembered, years before, when she was a little girl, being on a picnic somewhere with her parents — or the couple she had thought at the time were her parents — when her father had gone off and then come back and knelt on the rug they were having the picnic on and set down before her a handkerchief filled with wild strawberries, peeling the corners of the hankie back one by one, just as Sally was doing now.

The gun was small and ugly, with a broad, flat handle and a stubby barrel. The metal was scuffed and scratched and a piece had been chipped off the front sight. "It's called a Walther," Sally said, with a touch of pride in her voice. "It's German, a Walther PPK — see, it's engraved on the barrel. Godfrey gave it to me."

"Godfrey?" Phoebe was staring at the pistol.

"The old fellow who took me under his wing at the *Sketch* — remember? He said he pulled it out from under a German officer he had killed in the war. I didn't believe him, of course."

"But — but why have you got it?"

Sally picked up the little gun and held it on her palm again. "It looks harmless, doesn't it?" she said. "More like a toy."

"Do you know how to use it? Have you fired it?"

"Godfrey showed me how. He took me out to Epping Forest one day and let me fire it off at the squirrels. I couldn't hit a thing, of course. Godfrey said not to worry, it was really for close-up use — I liked that, *close-up use*. Afterwards we went to a pub and he tried to get me to agree to go to bed with him. He was an awful old brute, but he didn't seem to mind at all when I said no. I don't think he would have been able to do much, anyway, considering the way he drank. You should have seen his nose, a purple potato with pock-marks all over it. Poor old Godfrey."

Phoebe was still staring at the weapon. She could not take her eyes off it. She would have liked to pick it up, just to know what it felt like to hold a gun in her hand, yet at the same time the mere proximity of it made her shiver. It looked unreal — or, no, the opposite was the case: it was the most real presence in the room, and in its blunt matter-of-factness it made the objects around it, the tea mug, the loaf of bread, that pot of marmalade, seem childish and toy-like.

"Are there bullets in it?" Phoebe asked. "Is it loaded?"

"Of course," Sally said, and laughed. "It wouldn't be much use otherwise, would it?" She wrapped the pistol in its bandanna and stowed it in her bag. "I've no intention of ending up dead in the canal, like poor James," she said.

Phoebe stood up, and immediately felt dizzy and had to press her fingertips to the table to steady herself. "I'm going to phone my father," she said.

200

She rang his flat first but got no answer. Then she tried the hospital. The woman on the switchboard put her through to the pathology department. Quirke answered at once, as if he had been sitting by the telephone waiting for it to ring. He sounded guarded and tense and oddly distracted — she had to say her name twice before he registered it. She wondered if he had a hangover. She said she hoped she was not disturbing him. He was overtaken then by a fit of coughing — she imagined him leaning forward over his desk, his eyes bulging and his face turning blue. Drink and cigarettes would kill him in the end, she supposed. It shocked her not to be shocked at thinking such a thought. He asked her if everything was all right, but she could hear the rasp of impatience in his voice. Quirke had always disliked the telephone.

"There's someone here you should meet," Phoebe said.

"Who is it?"

She cupped her hand around the mouthpiece. "Jimmy's sister," she whispered.

There was a long moment of silence. "Jimmy Minor?" Quirke said, sounding almost suspicious. "I didn't know he had a sister."

"Neither did I." Again he was silent. "Meet us in the Shelbourne in half an hour," she said. "We'll be in the lounge."

She sensed him hesitating. "All right," he said at last. "I'll be there."

* * *

The air in grand hotels, dense, warm and woolly, always made Phoebe feel like a child again. Perhaps it was the nursery she was reminded of. The atmosphere in the lounge of the Shelbourne was particularly stuffy, with the mingled smells of coffee and women's perfume and wood smoke from the big fireplace at the far end of the room. When they entered, she noticed Sally, at her side, hanging back a little — surely she was not intimidated by the place? Phoebe had been coming here all her life and was used to the calculated opulence of the carpets and the heavy silk curtains, the gilt mirrors, the antique silverware, and those forbidding brown-and-black portraits leaning out from the flocked walls.

They were shown to a table in the bay of one of the high windows. On the other side of the street the trees behind the railings of St Stephen's Green thrashed in the wind and great grey spills of rain skidded along the pavement. Sally sat very straight in the broad armchair, perched on the outer edge of it, her hands clasped in her lap and her handbag on the floor by her feet. Phoebe thought of the gun in there, wrapped in its rag. It was almost funny to think of a visitor to the tea lounge in the Shelbourne Hotel armed with a loaded pistol.

Quirke was late, of course. They went ahead and ordered: tea and biscuits and a selection of sandwiches. Phoebe asked about life in London and Sally said how much she liked it there, for all the crowding and the bustle and the rudeness of bus drivers and people on the Tube. As Phoebe listened to this account of life in

202

the big city she had the impression of being ever so slightly patronised.

"But don't you sometimes consider coming back?" she asked. "To live, I mean, permanently."

"No!" Sally said, with a surprised little laugh. "I told you, my life is in London now. There's nothing for me here."

"But if you were to marry —?"

"I'll never marry."

The sharp certainty of it was startling. Phoebe was curious and would have tried to explore the topic further, but Sally's expression, blank and unyielding, stopped her.

Their tea arrived, borne to the table with a flourish on a big, gleaming silver tray. The waitress smiled at them. She was a plump girl with pink cheeks and fair hair tied back in a neat bun. Phoebe asked for a jug of hot water. "Certainly, miss," the waitress said, sketching a kind of curtsy. Phoebe thought again of the pistol in Sally's handbag and smiled to herself. She glanced about the room, at the people at the other tables. If only they knew!

She was pouring a second cup of tea for them both when Quirke arrived. When the introductions were done he pulled up an armchair and sat down. He had not taken off his overcoat, as if to signal that he did not intend to stay for long. He wore corduroy trousers and a bulky pullover and his shirt collar was open. It was strange to see him without a tie and his accustomed funereal black suit. Had he gone to work dressed like that? Then she remembered: it was Saturday. The

casual clothes gave him a faintly desperate air, as if he had been woken from a troubled sleep and had leaped up in a panic and thrown on the first garments that had come to hand. More and more these days he allowed himself to look dishevelled like this.

"I'm sorry about your brother," he said to Sally.

Sally looked down, then raised her eyes again. "Did you know him?"

"I met him," Quirke said. "And of course I read him in the papers. But I wouldn't say I knew him. He was a good reporter."

"Was he?"

It was a question not a challenge, yet Phoebe saw that it took Quirke by surprise. He blinked a couple of times and his eyes seemed to swell, as they always did when he was startled or at a loss. "Yes," he said, "I think he was. He had courage, and he was persistent."

"The *Clarion* ran a big story about him," Phoebe said, turning to Sally. "There was even an editorial, saying no one on the paper would rest until his killers were tracked down."

"Yes, I read that," Sally said. "I wondered how they could be sure there was more than one killer."

"No one is sure of anything," Quirke said. "That's the trouble. There's no apparent motive that we know of, and no clues." He paused. "Did Jimmy talk to you about his work?"

"Sometimes. When he wrote to me it was usually about generalities, about his life outside the office and the things he was doing, but" — she glanced at Phoebe — "he used to phone me from work sometimes, late at

204

night, and then he'd often talk about what he was working on."

Quirke nodded. Phoebe noticed that he was sweating. Yet he did not seem to be hung-over. She wondered if it was something to do with Isabel. This thought cast a small shadow over her mind. She was fond of Isabel, but she was not sure how she would feel if Quirke and she were to marry. But, no, no, it was not possible: Quirke, like Sally, would never marry.

"Are you going to have something?" she asked him now. "This tea is cold, but I could order a fresh pot."

He looked at her, frowning, as if she had posed a difficult conundrum and he was trying to solve it. "I'll have coffee," he said at last. She could see, however, that coffee was not what he really wanted. She signalled to the waitress.

Quirke was leaning forward tensely in his chair with his hands clasped before him. He looked, Phoebe thought, like a man on the verge of collapse, barely managing to hold himself together. Should she be worried about him? This was something new in her experience of him. She had seen him drunk and she had seen him in the aftermath of drunkenness; she had seen him in a hospital bed, bruised all over from a beating; she had seen his hands shaking as he confessed to her the truth of who her real parents were; but she had never known him to be in quite this kind of nervous distress. What was the matter?

He had turned to Sally again. "Did Jimmy ever talk about the people he was writing stories on? Did he mention names?"

"Well, yes," Sally said. "Sometimes he did."

"What about a Father Honan, Father Michael Honan? — Father Mick, as he's known. Do you remember that name?"

Sally shook her head. "No, I don't think so."

"Or Packie Joyce? — Packie the Pike Joyce."

"He sounds like a tinker — is he?"

"Yes. Deals in scrap metal. His name was in Jimmy's notebook."

Sally glanced at Phoebe, then turned to Quirke again. "James — sorry, that's what the family calls him — he did talk about tinkers, the last couple of times he phoned me. He was working on a story about them, I believe."

"What sort of story?"

"I don't know." She glanced again in Phoebe's direction. "He said it was something big. But then —" she drew down the corners of her mouth in a rueful, upside-down smile "— James's stories were always big, according to him."

"But he mentioned no names."

"No. He said he'd been to a campsite somewhere."

"Tallaght?"

She frowned in the effort of recollection. "Maybe that was what he said. I'm sorry, I can't remember. It was always late when he phoned — once or twice I fell asleep while he was talking."

The waitress brought Quirke's coffee. He drank some of it and made the same wincing face that he did when he took a first sip from a whiskey glass. "Are you

all right?" Phoebe asked him, trying not to sound overly concerned.

"Yes, yes, I'm fine," he said, with a trace of impatience. She noted that he did not meet her eye.

Sally excused herself and stood up and set off towards the Ladies, but then stopped and came back; throwing Phoebe a quick, conspiratorial look, she picked up her handbag and took it with her. When she had gone, Phoebe leaned forward and peered at Quirke closely. "Are you *sure* you're all right?" she asked.

Still he avoided her eye. "Of course I am," he said brusquely. "Why do you ask?"

"You look — I don't know. Were you drinking last night?"

He shook his head. Phoebe smiled — how boyish her father looked when he lied. "I had a bad night," he said, passing a hand over his face. "I didn't sleep well." He took up his coffee cup again. There was, she saw, a tremor in his hand. "How did she —" he jerked a thumb in the direction of the Ladies "— how did she contact you?"

Phoebe laughed. "She followed me."

"She what?"

"I kept having the feeling there was someone behind me, watching me, and then one day she overtook me in Baggot Street and we began to talk. She works in England, in London. She's a reporter, like Jimmy."

"Why was she following you?"

"Jimmy had talked to her about me and she wanted to see what I was like." She paused. "She's afraid, I think."

"Afraid of what?"

"She doesn't say. I think *she* thinks she's being followed."

"Who by?"

"I don't know. *She* doesn't know."

"Then why —?"

"Oh, Quirke," Phoebe said — she never called him anything but Quirke — "you're so literal-minded! Her brother was murdered and no one has the faintest idea who did it — why wouldn't she be nervous? Why wouldn't she imagine she was being followed?"

Quirke sat and gazed at her stonily, thinking. She could almost hear his mind turning over, like a car engine on a winter's morning. "Do you think she's told us everything she knows?" he asked.

"Yes," Phoebe said stoutly, with more conviction than she felt. Should she tell him about the pistol? "She's very straight — straight as a die."

Sally came back and sat down again. Quirke smiled at her, though Phoebe saw what an effort it cost him.

"Have you any idea," he said to Sally, "who might have wanted to harm your brother? Any idea at all?"

Sally shook her head slowly. "No," she said, "no, I haven't. You see, I didn't know much about James's life, the things he did, the people he knew and went around with — if there were people he went about with. He was always a loner."

"But you say he wrote to you regularly, that you talked to each other on the phone. He told you about Phoebe — weren't there others he mentioned?"

Sally looked aside, smiling her upside-down smile. "You have to understand, Dr Quirke, James lived so much in a world of his own invention. You knew him, you said —"

"I met him — I didn't say I knew him."

"Even so, if you knew anything about him you'd know how he — well, how he exaggerated. There was a side of him that was always a little boy who loved the movies. It was one of the things that made him so lovable."

Her eyes glistened. Frowning, Quirke glanced towards Phoebe, then turned back to Sally. "You realise," he said, "we may never find out who killed your brother?"

Sally looked at him. The light in her eyes had turned cold, and there was no sign of tears now. "*I'll* find out," she said. "I won't rest until I do."

Phoebe gazed at her, wondering at the sudden hardness in her voice, at that icy light in her eye. It occurred to her that she might have misjudged Sally Minor. She thought yet again of the hidden pistol wrapped in its red rag, and this time there was nothing amusing about it.

"Miss Minor —" Quirke began, but the girl interrupted him.

"Call me Sally, please," she said. "I always think 'Miss Minor' sounds like the name of a car." She smiled, though something brittle remained in her look.

Quirke nodded. "All right — Sally." He paused. "The police have a hard time of it, in this city," he said. "You know how it is — the authorities are not trusted, it's

part of our colonial heritage. People by instinct won't talk to the guards, and so —"

Sally interrupted him again. "You don't think I'm holding something back, do you?" she said, her smile growing all the more brittle.

A faint flush appeared on Quirke's brow. "No, of course not," he said, in a thickened voice. "I just thought there might be something you're not aware of, that you haven't thought of. Phoebe —" he glanced towards his daughter "— Phoebe says you have the feeling someone might be following you."

Phoebe frowned at him but he ignored her. Sally looked down, and fingered the clasp of her handbag. "I'm sure I'm just imagining it. I suppose I was frightened, when I heard of James's death —"

"How did you hear?" Quirke asked.

Sally made a small grimace. "My brother phoned me — I mean Patrick. He had that much decency, at least." The subject of her family was obviously an embarrassment to her, and she blushed. But was she blushing, Phoebe wondered, or was she angry?

"It must have been a great shock," Quirke said.

Sally gave a doleful shrug. "My hands were shaking for days afterwards," she said. Then she looked up. "But I'm not afraid now, Dr Quirke."

"I'm glad to hear it," Quirke said.

"Oh, I am afraid, in a way. It's frightening not to know what happened to James, and why."

"And you wonder," Quirke said, "if you're in danger too?"

Sally turned to Phoebe. "Do you think we could have some more tea?" She smiled apologetically. "I'm thirsty all of a sudden."

"Would you like something stronger?" Quirke asked. He turned about in his chair and caught the waitress's eye. "What will you have?" he said, turning to Sally again. "A sherry, maybe?"

"No, no," she said. "Tea will be perfect."

The waitress came, and Quirke asked her to bring another pot of tea, and added, conscious of Phoebe's eye on him, that he would have a glass of wine. Phoebe smiled at him grimly, lifting an eyebrow, but he would not look at her. At least, she thought, he had not asked for whiskey.

"What about that thing in the paper?" Sally asked. "That splash in the *Clarion?* Did the couple come forward, the couple who found James's body?"

"I'm afraid," Quirke said, "that was just the *Clarion* making noise, as usual."

"But what about the couple?"

"There was no mystery about them. They gave their details to the guards on the night that Jimmy's body was found. They knew nothing, they only happened on the — on the body."

Quirke was watching the waitress making her way towards them, bearing a tray with their tea and his glass of wine. She handed him the glass and he took it in both hands, almost reverently, and set it on the table. Phoebe tried not to let him see her watching him. His little rituals always fascinated her, fascinated and appalled her, but most of all they made her feel sorry

for him. Poor Quirke, he was so transparent. He sat there, making himself not look at the glass, and she counted off the half-dozen beats before he picked it up, trying to seem nonchalant, and failing. He took a long sip, followed by a grimace and a quick drawing in of breath. He set the glass down on the table again and cleared his throat.

"Do you think you might be in danger?" he said to Sally.

Phoebe poured the tea, while Sally watched her. A gust of rain clattered against the window above them, and something outside, an awning, perhaps, flapped in the wind and made a noise like distant thunder.

"My brother," Sally said slowly, still with her eyes on Phoebe's hands distributing the cups, "my brother used to be involved with — he used to be involved with a bad crowd."

"You mean Jimmy?" Quirke asked, sounding puzzled.

"No, no, my other brother — Patrick."

"Ah, yes. I met him. A bad crowd, you say?" He looked doubtful.

"Yes," Sally said, and hesitated. "Well, you know what it's like, up there on the border."

Quirke frowned. "Do you mean the IRA?"

"Yes," Sally said, and nodded, pressing her lips tightly together, and for a second Quirke had a vivid memory of her mother, standing in his office that day, with her son's body laid out on the slab in the next room, her mouth small and wrinkled. "It was a long time ago," Sally said, "and he was young." She laughed.

"You wouldn't think it, would you, seeing Patrick now, that he was ever young?"

Quirke dipped his head and took another quick go from his glass, as if, Phoebe thought, he imagined that if he did it quickly enough no one would notice. "Did he . . ." he hesitated ". . . did he take part? I mean, was he active?"

"No," Sally said, "I'm sure he wasn't."

Phoebe was looking from one of them to the other. "The IRA?" she said to Sally. "Are you joking?" She turned to Quirke. "They're not — they're not serious, are they? I mean, the IRA is just a bunch of hotheads, aren't they? Crackpots and hotheads?"

"Well, *they* take themselves seriously," Quirke said mildly.

"I used to think they were a joke," Sally said quietly, "until they blew up a Customs post a few miles from where we lived. One of their own men died in the explosion — he's held up as a martyr in the locality, now. But it gave our Patrick the fright he needed, and before we knew it he had packed himself off to Dublin to study for the law." She laughed coldly. "And now he's a thoroughly respectable pillar of the community."

"I remember that bombing," Quirke said, "but it's a long time ago now. Do you really think Jimmy's death might have been in some way —?"

"No," Sally said, "I'm sure it wasn't. Only, when something as dreadful as that happens, you imagine all sorts of things —" she turned to Phoebe "— don't you?"

"I'm sure it's true," Phoebe said. Yes, it was true: she knew from experience that it was.

Sally turned back to Quirke. "What about this priest you mentioned?" she said. "Have the guards talked to him?"

"No," Quirke said, "but he talked to me."

Phoebe was startled. "How did that come about?" she asked.

"He phoned me up. We met in Flynne's Hotel."

This time it was Sally who spoke. "And?" she asked.

"And nothing. He said he knew nothing about Jimmy, had never met him or spoken to him."

"And what about the other one, the tinker, what's-his-name?"

"Packie Joyce? A detective I know is going out to Tallaght to talk to him. He's asked me to come along."

His wine glass was empty. He turned again in his chair, lifting a hand to summon the waitress.

The rainstorm was thrilling. In Baggot Street the trees shivered and shook like racehorses waiting for the off, and fresh green leaves torn from their boughs whipped in wild flight down the middle of the road or plastered themselves to the pavements as if hiding their faces in terror. The two young women had to fight their way along, the gale ripping at their clothes and handfuls of rain spattering in their faces. When they tried to speak the wind filled up their mouths, and they had to turn and walk backwards with their arms linked, leaning close against each other so that their temples almost touched.

Sally thanked Phoebe for introducing her to her father and remarked on how good-looking he was. Phoebe did not reply to this. Yes, it was true, she supposed, Quirke was handsome; it was a thing she did not notice any more. For some time, though, when she still believed he was her uncle, she had been soft on him. It was silly, of course, and would have been even if he had not turned out to be her father. To recall now how she had felt for him in those days made her suddenly frightened, as if she were poised on the very tip of some aerial, intricate structure, the Eiffel Tower, say, or one of the arms of some great bridge, and the force of the feeling surprised her, and shocked her, too. She began to ask herself, as she had done so often in the past, how Quirke could have left her in ignorance for all those years, how he could have been so cold-hearted, but then she stopped. It was no good asking such questions. The past was the past.

They reached the house on Herbert Place in a flurry of wind and raindrops, and ran up the stairs and burst into the flat, laughing breathlessly and shaking the rain from their hair. "My feet are sopping!" Sally cried happily. "Your floor will be ruined."

They kicked off their shoes and struggled out of their wet coats, and Phoebe knelt and lit the gas fire, then said she would make something hot for them to drink, tea or coffee, or spiced lemonade, maybe, and went off into the kitchen. When after a little while she came back, carrying a tray with a jug and two glasses on, Sally was standing in rippling rain-light by the side of the window, looking down into the street. Her mood

had changed, had darkened. She was frowning, and gnawing at the side of her thumb.

"What's the matter?" Phoebe asked.

Sally started, and turned to her with a strange look, wild and distracted, then made the effort to smile. "I was thinking about James," she said, "thrown into the water, like some poor beast." She looked down into the street again. "Who could be so cruel?"

"I made us some hot lemonade," Phoebe said, conscious of how feeble it sounded. "I put cloves and honey in it. Come and sit by the fire and get warm."

Sally seemed not to have heard her. The rain-light made her face into a silver mask, solemn and burnished. "I feel so strange, just to think of it," she said. "And yet I can't let it go. I have to know what happened — I have to find out."

Phoebe went and set the tray on a low table by the fireplace and sat down on the rug there, folding her legs under her. After a moment Sally came and joined her. "I'm sorry," Sally said. "You're probably tired of hearing me going on and on like this."

"Of course I'm not," Phoebe said, pouring the lemonade into the glasses from a glass jug. "Jimmy was my friend."

They sipped their steaming drinks. "It's funny," Sally said, "how you all call him Jimmy. When he was at home he would never let anyone call him anything but James. He said it was bad enough being so small without having to be called by a little boy's name."

"I don't think I ever heard anyone calling him James, before I met you."

Sally was watching the soft blue flames playing over the ashy filaments of the gas fire. "I suppose he wanted to be someone else, up here." She smiled. "I think he was a bit ashamed of the rest of us, so boring and ordinary. 'Little people,' he used to say, 'that's what we are — little people.' He had such dreams, such ambitions. 'You'll see, sister mine, you'll see what I make of myself, some day.' "

She shifted her legs under her, making herself more comfortable. The spiced drink had given a glow to her cheeks, and the light of the fire set a reflected gleam in her eyes. "When I first went off to London he wouldn't speak to me, you know — wouldn't write, didn't telephone, nothing. I was annoyed, annoyed and hurt, thinking he had taken my brother's side against me. Then, after a month or so, a long letter arrived from him out of the blue, telling me all the news and asking me how I was liking London. I think he had been jealous of me, at first, and angry at me for being the one who had got away, out of Ireland altogether, while he was stuck here. That was supposed to have been him. He was the one who was supposed to be living in London and working in Fleet Street. But poor James, he couldn't hold a grudge for long. In that first letter he wrote I could read between the lines how envious he was of me, though he wasn't cross any more."

The rain was heavier now, and beat like sea-spray against the window. Sally sighed. "It's cosy, here," she said. "I feel protected." She smiled at Phoebe. "Thanks for taking me in. To tell you the truth, I hated that hotel, and was getting ready to go back to London,

until you spoke to me in the street. I knew straight off we'd be friends."

To Phoebe's surprise she felt sudden tears pricking her eyes, and only with an effort did she manage to hold them back. It was strange, to be so moved, to suffer such a sudden rush of tenderness, and for a moment she felt dizzy again.

"Has it occurred to you, Sally," she heard herself say, "that what my father said might be true, that you may never find out what exactly happened to Jimmy — to James?"

Sally frowned. "Do you think it's true?"

"Things happen here that never get explained, never get accounted for," Phoebe said. "Ask my father, he can tell you."

Now Sally laughed. "Don't forget, I grew up here — I know what this place is like, the secretiveness, the hidden things." Phoebe said nothing, and they looked away from each other. After a silence Sally said, "But they wouldn't — Dr Quirke, the guards — they wouldn't let James — I mean, they wouldn't let his death go unsolved, would they? Your father wouldn't let that happen — I know he wouldn't."

Again Phoebe was silent. Sally's words seemed to jangle for a moment in the air between them.

Sally took a sip from her glass. "This is lovely," she said. "Lovely and spicy, and warm."

"Yes," Phoebe said. "My mother used to make it for me, when I was little. The woman I thought was my mother, that is." Sally looked at her enquiringly and she shrugged. "Oh, it's complicated," she said.

218

"Yes, but tell me."

"My mother died when I was born, and my father — my father gave me away, to his brother, Malachy, his adoptive brother, really, and Malachy's wife, my father's sister-in-law." A small knot had formed between Sally's eyebrows, and Phoebe smiled sympathetically. "I told you it was complicated. My father and Malachy Griffin married two sisters. My father married Delia, who died, and Mal married Sarah, who brought me up."

"Sarah?" Sally said. "That's my name, you know."

"Yes," Phoebe said, lowering her eyes. "I thought it must be."

"No one calls me by it, of course."

"I could, if you like."

A silence fell between them.

"I thought they were my real parents, Sarah and Malachy," Phoebe said, "until — until my father told me the truth."

"When did he tell you?"

"When I was nineteen." Phoebe lowered her eyes and picked a loose fibre from the rug they were sitting on. "It doesn't matter, now. It was a shock at first, of course."

"But why . . .?"

Sally's voice trailed off and Phoebe looked at her, with a melancholy smile. "Why did Quirke give me away? I've never asked him."

"But —"

"There'd be no point. He wouldn't know the answer."

Sally nodded slowly. "And so you've forgiven him."

"Forgiven him?" Phoebe raised her eyebrows; it was as if the notion of forgiveness, of the necessity for forgiveness, had not occurred to her before. "I suppose I have. My father — Quirke, I mean — he's not — he's not like other people, you see."

"In what way?"

"I sometimes think he never really grew up. He's obsessed with the past — he was an orphan, and part of him is still that orphan. He has this look sometimes, I know it well, sort of furtive, and puzzled, as if there's a little boy hiding inside him and looking out through adult eyes at the world, trying to understand it, and failing." She stopped, and smiled, and bit her lip. "The fact is, I don't know my father, not really, and I doubt I ever will."

Sally, nursing the glass between both hands, was frowning into the flames of the fire. "It's all so — it's all so sad," she said.

"Oh, no," Phoebe said quickly. "I don't think of it as sad. He did tell me, in the end, he did confess the truth. Now I know who I am, more or less. That was something he gave to me, something that he doesn't have himself, something that no one can tell him. I have to think that's a mark of generosity —" she laughed "— or of something like it, anyway."

The storm had intensified and the wind was hurling big splashes of rain against the windows. They might have been in a boat ploughing through sea-spray. "It's so nice, here," Sally said. "You're lucky."

"Where do you live, in London?" Phoebe asked.

Sally pulled a face. "Kilburn," she said. "I have a room over a greengrocer's. The shopkeeper is Indian, with a little roly-poly wife and a dozen or so kids who fight all day and cry throughout the night." She looked about appreciatively. "I love the big windows here, and the high ceilings."

"Is the sofa very uncomfortable, to sleep on?"

"Oh, no," Sally said. "It's fine."

It was uncanny, Phoebe reflected, how little of herself Sally had imposed on the room. In the morning when Phoebe came out from her bedroom Sally had cleared away every sign of her having slept there, the bedclothes and the pillow folded away behind the sofa and the cushions straightened and the window open at the top to clear the night's staleness. In the bathroom, too, she kept her things all packed away in her vanity bag, including her toothbrush and toothpaste — Phoebe suspected she even had her own soap and kept that tidied away too when she was not using it. It really was a pity that Sally did not have a job in Dublin. They could get a bigger place, maybe, and live together; Sally would be the perfect flat-mate. And, indeed, Sally herself must have been thinking something the same, for now she said, "If I did come back, this is the kind of place I'd like to live in." She smiled. "No screaming kids, and no smell of curry all day long."

"But you said you wouldn't come back, that there's nothing here for you."

Sally looked into her glass; it was empty, but still she nursed it between her palms. "Oh, I know," she said, "but there *are* times when I think about it — coming

back, I mean, coming home. London is so big, so — so impersonal. Someone could murder me in that little room and I wouldn't be found for days — weeks, maybe." She laughed. "The smell of Mrs Patel's cooking would cover up anything."

Sally frowned. The word *murder* had fallen between them like a heavy stone. "Strange," she said meditatively, "how you can forget even the most terrible things for a while. I keep thinking James is alive, that the phone will ring and I'll pick it up and hear him say, 'Hi, sis,' the way he always did, with that silly American accent he liked to put on. Then I remember that he's gone, that he'll never phone me again, and I'm shocked at myself for having forgotten, even if only for a little while." She paused, and when she spoke again her voice was low and soft, as if it were coming from a long way off. "I dream about him, you know, every night. I dream we're children again, playing together. Last night we were in a meadow I remember from when we were small. There were always buttercups in it, in summer, and then, later, there would be dandelion clocks. We used to blow the fluff off of the dandelions, and the number of breaths it took to get rid of them all was supposed to tell you what hour of the day it was. Silly . . ."

A furious gust of wind made the window boom in its frame, and a fistful of rain rattled against the panes.

"Here," Phoebe said, "give me your glass."

She had risen to her knees, and discovered now, too late, that her left leg had gone to sleep, and as she reached out for the glass she felt herself beginning to

topple over. Sally, realising what was happening, put out a hand to steady her, but Phoebe kept falling sideways awkwardly, and suddenly they found themselves in a sort of embrace, Sally with her back arched and Phoebe leaning heavily against her. Their faces were very close together; they could each feel the warmth of the other's breath.

Later, Phoebe could not remember if it was she who had kissed Sally or if Sally had kissed her. Their lips met so lightly, so fleetingly, that it might have happened by accident. But it was not an accident. At once they drew back, and both of them began to speak at the same time, and stopped, flustered and half laughing. Then something happened in the air between them. It was as if lightning had struck. They were not laughing at all now. Slowly they leaned forward again, and again their lips met, deliberately this time, drily, warmly, exerting a soft, tentative pressure. Phoebe was aware of her heart beating, of the blood pulsing in her veins. They had both kept their eyes open, gazing at each other in surprised, wordless enquiry. Then they disengaged, and Phoebe sat back on her heels. Sally's face was below hers, tilted upwards; there was a faint flush on her cheeks and forehead and her umber eyes were lustrously damp.

"I'm sorry," Phoebe said. "I don't . . ." Words failed her. She did not know what it was she had begun to say. It seemed to her all at once that she knew nothing, and that, gloriously, there was nothing she needed to know.

Sally was shaking her head. "No no," she said, her voice congested, "there's no need . . ." But she too fell silent.

They looked away from each other in a sort of giddy desperation. Phoebe's heart was making an awful dull thudding, so loud that she thought Sally must be able to hear it. She struggled to her feet, shedding involuntary little moans of distress — that ridiculous leg of hers had pins-and-needles in it now — and limped off to the kitchen and stood at the window there with a hand to her mouth, gazing out unseeing at the rain. She was trembling all over, though not violently; she imagined this must be how a tuning-fork would feel when it had been softly struck. She realised she was listening intently and almost fearfully for any sound from the other room. She did not know what she would do if Sally were to follow her out here. What would they say to each other? What would they do? She had never kissed a girl before, never in her life; nor had she felt the urge to, so far as she knew. She caught her lower lip between her teeth. *So far as she knew* — what did that mean?

Still she strained to listen, but still there was no sound from the living room, or from anywhere else — the world seemed to have fallen into a shocked silence. She imagined Sally still sitting as she had left her, on the rug, with her legs folded under her, as confused and full of wonderment as she was.

What was she to do? What was she to think?

Maybe Sally would leave; maybe she would fetch her vanity bag and pack her things into her suitcase and

224

hurry from the flat and out of the house, without a word of goodbye, and be gone. At the thought, Phoebe felt something inside her drop suddenly, like something falling soundlessly in a vacuum.

She looked down. In one hand she was holding the lemonade glass, while the other was locked into itself in a fist, white-knuckled, quivering. The rain at the window seemed to be trying to say something to her, a slurred, secret phrase. Her heart was still struggling in her breast like a trapped animal. She turned up her clenched fist and opened it slowly. Pressed into an indent in her palm was what at first she took to be a small white pill with holes pierced through its centre. She gazed at it in bewilderment. Then she realised what it was. It was not a pill, but a button, a button she must have ripped from Sally's blouse.

They sat opposite each other at the kitchen table and talked for what seemed an age, holding themselves very straight, with their fists set down in front of them on the table, as if they were engaged in some contest, some trial of skill and endurance. Afterwards Phoebe would not be able to recall a single thing they had said; all she knew for certain was that the kiss had not been mentioned. How could it have been? For some things there were no words, she knew that. What she did remember was the urgency in their voices, or in her voice, anyway, the excitement, and the fear. She thought she had never known such a jumble of emotions before. There had been crushes at school, of course, but they had meant nothing. She recalled too

the night one Christmastime in that pub — Neary's, was it, or Searsons? — when a narrow-faced woman with thin lips painted crimson had kept staring at her and at closing time had come up to her and offered her a lift home, which she had refused. That was the extent of her experience of — what was she to call it? She did not know. Whatever it was that had occurred between her and Sally as they had sat on the rug in front of the gas fire was a new thing in Phoebe's life, unexpected, unlooked-for and frightening, but also, although she was not yet prepared to admit it, exciting, too — oh, exciting beyond words.

On they talked, on and on, with Sally smoking cigarette after cigarette, and gradually the sky outside cleared and the sun came out, angling sharp spikes of light down into the street. Sally said, in a very casual-seeming tone, she would get her things together and leave — she would go back to the Belmont — but Phoebe would not hear of such a thing. "I won't let you go," she said, though of course it did not come out as she had meant it to, and she felt herself blushing. "I mean," she added hastily, "there's no need for you to go, and anyway, the Belmont is a dreadful place. I won't think of you going back there."

"You've been very kind," Sally said, the words sounding stilted and formal. "But I feel I should go and leave you to get back to normal."

"Oh, no," Phoebe said quickly, and it sounded in her own ears like a wail, "you're welcome to stay as long as you like. I'm — I'm glad of your company. Honestly, I am," she added, almost in desperation.

226

"I know," Sally said. "And I'm glad to be here. But . . ."

In the silence that followed this exchange they had to look away from each other, clearing their throats. Phoebe knew that Sally was right, that she should leave the flat and go back to the hotel, but she knew too that she did not want her to go, not yet, not with everything unresolved between them. But how was anything to be resolved? The fact of that kiss, speak of it or not as they might, was a taut silken cord, invisible but all too tangible, by which they were held fast to each other now. Phoebe knew, and she wondered if Sally knew it too, that they should snap the cord at once, this moment, without delay. But would they?

Sally was gazing pensively into the street. "Everything is so confused," she said, in a far-away voice. "I feel — I don't know what I feel. Strange. Lost. When James — Jimmy, I mean, I may as well call him that, since everyone else does — when Jimmy died part of me died, too. That sounds like something someone would say in the movies, I know, but it's true. You can't imagine what it's like, being a twin. You're never just yourself, there's always an extra part, or a part missing. I can't explain. You know when people have an arm or a leg amputated they say they can still feel it, this phantom limb, that sometimes they can even feel pain in it? That's how I am, now. Whoever killed Jimmy killed a bit of me, too, but the bit that's dead is still there, somehow."

Phoebe wanted to take Sally's hand in hers, to hold it tightly, yet she knew she must not, must absolutely not.

She stood up from the table; it was a relief to be on her feet. "Let's go out and get some things for lunch," she said.

Sally shook her head. "I'm not hungry."

"You will be," Phoebe said. "Come on, we can go to the Q and L."

"The Q and L? What's that?"

"It's my local grocer's. Wait till you see Mr Q and L, in his check suit and his canary waistcoat. He looks the image of Mr Toad."

"Is that his name?" Sally said incredulously. "Queue-and-ell?"

"Of course not. That's the name of the shop. I don't know what he's called. He's sort of mad. Don't be surprised if he serenades you with a bit of opera, or does a pirouette."

Sally stood up. "Well," she said, "he certainly sounds different from my Mr Patel."

"Mr Patel doesn't sing or do ballet steps?"

"No. I'm afraid Mr Patel is a grouch."

They smiled at each other. Was it getting easier? Were they beginning to relax? It was as if, Phoebe thought, they had been walking for a long time at the very edge of a steep precipice, with the wind pulling at them, trying to drag them over, and now they had at last stepped away from the brink, and she felt shaky with relief but also with a faint regret for the danger that had passed.

They put on their coats and walked up to Baggot Street. The sun made puddles of molten gold on the rain-wet pavements, and above them small white puffs

228

of cloud were gliding across the sky, like upside-down toy sail-boats. Phoebe would have liked to link her arm in Sally's but knew she could not. Was this how it would be from now on, with even the most innocent token of friendship become suddenly suspect?

At the shop they bought a wedge of Cheddar cheese and slices of cooked ham and a bag of small hard Dutch tomatoes, two apples and some green grapes, and a packet of Kimberley biscuits. The shopkeeper, sleek-haired and fat, today wore a tweed hunting jacket and a waistcoat of hunting-pink instead of his accustomed canary-yellow one. While he served them he hummed under his breath the Slaves' Chorus from *Aida*, and when he handed them their change he did brief, sinuous passes with his hands, like an Oriental dancer, and said *thanky-voo*, as he always did, pursing his lips and opening wide his big round feminine eyes. The two young women dared not look at each other, and when they came out into the street they burst into laughter and had to stop, their shoulders shaking. "You're right," Sally said, in a muffled, delighted scream. "He's *exactly* like Mr Toad!" And, laughing, they leaned towards each other until their foreheads touched, and for a moment it was as if that kiss in front of the gas fire had never happened, or as if, having happened, it might happen again, but this time with the greatest simplicity and ease.

When they got back to the flat Phoebe opened the door to let Sally go inside, then excused herself and went back down the stairs to the bathroom on the return, and locked the door behind her. Sally's r

little valise was there, under the shelf by the bath. Phoebe knelt quickly and undid the clasps, and took from a pocket of her dress the little bone-coloured button she had somehow ripped from Sally's blouse, and dropped it inside the valise, and did up the clasps again and put the valise back in its place under the shelf. She stood up. Her knees were unsteady. She turned to go, then stopped, and stood in front of the mirror on the window-sill for a long time, gazing into her own eyes.

CHAPTER
SIXTEEN

On Monday morning Detective Sergeant Jenkins drove Quirke and Inspector Hackett in the squad car to Tallaght. Quirke had forgotten how far out it was, by the long straight road from the city. When they got there, they might have been arriving at a village in the deep heart of the country, rather than an outer suburb of the metropolis. It was early still and the main street had a sleepy look to it. All around were the soft low hills that vaingloriously called themselves mountains, their sheep-flecked slopes aglow with April's damp and dappled greenness. Quirke viewed the picturesqueness of it all with a cold eye. Being in the open like this, exposed in the midst of so much countryside, made him feel uneasy: he was a city man, and preferred his horizons bounded. Hackett, on the other hand, seemed in his element, and was in high good spirits. This, Quirke reflected gloomily, was another of the many ways in which he and the detective differed.

On the way out, as they rolled along with the low hedges flying past and the big car swaying on its springs, Hackett reminisced aloud about Packie Joyce, wild Packie the Pike, dealer in metals, tinker chieftain and unstoppable begetter of children — it was said he

had fathered as many as twenty-five or thirty offspring on a much put-upon wife, now deceased, and two or three of her red-headed sisters. "One time I got up the nerve to ask him why in the name of God did he have so many babbies," Hackett said. "'Listen here to me now,' Packie said, looming over me with that big mad head of his. 'When you're lying in the cold in one of them draughty caravans on a winter's night, I'm telling you, it's either fuck or freeze.'" Quirke, sitting beside Hackett in the rear, caught Jenkins's startled eye in the driving mirror; Inspector Hackett rarely swore, and was a famous frowner on bad language. "Oh, aye," he said now, chuckling, "he's some boyo, the same Packie — you'll see."

They were not sure where the Joyces' campsite was, and had to stop at the village post office while Jenkins went inside to ask for directions. Hackett sat with his knees splayed and his palms resting on his thighs and looked out with lively interest upon a scene quick with the tremors of spring. Cloud-shadows were pouring across the far hillsides. Quirke watched the detective sidelong and supposed he was thinking of the days of his youth in the windy Midlands. Hackett would always be a countryman.

Jenkins was gone a long time but at last returned and got in behind the wheel. "Well," Hackett asked the back of the young man's head, "did you find out the way?"

"Oh, I did," Jenkins said, and produced a sound that it took the two men in the back a moment to identify as a short low laugh. "It seems Mr Joyce is a well-known figure in these parts, all right. I had to listen for a good

232

five minutes to the postmistress's views on him and his tribe."

"A certain degree of disapproval, I imagine," Hackett said, and Jenkins once again laughed.

They reached the outskirts of the village and hesitated briefly at a crossroads. Jenkins extended his neck tortoise-like out of his collar and swivelled his head this way and that, and then turned on to an unpaved boreen. Ahead of them they saw a great pillar of rapidly rolling blackish-brown smoke. "That will be the ensign of the Joyces, I don't doubt," Hackett said drily. "They're awful fond of the fires."

They made slow progress, for the narrow little road had many twists and turns and many a deep and spring-tormenting pot-hole. Jenkins manoeuvred the big car with judicious caution. There were primroses in the hedges, and the hawthorn was in leaf already, and over the sound of the engine they could hear the shrill piping of blackbirds and even the robins' thinner calls. "Haven't they the life, all the same, the tinkers," Hackett said wistfully, "out in the good air, under God's clear sky?" He turned a teasing eye on Quirke. "Wouldn't you say, Doctor?"

"The average tinker's life expectancy is twenty-nine years," Quirke said, "and the death rate among their newborn is one in three."

Hackett sighed but seemed untroubled. "Oh, I don't doubt it," he said. "A good life but a short one, then."

Quirke said no more. He was not in a mood for Hackett's raillery; but, then, he reflected, was he ever?

233

He had woken that morning feeling dizzy again, and had lain on his back in a tangle of damp sheets for some minutes watching the light fixture in the ceiling above him; it seemed to be jerking repeatedly from right to left, like the same miniature racing car shooting again and again past the winning-flag. When at last he got up, putting one explorative foot after the other gingerly to the floor, he thought he would fall over from light-headedness. He had often suffered vertigo on mornings following drinking bouts, but that was a different sensation, more an annoyance than anything else, a thing to be endured until it wore off, as it inevitably did; that was just ordinary giddiness, and not frightening, like this new kind. He went into the kitchen in his pyjamas and sat at the table in the cold, drinking cup after cup of bitter black coffee and smoking a chain of cigarettes. At first the coffee made the dizziness worse, then better, and the nicotine calmed his nerves. Yet it could not be ignored or pushed aside any longer. Something was the matter with him; something was amiss.

Was he ill? There had been the hallucinations, accompanied by a general feeling of vague physical distress, and now, this morning, there was this new kind of vertigo. After his experience at Trinity Manor, when he had imagined talking to the old man in the kitchen, he had gone over it all again and again in his mind, trying to understand it, to account for it. But could a damaged mind examine its own processes, and if it could, how were its findings to be trusted? Everything might be an hallucination.

What he felt was not so much fear as a kind of wonderment, tinged with rancour. Why him, why now? — the usual, vain protests. Could he not come up with anything better, anything that might actually help? He padded barefoot into the living room, keeping close to the walls for fear of falling over, and made a telephone call to his adoptive brother. Malachy himself answered, sounding wary as always. Quirke asked if he could come round, saying there was something he wanted to ask Mal's advice on. Malachy began to reply but someone spoke behind him — it sounded to Quirke like the voice of Malachy's wife Rose — and Malachy put his hand over the receiver. Quirke waited, hearing himself breathe; telephones, like mirrors, contain inside them another version of the world. Then Malachy spoke again, saying that he would be in that evening, if the matter could wait until then. "Thanks, Mal," Quirke said. "I'll see you later." Even the sound of Malachy's voice was some sort of comfort. Help was at hand, it seemed to say; there would be help, even for such a one as Quirke the reprobate. Good old Mal, good old dull, dependable Malachy.

Hackett was speaking again. Quirke turned to him, trying to concentrate. "What?" he said. "Sorry, my mind was . . ." *My mind is decaying, Hackett. It's crumbling, it's falling asunder.*

"I was saying," Hackett said, pointing ahead, "there's the man himself, in all his glory."

They were approaching the camp site, a long, straggling field that tilted down to a meandering stream with whins and thorn bushes along its banks. The place

had the look of a battlefield after a prolonged and relentless engagement between two mechanised armies. Rusted hulks of motorcars lay about in attitudes of abandonment, most of them sunk to the axles in mud, windscreens smashed and bonnets gaping like the jaws of crocodiles, and there were torn-out engine boxes and mounds of tyreless car wheels, and car doors that had been wrenched from their hinges and thrown one on top of another in beetling stacks. There were bundles of steel girders, rusted like everything else, and coils of steel cable so thick and heavy it would have taken two or three men to lift them. Old electric cookers stood at inebriate angles, and half a dozen scarred and pitted bathtubs were ranged upended in a broad ring on the trodden grass, a bizarrely hieratic and solemn arrangement, reminiscent of a prehistoric stone circle.

In the midst of all this, on a low hillock, a great fire of car and tractor tyres was throwing up giant spear-heads of black-edged flame and dense belchings of greasy black-and-tan smoke. Tending the inferno were a troupe of ragged, stunted children, under the direction of an enormous hulk of a man — built, Quirke observed to himself, on the proportions of an American refrigerator — with a shock of oily hair as black as the blackest of the smoke from the fire. This was, unmistakably, Packie the Pike. The scene was archaic and thrilling, and dismaying, too, in its violence and volatility. "Christ," Quirke said, under his breath, "add music and it's a scene out of Wagner."

Hackett gave a histrionic start. "Whoa!" he cried. "Did I hear someone speak?"

236

Quirke glowered at him. "What?"

"I thought you'd lost the power of speech, you'd gone that quiet."

Quirke turned away and looked out through the window beside him. Those hills seemed closer in, somehow, a stealthily tightening ring.

They entered the encampment by a gateless gateway and the car bumped forward over the grassy ground, Jenkins clutching the juddering steering-wheel like a sea-captain wrestling a trawler through a sudden squall. "Stop here," Hackett said, when they were still a good way short of the fire and its capering, dwarf attendants. "We don't want the heat of them flames getting at the petrol tank and blowing us all to kingdom come."

When Jenkins applied the brakes the big car slewed on the sodden ground. Hackett and Quirke got out, and Hackett glanced at Quirke's handmade shoes. "You're hardly shod for this terrain, Doctor," he said, with undisguised amusement.

Packie the Pike had been watching them from the corner of his eye and he came towards them now, wiping the back of a hand across his mouth. In the other hand he grasped a long metal rod with a sort of hook at the top, which he had been using as a makeshift giant poker, prodding the hooked end among the burning tyres and making them vent angry geysers of flame. He wore what must once have been a respectable pin-striped suit, and a soiled white shirt, the collar of which was open on an abundance of greying chest-hair. His great long coffin-shaped face was blackened from the smoke and gleaming with sweat, and through the

eyeholes of this wild mask a pair of stone-grey bloodshot eyes glared out, ashine with what seemed a transcendent light. These eyes, and the scorched face and the staff with its crook, gave him the look of an Old Testament prophet lurching in from the desert after many days of solitary communing with a tyrannical and vengeful God. "By Jesus," he called out jovially, in a hoarse but booming voice, peering at the detective, "is it the Hacker? — is it the man himself?"

Inspector Hackett went forward and took the big man's hand and shook it. "Good day to you, Packie," he said. "How are you?"

"Oh, shaking the devil by the tail," the tinker declared. He had to shout to make himself heard above the roar and sizzle of the fire.

"Are you well in yourself?" Hackett asked.

"I am indeed — sure, amn't I the picture of health?"

Hackett looked beyond him to the fire, where the children had ceased their tending and stood staring in wide-eyed silence at the two strangers and the car behind them with Jenkins sitting at the wheel. "That's some blaze you have going there," the detective said.

"It is that," the tinker agreed.

"And what's it for, may I ask?"

"Ah, sure, we're just rendering the old wire, like."

This meant, as Hackett would later explain to Quirke, that Packie and his band of fiery sprites were burning rubber-encased electric cable to melt the copper wire inside, which they would harvest from the ashes tomorrow, when the fire had gone out and the embers had cooled. It was a lucrative business, for the

238

price of copper was still high, more than a decade after the end of the war.

Now it was Packie's turn to look past the inspector to where Quirke stood a little way back with his hat pulled low over his left eye and his hands thrust deep in the pockets of his overcoat. "This is Dr Quirke," Hackett said.

Quirke came forward, and Packie squinted at him, measuring him up. Neither man offered a handshake. Hackett looked from one of them to the other, with a faint smile.

"Come on, anyway," Packie said, addressing Hackett, "come on and have a sup to drink, for I've a thirst on me that would drain the Shannon river."

He turned to the children standing about the fire and shouted something, not a word of which Quirke recognised, a harsh, growling command, and at once the children bestirred themselves and went back busily to tending the fire. Packie, shaking his head, addressed Quirke this time. "Them *gatrins*," he said, jerking a thumb over his shoulder, "have my heart scalded, for they won't work, no more than they'll do their learning."

He led the way across the hummocky ground towards a straggle of wooden caravans drawn up in an untidy circle. Off to the side, a herd of horses, stocky, short of leg and fierce of aspect, were cropping the scant grass; as the three men approached, a number of these animals looked up, without much interest, flicked a white tail or a mane the colour of woodbine blossom, and went back to their grazing. The caravans,

cylinder-shaped, had a window at the back and at the front two smaller, square windows on either side of a varnished half-door. The rounded roofs were sealed with matt black tar, but the two wooden end walls were decorated with swirls of glossy paint — scarlet, canary-yellow, cerulean blue. At the largest one of them, Packie halted and banged on the door with his iron staff. He turned to the two men and winked. "You'd never know what state the *mull* might be in," he said, in a stage whisper, grinning, "putting on her inside wearables or trailing around in none at all!"

There were scuffling sounds inside the caravan, then the soft thump of bare feet on the wooden floor. The half-door was drawn open at the top and a woman put her head out of the dimness within and peered suspiciously first at Inspector Hackett and then, more lingeringly, at Quirke. She had a narrow face, with freckled milk-pale skin, and a great mane of hair, black and shiny as a raven's wing, which she raised a hand to now and swept back from her forehead. She wore a white blouse with mother-of-pearl buttons, and a necklace of tiny, unevenly sized pearls. Her eyes were of a flint-green shade, the lids delicate as rose petals. Quirke thought of some wild creature, a she-fox, perhaps, or a rare species of wild cat, lithe and sleek and indolently watchful.

Packie Joyce spoke to the woman, and she said something back. This exchange too Quirke could not understand. The woman drew in her head, and a moment later appeared again, with a shawl of faded tartan draped over one shoulder. She opened the

240

bottom half of the door and leaped down lightly to the ground. She wore a loose red skirt, and was barefoot, with black dirt lodged under her toenails. Behind her, a second figure appeared in the doorway, a girl of twelve or thirteen, ethereally pale and thin, in a dirty, sleeveless grey dress that was too big for her, and that hung on her crookedly, like a sack. The woman turned and spoke to her sharply, and she descended listlessly from the caravan, keeping her eyes downcast. Her lank, ash-coloured hair was braided in a long, polished plait at the back. There was a suppurating cold-sore on her lip. The woman put an arm around her shoulders and, ignoring Hackett, gave Quirke a last and seemingly scathing glance and sauntered off, tossing that long train of night-black hair behind her. The child too looked back at him, and something in her eyes made him almost shiver. They seemed to him eyes that had seen many things, things a child should not see.

The other caravans in the circle seemed to be empty, or if they were not their inhabitants were unnaturally quiet. Perhaps they had witnessed the strangers arriving and had withdrawn into hiding, out of which they were watching now, silent and unseen. Under one of the caravans Quirke spied a dog, a strange feral-looking beast with narrow flanks and a wolf's sharp muzzle. It had captured something — what was it, a rabbit, or a cat, even? — and had it pinned to the ground on its back and was devouring its innards, stabbing those wedge-shaped jaws into the torn-open stomach and pulling out long, glistening strings of purplish gut and gobbets of plum-coloured inner organs. The creature

that was being eaten, whatever it was, seemed, impossibly, to be alive still, for its up-flung limbs waved helplessly and its black paws twitched. Quirke looked away. Hackett had turned to him with an enquiring glance, but he only shook his head.

Packie Joyce had pushed open the lower half of the caravan door, and now he put up two hands and grasped the door jambs at either side and, with surprising agility for a man of such bulk, hoisted himself up and in through the doorway. He turned back and threw down an old tin bucket. "Step on that, lads," he said. "I'd not want you to break a limb and be sending the sheriff out to haul me before a court of law on a charge of criminal neglect."

Quirke, moving forward, could not resist a glance back at the ravening dog. Bewilderingly, it was different now, was no longer wolf-like, in fact it was merely, as he saw, a half-starved whippet or a stunted greyhound, and what it was gnawing at was not another animal but only a bone, meatless and streaked with mud. Feeling Quirke's eye on it the dog cringed away, moving backwards and dragging the bone along with it. Quirke passed a hand over his face. He could feel himself beginning to sweat.

Hackett set the bucket upturned on the ground and clambered on to it, with difficulty — Quirke had to give him a push in the small of the back; getting him up and through the doorway was like trying to stuff a pillow into a too-small pillowcase — then Quirke followed, grunting from the effort.

Inside, the caravan was unexpectedly spacious, even though the three of them, Packie the Pike especially, could only stand upright at a stoop. There were two long, low beds, one on each side, hardly wider than benches, with a small wooden cupboard set between them. Inside the door, on the right-hand side, there was a pot-bellied stove with a crooked and slightly comical tin chimney sticking up through a hole in the roof. Under the lid of the cupboard was a panel of wood that could be pulled out to make a sort of table, and Packie pulled it out now, and bade his two visitors to sit.

They sat down on the beds, facing each other, their knees almost touching. A vague image, the merest wisp, stirred in the furthest reaches of Quirke's memory. He seemed to see himself as a child of four or five, playing house together with a little girl of the same age, she pretending to be Mammy and pouring imaginary tea for him out of a jam jar. The memory, if memory it was, startled and unsettled him. Where in the wilderness of his lost and solitary childhood could he have taken part in such a game? Again he put up a hand and this time briefly covered his eyes. He had once more that sense of having split into two, of being himself and at the same time some other, alien to himself and yet somehow not unknown.

Packie the Pike knelt on one knee and rummaged inside the cupboard and brought out a milk bottle stoppered tightly with a wadded twist of paper. "You'll have a *sringan*, lads, aye?" Packie said, holding up the bottle. It was three-quarters full of a clear, silvery and slightly clouded stuff.

Quirke eyed the bottle, passing the tip of his tongue over his lower lip. Oh, yes, yes indeed, he would have a drink. The liquor in the bottle was the same colour as the light coming in at the windows at either end of the caravan.

Packie delved again in the cupboard and this time brought out three small, bulbous glasses with thick rims and set them on the makeshift table. In fact, as Quirke quickly saw, they were not glasses, but glass jars of the kind that potted meat came in, adapted to a new use. Packie poured a generous measure from the milk bottle into each of them, and handed one to Hackett, and another to Quirke. Hackett held the liquor aloft and peered at it with a narrowed eye. "Is this what I think it is, Mr Joyce?" he asked.

Packie looked down at him in wide-eyed innocence, a huge, jovial and dangerous man smelling of burned rubber and immemorial dirt. "This," he said, "I call the Honey of the West. It was sent to me by a cousin of mine in Connemara, the Jinnet Joyce, a fine upstanding man and a great distiller of the potato."

"You know it's against the law to be in possession of illicit liquor," Hackett said.

"Wisha, man, don't take the good out of it! You're on my territory now. Let's have none of that old talk about what's legal and what's not. Drink up now and don't be shy."

Quirke drank. The poteen washed against the back of his palate, a liquid flame. The taste, or lack of it, reminded him of surgical spirit, a clandestine nip or two of which he would take sometimes of a morning

244

when the tasks and trials of the day ahead seemed particularly daunting. He felt straight away the alcohol sliding into his veins; it was like the welcome return of an old and happily disreputable friend.

Hackett set his drink down on the table and smacked his lips. "That's fine stuff, right enough, I'll give you that, Packie," he said. "Of course" — he shot Packie a meaning look — "I'm only sampling it in the line of duty, you understand, and before I go I might have to enquire after the exact whereabouts of your cousin in Connemara."

Packie gave a great laugh, the wattles at his throat wobbling. But it was not a laugh, not really, only a noise the big man made, and those sharp grey eyes of his were watchful as ever.

Hackett regarded him, smiling. "Speaking of illegal acts," he said, in an affable tone, "did you hear tell of a raid the other night on that ESB warehouse over at Poulaphouca?"

"ESB?" Packie said, with an exaggerated frown. "What's that when it's at home?"

"The ESB, Packie, is the Electricity Supply Board, as you well know, and it had God knows how many miles of best copper cable stored over there at the Poulaphouca generating station, until some bright sparks broke in on Thursday night and made off with the lot. I suppose you wouldn't know anything about that?"

Packie shook his head sorrowfully and turned to appeal to Quirke. "Isn't the Hacker here a fierce suspicious hoor?" he said. He smiled benignly at the

detective, yet for a moment it seemed to Quirke that the tiny space into which the three of them were crowded had grown narrower still. "Is that why you're out here today, now, is it, Mr Policeman?" Packie said, his voice suddenly grown soft. "To be accusing me of being a *sramala* and robbing the state of its valuables?"

Hackett smiled back at him. "No, indeed, Packie," he said blandly, "that's not why I'm here."

Packie nodded slowly, narrowing again his wolfish grey eyes. He was still standing at a stoop, and now he lowered the backs of his thighs against the rim of the cold stove and seemed to relax, giving a soft sigh.

Quirke had finished his drink and glanced again in the direction of the milk bottle. He was aware that anything might happen here, that any kind of violence might break out at any moment, for Packie the Pike was plainly a dangerous man. He did not care. He wanted another drink. Hackett seemed perfectly at his ease, sitting there in his big overcoat with his hands resting on his fat thighs and his hat on the bed beside him. Quirke was speculating, as so often, as to what might be going through the detective's mind. Perhaps nothing was happening in there, behind that forehead marked with a thin pink crescent made by the seam of his hatband; perhaps at moments such as this Hackett functioned entirely by instinct. Quirke wondered how that would be. As for himself, it seemed to him he had no instincts, or not the kind that the detective would operate by; everything Quirke did, so he felt, was predetermined by laws laid down he did not know when, or how, or by what agency. He was a mystery to

himself, now more than ever, in this new and terrifying mental confusion that had befallen him.

The tinker leaned forward and grasped the milk bottle by the neck and filled up again the three little glass pots.

"Tell me, Packie," Hackett said, revolving his glass on its base, "do you know of a young fellow by the name of Minor — Jimmy Minor?"

Packie, leaning back once more against the stove, did not look at him. "Minor?" he said, and made a show of reflecting deeply. "Who would he be?"

"He *was* a reporter," Hackett said. "For the newspapers."

The tinker was looking into his drink. "Why would I know him?"

"What I'm asking is *if* you knew him."

There was a silence. Quirke watched the detective. Hackett, he reflected, was like one of those jungle predators that go slack and still at the approach of their quarry. Perhaps that was what it took to be an investigator, that capacity to wait in watchful calm, patiently.

Packie the Pike sucked his teeth. "What would a newspaper man be doing out here?" he said.

Hackett turned his gaze to the rounded ceiling. "Well, he might, for instance, have been asking after a certain cleric whom I'm sure you do know."

Packie glinted at him. "What cleric?"

"Father Michael Honan — Father Mick. You do know him, now, Packie, don't you?"

Packie scowled, and said nothing, and looked away again.

Quirke brought out his cigarette case, clicked it open and offered it flat on the palm of his hand to the tinker. Packie took two cigarettes, clipping one of them behind his ear. Leaning down to the flame of Quirke's lighter he gave Quirke a merrily conspiratorial glance, and winked. The lighter's petrol smell blended with the big man's stink and Quirke felt his nostrils constrict. In his mind he saw again the phantom dog under the caravan rootling in the guts of its splayed and twitching victim. Malachy — he would go to see Malachy this evening, yes, yes, he would. Malachy would help him. He had a sensation of falling, slowly falling, inside himself.

There was a sound outside and a face appeared at one of the little square windows behind Packie's shoulder, a young man's face; it was there for a moment and then was as quickly gone as it had come. Quirke did not know if Hackett had seen it.

"What do you say, Packie?" Hackett said. "Tell us, now, did the newspaper chap come out here to ask about Father Mick?"

Packie gave a sort of growl deep in his throat. "I have no dealings with the *cunyas*," he said.

"*Cuinne?*" Hackett murmured, cocking his head to one side. "That's a word I don't know, Packie."

"The *cunyas* — the priests!" Packie said. "Them are for the women to be dealing with, and the *gatrins*. The *cunyas* do be always on about sending the young ones to school, when they're not cajoling the women to tell them their *shakos*."

"*Shakos?*" Hackett said, elaborately frowning. "That's another one I never heard of."

"Their sins," Packie said, with a dismissive shrug.

"God, Packie," Hackett said, "we're getting a great education here today." He turned to Quirke. "Isn't that so, Doctor? Words you never knew before."

The tinker glanced towards Quirke with a sardonic eye. "The Hacker here," he said, "thinks he's a great speaker of the Cant — that's our talk, you know, our own lingo." He turned back to the detective. "The *cunyas* love to hear the women telling their sins. It gives them a rise, so I hear, and sure who'd begrudge them, the poor hoors, with their yokes lashed tight to the inside of their leg to keep them from doing harm." Again he threw up his head and gave the hooting laugh that was not a laugh.

Hackett put the glass pot on the table and picked up his hat, seeming about to depart. He stopped, however, and raised a hand to his forehead, acting the part of a man suddenly struck by a thought. "Did I mention, by the way, Packie," he said, "that Minor, the newspaper chap, got himself killed — murdered, in fact?"

Again Quirke seemed to feel the curved walls around them drawing inwards sharply. The poteen had set up a buzzing in his head that was distracting in a faintly euphoric way — he was getting drunk, in other words, and was glad of it. He looked about. He had finished his cigarette and did not know what to do with the butt. He wondered, with vague inconsequence, where the woman kept her things, her clothes, and so on — under one of the beds, maybe? How did they live, these

people? He realised he knew nothing about them or their ways. Maybe the woman did not keep her clothes here; maybe there was another caravan, for sleeping in, and dressing in. He thought of the dark glance she had cast at him, of her shining black mane of hair, of the careless slouch of her hips. He thought too of the child's glance out of those wounded eyes. They knew something, those two, and he wondered what it was. He swallowed more poteen. His temples were tightening and his cheeks had taken on the glassy sensation that drink always brought.

Packie was still leaning against the pot-bellied stove, gazing with studied interest at the little glass jar he was holding in his fingers.

"You know Father Mick is going away, do you, Packie?" Hackett said. "They're sending him off to Africa, to convert the Hottentots." He paused. "He'll be a great loss to your people, I'd say."

"I told you," the tinker said, "I have no truck with them fellows."

"Ah, but Father Mick isn't like the rest of them, now, is he?"

Packie gave him a sullen look. "The priests is the priests."

"I won't deny that," Hackett said, turning the brim of his hat in his fingers. "Does he come out here often, Father Mick?"

"He don't come out at all, any more," Packie said. He lifted the glass jar to his lips and emptied it. "He's not welcome here," he said. "We don't need him or his like."

250

Hackett smiled wistfully. "So the women have no one to tell their sins to, any more?"

The tinker banged the glass pot down on the little table and glared at the detective, thrusting his great shaggy head forward, his stony eyes widening. Quirke felt a surge of blood in his throat. He wanted something to happen, he realised, wanted violence, sudden lunges, the sound of fists on flesh. He thought: *I would like someone to die.*

Hackett made no move. His hat was still in his hands, and he was still calmly smiling, looking up at the tinker who was towering over him, enraged and glaring. "What did you say was the word for a sin?" he said. "*Shako*, was it? I must remember that. Yes — a handy word to know."

He stood up from the bed, a short, pudgy man with a few wisps of black hair combed across his balding pate and a frog's wide slash of a mouth. Suddenly Packie the Pike laughed again, and leaned back, the bulging muscles of his neck relaxing. "You're a fierce man, Hacker," he said. "A fierce man."

Hackett smiled, those bloodless lips wider and thinner than ever. "No fiercer than yourself, Packie," he said quietly. He looked at the tinker in silence for a moment, smiling. "You wouldn't be lying to me, now, would you? For as you know —" his smile softened, the outer corners of his eyes wrinkling "— I'm not a man to be lied to."

They stood a moment, the detective and the tinker, regarding each other. Quirke felt again that rush of anticipation in his throat. What would he do, if Packie

were to launch himself at the detective? He pictured the three of them locked together in a grunting struggle, the caravan rolling and pitching, the stove's crooked chimney toppling and the windows shattering. He grinned to himself blearily.

After a moment Packie smiled, showing a mouthful of big crooked teeth the colour of old and stained ivory. "Ah, sure, now, wouldn't I know better than to be lying to you, Hacker, my old *sreentul?*" he said.

The inspector nodded sceptically. "Of course, Packie," he said. "I know you're the soul of honesty."

He turned, and ducked through the half-door and stepped down by the upturned bucket to the ground. Quirke made to follow him but the tinker put a hand on his arm. "What class of a doctor are you, anyhow?" he asked.

"Pathologist," Quirke said, his thickened tongue giving him a slight lisp. "Corpses." For a second he saw again Jimmy Minor lying on the trolley, the bruised face, the weals on his chest and flanks, the mangled pulp at his crotch.

Packie the Pike chuckled. "Begod," he said, "the Hacker brings his own sawbones around with him, do he? That's a good one."

Outside, a watery sun was shining but it had begun to rain, fat, glistening drops falling at an angle and smacking against the side of the caravan. Hackett, wearing his hat, was halfway to the car already. Quirke, glancing about quickly in search of the black-haired woman, spied two young men sitting in the front seat of one of the wrecked cars, smoking cigarettes and

watching him through the glassless windscreen. One of them, a raw-faced boy of sixteen or seventeen, was the one who had looked briefly in at the little window behind Packie's shoulder. He had greasy black curls and a snub nose and a mouth-breather's sagging lower lip. The other one was older, in his mid-twenties, swarthy as a flamenco dancer, with a face as sharp as an axe-blade. They watched him impassively as he went by, following in Hackett's wake.

Jenkins started up the car and the exhaust pipe burbled a bubble of ash-blue smoke. The far hills crouched, getting ready to spring. Quirke turned up the collar of his overcoat. He glanced back once at the two young men, watching him, then opened the rear door and climbed in beside Hackett.

As they drove back towards the city Hackett sat in silence, drumming his fingers on the armrest beside him.

"So," Quirke said, "what do you think? Was he lying?" He widened his eyes and blinked, trying to keep the world in focus. He had not drunk enough poteen to account for this fuzziness. He put the palm of his hand against his forehead, cupping it tenderly. His poor head; his poor brain.

Hackett went on gazing out of the window. "Was Packie lying?" he said. "Oh, he was lying, all right."

"About Jimmy Minor?"

The detective laughed softly. "About everything."

CHAPTER
SEVENTEEN

David Sinclair, stepping ahead of Phoebe through the doorway of the flat, paused and went very still, his face settling into a blank mask. Phoebe thought, not for the first time, how uncanny it was, the way he could control himself, showing hardly a sign of what he was thinking, what he was feeling. Weren't Jewish people supposed to be emotional and demonstrative?

He did not often call on her unannounced, but this evening — this evening of all evenings! — he had just appeared at the front door with his hands in the pockets of his overcoat and his collar turned up. When he rang the bell she had gone down to let him in, and as they were coming up the stairs she had tried to think how to tell him about Sally being in the flat, but somehow there seemed no way of saying it that would sound natural. Now, of course, David was surprised to see this stranger standing in front of the fireplace, applying her lipstick in the mirror over the mantelpiece. He would assume Sally was a friend of Phoebe's who had called in, for he would have no way of knowing who she was, much less that she was staying here; what would he say when he found out the true circumstances? David did not like surprises. He had

been away for the weekend, visiting his aunt in Cork. Sometimes Phoebe wondered about this aunt, if she really existed and were not a convenient invention. But where had he been, if not in Cork? She had no reason to be suspicious, and yet she was.

Phoebe stepped past him in the doorway, arranging a smile as she did so. "Sally, this is David Sinclair," she said, with a brightness that sounded fake even to her. "David, Sally Minor — Jimmy's sister."

Sally turned from the fireplace as David advanced, and the two shook hands. Sally knew who he was, for Phoebe had told Sally about him. But Sally's knowing about David was all the more reason for Phoebe to have told David about Sally. She began to feel slightly sick. It was teatime and she and Sally had been getting ready to go to the Country Shop. Why had David not telephoned to say he was on his way to the flat? He rarely did anything unannounced or unplanned for. She did not dare to look at him directly — had she felt his attention sharpen at the way in which she had said Sally's name? She told herself she was being ridiculous. What had she to feel guilty about? A kiss? She was no longer sure it had really happened, that she had not imagined it.

This was Sally's third day at the flat. On the previous day, Sunday, Phoebe had said there was someone she had to visit — "My aunt," she had said, taking her inspiration from David, "she's quite ill, I go to see her every Sunday." Of course there was no aunt, but the prospect of spending the long, idle day alone with Sally had frightened her. So she had taken herself off to the

Phoenix Park — it was the only place she could think of — and had spent a miserable afternoon trailing around the zoo, gazing blankly at the animals in their cages and being gazed back at with matching indifference. That evening Sally, perhaps sensing Phoebe's nervousness, had gone to the pictures on her own and had not come back until after midnight, by which time Phoebe had made sure to be in bed.

"Actually," she said to David now, "we were just going out."

She could feel him looking at her with a darkly quizzical eye. "May I come along?" he asked.

"Of course," she said. "I'll just get my coat."

She hurried into the bedroom. She knew she should not have left the two of them alone together. They were strangers: they would be desperate to think of something to say to each other. She glanced around the room in a panic. Everything her eye fell on had a suggestive aspect, the big ugly bed, her slippers beside it, a salmon-coloured chemise that had slipped from the back of a chair and lay in a silken heap on the floor, like an illustration of her distraction and helplessness and, yes, of her sense of guilt, too. The thought came to her: *Do I love David?* How strange, that she had never asked herself this question before. Somehow it had not come up in her mind; it had not seemed relevant to anything that they had together. Why ask it now? She pressed her eyes tightly shut and stood for a moment with her head bowed, trying to gather together the parts of what seemed her scattered self. How deep the darkness was behind her eyelids; how frightening were

256

those depths. She grabbed her coat from the wardrobe, leaving the metal hangers jangling on the rail.

When she returned to the living room Sally had gone back to the mirror while David was standing by the window with his hands in his pockets, looking into the street. The silence between them seemed contrived. Had they been talking about her, and stopped when she came in? But what would they have been saying — what would they have had to say about her? "Well, then," she said, trying to sound normal, "shall we go?" But what was normal, now?

When they came out into the street the sun was suspended low in the sky and the pavement before them, lately rained on, was all a shivery glare. Seagulls, unnaturally white, were wheeling at an immense height against an anvil-shaped, lead-blue cloud hanging over Merrion Square. They walked along, she and David, with Sally in the middle. The silence between the other two seemed to Phoebe peculiar. Strangers when they meet always chatter at first, to cover the awkwardness of being new to each other. David and Sally, however, seemed to have nothing to say, and, more, seemed not to feel the need of saying anything.

The Country Shop was crowded. The customers were mainly women, who had stopped in to drink a restorative cup of tea after a day's shopping. They found a table at the back, near the service door. Phoebe, with a sudden pang, recalled that this was one of the places where she used to meet Jimmy Minor, in what already had come to seem to her the old days. David was offering a cigarette to Sally, but she smiled

257

and shook her head. "I only smoke these," she said, taking out her packet of Craven A. "I'm a craven creature."

David, lighting up, only nodded distractedly. Phoebe watched him. What was he thinking about that the notch between his eyebrows should have deepened so? He held out the flame of his lighter, and as she leaned down to it Sally, for the briefest instant, touched a finger to the back of his hand. Phoebe quickly looked away. Sally's presence was making her see David with a new eye. How little she knew about him, after all. At once the question rose again in her mind: *Do I love him?*

"I'm sorry about your brother," he said now to Sally. He rotated the glowing tip of his cigarette against the edge of the ashtray before him on the table. "I didn't know him very well. He was Phoebe's friend, really."

Sally frowned and looked off to one side. "I don't think anyone knew him very well," she said. "He wasn't the kind of person who revealed things about himself — not the important things."

"Yes," David said. "I had that impression."

Despite herself, Phoebe was a little shocked by this brief exchange. So much more seemed expressed in it than the words would warrant. Or was she imagining it? "We used to meet here often, Jimmy and I," she heard herself saying. She gave a little laugh. "He always looked so out of place, among the housewives and the men in tweed suits."

For some reason this made the other two go silent again; it was as if now she were the one who had said

something inappropriate, something indiscreet. She let fall a soundless sigh. Why did everything have to be so awkward and difficult? It could not only be because she had not told David about Sally staying at the flat — that could not be it. Or was it that kiss again, spreading its heat over everything?

At last, as if he had bethought himself, David began to make small-talk, asking Sally where she lived, and what she worked at, and how life was in London nowadays — were the people there at last beginning to get over the war? "Oh," Sally said, "everyone is cheerful and keeping busy — you know what Londoners are like."

David nodded, but Phoebe was thinking that *she* did not know what Londoners were like, that in fact she had been to London only once, when she was young and her parents, her supposed parents, had brought her there for a weekend. What she remembered, and only vaguely, were the big department stores, Harrods, and Selfridges in Oxford Street, and the bomb craters everywhere, with pools of stagnant water standing in them. She seemed to recall the city smelling still of cordite and domestic gas and broken mortar and death. She thought now of Jimmy's body floating in the canal, in the darkness, *like* — the words had formed themselves in her mind before she could stop them — *likc a dog*. She wondered if David had seen the body when it was brought into the hospital. She had not asked him, nor would she. She seemed to remember her father saying David had been off that day. A week

259

ago exactly that had been — only a week, yet it seemed so much longer.

"I lived there, for a while," he was saying, "in London. Hammersmith."

"That must have been nice," Sally said. "I'm in Kilburn." She smiled. "That's *not* so nice."

The waitress came and they ordered things, though a moment afterwards Phoebe had forgotten what things they were.

"Sally thinks," she said, "that Jimmy was killed by tinkers."

The blurted words had come unbidden, and they fell on the table like something falling in a dream, slowly, with a silent crash. David, his head lowered, gave Sally an upward glance. "Why do you think that?" he asked. Phoebe he ignored, as if it were not she who had said it, as if the words had somehow spoken themselves.

"I'm not sure that I *do* think that," Sally said. She smiled uncertainly, and glanced at Phoebe. "I'm not sure what I think. No one seems to know what really happened."

Someone murdered him, Phoebe wanted to say, *someone beat him to death and threw him like a dog into the canal — why not tinkers? It's as good an explanation as any.* But she knew, of course, that it was not an explanation. What was the matter with her? she wondered. Why was she feeling so upset? David was looking at her now, thoughtfully, leaning his face away from the smoke of his cigarette. "What does your father think?" he asked.

Phoebe shrugged. "He doesn't know what happened." She felt an involuntary shiver, of anger, so it seemed to her — but why was she angry? "No one knows."

They were silent again, all three, their eyes fixed on the table. Phoebe had the impression of something happening, some slow unfolding, from which she was excluded. David looked up at Sally again. "It must be very painful for you."

Sally pressed her lips together and nodded. "Yes," she said, "it is. I loved him."

"They were twins," Phoebe said. Yet again she regretted having spoken, of having blurted out more awkward words. It was not her business to say these things.

She was glad when at that moment the waitress came with their tea.

David was speaking to Sally again. "You were twins," he said. "I see. That must make it even harder for you."

Sally took a deep breath. "Yes," she said, "yes, it does."

Tea. Bread. Little sandwiches. Biscuits. Phoebe ate, and drank, and tasted nothing. A wave of misery was welling up in her, unaccountably. Something was being lost — that was how it seemed: not that she was losing something, but that something was losing itself. What was it? She felt as if one whole side of her life were shearing off and toppling slowly into the sea.

She watched Sally's small hands, slightly chafed and reddened, with their square-cut fingernails and milk-blue veins.

She remembered a lesson from her school days: *amo, amas, amat*. Love, yes. *Amo*, I love. But whom did she love?

David was leaning across the table to stub out his cigarette in the ashtray, and now he glanced back at her, sidelong, enquiringly, as if she had said something. Had she, without realising it?

Lifting her cup to her lips, Sally smiled to herself, as if at some private remembrance. Phoebe studied her, her delicate, freckled skin, her hair the colour of autumn leaves under water, those darkly luminous eyes. What had she and David been doing when Phoebe was in the bedroom, fetching her coat? What had passed between them that the silence should seem so strange when Phoebe returned and they were standing there, David at the window with his back to the room and Sally in front of the mirror above the fireplace? Had they kissed, as she and Sally had kissed, in front of the gas fire, that night when the lightning struck?

Amo, amas, amat.

Amamus. We love.

CHAPTER
EIGHTEEN

The heavy evening rain had turned to mist, fine and light as cobweb, that did not so much fall as drift vaguely this way and that through the dense and glossy darkness. On Ailesbury Road each streetlamp had its own penumbra, a large soft bright ball of filaments streaming outwards in all directions, and the lighted windows of the houses were set in frames of the same muted yet luminous grey radiance. Quirke had told the taxi driver to drop him at the corner of Merrion Road, he was not sure why, and from there he had set off to walk up to the house, his hat pulled low on his forehead and the collar of his overcoat drawn tight around his neck. He had a scratchy sensation at the back of his throat. Was it the lingering effect of the poteen, or was it the malaise that had been threatening for days? The possibility that he was starting a cold or a dose of flu struck him as grimly comic. If he was dying, it seemed now that he would die sneezing.

He kept his eye warily on those streetlamps with their furry haloes. Over the past couple of days he had developed a new symptom of whatever it was that ailed him. It was not a matter of hallucinations, like the one he had experienced with the garrulous old major-domo

at Trinity Manor, or when he had thought he had seen the lupine dog under the tinker's caravan — no, this was more a notion, a concept, a menacing and ever-present potentiality. What he felt was that there was a light somewhere, jittery yet constant, shining urgently at him, which, however, he could not see, and, he suspected, never would see. He knew what it was like, he could even describe it, were he to be called upon to do so: a circular white beam, intense yet somewhat diffused around the edges, and flickering, as if some component of the general apparatus, a taut, vertical wire, perhaps, were passing rapidly back and forth in front of it. It was off to his right, positioned in the middle distance, mounted, he thought, on a tripod or a tall, slender pillar, or possibly a pole, but a rickety affair of some kind, anyway. Yet how could he know these things? How could he have even a general idea of them? For no matter how hard he tried to see it, whipping his eyes to the right suddenly to catch it off-guard, as it were, the light always eluded him, always shifted on the instant, just beyond the margin of his vision. He was like, he thought, a dog chasing its own tail. There was no doubt that the light was his, that it had been set up and intended for him and him alone, but whether as guiding glow or a wrecking light he could not say.

He stopped at the house and opened the wrought-iron gate. The hinges, with the mist for lubricant, did not set up their usual screeching. He looked up; the windows were dark, upstairs and down, though there was a half-moon of light in the transom

above the front door. He climbed the granite steps, noting the glinting flecks of mica in the wet stone. The bell jangled afar in the depths of the house. He had to wait a long time, the garden smells of loam and rained-on greenery heavy in his nostrils. The irritation in his throat was worsening steadily. He wondered if Mal would have any brandy in the house. There would be plenty of bourbon and gin, thanks to Rose, but it was brandy he needed tonight. Brandy, and other kinds of succour.

In the end it was Rose herself who opened the door to him. She was wearing slacks and a short jacket with enormous sleeves — a kind of kimono, was it? The light of the hall at her back made a haloed blaze in her dyed blonde hair, reminding Quirke of the dandelion heads of the streetlamps.

"Quirke!" Rose exclaimed, sounding surprised and, it seemed, not entirely pleased.

Quirke took off his hat and shook raindrops like a scattering of jewels from the crown. "I phoned Mal this morning."

"Yes, you did," Rose said drily, in her slowest Southern drawl. "But he forgot to tell me you were coming round. He forgets everything, these days. Come on in. You don't look good."

She took his hat and coat and hung them on a coat-rack, and led him along the broad high hall, with its gleaming parquet and gilt chairs and massively framed ugly dark-brown portraits of bewigged, puce-faced worthies of an age or ages long gone. The mansion had been the embassy of some minuscule

European principality — Quirke could not remember which one — and when for some reason the mission had been abruptly withdrawn Rose and Malachy had bought it as it stood, furnished, carpeted, complete with chandeliers and all manner of quaint and curiously lifeless bijouterie. Quirke could not think why they had wanted it. It would never be a home.

He watched Rose's slim rear end as she walked ahead of him. She was still a handsome woman. He had gone to bed with her, once, a long time ago. Did Mal know about that? Would Rose have told him? But Rose and Mal, now — that was a conundrum Quirke knew he could never hope to crack.

"Have you had dinner?" Rose asked over her shoulder.

"Yes, I ate something," Quirke said, though it was a lie.

"We just finished supper, Mal and I. These days, our evenings draw to a gentle close earlier and earlier. I think eventually we'll find ourselves retiring for the night some time around mid-afternoon." She glanced back at him with an eyebrow lifted. "You do look terrible, Quirke."

"I think I'm getting a cold."

"Sure seems it's going to be an awful bad one."

They went through a green-baize door and down three steps into a much narrower hallway. This had been formerly the servants' quarters. "We're living modestly, these days," Rose said, and roiled her eyes.

She opened the door into what must have been the servants' parlour, a low-ceilinged room of a brownish

aspect, with a big oak table in the middle of the floor and framed and faded hunting prints on the walls. There was a single window, four square blank panes holding back the darkness. In a tiny grate in one corner a coal fire was burning. The air in the room was so warmly heavy that Quirke at once felt a headache starting up. The only light was that of a standing lamp beside the fireplace, with a shade that looked to Quirke as if it might have been made from dried human skin.

Malachy was sitting under the lamp in a ragged old green-upholstered armchair that sagged so low he seemed almost to be reclining on the floor. Now he put aside his newspaper and rose from the depths of the chair, uncoiling his long, angular frame — Quirke was reminded of the outsized wooden calipers that some Christian Brother in some institution long ago used to beat him with — and came forward, smiling, and fumbling with his rimless spectacles, which seemed to have got entangled somehow in his hair. "Quirke," he said in greeting, "you're looking well!"

Quirke and Rose exchanged a glance.

"How are you, Mal?" Quirke asked.

Direct and simple questions always seemed to confuse Malachy. He had got his glasses off at last and stood blinking, still vaguely smiling. He wore a checked shirt and a dark-red bow-tie and a fawn cardigan with leather buttons in the shape of some kind of nut. Quirke glanced down and was surprised to see that his brother was wearing shoes, not slippers; over the years Malachy had become definitively a carpet-slipper man.

"How about a drink, boys?" Rose asked, setting a hand on her hip. "Quirke — what will you have?"

"Brandy, if you've got it."

She gave him a wry look. "It's the Dry Gulch Saloon here, Doc. You can get anything you want."

She went out, and the two men stood facing each other in a suddenly discomforted silence, which Malachy at last broke. "You said on the phone you —" he began, but Quirke lifted a hand to stop him, saying, "Let's wait till I've had my drink." He looked about at the brown walls with their sporting prints dimly illumined by the lamp with its skin-coloured shade. He felt a sudden sinking of the heart. What help would there be for him here? And yet he heard himself say, "I think I'm sick, Mal."

Malachy nodded, as if this were not news at all. "In what way?" he asked.

"I don't know. My mind, my brain — I think there's something wrong with it."

"Have you been drinking?"

"For Christ's sake, Mal!"

"I don't mean now, I mean have you been drinking lately? Have you been on a binge?"

Quirke shook his head. "It's not the drink."

"That's what everyone says," Malachy said, with a faint smile.

"Well, in my case it's true," Quirke snapped. "I know what it's like, I've had the DTs. This is different."

Malachy was gazing at him myopically, smiling with an almost mournful tenderness. "Yes," he said, "I can see you're in distress. Tell me what I can do."

Quirke gave a sort of laugh. "I was hoping *you'd* tell *me* that."

Rose came back then, carrying a silver tray with glasses, a brandy snifter and a decanter and various bottles. "Here's your medicine, Doctor," she said to Quirke. She put the tray down on the table and picked up the decanter and began to pour. "Say when."

After she had distributed the drinks — Quirke's goblet of brandy, a thimble of sherry for Malachy, rye whiskey for herself, on the rocks — they sat down in front of the fire, she and Quirke on a small sofa covered in crimson velvet with bald patches and Malachy reclining again in the green armchair with his long legs stretched out almost horizontally in front of him. The chair reminded Quirke of some aquatic animal, a denizen of moss-hung everglades.

He fixed his eye on the heart of the fire, a tremulous white-hot hollow. "I've begun to see things," he said. "I'm having hallucinations." He sensed Rose and Malachy looking quickly at each other and away. He leaned forward heavily, nursing the brandy glass in both hands. Beside him Rose exhaled a breath and moved back on the sofa. He looked sidelong at the whiskey glass she was balancing on her knee. She would despise him, he knew, for what he was confessing. Rose did not believe in infirmities of the mind, put all that down to weakness and sickly self-indulgence.

"What are these hallucinations?" Malachy asked. He was running a fingertip around the rim of his sherry glass. If the glass were to produce the high-pitched note

that glasses did when they were stroked like that, Quirke thought, he would scream.

"They're just — hallucinations," he said, lifting a hand. "I see things, things that usually happen only in dreams, but I'm not asleep, I'm there, walking through them, being part of them." He described his visit to Trinity Manor and what had happened in the kitchen with the old serving man, whatever his name was — what had happened, or what he had imagined had happened. "Other things, too," he said. "I see animals, weird animals that I know are not there, and yet I *see* them. And then there's this light . . ."

He stopped. In the fire a coal fell and a drop of molten tar ran out of it, hissing in the flames. "What light?" Malachy asked, after a moment.

Quirke could smell the tar boiling in the fire. He shut his eyes. Childhood again, and him as a boy prising lumps of tar from cracks in a metalled roadway. Arrows, their heads made from six-inch nails hammered flat and pushed into the cleft of a stick and lashed tight with twine that in turn was smeared with tar. The feathering, how was that done? He could not remember. Bows and arrows, the harsh cries of boys pretending to be Red Indians, and someone making the sound of a ricocheting bullet. He opened his eyes and looked again into the white heart of the fire. He felt dizzy. "What?" he said.

"You were talking about a light," Malachy prompted.

"Yes. I don't see it. I just know it's there" — he waved a hand again — "off to the side, but when I try to look directly at it, it moves out of range."

270

Malachy nodded slowly. His puzzlement was obvious, though he was trying not to show it. "I could have a look at your eyes — I think there's a 'scope somewhere in the house."

"No no no," Quirke said, with weary impatience. "It's not my eyes, my eyes are all right. It's my head — my mind. My brain."

Malachy coughed, and drew himself forward in the armchair, linking his fingers together. "Perhaps," he said, "perhaps you need to see a specialist? There's a good one in St John's. They say he studied in Vienna —"

Rose stirred and, with a grunt, got to her feet. She stood a moment, looking down at Quirke. A melting ice cube in her whiskey glass gave a submerged, agonised crack. "I think," she said, "I'll leave you two to get on with this. I have some needlepoint that needs attending to."

She left the room, humming to herself. The two men sat in silence, gazing into the fire. There was a faint, urgent sound — a bush outside the window was tapping one of its twigs against the glass. "I don't need to see anyone at St John's," Quirke said wearily. He had been there already, more than once, to be dried out; he did not want to see those grim interiors ever again. "I need an X-ray. I need —" he gave a short laugh "— I need my head examined."

"I see," Malachy said, and unclasped his fingers and put the tips together and steepled them under his chin. "You should see Philbin, in the Mater. He's still the best there is." It was Philbin, Quirke remembered, who

had treated Malachy's first wife, Sarah. She used to say that too, *I need my head examined*, making a joke of it. And then she had died. "I could call him in the morning for you, if you like," Malachy said.

"I can call him myself."

"Yes, I know you can." Malachy did his melancholy smile. "But let me do it for you."

"All right. Thanks."

Malachy rose from the depths of the armchair and picked up a pair of metal tongs and began to put coals on the fire, scrutinising each lump as if he were measuring it for size and quality. Quirke watched him with grudging fondness. Malachy had helped him before, in the past, but he had done him disservices, too.

"What are you up to, these days?" Malachy asked.

Quirke was lighting a cigarette. It was the fourth or fifth since he had sat down, and the inside of his mouth was raw and his throat felt scratchier than ever. "You remember Jimmy Minor, Phoebe's friend?"

"Yes, I read about him in the papers. A tragic business." Holding a lump of coal aloft in the claws of the iron tongs, he glanced back at Quirke with an almost mischievous glint. "I suppose you're investigating his death, you and your friend Hackett."

"Investigating is a strong word. We're not exactly Holmes and Watson."

"You're quite the pair of sleuths, though."

He put away the tongs and sat down again. The fire hissed and crackled, sending up a snaking column of dense, yellowish-white smoke. "Could that be what's

troubling you?" he said. "I mean this young man's death? It seems to have been very violent, from what I read in the papers."

Quirke rose and went to the table and the tray with the decanter on it. He poured himself another brandy, a good inch of it. "No," he said, returning slowly to the fire. "My troubles are all my own work."

"Yes," Malachy said, groping for his sherry glass where he had set it on the floor beside his chair. "I think you're overwhelmed, Quirke."

"Overwhelmed?"

Malachy blushed a little. "Yes. By yourself, by your life. You must do something about it."

"Such as?"

Malachy hesitated for only a second. "You have to forgive yourself," he said.

"Forgive myself?" Quirke stared. "For what?"

"For whatever it is that's burdening you." Malachy located his glass and fished it up, but it was empty. He turned it in his long, pale fingers, looking through it from the side. "The things that happened to you when you were a child, they were no fault of yours."

Silence fell like a blade, and the already dim light in the room seemed to darken further for a moment. The twig tap-tapped at the window. Quirke was thinking of how Malachy's father, Judge Garret Griffin, had played a role in the things that had happened to him in his childhood.

"Tell me, Mal, do you think Garret was my father?"

Again the light in the room seemed to dim. This was the question that had stood unasked between them

since they were boys together, growing up in Judge Griffin's house. There had been a young woman, Dolly Moran, who had worked years ago in that house and who might have had a child and been forced to give it up to adoption. The facts were unclear, buried, deliberately so, in the murk of time. If there had been a child, was Garret Griffin the father of it? — of him? Quirke had been taken from an orphanage and given a new life by the judge and his wife. By then Dolly Moran was gone. So many mysteries, Quirke thought, so many questions, unasked and unanswered.

Malachy took a slow breath. "I don't know," he said. "My father never talked about it — he never talked about any of those things."

"You protected him when those things were threatening to come out."

"Yes, I did," Malachy said, lifting his chin defiantly. "I did what I could." He lowered the sherry glass and looked hard at Quirke. "He was my father."

Quirke drank his brandy. He felt strangely calm, remote almost. It was a shock to discover how little he seemed to care, suddenly, about all this, where he had come from, who his parents were, what his real name might be — these patches of darkness in his past had seemed deep pools in the depths of which he might some day finally be lost to himself. Now, all at once, they were what they were, mere gaps, mere absences. He should have asked that question of Malachy a long time ago. He should have asked it of Garret Griffin.

274

re. Her own life at the moment seemed
ed and difficult than the plot being acted
with such large gestures, such overblown

mind strayed. Watching the actress on the
und herself wondering what it would be
someone. A person would have to be very
eed to do such a thing. She thought of the
's handbag. She knew it was there — Sally
ful ever to leave it out of her keeping — yet
real, as unreal as Bette Davis pretending to
ess when everyone knew she was a lavishly
Hollywood film star.
vas sitting in the middle, with David at her
and Sally at her left. They seemed to be
the picture. She had known Sally for only a
the time that she had known David, yet she
she knew more about her, or at least
more about her, than she did about him.
kind, attentive, intelligent, all the things a
was supposed to be, yet it seemed to her that
n, at the very core, something was lacking in
essential spark. It was not just to do with
was a remoteness to his dealings with the
world of which she was only a part. She did
t him for this, or feel neglected. In a way, his
ent was one of the things that made him
e, since he demanded so little of her. What was
between them was, simply, passion; she saw that
w that she had met Sally.

He studied the amber lights in his glass. The brandy
held an image of the fire, tiny and exact. "Time to go,"
he said.

Malachy did not answer — perhaps he had not
heard? He seemed sunk in himself, lost perhaps in
the shadows of his own past. Quirke tossed back the
last of the brandy and stood up. He had drunk too
much, again, and felt lightheaded. He put a hand to
the back of the sofa to steady himself. Mal rose
slowly. "I'm glad you came to me," he said. "It
means something."

"Does it?"

"Yes." He laid a hand on Quirke's shoulder. "I'll call
Philbin first thing. He'll get you in for an X-ray straight
away."

Quirke nodded, looking at the floor. "Right. Thanks."

Malachy still had his hand on his shoulder, then
slowly he took it away and let it fall to his side. "Look
after yourself, Quirke," he said.

Quirke walked along the hall, his shoes squeaking on
the parquet. Malachy had not offered to see him to the
door, and he was glad of it, for by now he was
regretting having come here to ask help of his
quasi-brother and let him see how weak he was, how
defenceless. On an ormolu table below one of the
antique portraits there was a bell jar with, inside it, a
stuffed parrot, of all things, perched on a marble stand.
Quirke wondered idly as to its provenance. What
eccentric diplomat, what homesick third secretary, from
Liechtenstein or Baden-Württemberg, had brought it

here, a memento of home, perhaps, of a happy childhood tinted with the colours of bright plumage and loud with the harsh cries of Fritzl or Lou-Lou here, the magical talking bird? The past, the past — everyone tried to hold on to it, this thing that had gone, festooning its immateriality with beads and baubles, with bits of themselves.

Rose must have heard him approach, for now she appeared out of one of the absurdly grand reception rooms that lined the hallway. "Did you have a nice heart-to-heart?" she asked sarcastically, leaning in the doorway.

"Hardly," Quirke said. "I don't think Mal is any better at locating that particular organ than I am. The heart, I mean."

"Oh, I don't know," she said, looking him up and down. "Mal has a heart — you, on the other hand, have a soul."

"What's the difference?"

"All the difference in the world."

She smiled, glancing down, then stepped forward and kissed him on the mouth, pressing her body lightly against his. Her breath tasted of whiskey and cigarette smoke. He put his arms around her. She was so slender, and almost weightless; soon she would begin to get old. He bent his head and laid his forehead on her shoulder. She moved back, and he lifted his head, looking at her enquiringly. She gave a shrug. "Old times," she said.

"Rose, I —"

"Ssh." She reached and smiled. "Don't g It's all we have."

He nodded. She tool and gave them to him. night surged forward in the wet garden and, bey and city, and world. He

On Merrion Road h passing taxi. He saw him under the night, like an o When at last a taxi arrived peered up at him suspiciou big black coat and his dre into the back seat.

"Tallaght," he said.

When they had finished their Phoebe and David took Sally was Phoebe's idea. She wante dark for an hour or two, not even, just watching these en creatures flit across the screen trouble for themselves and anyo enough to wander into their cir been to the Carlton the previous went to the Savoy, across the roa film Bette Davis was seen shootin being sent for trial for murder. mind wandered and when she t again she could not catch up with

She did not ca far more tangl out before her emotions.

Again her screen, she f like to shoot desperate in pistol in Sall was too care it seemed ur be a murder successful

Phoebe right hand absorbed i fraction of suspected understo David wa boyfriend deep dow him, som her. The world, t not rese detachm attracti lacking now, n

What if David asked her to marry him? The thought made her tremble, which in turn was a shock. Why was everything suddenly so fraught? Nothing more had happened between her and Sally, after that kiss, but the effects of it still reverberated in Phoebe's nerves and along her veins, so that she felt as if it had taken place but a moment ago. She was, she realised, sharply conscious of Sally's physical presence in the seat beside hers. Sally had a nice smell, violets, she thought it must be, a perfume of violets, mingled with a faint milkiness; there was something about Sally's smell that reminded Phoebe of someone else, someone she had known, but she could not think who.

When the picture was over they boarded a bus, and went up to the top deck and sat at the front, Phoebe and David together in one seat and Sally sitting alone on the other side of the aisle. A fine rain was falling that misted the windows, and the neon signs above the shops wobbled like undersea lights. The three of them hardly spoke. The pictures always had that effect. Phoebe had noticed it before: people came out like zombies, caught halfway between the screen fantasy they had been absorbed in and the ordinary, familiar world of buses and rain and huddled passers-by.

When they got to the flat Phoebe lit the gas fire and went into the kitchen to make coffee. But there was no coffee, and she returned to the living room to ask if cocoa would be all right. Sally was standing by the window, as David had stood earlier. She was looking down into the street, though there could not have been much to see, with the darkness, and the rain. David was

sitting in an armchair, leaning forward with his elbows on the armrests, smoking a cigarette. They looked, Phoebe thought, like a couple who had just had a fight and had turned away from each other in a seething silence.

When Phoebe spoke, David gave her a strange, blank stare that lasted only a second but that shook her nonetheless. Had they said something to each other — had there been a disagreement between them? How would there have been time? She had been away in the kitchen for no more than a minute or two. Had one of them said something about what had happened earlier, when they had known each other for only a matter of minutes? *Had* they kissed then? Had they? She could not believe it, it seemed preposterous, a figment of her overheated imagination. Yet the possibility gnawed at her. What was she to believe? What was she to trust?

She made the cocoa in a saucepan. Her hands would not stay steady. Outside, the horn of a passing car sounded. Why would anyone need to blow a car horn in a deserted street, at night? She carried the saucepan to the table and began to pour the cocoa into three mugs. Abruptly she remembered who it was that Sally's smell reminded her of — Jimmy, of course! How could that be? Jimmy, a chain-smoker, had smelt of cigarettes and not much else, as she remembered him. Yet it was definitely Jimmy who had come unbidden to her mind as she'd sat in the cinema feeling the warm proximity of Sally's body and breathing in her milky, violet smell.

They drank their cocoa and talked a little about the picture. David had thought it silly, though he admired

280

Bette Davis's acting, or so he said. Sally gave no opinion. She seemed distracted. David smoked another cigarette, and when he had finished it he rose and said that he should be going. He nodded goodbye to Sally, who smiled at him absently. Phoebe walked him to the door of the flat. On the landing she expected him to kiss her, but he only smiled instead, vaguely, as he had smiled at Sally, and went off down the stairs.

When she returned to the living room, Sally was sitting in the armchair where David had sat, leaning forward with the mug clasped between her hands. She glanced at Phoebe, but said nothing. Phoebe waited. Did she not have anything to say about David, this man she had met for the first time tonight, Phoebe's boyfriend? But Sally, it seemed, had nothing to say.

"I have a headache," Phoebe said. "I think I'll go out for a walk."

She was angry, at David, at Sally, at herself.

"A walk?" Sally said, turning to her. "In this weather?"

Phoebe did not answer, only took up her coat. She had never realised before how much she disliked the smell of cocoa.

Sally had been right, of course: it was foolish to have come out like this, in the darkness and the drifting rain. She had not even thought to bring an umbrella. Yet she could not go back. At the foot of the front steps she turned left and walked in the direction of Huband Bridge. She could see the willow tree there, beside the

bridge, leaning in the light from the streetlamp with a fuzz of sallow mist surrounding it.

The street was deserted, and the only sound was that of her own footsteps clicking on the pavement. Her mind was in turmoil. Inside her she seemed to be suddenly in a strange place, where she no longer knew the people she had known, the people she thought she had known. Was this jealousy? Was this what it felt like to be jealous, this frenzy of the mind and this dull, hard pain in the breast? Faces rose up, David's face, Sally Minor's, and hung there before her, stark, hollow-eyed, like the masks in an ancient Greek play. She was in a sort of panic; she imagined herself revolving slowly round and round, like someone who had been hanged. She did not want to feel this way; she did not want to be thinking these thoughts.

They had not kissed. David and Sally, they had not kissed, she was sure of it. That was all the work of a fevered imagination. It was. *It was.*

If only Sally had said something about David, something simple and innocent. *He's nice. I like him. You're lucky.*

She wished Sally would go. She wanted her to go now, to be gone when she returned, gone back to Kilburn or wherever it was, to her flat over Mr Patel's shop, to the smell of curry and the sound of the grocer's children squabbling. She wanted never to have known her. She wanted that kiss not to have happened. She wanted —

She had not heard him come up behind her. Afterwards, it seemed to her that before anything else

282

she had caught his smell, of cigarette smoke and wet sheepskin. He was wearing the same cloth cap — she recognised it at once. Strange, how she could think of so many things in such a short span of time, a couple of moments, no more than that, before he stepped in front of her and caught her by the wrist. He was the man who had come into the café that first day and looked at Sally and at her before going out again, into the rain. He was the same man who had been standing opposite the flat, by the railings above the tow-path, with a cigarette cupped in the palm of his hand. Why had she not paid him more attention?

He had thrust his face close up against hers and was saying something. He had not twisted her arm, he was only holding it, but in such a steely grip that she feared he would crush the little knob of bone at the side of her wrist. Should she scream? She was sure her voice would not work.

What was he saying? She could not make it out. She tried to concentrate. The police would ask her what he had said: they would want to know the words, the exact words. *"Listen,"* he said, in a savage whisper. *"Listen to me, you fucking bitch."*

Behind him she saw the willow tree by the bridge, its hanging head wreathed in glowing grey light. With the greatest feeling of surprise she asked herself if this was where she was going to die, if this was the moment.

CHAPTER
NINETEEN

The rain, the endless rain, was still drifting slantwise when the taxi swung into the main street in Tallaght. The driver, a burly fellow with a wheeze, had already complained breathily of having had to come so far out of the city, and Quirke had annoyed him all the more by pointing out, with weary sarcasm, that it was a taxi he was driving, and that the meter had clocked up two pounds so far and was still running. "Bleeding middle of the night, too," the driver said, with an angry gasp, and lapsed into a sulk. It was not yet nine o'clock. Quirke sighed. He had done so much in this long day, had travelled so far, and he was tired. He had the sense of things closing up, of the big top being dismantled and the animals being shut away in their cages, of the spangled bareback rider taking off her grease-paint by the light of a flickering lamp.

They passed through the village, and at the crossroads Quirke pointed to the muddy lane leading to the tinkers' site. "I'm not going down there," the driver protested indignantly. "That's where them knackers have their camp." Quirke told him to stop, saying that he would walk the rest of the way. The fellow turned in his seat and peered at him incredulously. "I'm telling

you," he said, "there's nothing but tinkers out here."
Quirke, getting out his wallet, did not reply.

Outside, in the darkness and the stealthy rain, Quirke stood and watched the headlights of the taxi as it reversed along the boreen, until it turned with a crashing of gears and drove off. The night closed suddenly around him. It had a wild smell, like the smell of an animal's wet pelt. He waited for his eyes to adjust. The darkness had a glassy shine. When he took a step there was a squelching sound, as his right foot, in its expensive Italian shoe, sank into the mud of the laneway. He lifted his head, flaring his nostrils. He was aware of a sense of violent exultation, of feral hunger — but what was he exulting at, for what was he hungering?

The darkness was so dense it doused even the imagined searchlight that for days had been trained upon him from just beyond the perimeter of his vision. He spied, off at a distance, the real lights of Packie the Pike's encampment. He did not know why he had come here. In his mind he saw again the black-haired woman walking away from the caravan, and the child with her, and the two of them looking back at him with something in their eyes, some dark knowledge. He blundered onwards. Despite the lights ahead of him and the muddy and all too palpable ground underfoot he had no real spatial sense. He might have been in flight, not through the sky, exactly, but in some sort of elevated, clouded medium in which he was weightlessly sustained.

He came to the gateway into the camp, though he felt it rather than saw it, a yawning gap in the moist and

somehow restive gloom. He walked through it. The mud was deeper now, more viscous. There was a smell of horses. Then a dog barked, close by, and he stopped. The animal approached, a slithering dark shadow against the deeper darkness. He saw a flash of fangs, and was frightened, but then the thing was rubbing its flank against his legs, whimpering. He leaned down and touched its slick, wet coat. "Good dog," he said softly. To this creature, he supposed, he would seem a new species of human, soft-voiced and ingratiating, harmless, unworthy of serious challenge.

He moved on, the dog keeping close at his heels. There was music somewhere, someone playing a melodeon, or maybe it was a mouth organ. Before him there was the light of a bonfire. Was it the tyres burning still? No, the fire was smaller, and in a different place, and against its flickering glow he saw the ring of caravans. He stopped again, thinking of the two young tinkers he had seen earlier, sitting in the rusted wreck of the car, watching him and Hackett. He could die out here: he could have his throat slit and no one would know. Packie and that gang of children he had seen around the bonfire would take his body and bury it somewhere, or throw it on the fire, even, and burn it to ash. Thinking these things he experienced a renewed and almost sensuous thrill of fear.

Again he walked forward; again the dog followed.

He saw her, as he had seen her the first time, putting her head out at the door of one of the caravans, the light of the fire lacquering her raven-dark hair and lighting her thin, sharp face. Would she be able to see

286

him, out here in the darkness? She was sure to have keener eyesight than he — they could probably see in the dark, these people. He moved towards her. The ground was uneven and he was afraid of slipping in the mud and falling. He felt like a sleepwalker, walking in a dream. The woman still leaned there, her arms folded on the door-frame. The rain must be falling on her, did she not mind it? There was lamplight at her back, and her eye-sockets were blank black hollows. How had he recognised her, in the dark, and at such a distance? He had just known it would be she, and she it was.

He came up to the caravan and stopped. Her face was no more than a foot above his, yet her eyes were still lost in pools of darkness. She seemed to be smiling, coolly, unsurprised. "Wisha, it's yourself," she said softly. "I thought you'd be back, all right." He did not know what to say in reply. His rain-sodden overcoat hung heavy on his shoulders, and his feet in their wet shoes had begun to ache from the damp and the cold. He took off his hat and held it against his chest. "Will you come in, itself?" she said. Her tone was one of amusement and faint mockery.

"I don't know if I should," he said.

She appeared to consider this for a moment, then gave a low laugh. "You should not," she said. "But all the same you will."

She withdrew her head, and he heard the sound of her bare feet on the floor inside, and the caravan swayed a little, its axles creaking. He stepped forward and pushed open the bottom half of the door and, grasping the frame at either side, as he had seen Packie

the Pike do earlier, he hoisted himself aloft, and ducked through the narrow entrance.

The interior of the caravan was fitted out in much the same way as the one he had been in that afternoon, with a bed or bench along either side and an iron stove beside the door. There was a lace curtain above each of the beds, both of them drawn back and tied at the bottom with a piece of blue ribbon. Illustrations cut from glossy magazines were pinned to the sloping walls — pictures of landscapes with castles and greenswards, reproductions of paintings, a colour photograph of Marilyn Monroe pouting at the camera. An oil lamp was suspended from the ceiling, and the stove was burning, and the air was heavy with the smell of paraffin and of wood smoke, but behind these smells there was a fragrance too of some herb or spice that he could not identify.

The woman was sitting on the bed on the right, rolling a cigarette. Her fingers were slender and delicate, but the nails, like her toenails, had sickles of black dirt underneath them. She had on the same white blouse she had worn earlier, and the same red skirt. There were small pearl studs in her ear-lobes. She did not look at him, but concentrated on making the cigarette, a tongue-tip stuck at the corner of her mouth. He could think of nothing to say, and merely stood there, in his wet overcoat, holding his hat.

Then he noticed the girl, the one he had seen with the woman earlier. She was sitting on the other bed, half concealed by the swathe of lace curtain beside her. She had her back to the end wall, and had drawn her

288

knees up and encircled them with her arms. She was watching Quirke with a solemn and unwavering gaze. He smiled at her, smiled as best he could. She did not smile in return, only went on gazing at him, as if she had never seen him or the like of him before.

The dog, abandoned outside, whimpered piteously. The woman stretched out a leg sideways and pushed the bottom half of the half-door shut. Inside the stove a log fell with a muffled sound.

The woman sat forward, with her elbows on her knees, the cigarette in her mouth, and looked at Quirke. He fumbled for his lighter. The flame lit her face briefly, and found a glint in her glass-green eyes. "Sit down, will you?" she said. "You're making me dizzy, standing up there like some sort of bloody bird."

He took off his overcoat and laid it on the end of the bed where the child was sitting, and set his hat down on it, then sat himself between it and the silent child. He and the woman were almost knee to knee now, as he and Hackett had been this afternoon. Was he here, he suddenly wondered, or was he imagining it? Was this another phantasmagoria he had stumbled into?

"This is my place," the woman said, "my own, so you needn't be fearing anyone will come."

"Why would I be afraid?" he asked.

The only answer she gave him was an arch, thin-lipped smile.

She smoked her cigarette. She seemed wholly incurious as to why he was here, why he had returned, so soon. He could hear the child's congested breathing.

"What's your name?" the woman asked.

"Quirke."

She nodded. He had the impression of her taking the name and testing it, as she would test a gold coin between her teeth. "I'm Molly," she said. "Molsh, they call me — *he* calls me."

She watched him through the smoke of her cigarette. The girl on the bed was still fixed on him too, and he felt himself shrinking snail-like before these two pairs of unrelenting eyes.

"And that's Lily," the woman said, indicating the child with a lift of her chin.

"Is she your — is she your daughter?" Quirke asked.

Molly went on gazing at him, as if she had not heard, as if he had not spoken. Her mind seemed permanently elsewhere, engaged in some subtle and absorbing calculation. "She's *aras*," she said, and seeing his blankness she touched a finger to her temple and gave it a half-turn clockwise. "Born that way, and nothing to be done for it." She turned to the child and spoke in a loud, calling voice. "Are you all right there, Lily?" The child said nothing, only shifted her slow gaze from Quirke to the woman, as if turning some heavy thing on a pivot, with much effort. "Ah, you're grand," the woman said to her soothingly. "You're grand, so you are."

The dog gave a final, angry yelp, and they heard it trotting away, grumbling to itself.

"Were them two *nyaarks* outside, did you see?" Molly asked of Quirke. "Mikey," she said, "and Paudeen."

"I don't know who they are," Quirke said.

"Packie's sons. I saw them giving you the eye, yourself and the peeler, when the two of yiz was going off today."

"No," Quirke said. "I didn't see anyone, except you." He did not know why he had lied.

She gave a grim little laugh. "That's good," she said. "Them boys would make short work of you."

"Would they? Why?"

This time she laughed aloud. "Oh, aren't you the innocent, now?" she said merrily.

There was a brief pause. "Is Packie here?" Quirke asked.

"And where else would he be?"

"I don't know. I thought he might have business somewhere."

This amused her. "Business, is it? He always has business, but he don't move much from the home place here."

"Is he your — your husband?"

She scowled faintly. "I'm his *mull*."

"*Mull*," Quirke said. "Does that mean wife?"

"*Mull* is woman," she said, and turned her face aside with a grimace of distaste, as if something sour had come into her mouth. After a moment she spoke again. "My sister was his missus. She died."

He lowered his voice to a murmur. "And Lily? Is she yours?"

She wrinkled up her face in disgusted incredulity. "Are you joking me?"

"I'm sorry," he said. "I didn't mean to . . ."

Cinnamon, that was what he had been smelling: cinnamon, a soft brown fragrance. For a moment in his mind he saw a desert under moonlight, the cliff-like dunes glimmering, their edges sharp as scimitars, and in the distance, at the head of a long plume of dust, a line of camels and their drivers, and mounted on the camels swarthy sharp-faced men in turbans, and behind them their women, veiled, bejewelled, plump as pigeons.

"There was a young man," he said. "He worked for the newspapers, Jimmy Minor was his name. Small fellow, small as a child, almost. Smoked a lot. Did he come here? Did you see him, ever?"

She moved sideways along the bed to the stove, and with a metal hook opened the fire-door and threw the butt of her cigarette into the flames, and shut the door again. No, Quirke thought, he was wrong. What he was smelling was not cinnamon but some kind of sweet wood that was burning in the stove, maybe rosewood, or cedar. He wondered again if he were really here. Yet would he be smelling this smell if it was all in his imagination? This woman sitting before him, the girl on the bed, would they be so real? He made a fist of his right hand and dug the nails into his palm. He could feel that, all right. Yet how could he be sure his nerves were not deceiving him? Thinking this, he felt the by now familiar dizziness, as if he were standing on the rim of a precipice and the dark emptiness were calling to him to jump, to *jump*. But he would not jump, no, he would not. He had so many things to do yet, so many things. He would not die.

The woman was rolling another cigarette. She was expert at it, shaping the slim white cylinder between her fingers and licking the gummed edge of the paper with the sharp moist tip of her scarlet tongue. When she had finished the cigarette she offered it to him. He took it, and thanked her. She began to roll another for herself.

"Did Jimmy Minor come here?" Quirke asked. "Did you see him?"

"The *sharog?*" the woman said, tapping one end of the rolled cigarette on her thumbnail.

"*Sharog,*" Quirke said. "What's that?"

She took a light again from his lighter and leaned back and expelled a cone of smoke upwards into the vault of the ceiling. "The redhead," she said.

Quirke nodded. "Yes, that's right. Jimmy Minor had red hair."

She edged along the bed again, and took up a kettle from somewhere on the floor, and with the metal hook lifted the cover of the stove and put the kettle on the hotplate. A few drops of moisture hissed and skittered on the glowing metal.

Again Quirke was aware of the child's laboured breathing. Asthmatic, he thought distractedly. She stirred herself now and got on all fours and crawled along the bed, past the loop of lace curtain, and reached out a hand towards Quirke and made to take the cigarette from his fingers. He drew back instinctively but the child reached after him, until he felt he had no choice but to relinquish the cigarette. She took it, holding it between two fingertips and a

293

thumb, and sat back against the wall as before and took a deep draw of smoke. The woman laughed. "You'll be *grit*," she said to the child, who ignored her, and took another puff.

The water in the kettle began to grumble in its depths.

The woman, with her eyes still on the child, spoke to Quirke. "Did you ask himself about the *sharog?*"

"Packie, you mean?" he said, "Yes, I asked him."

The woman nodded. "That's why the *shade* was here, I suppose?"

"The *shade?*"

"The peeler," she said impatiently, "the police fellow." She stood up and opened a small cupboard on the end wall near the stove and took out a billycan and a yellow Campbell's tea tin. She spooned leaves from the tin into the billycan. They did not seem to be tea leaves: they were of a lightish-brown colour and looked weightless and brittle. She poured water from the kettle over them, standing close by Quirke, and the odour of her unbathed flesh, biscuity and warm, filled his nostrils.

The child, still smoking Quirke's cigarette, was caught by a fit of coughing. She leaned forward, hacking and gasping, until her face took on a bluish pallor. The woman paid her no heed, and at last the attack passed, and the child leaned back again and sat with her head bowed, panting. Quirke took the remaining half of the cigarette from her fingers and dropped it to the floor and ground it under his heel.

"He was killed," he said to the woman, "murdered. The young man, I mean, the — what was the word? — the *sharog*."

"Was he now," the woman said, showing no surprise. She went to the cupboard again and took from it two unmatched teacups and handed one to Quirke; he held it out to her and she filled it from the billycan. "Take a swallow of that," she said.

Quirke sniffed at the drink. It had a dry, bitter aroma, like wormwood. He sipped. A sharp taste, too, whiskeyish, slightly rancid, with a hint of peat in it. "What is it?" he asked. The woman did not answer, only watched him. He drank some more of the strange brew. The child's eyes too were on him again now. Was this woman trying to poison him? It did not seem to matter, really. He leaned back on the bed, and only when the muscles of his back relaxed did he realise how tensely he had been holding himself since he had first sat down.

He took another drink of the hot, bitter brew. The cup had things painted on it, figures in kimonos, a little lake with a crane flying over it, or a stork, perhaps, and distant, snow-fringed hills. All these tiny details — they had to be real. "Will you tell me about Jimmy Minor?" he said to the woman.

"Tell you what about him?"

"Someone, some people, murdered him, and threw his body in the canal."

The woman sat down again on the bed. She had poured a little of the stuff from the billycan for herself, but she had hardly touched it. She gazed before her,

blank-eyed. "He was here, aye," she said. "He come to ask about the other one."

Quirke waited a moment, then spoke. "What other one?"

"The *cuinne*."

He drew in a deep, slow breath. "The *cuinne*," he said. "The priest, yes?" He had a swoony sensation, and something inside him seemed to dip and then right itself again with a soundless effort. He heard afar that music again, a soft lament on mouth organ or melodeon. *Hohone, hoho-honan* . . . "What priest?" he asked. "Father Honan, was it? He came here too, didn't he? Father Honan?" The name sounded strange to him — it had a soft, keening sound: *hohonan, hohone.* "Father Mick, they call him."

The woman, still gazing before her, now smiled an angry smile. "Aye," she said, in almost a whisper. "Aye — Father Mick. The other *sharog*."

Leaning for support against the wet railings Phoebe watched the man march swiftly away in the rain, swinging his arms, his cap pulled low and his sheepskin jacket drawn tight around him and his boot heels banging on the pavement. Later she remembered thinking that he must have been a soldier at some time. She saw him turn right and cross the little stone bridge, and then he was gone.

She had thought he was going to kill her. He had seized her wrist and held it in his iron grip, crushing it, and put his face up close to hers and spoken to her in a low, harsh voice. His breath was hot and had smelt of

drink and of something meaty. She had not wanted to see his eyes and watched his mouth instead. He had a lantern jaw and as he spoke to her he bared his lower teeth. She could barely understand the words that he was spitting into her face. He spoke a name, *Costigan*, that she recognised, but did not know how, or from where. She had been terrified and she was shaking still; she could hear her own teeth chattering and she was afraid she would wet herself. All she could think of was that the man might come back, might come back and grab her by the wrist again and call her names and warn her to warn her father . . .

She pushed herself away from the railings and began to walk. She was trembling so badly by now she was surprised her bones did not rattle. She was going in the same direction as her attacker; should she not go back to the flat? But Sally was there; she did not want to see Sally. She went on. She had difficulty keeping in a straight line — her knees knocked together and her feet kept getting in the way of each other and she felt she was going to trip at any moment and fall headlong on to the wet pavement.

She turned into Mount Street Crescent. The flank of the Pepper Canister church loomed above her, foursquare and reassuring. Sanctuary. That was what she was in need of.

In Mount Street itself the air was gauzy. She put her hand up to her face and found that she was crying. She searched in her pockets for a handkerchief but could not find one. Why had she come out without her handbag? Or had she brought it with her and had the

man stolen it? No, he had not meant to steal from her; that had not been what he was about.

Before she knew it she had mounted the steps shakily and was ringing Quirke's doorbell. *Please, Quirke,* she thought, *please be home.* She pressed the button again, and kept her finger on it, and heard, very faintly, from three flights up, the bell shrilling in her father's flat that she knew now with certainty was empty. All at once her knees gave way, and even though she clutched at the brass doorknob she could not hold herself upright, and slowly she slid down with her back against the door until she was sitting in a heap in a corner of the doorway, weeping.

A moment had passed, it seemed no more than a moment, yet all at once everything was different. He was no longer sitting, with the china cup in his hand, but lying, rather, lying full length, on his back, on the narrow bed. How could that be? He let his eyes roam over the vaulted black ceiling above him. He was quite calm, quite at ease, and this surprised him. He looked to the side. The child was asleep in the other bed, with a blanket pulled over her and her thumb in her mouth. Her eyelids were pale pink and burnished, like the inside of a seashell, and it seemed to him he had never before seen anything so delicate, so lovely.

He braced his hands on either side of him on the bed and raised himself up a little way. The woman was leaning on the open half-door again, with her head and shoulders outside, just as she had been leaning when he arrived. He must have made a sound for now she

turned and looked at him. He sat up, still pressing his hands against the bed for support, but there was no need: he was no longer dizzy. In fact, his head was wonderfully clear. He had been sleeping. The woman must have drugged him — there must have been something in the drink she had given him. He did not care. He had not felt so rested in a very long time.

"I'm sorry," he said, "I seem to have . . ." He did not know what to say. It did not matter. Nothing mattered.

The woman shut the window and advanced slowly between the beds and stood looking down at him. Her expression was one of mild interest, tinged with amusement. "I was keeping an eye out for himself," she said. "Had he of found you here he'd say we were *spurking* and that'd be the end of you."

"*Spurking?*" Quirke said.

"Doing it, you know." She bit her lip, laughing a little. "*Spurking*, we call it."

"You said this was your place," he said, "that no one would come here."

"Himself knows no bar," the woman replied darkly.

Quirke looked again at the sleeping child. She was breathing through her mouth, making eerie animal sounds, little yelps and whinnies. "Dreaming," the woman said, looking too at the girl. "What about, God knows."

She sat down beside Quirke on the bed. He looked at her toes braced on the bare planks of the floor. Feeling his look, she waggled them. "What did you give me to drink?" he asked.

"'Twas tea" — she pronounced it *tay* — "and nothing but. You had a great sleep, all the same. You're the weary man, surely."

He smiled sidelong at her. "Yes, Molly," he said, "I'm the weary man." He took out his cigarettes and offered her one, but she shook her head, with a flick of disdain. He found his lighter. He wondered if his wallet was still in his pocket — she could have stolen it, while he was enjoying his great sleep — but he did not bother to check. It was pleasant and restful, sitting here beside her in companionable warmth; he was at peace, after so many tempests. "Tell me about the priest," he said. "Tell me about the two of them, the two *sharogs*."

"Tell you what?" she asked. She was smiling sideways back at him now, a teasing light in her eye.

"Tell me who killed the young one. Tell me who killed Jimmy Minor."

She went to the stove and opened the fire-door with the metal hook and lifted a log from a wicker basket under the bed in which the child was sleeping. She dropped it into the glowing embers and shut the door again. Quirke looked to the half-door that was open at the top and saw the moon shining low in the sky, a strangely small but intensely bright silver disc. When had the rain stopped? He drew back his cuff and looked at his watch, and was astonished to see that it was just coming up to ten o'clock. It seemed to him he must have been asleep for hours, but it could hardly have been for more than a few minutes. How had he come to be lying down, in the first place? He had no memory of stretching out on the bed — had Molly helped him?

Strangely, it did not trouble him not to know these things. His muddy shoes had begun to dry out, he could feel the tightness of the leather.

The stove tended, Molly sat down again, but this time she sat opposite him, on the bed in which the girl was sleeping. Quirke looked into the opening of her blouse, at the slope of her breasts and the soft shadow between them. *Spurking:* he smiled to himself.

Molly had set a hand lightly on the girl's narrow forehead. Nothing, it seemed, could wake her from her sleep. "'Twas the *cuinne* that done it," Molly said.

The dog had returned, and was outside, whimpering to be let in.

"The priest?" Quirke said. "What did he do?"

A long interval passed before Molly spoke again. The moon shone in the window; the dog still whined. Quirke saw again the priest leaning against the bar in Flynne's Hotel, smoothing his tie with his hand and lifting the whiskey glass in the other and smiling at him over the rim.

"They're a queer crowd, them priests," Molly said. "I'll have naught to do with them. Himself it was that brought him here."

"Packie, you mean?" Quirke said. "It was Packie who brought Father Mick here?"

"Aye." The child in the bed gave a little mewling cry, as if she were in pain, and Molly laid her hand once more on her forehead. "Took a great interest in this one, he did," she said. "Told Packie he could help her, could teach her book-learning and the like. 'What book-learning,' I said to himself, '— what

book-learning could he teach her, and her with no more than a scrap of understanding?' *Oh, no,* he says, *Father Mick will learn her, Father Mick is the man.*" She was looking down at the girl, and her mouth tightened. "So he started coming out here, every week, of a Sunday night. I knew by the look of him what he was."

"And what was that?" Quirke asked.

She seemed not to have heard him. "Taught her, all right, he did — oh, aye, he taught her."

"What kind of things did he teach her?"

She looked at him, her face tightening. "The like that you wouldn't find in any decent reading-book. Had them all at it, at the learning, so-called, all the lads and the girleens in the camp. Himself was delighted. *Oh, they'll all be great scholars,* he'd say, *they'll get grand jobs and keep me when I'm old.* The *mugathawn.*"

She stopped. Quirke eyed the moon in the window, and the moon eyed him back. His throat had gone dry. He saw again the priest standing at the bar in Flynne's Hotel that rainy night, and turning with a smile of broad disdain to watch the red-faced young man walking stiffly in the wake of his angry girlfriend. What was it he had said? Something about love, and love's difficulties. "And what did you do?" he asked.

It was some moments before Molly replied. "I didn't know," she said, very softly. She stroked the forehead of the sleeping child. "She never told me."

"Why not?"

"Why? You might as well ask the wind why it blows."
She slowly shook her head. "She wouldn't tell me, but
then there was no more hiding it."

"Hiding what?"

"That she was *granen* — in the way of a babbie
coming. And she hardly more than a babbie herself."
She stopped, and Quirke saw to his surprise that she
was smiling, coldly, with narrowed eyes. "She told *him*,
though."

Quirke waited a beat. "She told Packie?"

The woman nodded. "Aye. She told him it was the
sharog, and all about the things he done to her — and
not only her."

"What do you mean?"

"Sure, wasn't he doing it with half the childer in the
camp!"

"There were other girls, like Lily —?"

"Girls, aye, and the lads, too, the ones he was
supposed to be teaching the book-learning to. He
didn't care what they were, so long as they were
childer."

"Why had none of them spoken? Why hadn't they
told what was happening?"

She looked at him pityingly. She did not have to
speak: he knew what the answer was. To whom would
he have spoken, when he was a child at Carricklea?
Who would have believed him? Who would have so
much as listened? "What did Packie do," he asked,
"when she told him?"

"He wouldn't have it that it was the priest, of
course, so he sent Mikey and Paudeen after that

poor young fellow instead. Somebody had to pay the price."

"But you knew it wasn't Jimmy Minor that she meant when she said it was the *sharog*. You knew which of the two it really was."

"Ach!" She made a grimace, screwing up her mouth as if to spit. "What matter was it what I knew? Himself knew it too, anyway."

"But he knew it wasn't Jimmy."

"What matter? It was the *sharog* done it, and that was enough for him. Sure, you couldn't touch the priest — you'd have no luck after that."

"And the baby?" he said. "What happened?"

The woman was gazing at the child, her hand still resting on her forehead. She shrugged. "She hadn't a strong enough hold of it. How could she, after the sinful way it came to her?"

"I see."

"Do you, now?" The woman glanced at him from under her eyelashes, smiling in malice. "So you're satisfied, then. You had the great sleep, and learned what you came to learn, and now you'll be off."

He gazed back at her, and slowly her smile faded, and she looked away from him.

"Why did you tell me?" he asked.

"Why would I not?" she answered quickly, with a flash of almost anger.

"And what if *I* tell?"

She brought out her tobacco and papers and set them in the lap of her red skirt and began to roll a cigarette. "Who would you tell?" she asked.

"The guards?"

That seemed to amuse her, and she nodded to herself, bleakly smiling. "Mikey and Paudeen will be gone by morning across the water, on the boat."

"To where?"

"Over to Palantus — England, as you'd say. That's the place to get lost in."

Quirke expelled a low, slow breath. "So," he said. "Packie is sending them off, yes?"

She shrugged. "They'll not be found, the same two, and there's no use that peeler looking for them — you can tell him that from me. Them are the boys that knows how to hide."

The moon was edging its way out of the square of velvety sky above the half-door. How strange a thing, Quirke thought, a silver ball of light floating there in the midst of that dark emptiness.

Molly stood up, the cigarette unlit in her fingers. Quirke looked up at her. "Go on," she said, "go on off now. I've said enough and you've heard more than is good for you." He rose to his feet. He was a head taller than she was. "You'll not come round here again, I know," she said, lifting her eyes to his.

"Will I not?"

She put up a hand and grasped the back of his neck and drew his head down to her and kissed him. He smelt the harsh scent of her body and breathed her gamey breath. He made to put his arm around her waist but she drew back from him quickly. "Go on now," she murmured, pressing both her palms against his chest. "Go on with you."

He stepped back. Outside, the dog gave a soft, beseeching yelp. The faint music had started up again. Or was it, Quirke wondered, only the wind, keening?

CHAPTER
TWENTY

He walked back into the village and found a hackney cab to drive him home. Slumped in the back seat he had slept again, briefly, and had only woken up when the car was pulling into Mount Street. When he saw the figure slumped in the doorway he thought it must be one of the working girls who patrolled there at night looking for business. They all drank, and this would not be the first time he had stumbled on one of them passed out in a stupor. He climbed the steps and crouched down beside her and put a hand on her shoulder. She flinched, and looked at him, and then in a flash of pallid moonlight he saw who it was.

"Christ," he said. "Phoebe!" His heart pounded and his mouth had suddenly gone dry. She clung to him, and said she was sorry, that she had not meant to give him such a shock. He got her to her feet and opened the door with his key. "I'm sorry," she said again, but he told her to shush, and led her into the hall. She seemed not to be hurt, yet she was so shaken he had to help her up the stairs.

In the flat he put her sitting in one of the two armchairs that stood at either side of the gas fire. She was still trembling. Her skin had a greenish pallor, and

her eyes as she stared fixedly before her seemed enormous. He fetched a blanket from his bed and wrapped it about her shoulders. Then he went into the kitchen and poured a brandy and carried it back into the living room. She drank a little of it and began to cough. "Tell me what happened," he said, keeping his voice steady.

She told him how she had gone out for a walk and how the man in the sheepskin jacket had overtaken her and caught her by the wrist and pushed her back against the railings. "I thought he was going to kill me," she said.

"Who was he?"

"I don't know. I had seen him before, though, when I was with Sally. I think she thought he was following her, when all the time it was me he was after. It's almost funny, isn't it?"

He crouched down beside the arm of the chair, sitting on his heels, and took her hand. It was cold, cold and moist, and seemed so thin and frail that he felt his heart contracting. "What do you mean, he was after you?"

She shook her head slowly, gazing at the fire as if mesmerised. Her voice when she spoke sounded wispy and far-away. "When I was little," she said, "there was a gas fire like that in the nursery, behind a screen. I never understood about the gas. I thought it was the filaments themselves that were burning, and I was always puzzled why they didn't get burned up."

Her hand lay in his, chill and lifeless, like the corpse of a bird. "Tell me what happened," he said again.

308

She turned her face to him and blinked slowly. She had stopped shaking, and all her movements now were ponderously slow, as if she were moving under water. "He cursed at me," she said, "and crushed my wrist in his hand. I thought he was going to break the bones." She took her hand from his and drew back the cuff of her blouse from her other hand and showed him the bruises. "You see? I couldn't believe the strength of his grip."

Quirke stared at the livid marks on her wrist, his mouth twitching. "What did he say?"

She turned to look at the fire again. "He said to tell you," she said, "that he was from Mr Costigan, and that Mr Costigan wanted you to know that he was keeping an eye on you."

He let the telephone ring for a long time, and was about to hang up when Isabel answered. She sounded sleepy and irritated. "Who is this?" she demanded. He said he was sorry, he knew it was late but he needed her to come round. "Phoebe is here," he said. "She's had a fright." Isabel was silent for a moment. He supposed she was disappointed; no doubt she had thought he was calling because he was lonely and wanted her company. "Of course, I'll come straight away," she said, trying to inject warmth into her voice and not quite succeeding. In the midst of a squabble recently she had said she was tired of hearing him talk about Phoebe. "In fact," she had said, putting a hand on her hip and striking a pose, "I have to say I'm disenchanted in general with your daughter, whom you spoil, and whose

309

whims and fantasies you indulge." He would have been angrier had he not been distracted by the thought that she might have rehearsed this speech, for certainly she had delivered it as if she were on stage. They had been friends once, she and Phoebe; Isabel was another thing he had taken from his daughter.

He went back to the living room. Phoebe was sitting forward in the armchair, nursing her bruised wrist in her other hand and gazing intently at the fire. He thought of her as a child, in Mal and Sarah's house, sitting like this before the gas fire there, wondering why the filaments did not burn away.

Fifteen minutes later Isabel arrived, brisk and bright as a hospital nurse, the heavy fur of her coat exuding the coolness of the spring night outside. She sat on the arm of Phoebe's chair and held her undamaged hand, as Quirke had held it a while ago. "The troubles your father gets you into," she said, clicking her tongue. She glanced over her shoulder at Quirke. "Who is this Costigan person and why is he sending you warnings?"

Quirke was lighting a cigarette. "He's what you might call a manager, I suppose. He makes things happen, or prevents them."

"Is he the one who had you beaten up, that time?"

"Yes, I think so."

He came forward and stood with his back to the fire. Phoebe sat, silent and staring, like one of El Greco's afflicted saints. Isabel regarded Quirke, shaking her head. "And how have you annoyed him this time?" she asked.

"I'm not sure."

"That means you know but you're not prepared to say." He offered her a cigarette but she waved it away. "It's one thing to have you beaten up," she said, "God knows, I often think of doing the same thing myself, but sending thugs to attack your daughter in the street, that's too much."

"Yes. I know."

"It's to do with Jimmy Minor's death, isn't it?" She looked down at Phoebe. She was still holding her hand. "Phoebe? Is it?"

Phoebe shrugged listlessly. "I don't know," she said. She lifted her eyes and looked at Quirke. "Is it, Quirke?"

He sighed, and leaned an elbow on the mantelpiece and told them about Packie the Pike, and what Packie's woman had told him. When he had finished they were silent, all three, for a long time. Then Isabel spoke. "So he was killed by mistake, Jimmy Minor?" she said, with bitter incredulity.

"I don't think I'd call it a mistake," Quirke said. He considered the toes of his shoes. "Someone had to die, and it couldn't be the priest."

Isabel snorted. "Why not? He raped their child."

"Jimmy should have stayed out of it," Quirke said.

Phoebe looked up at him, frowning. "Are you saying it was his own fault?"

"No, I'm not saying that. He didn't know the kind of people he was getting involved with."

Isabel was suddenly indignant. "A pack of tinkers —?" she began.

"Not just them," Quirke said. "Costigan, the Church. All that." The moon, he saw, was in the window here, too, its crooked face leering down.

"How did Jimmy know about it?" Phoebe asked. "How did he find out about this priest, and what he'd done?"

"Someone must have told him," Quirke said.

"Who?" Isabel demanded.

"The same person who told me."

Isabel was watching him closely now. "The tinker's woman? You seem to have had quite a cosy chat with her."

Quirke said nothing to that, and turned away.

Another silent interval passed, then Isabel spoke again. "So: what will you do?" she asked.

"I'll talk to Hackett," Quirke said.

"Your detective friend?" Isabel curled her lip. "And what will *he* do?"

"He'll go after Packie Joyce."

"Will he arrest him?"

"I don't know. He'll try to get Packie's sons back from England. If they can be found."

Phoebe suddenly stood up, letting the blanket fall from her shoulders. "Nothing ever happens," she said in a thin, bitter voice. "People commit murder and get away with it." She looked at Quirke, her lower lip trembling. "You let them get away with it."

Quirke stepped forward, putting out a hand, but she drew away from him quickly. "Don't touch me," she said.

312

"Nobody kills a priest," Quirke said, his voice gone weary. "Not even the likes of Packie Joyce will kill a priest. It's what I said — Jimmy should have stayed out of it."

There was a brief silence, then Isabel rose from where she had been sitting on the arm of the chair. "Come on, Quirke," she said, "walk your daughter home. I'm off."

They waited in the street for a taxi, and when one came Isabel turned to Quirke and kissed him quickly on the cheek and gave him a hard look, gazing searchingly into his eyes, then stepped away and said she would phone him in the morning. Quirke and Phoebe watched the taxi drive off, then turned and walked up the street, across the crescent, past the Pepper Canister. The moon was bright enough to throw sharp-edged shadows athwart the pavements. The wind had dried up most of the rain but here and there patches of dampness persisted, gleaming like pewter. At the corner of Herbert Place Quirke glanced across at the canal in the darkness and the towpath leading away into the denser darkness under the trees.

"Is that girl staying with you still?" he asked. "Jimmy's sister?" Phoebe nodded, tight-lipped; she was still angry at him. He did not blame her; he was angry at himself. "Will you tell her what I've told you?"

"I don't know," Phoebe said, keeping her eyes fixed straight ahead.

A white cat crossed the road in front of them, padding along swiftly with its belly low to the ground.

When it reached the railings on the other side it stopped, with one paw lifted, and looked back at them, its eyes flashing like shards of glass. Quirke thought of Packie's woman, felt again her hand on the back of his neck, her lips on his. He was tired; he longed for sleep.

They came to the steps of Phoebe's flat. She had her key in her hand. He asked if she would like him to come up with her, but she said no, she would be all right. "Tell her," he said, "tell Jimmy's sister I'm sorry."

Phoebe opened the door of the flat and went in. There was a smell of cocoa still. For a second she felt all the crushing weight of the world's banality and indifference. She took off her coat and hung it on a hook on the back of the kitchen door. She paused, taking a deep breath, then walked forward, into the living room, where Sally, standing by the window, turned to her with a strained, expectant look, and lifted a hand to her hair.

Later, lying in bed, Phoebe gazed up into the darkness, nursing her aching wrist against her breast. Her eyes felt scalded but she could not sleep. She and Sally had gone and sat at the kitchen table, as they had sat that first night, and Phoebe had talked while Sally listened, the darkness pressing eagerly against the tall window beside them, as if trying to overhear what was being said. Now and then a car went past, and once someone had laughed in the street, directly below. As she spoke, Phoebe had the impression of pouring something, some clear, cold liquid, into a bottomless vessel. Sally, even as she sat there, seemed to be moving away from her, sliding backwards smoothly, silently,

inexorably, as if the walls all around them had dissolved and they were suspended in space, two planets locked in mutual repulsion. At the end, when Sally knew everything that Quirke had found out, she had risen from her chair and walked into the living room and stood again at the window, her arms folded, holding herself tightly, staring out into the dark. Phoebe had left her there, and gone into her room and undressed quickly and got into bed and turned out the light. But sleep would not come.

Now she thought of David. Had he and Sally kissed, in that brief moment when they were alone? She found she did not care. Nothing would ever be the same again.

At last she fell into a restless sleep. She dreamed of the man in the sheepskin jacket, except that in the dream he was also Jimmy Minor. *Tell Quirke*, he said, *that I'm watching him*. And he laughed.

A chink of sunlight coming in at the window woke her. She lay for a moment, listening, testing the silence. Nothing came back. She went out to the living room. Sally was gone: she had packed her things and slipped away in the night. On the table, there was a note, scrawled with a pencil in large letters on the inside of a torn-open Craven A packet. *Thanks. S.* In one of the loops of the S there was a small, bone-white button. Phoebe stared at it, then picked it up and put it to her lips.

He had always loved the trappings of his faith, the heavy silk vestments in their gorgeous hues of green

and blue and purple, the mingled perfumes of incense and lilies, the glint of candlelight on paten and pyx, the weight of the jewel-encrusted chalice when he lifted it in both hands above his head and the altar-bells behind him began their urgent jangling. It was, he knew, a kind of idolatry, but he felt the Lord would forgive him, since the Lord forgave so much. Yes, he loved the Church and all it stood for, yet on mornings like this, dank and rainy, he could not prevent his heart sinking when he came through from the sacristy and genuflected before the altar, under the ruby eye of the sanctuary lamp, and felt the chill of the marble floor strike upwards into his bones.

The nave was dim and draped with tall shadows. Crossing himself, he proceeded with grave tread from the altar and down the side aisle towards the confessional, counting out of the corner of his eye — one must not be seen to look directly — the number of penitents awaiting him. There they knelt in line, hunched and meek, the two old biddies who were his regulars, a bald, portly fellow he had not seen before (a Guinness clerk, he surmised, or something lowly in a bank), three restive schoolboys and a woman in a fur coat and a hat with a black veil. He set his name-tag in the slot above the door of the confessional and stepped into his place in the central box that always reminded him of an upright coffin. He was pulling the narrow double doors closed before him when he glimpsed a young woman approaching along the aisle. She was plainly pregnant. His heart sank deeper in his breast. Pregnant girls were always difficult.

In the gloom of the confessional he settled himself on the narrow seat and heard the two old women enter the penitential boxes to right and left of him, and kneel. He slid back the wooden panel by his right ear and dimly glimpsed the vague old face beyond the grille. *Bless me, Father, for I have sinned* . . . He knew already what the list would be — envious thoughts, inattention at mass, a sixpence diddled from the greengrocer — and he let his mind wander. Africa. His beloved Nigeria, where he had spent three happy years as a missionary. Big-bummed women, the men all grins and gleaming teeth, and the children, with their chocolate skin and potbellies. Simple souls, eager to please, yearning to be loved. He closed his eyes. Loving, that was the problem. The image rose before him of two native children, a boy and a girl, brother and sister, naked, standing hand in hand in sunlight with their backs to him, their faces turned, smiling at him over their shoulders. He recalled the feel of their dark, gleaming skin, the softness, the velvety warmth of it. Such innocence, such — such fragility. Bless me, Father, for I have sinned.

He had forgotten about the young woman until her turn came. He was tired, tired of people's petty weaknesses, of their earnests of contrition, of their self-delusions, their evasions. In Africa, sin was colourful, a joyful glorying in all the dark possibilities the world had to offer. Here, these poor people, his own, were too small in spirit to be damned. Yes: Africa. He was glad to be returning there.

At first the young woman said nothing. He supposed she was steeling herself, working up her courage.

Unmarried, no doubt. "What is it, my child?" he asked softly, leaning his ear towards the grille. "Are you in trouble?"

"I don't go to confession any more, Father," she said.

He smiled, sitting there in the shadows. "Well, you're here now. What have you to tell me?"

Again she was silent. He tried to make out her features, but she kept her head lowered, and anyway it was difficult to see through the grille. He caught a whiff of her perfume. She was nervous; she seemed to be trembling. This was going to take a long time and require much finesse on his part.

"I've nothing to tell you," she said. "But I want to ask you something."

"Yes, my child?"

She paused, then gave what seemed a laugh, bitter and brief. "Who forgives you *your* sins, Father?"

He felt a shivery sensation, as if a drop of icy liquid had coursed down his spine. "God does," he said. "Who else?"

"And does He see into your conscience, do you think?"

"Of course. God sees everything, inside us and out." He let his voice go gentle. "But it's not my conscience we need to speak of here, is it?"

"Oh, yes, Father, it is."

He drew near to the grille again and tried to see her. "Do I know you, my child?" he asked.

"No," she said. "And I'm not your child."

She was doing something to her clothing, fumbling with something. He saw a glint of metal, too. "You're

troubled," he said. "Tell me what it is." What was she doing? What was it she had in her hand? "Who are you?" he said. "What is your name?"

She did not speak. He turned his head away from her and looked down at his clasped hands where they rested on his soutane. The stole around his neck, a tasselled silk collar, was as white as bare bone.

She was afraid her nerve would fail her. She had thought everything out, had gone over it again and again in her mind, hardening herself. This was, she knew, the only way. Phoebe's father would not do anything; neither would the police. It was up to her to make sure justice was done, and now she was going to do it. Were there people outside, she wondered, in the church? She had waited for nearly half an hour, loitering in the dimness just inside the door, until no more people were coming to join the line awaiting confession, but she could not be sure that latecomers had not arrived since she had slipped into the box. Anyway, a church was never completely empty: there were always those vague old men who attended to things, lighting candles, putting fresh flowers on the altar, whom no one ever noticed. Well, she would have to risk it. Even if she were seen, who would remember what she looked like? The place was barely lit, and people never remembered details, or if they did they always got them wrong.

She pulled the cushion she had taken from Phoebe's flat from under her blouse, not without difficulty — there was so little room — and wrapped it around the

pistol. He had turned aside, offering her his profile behind the grille. She heard him sigh. Should she say something, give him some warning, however brief? He would want to pray, make an act of contrition. She did not believe in any of that stuff any more. She drew the cushion tighter around the gun. Her finger was on the trigger.

James, she said to herself. *Oh, Jimmy.*

It was a terrible noise. It seemed the confessional had exploded around her, and she was deafened for a moment. The flame from the barrel had set the cushion on fire, and she dropped it quickly and trampled it with her knees, singeing her stocking. The smell, too, was awful, of powder and burning feathers. She glanced in through the grille, in which there was a ragged hole, the tips of the torn wires still smoking.

He was slumped to the side, a dark stain spreading below his ear. She heard someone shout *Oh, Jesus!* She scrambled up and pushed open the narrow door of the confessional with her knee, almost tripped on the smouldering cushion, then was out and running down the aisle. The gun fell out of her hand and skittered along the flagstones; she ran after it and stopped it with her foot, snatched it up, ran on. There were voices behind her, a man shouting and someone screaming. When she got to the door a woman in a headscarf was coming in, and the two of them collided and grappled clumsily for a moment, before she freed herself and got through. She had an urge to keep running but knew that she must not.

Outside, a heavy shower of rain had started, and the people in the street were hurrying along through the gloom with their heads down. No one looked at her, no one paid her any heed. She walked on, with her hands in her pockets, clutching the pistol. It was still hot.

She got on a bus. It was crowded, and rolled drunkenly through the rain-washed streets, trumpeting now and then like an elephant. She watched the blurred windows of the shops passing by. Her mind was numb, she felt nothing, nothing. They would cover it up, she supposed, as they covered up everything, every scandal.

No, she did not care. Yet it came to her that of all the things she had done in her life, most of them could have been undone. But not this.

In the station she set off to collect her bags from the left luggage place, but first went into the Ladies. It was only then, looking in the mirror there, that she saw the speckles of blood on her face. His blood. She did not care. She had got justice for her brother. She had done what was needed.

CHAPTER
TWENTY-ONE

When she looked out of the window she was startled to see Quirke standing on the far pavement, by the railings above the towpath, in a splash of sunlight under the trees, where that other time she had seen the man in the cap and the sheepskin coat with the cigarette in his fist. Quirke spotted her at the window and lifted his hand in an oddly tentative wave that seemed to her more like a gesture of farewell than greeting. What was he doing out at this hour? For Quirke was anything but an early bird.

She had been about to leave for work, and now she put on her coat and took up her handbag and ran down the stairs, thinking something must be wrong, that something calamitous had happened, and Quirke had come to tell her about it.

He was lighting a cigarette as she crossed the road. Instead of greeting her he pointed a finger upwards at the cloudless, china-blue sky. "Do you realise," he said, "that it hasn't rained in the last ten hours?"

She laughed, mostly from relief — if there had been bad news Quirke would have told her at once. "How do you know?" she said. "Have you been up all night, watching the sky?"

"More or less. I'm not sleeping much, these days."

She regarded him quizzically. "Why didn't you ring the bell?"

"It was pleasant, standing here." He glanced about. "Memory Lane, for me, around here."

"Quirke, I'm on my way to work."

He smiled at her vaguely, thinking of something else, she could see. "Take an hour off," he said.

She laughed again. "I can't! How can I?"

"Oh, come on. I'll square it with Mrs Cuffe-Dragon. There's something I want us to do."

"What is it?"

"You'll see. It's on the way."

He took her by the elbow and they turned and set off in the direction of Baggot Street. It was indeed a fine spring morning, bright and clear, the air all flashes of gold and fragile blue. The trees above them bustled with birds. The sawmill on the other side of the canal was busy already, and the fragrance of freshly cut wood was a kind of grace-note amid the smell of exhaust fumes and the smoke from buses.

They had gone some way before either of them spoke again. "Have you heard from her?" Quirke asked.

"From Sally? No, of course not. What about Inspector Hackett? Has he had news of her?"

"They traced her as far as Holyhead and the London train. She didn't return to her flat. She may not be in London — she could have got off that train anywhere along the way."

"She's disappeared, then." She smiled wryly. "Maybe she and April Latimer will meet up somewhere. My two vanished friends."

Quirke glanced at her. "*Was* Sally your friend?"

"Yes. Yes, she was, in a way, I think."

Again they walked in silence. Then Quirke said, "You didn't have to tell me about the gun. Why did you?"

"When she disappeared I knew she was going to do something." She paused. "Why didn't you warn that priest?"

Quirke did not answer. They walked on. Baggot Street was a sweep of sunlight, hard-edged, pale gold, glistening. Mr Q and L was standing in the doorway of his shop, smoking a cigarette. He was wearing his canary-yellow waistcoat today — it fairly glowed in the sunlight. Even though she was on the other side of the street he recognised her, and sketched a comically elaborate bow, inclining his big round head and making a hoop with his hand from chin to navel and showing her his palm, cavalier-fashion.

"I spoke to Hackett about Costigan," Quirke said, "about him sending that fellow after you."

She said nothing. She was not sure she wanted anyone knowing what had happened that night in the rain when the man in the sheepskin coat had overtaken her and grabbed her by the wrist. She wanted to forget it herself, as if it were something indecent that had been done to her and the only way to get rid of the stain would be to expunge even the memory of it. "It seems," Quirke went on, "he's been fiddling his tax, the

324

same Mr Costigan. Hackett thinks he can get him that way."

"Like Al Capone," Phoebe said drily.

"Exactly," Quirke said, ignoring or perhaps not noticing her sarcasm. "Like Al Capone."

"And what about those tinkers, the ones who killed Jimmy?"

"Disappeared too, like your friend Sally, into the depths of darkest Palantus."

"Palantus?"

"It's their name for England."

The trees along Baggot Street leading into Merrion Row were delicately dusted with the season's first green buds. "I'm thinking of going away," Phoebe said.

"Oh, yes? Where to?"

"I don't know. London, maybe." She smiled. "Palantus."

"For how long?"

"I don't know that, either." She looked down at the toes of her shoes. How odd it was, sometimes, to see oneself in motion, one foot going in front of the other, turn and turn about. "On my next birthday I'll have my money from Grandfather Crawford."

Josh Crawford, Rose's first husband, had left his granddaughter a considerable legacy in his will. "You'll be an heiress," Quirke said. "Watch out for fortune-hunters." He paused. "What about Sinclair? — David, I mean."

She dropped her eyes and looked at her shoes again. "What about him?"

"Have you told him you're going away?"

"I haven't decided finally, yet," she said, in a neutral voice.

They walked on. The doorman at the Shelbourne in his grey coat greeted them, lifting his top hat. Across the street a line of jaunting cars was parked, the horses steaming in the sun.

"How did they keep it out of the papers?" Phoebe asked.

"Holy orders, from on high. The Archbishop's Palace telephoned the newspapers, told them the Church was treating Honan's death as an internal matter and said no report of it was to be printed yet, until they'd completed their inquiry."

"Can they do that? Can the Church do that?"

"They can. Carlton Sumner, at the *Clarion*, raised an objection, of course. The archbishop himself phoned him. His grace was prepared, he said, to hurt Sumner where it would really hurt — in his pocket, that is."

"What did he mean?"

"Oh, the usual. If Sumner went ahead and printed the story, the bishops would be directed to write a pastoral letter to be read out from every pulpit in every church in the country next Sunday morning, instructing the faithful to shun not only the *Clarion* but all of Sumner's other publications too. And the faithful, as always, would obey. It's what's known as a belt of the crozier. It's very effective."

Phoebe was shaking her head incredulously. "Poor Jimmy," she said.

They crossed at the top of Dawson Street. A chauffeur in a peaked cap was manoeuvring a long,

326

sleek Bentley through the narrow entrance way of t.
Royal Irish Automobile Club.

"I might be going away myself," Quirke said,
glancing at the sky.

"Away? Where to?"

He smiled. "Like you, I'm not sure."

Phoebe nodded. "I'll ask you a version of the same
question you asked me: what about Isabel?"

"No," Quirke said, "Isabel won't be coming with me.
If I go."

In front of Smyth's on the Green there were daffodils
set out in pots. Quirke had never been able to see the
attraction of these vehement, gaudy flowers.

"Where *are* we going?" Phoebe asked.

"Just here," Quirke said, pointing across the road to
Noblett's sweet shop on the corner of South King
Street. In the window were displayed all manner of
confections, set out in the shop's own royal blue boxes.
They crossed the road, and as they entered the shop the
little bell above the door gave its silvery tinkle. The girl
behind the counter was tall and soulful, with pale
features and long black hair. She smiled at them wanly.

There used to be, Quirke said to the girl, a box of
sweets called, if he remembered rightly, Fire and Ice.
"They were pineapple-flavoured, and the sweets came
in two sorts, clear amber and a white crunchy kind. Do
you still sell those?"

"Of course, sir," the girl said. She came from behind
the counter and opened a narrow panel behind the
display window and reached an arm through.

Phoebe was watching Quirke with a puzzled smile. Don't you remember?" he said. "I used to bring you here every Christmas when you were little and buy you a box of them — Fire and Ice."

"Oh, yes," Phoebe said. "Of course — of course I remember."

"Here you are, sir."

The girl held up the box for Quirke to see. Under the cellophane covering the sweets were as he had described them, light amber and chunks of snowy white.

"Yes," Quirke said, and had to smile. "Yes, that's them."

They walked in St Stephen's Green, under the budding trees. The sunshine for all its brightness gave little warmth, and the air was sharp. Ducks waddled on the path beside the pond, waggling their tails and quacking. "This is where we used to come, then, too, after we'd been to Noblett's and you had your sweets. Then we'd go to the Shelbourne and you'd drink hot chocolate and put your sweets under the table and eat them on the sly."

Phoebe nodded, smiling. She had the box of sweets under her arm. "Tell me where you're going, Quirke," she said.

"Hmm?" He looked at her distractedly, calling his thoughts back from the days when she was young and still thought he was her uncle.

"You said you were thinking of going away."

"Did I? Oh, I don't know. I may have to go. We see." He stopped, and put a hand on her arm and mac her stop with him. "I'm sorry, Phoebe," he said.

She gave him a puzzled look. "For what?"

"For everything." He gazed at her, still holding her by the arm, smiling at her helplessly. There was so much to say, and, he realised now, no way of saying it. It seemed to him this girl, so pale, so serious, so intent, was the only creature he had ever loved. He had got Delia while wanting Sarah, her sister, but getting and wanting, what had these to do with love? "I wronged you," he said, "I wronged you grievously, and I'm sorry."

She looked at his hand on her arm. "You're beginning to frighten me, Quirke," she said.

"Yes, I know." He shook his head in annoyance at himself. "I shouldn't try to —" He stopped, and took his hand from her arm and let it drop to his side. "The fact is," he said, with a sad, lopsided smile, "it's too late, isn't it?"

"Too late for what?"

"For everything," he said again.

He leaned his face down suddenly and kissed her cold cheek. Then he gave her that strange, crooked smile again, and turned and walked away.

She watched him go, through light and shade, under the trees. When she could no longer see him she went and sat down on a metal bench. In the flowerbed beside her the daffodils leaned their heads as if listening to some far, faint sound. She set the box of sweets on her lap and laid her hands on it. It was wrapped in brown

..per and tied with string. She had no memory of Quirke bringing her to that shop, all those years ago; no memory at all. What had he called the sweets? Fire and Ice? Yes, she thought: fire and ice.

Quirke watched the clock on the wall of the waiting room. It had a clay-white face and long, spindly black hands. It was an electric clock, he saw, for the second hand swept round and round in smooth, swift circles. He remembered the clocks in Carricklea, big wooden affairs that old Crowther, the janitor, wound once a week, with a big shiny key. They had Roman numerals, and their second hands progressed in a series of tiny jerks, quiveringly. What became of things, he wondered, things like those old clocks? They would hardly be there still, would they? Carricklea had been shut down a decade ago; the building was empty now, so far as he knew. Would someone have bought the clocks, some local watchmaker, maybe, or tinkers, looking for a bargain? He thought of the tinker woman, Molly, intently rolling her cigarettes in the light of the oil lamp, her black hair gleaming. He remembered the taste of her mouth, its wild tang.

There were two other people waiting. Patients. Was he a patient, too? Not yet, strictly speaking. They had put him to stand against the cold metal plate, with a lead blanket to protect his chest from the radiation. "Quite still now, please, Dr Quirke!" The machine, pointing at his head, had whirred a moment, and it was done. The radiologist had given him the X-ray plate in a buff envelope and sent him upstairs, where he had

330

handed the envelope to the receptionist, a steel-haired woman with butterfly glasses who had smiled at him coldly, showing her teeth, and directed him to a chair while she went into the consultant's office, with the envelope.

Ten past ten on a sunny weekday morning. Through a tall window on the far side of the room he could see down the length of a narrow garden to the mews at the back of Fitzwilliam Place. Rain and shine, rain and shine, turn and turn about. Volatile weather, the world busying itself, fraught with burgeoning life.

Twelve minutes past.

Of the two waiting with him, one was a middle-aged woman, handsome, with permed auburn hair and worried brown eyes. She kept opening her handbag, searching in it, then shutting it again with a sigh. She had smiled at him when he came in, with that important-looking envelope in his hand, which she had pretended not to see. An envelope that big had to have something serious in it. Maybe she had handed hers in already.

The other person was a young man with a cocky expression and narrow oiled black sideburns. He reminded Quirke of someone, though he could not think who. He had a jittery leg, the left one, it beat away like the arm of a sewing-machine, the knee fairly bouncing, though he seemed unaware of it.

He had been about to leave the flat, on the way here, when the telephone had rung, and he had stopped, hat in hand. Who would be calling him at this hour? He thought of not answering it, but then picked up the

receiver. Hearing Hackett's voice, he put it down again, without a word. He did not want to speak to Hackett now. Whatever it was, it would have to wait.

The receptionist came out of the consulting room. She had a curious way of opening the door only some inches and insinuating herself around it and then closing it soundlessly behind her. Was it that she had instructions to let none of those waiting have even a glimpse into that secret inner place, before their turn came to enter and be told the good news or the bad? She sat down at her desk. Quirke had always liked the way that women, before sitting down, would run a hand deftly under the seat of their skirts, smoothing them out.

Isabel. He should have called Isabel. If the news Philbin had for him was bad, it would be all the harder now to break it to her. Yes, he should have called her, should have told her where he was, what he was waiting for, so she would be prepared.

The woman with the perm was first in. Sweetman was her name, he heard the receptionist say it. She rose, clutching her handbag, and walked forward towards the white door, starkly smiling. Sweet Mrs Sweetman. Quirke silently wished her well. He and the young man exchanged a blank look. Frankie the barman! That was who he looked like — the same smooth hair and blue-shadowed chin, the same oily glance, the same cockiness.

Fifteen minutes past. The second hand swept on, unfaltering.

He sneezed violently, making the receptionist sta
and stare at him. His cold was coming along nicely.

At half past, Mrs Sweetman emerged from the
consulting room. Quirke and the fellow who looked like
Frankie scanned her face surreptitiously, searching for a
sign. She gave none, and passed them by, leaving a
trace of her perfume on the air.

Quirke sat back on the chair and folded his arms. He
had time left, Frankie boy would be next. But he was
wrong. The receptionist was looking at him, smiling her
polite, frigid smile. She nodded. "Mr Philbin will see
you now, Dr Quirke," she said. Mister. Doctor. She
knew the hierarchical niceties.

He rose and stepped forward, leaden-footed, and as
he did so he saw in his mind yet again that path by the
canal, and the darkness, and the darkly attendant trees,
and someone walking towards him, out of the night.

Author's Note

Cant, or Shelta, is the secret language of Irish travellers who, in the 1950s, were known universally, and unpejoratively, as tinkers. The origins of this colourful patois are obscure, and travellers are still reluctant, understandably, to reveal a full vocabulary. The word "Cant" probably comes from the Irish word *caint*, meaning "talk". "Shelta" may be a corruption of *siulta*, the Irish word for "walking", as in *Na Daoine Siulta*, the "Walking People".

Two authoritative sources on Cant are *The Secret Languages of Ireland*, by R. A. S. Macalister (1937) and "Irish Tinkers or 'Travellers': Some Notes on Their Manners and Customs and Their Secret Language or 'Cant' ", by Pádraig Mac Gréine (*Béaloideas*, 1931).

Glossary of Cant words used in the text

aras: soft in the head
cuinne: priest
gatrin: child
granen: pregnant
grit: sick

mugathawn: fool
mull: woman
nyaark: rascal
Palantus: England
shade: policeman
shako: sin
sharog: a red-haired person
spurk: fornicate
sramala: robber
sreentul: friend
sringan: drink (alcoholic)

My thanks to

OLIVIA O'LEARY,

and, as ever, to

DOCTOR GREGORY PAGE,

who knows everything there is to be known
about injury, dying and death

Vengeance

Benjamin Black

On the east coast of Ireland, Victor Delahaye, one of the country's most prominent citizens, takes his business partner's son out sailing. But once at sea, Davy Clancy is horrified to witness Delahaye take out a gun and shoot himself dead. This strange event captures the attention of Detective Inspector Hackett and his friend Pathologist Doctor Quirke. The Delahayes and Clancys have been rivals for generations and the suicide lays bare the perplexing characters at the heart of the mystery, from Mona, Delahaye's young widow, to Jonas and James, his enigmatic twin sons; and Jack Clancy, his down-trodden, womanizing partner. And when a second death occurs, Quirke begins to realise that terrible secrets lie buried within these entangled families; and that in this world of jealousy, ruthless ambition and pride — nothing is quite as it seems . . .

ISBN 978-0-7531-9158-3 (hb)
ISBN 978-0-7531-9159-0 (pb)

A Death in Summer

Benjamin Black

When newspaper magnate Richard Jewell is found dead at his country estate, clutching a shotgun in his lifeless hands, few see his demise as cause for sorrow. But Doctor Quirke and Inspector Hackett realise that, rather than a suicide, "Diamond Dick" has in fact been murdered. Jewell had many enemies and suspicion soon falls on one of his biggest rivals. But as Quirke and his assistant Sinclair get to know Jewell's enigmatic wife Francoise d'Aubigny, and his fragile sister Dannie, it becomes clear that all is not as it seems. As Quirke's investigations return him to the notorious orphanage of St Christopher's, events begin to take a much darker turn. Quirke finds himself reunited with an old enemy and Sinclair receives sinister threats. But what have the shadowy benefactors of St Christopher's to do with it all?

ISBN 978-0-7531-8920-7 (hb)
ISBN 978-0-7531-8921-4 (pb)

Elegy For April

Benjamin Black

As a deep fog cloaks Dublin, a young woman is found to have vanished. When Phoebe Griffin is unable to discover news of her friend, Quirke, fresh from drying out in an institution, responds to his daughter's request for help.

But as Phoebe, Quirke and Inspector Hackett speak with those who knew April, they begin to realise that there may be more behind the young woman's secrecy than they could have imagined. Why was April estranged from her powerful family, the Latimers? And who is the shadowy figure who seems to be watching Phoebe's flat at night?

As Quirke finds himself distracted from his sobriety by a beautiful young actress, Phoebe watches helplessly as April's family hush up her disappearance. But when Quirke makes a disturbing discovery, he is finally able to begin unravelling the web of love, lies and dark secrets that April spun her life from . . .

ISBN 978-0-7531-8774-6 (hb)
ISBN 978-0-7531-8775-3 (pb)

The Lemur

Benjamin Black

William "Big Bill" Mulholland is an Irish-American electronics billionaire. An ex-CIA operative, he now heads up the Mulholland Trust, with the help of his daughter Louise. When he gets wind of a hostile biography planned for him by the investigative journalist Wilson Cleaver, he commissions his daughter's husband, John Glass, to pen the official line. Former journalist Glass employs a researcher to find out "all the facts", but is horrified when the young man tries to blackmail him, fearing that his own secrets, as well as the Mullhollands', are at risk. He slings him off the project, only to hear from the NYPD that the man he has nicknamed "the Lemur" has been found fatally shot . . . Silence cannot be bought — even by one of New York's wealthiest families.

ISBN 978-0-7531-8272-7 (hb)
ISBN 978-0-7531-8273-4 (pb)